Valerie Mendes is Chief Curator of the Textiles and Dress Department at the Victoria and Albert Museum. She began her career at Manchester University's Whitworth Art Gallery, and has curated numerous exhibitions and published widely on twentieth-century fashion and textiles.

Amy de la Haye is Senior Research Fellow at the London College of Fashion and is a freelance dress historian, curator and creative consultant. From 1991 to 1998 she was Curator of Twentieth-Century Dress at the Victoria and Albert Museum. She has lectured widely and published extensively on the subject of twentieth-century fashion.

## World of Art

This famous series provides the widest available range of illustrated books on art in all its aspects. If you would like to receive a complete list of titles in print please write to:

THAMES & HUDSON
181A High Holborn
London WC1V 7QX

In the United States please write to:

THAMES & HUDSON INC.
500 Fifth Avenue
New York, New York 10110

Printed in Singapore

Mrs Charles James, in a gown by Charles James, *c.* 1948.
Photo by Cecil Beaton.

**Valerie Mendes**
**Amy de la Haye**

# 20th Century Fashion

280 illustrations, 66 in color

THAMES & HUDSON

*For Peter and Sam*
*For Kevin and Felix*

© 1999 Thames & Hudson Ltd, London

First published in paperback in the United States of America in 1999 by Thames & Hudson Inc., 500 Fifth Avenue, New York, New York 10110

Library of Congress Catalog Card Number 98-61433
ISBN 0-500-20321-0

Designed by Liz Rudderham

Printed and bound in Singapore

# Contents

6    Foreword

Chapter 1
10    1900–1913: Undulations and Exotica

Chapter 2
48    1914–1929: La Garçonne and the New Simplicity

Chapter 3
76    1930–1938: Recession and Escapism

Chapter 4
104    1939–1945: Rationed Fashion and Home-Made Style

Chapter 5
126    1946–1956: Femininity and Conformity

Chapter 6
158    1957–1967: Affluence and the Teenage Challenge

Chapter 7
192    1968–1975: Eclecticism and Ecology

Chapter 8
220    1976–1988: Sedition and Consumerism

Chapter 9
252    1989–1999: Fashion Goes Global

274    Bibliography
282    Sources of illustrations
282    Acknowledgments
283    Reference index

# Foreword

The ephemeral nature of fashion distinguishes it from other modes of dress such as ceremonial, occupational and ethnographic. In the twentieth century the fashion system came to revolve around the exacting biannual schedule of Autumn/Winter, Spring/Summer collections and was then extended to include mid-season collections and speciality lines. The period witnessed a major shift in the output of top designers, from haute couture, which was, and still is, hand-crafted and custom-made for each client, to the design of cheaper, limited-edition diffusion lines and rapidly manufactured ready-to-wear fashions.

Fashion's inherent obsolescence, whereby clothes are discarded on the basis of the desire for stylistic novelty rather than for utilitarian reasons, generates passionate response from consumers and theoreticians alike. Fashion has been held up to ridicule, condemned as an insidious form of capitalist manipulation and dismissed as a merely frivolous aesthetic phenomenon - since it is forever changing, it can be of no lasting value. In *The Theory of the Leisure Class*, Thorstein Veblen famously highlighted the 'conspicuous consumption' component of fashion as early as 1899 and his description, applied to a lavish ensemble of 1900, holds good a century later for a 'look at me' garment emblazoned with a designer logo.

Fashion has attracted the attention and endorsement of an expanding range of academics, increasingly fascinated by its multi- and inter-disciplinary significance. Thus the work of psychologists, anthropologists, economists, philosophers, sociologists, theatre and film designers, as well as dress historians, has bestowed an academic validity on fashion. Allied to the burgeoning involvement of cultural historians and semiologists, this has led to the recent proliferation of courses in fashion studies at every educational level, from primary school to university. Lacking the comprehensive documentation of other arts, the diverse literature of fashion is now expanding rapidly and can be divided into broad theoretical, historical and object-based strands. A growing preoccupation with personal appearance since the end of the Second

World War, fuelled by ever-increasing fashion coverage in the press and television, 'costume' films and exhibitions, has led to a boom in interest in current as well as historical fashion. The latter has assumed a key role in the business of heritage reconstruction, now a potent part of cultural life in Europe and North America.

What makes fashion so popular is its democratic accessibility: everyone participates in the process of dressing and adornment, experiencing its pleasure and its pain, and, expert or not, everyone feels confident to pass comment. Interpretation of fashion depends not only on incontrovertible facts but also on the standpoint of each commentator. Analysing a collection of twentieth-century garments, a museum curator, a psychologist and an economic historian will inevitably stress different aspects of the history of the clothes, their meaning and their construction. At the end of the twentieth century, the scholarly forum is broadening as specialists share their varying perspectives. And the exclusive world of élite fashion has become more widely accessible as designers establish websites and produce CD-Roms of their catwalk shows.

The constant quest for the new, and the frenetic rate at which the fashion industry necessarily operates (compelled by complex internal forces and external demands) means that traditionally designers have rarely had the time to pause and consider the recording of their own history. Their seasonal collections are dispersed at a retail level, studios hold sample sales and, with the exception of press books, little documentation has been retained. However, this is changing, partly in light of retro-trends and the drive to accumulate factual evidence to deal with the ever-increasing number of copyright disputes. Madeleine Vionnet was exceptional in maintaining meticulous photographic records and actual examples of her creations to safeguard her rights. Long-established firms have come to treasure their surviving archives (however small) as they commission new talents to revamp their future image while exploiting their past. Individual designers and clothing companies now construct their histories by acquiring items from previous collections, often from sales of twentieth-century fashion – a growth area actively promoted since the 1960s by the world's leading auction houses. A plethora of monographs and designer biographies provide illuminating commentaries, the latter occasionally peppered with grandiose claims.

From the mid-1980s, keen to be in the vanguard and increase visitor numbers, museums harnessed the popularity of fashion – even institutions dedicated to the representation of war and the

fine arts presented major exhibitions. Likewise, fashion was embraced by a host of manufacturers alert to its potential in the marketing of a diverse range of goods, from carpeting to motor cars. Single-issue magazines, notably interior design periodicals, broadened their remit to embrace the subject. Academic and commercial interests converged within a few avant-garde boutiques that sold, alongside their experimental designs, progressive fashion publications.

Fashion is an indicator of individual, group and sexual identity. Furthermore, its fluidity reflects shifts in the social matrix. Thus in the early twentieth century, fashion revealed rigidly defined class stratification and protocol while sixty years later it illustrated the erosion of the social hierarchy and the triumph of the young. Over the years, the dominance of high fashion has devolved into an 'anything goes' dynamic which permits consumers to happily juxtapose designer-label clothes with period and ethnic finds as well as with high street bargains. The emergence of youth subcultures, with their own distinctive codes of adornment, originally offered a counterpoint to the prevailing vogue and, perhaps ironically, came to exert a powerful stylistic influence upon international catwalk trends.

*20th Century Fashion* explores the changing discourse of Western fashion throughout a fast moving period that saw a revolution in communications, travel and manufacturing, all of which had a major impact on style and clothing. It moves from the rarefied ambience of Paris couture in the early 1900s to the instant and global accessibility of fashion on the Internet in the 1990s. It shows how top designers in Paris, building on the achievements of nineteenth-century couturiers (not least those of Worth), and supported by the powerful Chambre Syndicale de la Couture (founded in 1868), consolidated their positions, and how, in the second half of the twentieth century, they successfully defended the supremacy of the capital of high fashion. Though Paris remained the fulcrum, however, the development and growth of designer fashion in America, Italy, Britain and latterly in Japan is also examined, emphasizing the interplay between national traits and the international look. In 1999, predicting the emergence of a truly global industry for the twenty-first century, the media coined the phrase 'planet fashion'.

Although it touches on the multiplicity of interpretative methods, this is a chronologically structured survey that concentrates on the significant factual aspects of the evolution of twentieth-century fashion. It focuses on international movements

and highlights works by innovators from each period. Exciting and at times revolutionary developments are put into context by reference to prevailing socio-economic, political and cultural circumstances. Avoiding the arbitrary divisions of the century into decades, chapters are organized around major shifts in style and world events.

Such a compact study precludes minutely detailed analyses and thematic examinations, though pathways for further investigations are provided, supported by an extensive bibliography. While pointing up the main achievements of famous designers (both for fashion and accessories) and outlining the centrality of metropolitan fashion centres, the works of some lesser-known talents are also considered. The significance of mass production and the styles of subcultures are charted and their relationship to high fashion discussed. As all designers testify, fabrics are fundamental to their art, so account is taken of both the exclusive materials of high fashion and the influential 'man-made' inventions of textile scientists in the twentieth century.

By providing a thorough introduction to one hundred years of fashion, it is intended that this text should serve as a catalyst for further explorations in a field that offers limitless opportunities.

# Chapter 1: 1900–1913
## Undulations and Exotica

'La Belle Epoque', 'The Age of Opulence' and 'The Edwardian Era' are familiar names for the period from 1900 to 1914. They conjure up images of groups of elegantly attired men and women of power and elevated social rank engaged in leisurely pastimes – strolling on the promenade at Biarritz, riding in London's Rotten Row, enraptured at the Metropolitan Opera House in New York or yachting at Cowes on the Isle of Wight. In the hands of the Establishment and the *nouveaux riches*, wealth was flaunted in extravagant styles of living and was particularly evident in luxurious dress for women. The dictates of fashion were rigidly followed; to depart from the norm was to risk social ridicule. Status, class and age were clearly signalled by dress. In the early 1900s women's fashion manifested the last vestiges of late-nineteenth-century style. In 1907 subtle changes were discernible, but it was not until between 1908 and 1910, with the advent of Diaghilev's Ballets Russes, compounded by the designs of Paul Poiret, that there was a significant redirection of fashion. Menswear was not subject to the constant decorative fluctuations of female dress but followed a strict sartorial code which emphasized the values of tradition and understatement.

For the style-conscious, affluent inhabitants of cosmopolitan centres worldwide, Paris remained the undisputed home of high fashion. A Paris label was the ultimate endorsement, establishing its owner as an arbiter of taste and a member of fashion's upper echelons. If the genuine article from a prestigious rue de la Paix address was too expensive, the nearest equivalent, made by copyists, had to suffice. Designers and purveyors of clothes took their inspiration from the widely publicized, lavish creations of the great Parisian couturiers. The Exposition Universelle in Paris in 1900 – an auspicious start to the new century – provided an ideal international forum for Parisian designers to proclaim their universal superiority. The Chambre Syndicale de la Confection pour Dames et Enfants arranged an impressive display of works by twenty leading couture houses: 'Les Toilettes de la Collectivité de

1. The *beau monde* in their summer finery at the seaside resort of Deauville in France in 1903. The pale, lavishly trimmed gowns with trained skirts and high-necked, 'pouter pigeon' bodices were typical of high fashion of the period. Expensive accessories – hats adorned with feathers or artificial flowers, long-handled parasols, tiny handbags and kid gloves – completed each ensemble. The elegant man, in immaculately tailored morning coat, almond-toed shoes and straw hat, is Count Mathieu de Noailles.

2. Worth's elaborate display, 'Going to the Drawing Room', at the Exposition Universelle, held in Paris in 1900. Realistic shop window mannequins (with carefully sculpted wax features) were dressed in the designer's finest creations, ranging from a maid's ensemble to a court presentation robe.

la Couture'. The President of the Chambre Syndicale explained that they wished to convey the vitality and importance of their industry, one which imposed its taste and creations on the entire world. The exhibits were remarkable – extravagantly decorated with beads, sequins, embroideries, laces, imitation flowers and a wealth of ruches and ruffles.

Beneath the outer garments that completed her toilette, the fashionably dressed woman of the early 1900s was encased in various layers of underwear. Getting dressed and undressed were laborious, time-consuming tasks requiring the assistance of a lady's maid. First came the chemise and drawers or combinations in fine white cotton, elaborately embroidered in whitework, trimmed with lace, and with narrow ribbon drawstrings. This was followed by the corset, the critical shape-making component which dictated the wearer's deportment and the lines of her outer clothes. Women complained about the discomfort of corsets, and dress reformers, including medical practitioners, deplored the physical damage these garments inflicted on bones and internal organs. Publications such as the quarterly *Dress Review* of the Healthy and Artistic Dress Union urged their readers to discard

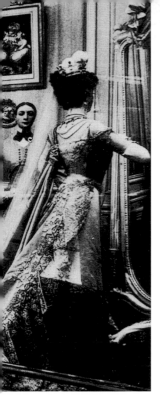

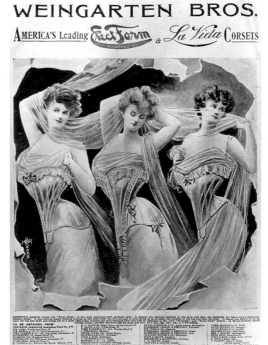

3. *Above right*: The S-bend silhouette that characterized the early 1900s was achieved by rigid corsetry. The American-made corsets shown in this advertisement were displayed in profile to emphasize the pronounced curves and remarkably full monobosoms they would produce. For the sake of modesty, wispy drapery floated around the three figures.

corsets altogether and adopt the less restrictive breast girdle, but those in search of the ultimate shape decreed by fashion were prepared to suffer.

Fashion's mainstream largely ignored the reform movement from its inception in the 1850s to its demise in the early twentieth century. Corsetry was a profitable business and skilled corsetières were in great demand. In the plentiful contemporary illustrations, corsets are given a seductive appeal that belies their true nature. Surviving examples reveal the grim realities of heavyweight coutil (a thick cotton twill fabric), plentiful rigid boning (steel or whalebone) within reinforced casings, and sturdy, centre-front steel busks with heavy-duty stud-and-loop fastenings. The most expensive and showy corsets were made of brightly coloured satin, lined for strength and durability. To achieve the necessary slenderness they were tight-laced through eyelet holes, usually along the centre back. Both long and short corsets were straight-fronted and constructed so as to coerce bodies into desired and apparently desirable S-bend curves with minute waists and low, protuberant monobosoms balanced by rounded posteriors. Most incorporated long elasticated suspenders or hose supporters

3

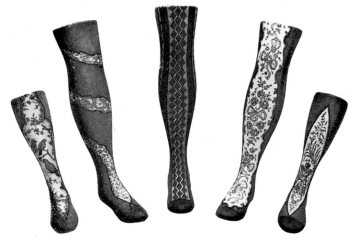

4. Evening stockings were often highly decorative. The motif of the snake curled around the leg (second from left) became especially popular after stockings with sequinned snakes were shown at the 1900 Exposition Universelle in Paris. These French examples date from around 1903.

which had been replacing garters since the late 1880s. These held up a variety of stockings which were carefully coordinated with each ensemble. For day and sporting wear, stockings were usually made in cotton, wool or lisle, either plain or with restrained clocks and stripes. In the evening, an *élégante* would wear de luxe French silk stockings with elaborate lace inlays and embroideries. Stockings with appliqué snakes coiled around the legs were the ultimate in daring. Prettiness was confined to the lower part, for the rare occasions when long skirts swished aside to reveal tantalizing glimpses of feet and ankles.

    Having laced her mistress into voluptuous curves and fastened a delicate corset cover over the stays, a maid would then help her into the first of the day's outfits. Many memoirs, biographies and social and economic histories document this period, providing information on the lives and accoutrements of Western society's fashion-setters, from duchess to demi-mondaine. Sources such as Sonia Keppel's *Edwardian Daughter*, Ursula Bloom's *The Elegant Edwardian* and Consuelo Vanderbilt Balsan's *The Glitter and the Gold* offer valuable commentary on clothes in England, where high society revolved around the court of the pleasure-loving Edward VII and followed the annual pattern established by the London Season. This lasted from the beginning of May until the end of July and included a variety of private functions held at great London houses as well as major public occasions from the races at Ascot to the Eton and Harrow cricket match. After their London revels, the gentry left for summer pleasures abroad. Other European cities and royal courts held their own Establishment events, all of which demanded appropriate attire. The United

States had its Social Register, which identified influential citizens, and in the 1890s Mrs Astor compiled a more exclusive personal list of New York Society known as the 'Four Hundred'. Women of wealth, from aristocrats to cocottes, were required to possess and maintain enormous wardrobes to meet the needs of the social round. A range of gloves, furs, fans and almond-toed shoes, the 'little etceteras of fashion', ensured that each outfit was properly accessorized. A long, slender umbrella, parasol or walking stick frequently provided the finishing touch. 5

Although the cosmetics industry was small-scale in comparison with what it would become after the First World War , makeup and scents became an increasingly important part of the quest for beauty. Considered vulgar at the time, cosmetics were neverthe- 6, 8 less sparingly but skilfully applied within the confines of the boudoir. At the turn of the century *papier poudré* came in small booklets: a leaf passed over the face concealed shiny patches and toned down blemishes. Electrolysis was available for the perma- nent removal of superfluous hair, moles and birthmarks. Much emphasis was placed upon a natural, healthy complexion and

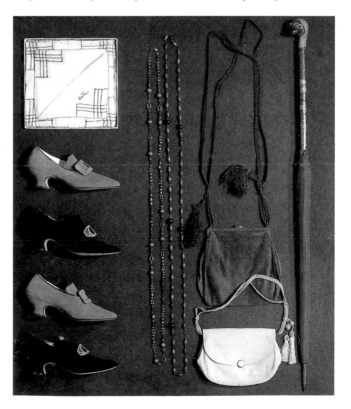

5. Accessories from the period 1908 to 1914: shoes with louis heels, high tongues and almond toes; bags with long handles; long, bead necklaces and a monogrammed pocket handkerchief.

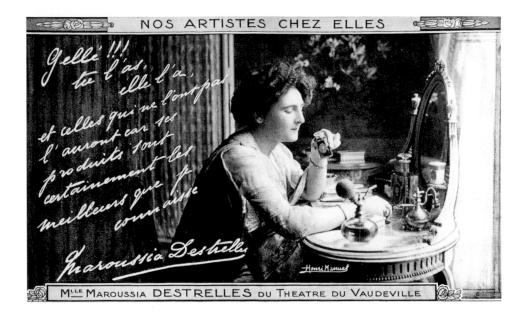

M<sup>LLE</sup> MAROUSSIA DESTRELLES DU THEATRE DU VAUDEVILLE

6. Cosmetics were considered vulgar, so manufacturers advertised with care. Sometimes, as in the advertisement above, actresses were called upon to endorse certain products: Mademoiselle Maroussia Destrelles of the Théâtre Vaudeville, Paris, lent her name to the manufacturer Gellé.

7. For those whose natural hair was not plentiful enough to achieve the full, upswept styles of the period, help was at hand. Hairdressers, among them Marius Heng (of Paris), offered hairpieces (postiches) that would provide the body and deep waves that were considered essential. Marius Heng also offered special hairpieces in white or grey for balding or ageing women. From *Femina*, 1905.

Marius Heng

ses postiches

33. Rue Bergère

Pour avoir de beaux cheveux, il faut les bien soigner et pour ne les point casser en les ondulant, se coiffer avec les postiches de la Maison

*Marius Heng*

*Marius Heng*

fait, pour dame chauve âgée, des modèles spécia en cheveux blancs ou gris, toute beauté, et à des p défiant toute concurren

Marius Heng

33, Rue Bergère, 33

✂ ✂ Envoie franco ✂ ✂
Catalogue sur Demande
TÉLÉPHONE 210-72

therefore on skin treatments. Purifying pills such as Beecham's and Whelpton's claimed to bring the blush of health to pallid cheeks. Many women pinched their cheeks and bit their lips to achieve a becoming pink, while the more daring resorted to tinted lip salves and rouges – a practice considered by some to be rather 'fast'. Favourite scents in the 1900s tended to be light with a country garden aura – 'Moss Rose', 'Lavender', 'May Blossom' and even 'New Mown Hay' – while exotic notes were struck by headier perfumes such as 'Phul-Nana', an extract of Indian flowers.

A fine head of hair was still thought to be a woman's 'crowning glory'. Girls wore their hair long until they came of age at eighteen, when it was swept up in one of the popular wide, full styles. Women with less than abundant locks achieved the necessary volume by using false hairpieces, and pads known colloquially as 'rats', which were secured by hairpins and combs. Curling tongs kept coiffures temporarily aloft, though in 1906 Charles Nestlé (born Karl Nessler) introduced his time-consuming permanent waving method which offered bouffant styles without additional pads and postiches. Men and women with falling or problem hair tried tonics or restorers such as 'Harlene' (promoted as 'the great hair producer'). A variety of hair colourings and anti-grey potions were marketed for both sexes.

The top rung of the hierarchy of fashion was occupied by the *grands couturiers* with their select band of clients. Smaller dress-

9. Fur salon at Redfern, Paris, 1910. Haute-couture clients were pampered in elegant surroundings. This carefully posed photograph captures a furrier working on a cape's ermine border, a house mannequin modelling a fur stole and a customer contemplating a lace-edged ermine accessory.

making concerns met the requirements of the middle classes who were also customers for fashionable ready-to-wear stocked by department stores. Mail order was a boon to many. Paper patterns were cheap and sewing machines made home dressmaking a cost-effective option, despite the fact that an evening gown required many yards of fabric plus all the fancy trimmings. The poor and underprivileged seldom bought new clothes, relying instead on the second-hand market, hand-downs and charity. Upper-crust traditionalists supported the status quo and deplored the habit of servants copying their mistresses' clothes. Dressing according to 'one's station in life' and the custom of restricting servants to black dresses, caps and aprons were applauded.

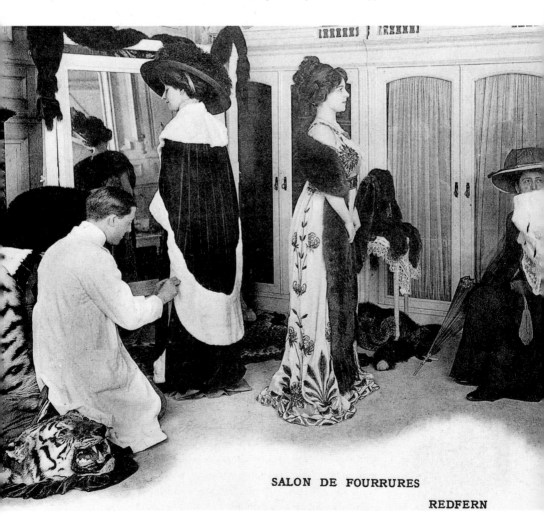

SALON DE FOURRURES

REDFERN

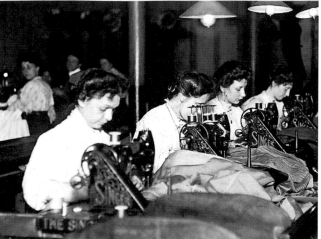

10. A 1909 photograph documents a less appealing side of the fashion world – seamstresses working long hours bent over their machines beneath rudimentary lighting.

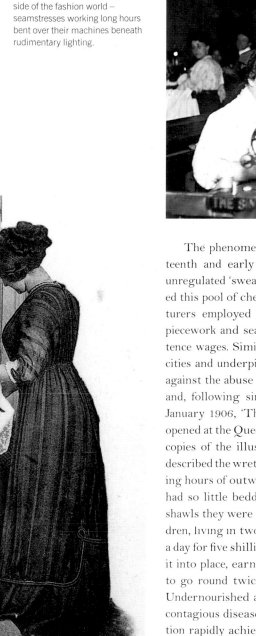

10, 13

The phenomenal growth of ready-to-wear in the late nineteenth and early twentieth century depended largely on the unregulated 'sweated industries'. Exclusive dressmakers exploited this pool of cheap labour to finish garments. British manufacturers employed dressmaking and tailoring outworkers on a piecework and seasonal basis which barely earned them subsistence wages. Similar circumstances prevailed in most European cities and underpinned the US fashion industry. The movement against the abuse of these workers gradually gained momentum and, following similar exhibitions held in Berlin in 1904 and January 1906, 'The Daily News Sweated Industries Exhibition' opened at the Queen's Hall, London, in May 1906. The first 5,000 copies of the illustrated catalogue sold out within ten days. It described the wretched living conditions, ill health and long working hours of outworkers, including details of shawl fringers who had so little bedding that they were forced to sleep under the shawls they were trimming. One fringer, a widow with four children, living in two rooms, worked an average of seventeen hours a day for five shillings a week. She plaited each fringe and knotted it into place, earning ten pence for a large shawl which she had to go round twice with sixteen yards (15 metres) of fringing. Undernourished and often ailing, some outworkers transmitted contagious diseases through the clothes they made. The exhibition rapidly achieved its aim of acquainting the public with the evils of 'sweating', though it was many years before reformers and trade unions asserted their influence and legislation was introduced to protect the workforce.

Those who aspired to be fashionable were able to keep up with the latest trends by consulting women's magazines. France had developed an ultra-sophisticated fashion press which supported both the Paris trade and the luxury textile industry based in Lyons. With the growth of photography in the late nineteenth century, journals were quick to replace traditional fashion line drawings with photographs. *Les Modes* led the way, printing photographic reproductions that are remarkable for their clarity. Numerous periodicals were devoted entirely to fashion; others, like the *Lady's Realm*, covered the entire spectrum of women's interests, but always included illustrated fashion commentaries. Reports centred on Paris innovations, and texts were peppered with the tempting description – 'the latest Paris Model'. Newspapers also kept readers in touch with fashion. In London, the *Evening Standard and St James Gazette* printed Bessie Ayscough's fashion drawings while in 1900 the Paris edition of the *New York Herald* launched a weekly supplement devoted entirely to fashion.

Throughout Europe and the US, department stores, chiefly established in the nineteenth century, came into their own. These retailing giants exerted an enormous influence on fashion. Most had dressmaking and tailoring workshops as well as ready-to-wear sections. Customers in London were offered comfort and good service by the likes of Harrods, Swan & Edgar, Debenham & Freebody and, from 1909, Selfridges – the vast Oxford Street emporium established by the American-born businessman Gordon Selfridge. Paris had its *grands magasins*, including Galeries Lafayette, Au Printemps and La Samaritaine. In the US, there were Bergdorf Goodman, Henri Bendel and Neiman Marcus (founded in 1907). Most stores also produced mail-order catalogues and accessories on approval.

The fashionable look of the period was also disseminated through postcards and cigarette cards. These reached a wide audience and cut across class divisions. In addition to such male-orientated topics as Boer War generals, football club colours and baseball players, cigarette cards featured photographs of lavishly attired actresses and celebrities as well as scantily dressed beauties and dancers. But though cigarette packs were deemed suitable vehicles for the likes of the dancer Loïe Fuller; the Gibson Girl, Camille Clifford; and the music-hall artist Gaby Delys; postcards and magazines were considered more seemly outlets for portraits of more refined actresses and members of the aristocracy. For these, thespians and countesses alike sat for their portraits in photographic studios, flaunting their most impressive gowns.

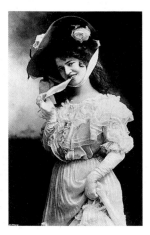

11. In the early 1900s postcards of actresses and 'beauties' were produced in great numbers and helped publicize current fashions. The actress Miss Alice Russon poses coyly in her frothy summer gown for this postcard of 1906.

12. *Opposite, above*: Outside Harrods, London. By 1909, when this illustration was made, the exaggerated curves of the early 1900s had been supplanted by leaner, straighter silhouettes topped by enormous, decoratively trimmed hats. Dapper men-about-town wore top hats with morning and frock coats, and bowlers with the less formal lounge suits that were becoming increasingly popular.

13. *Opposite, below*: In cramped working conditions, milliners created lavish hats – many trimmed with ostrich feathers. Paris, 1910.

11

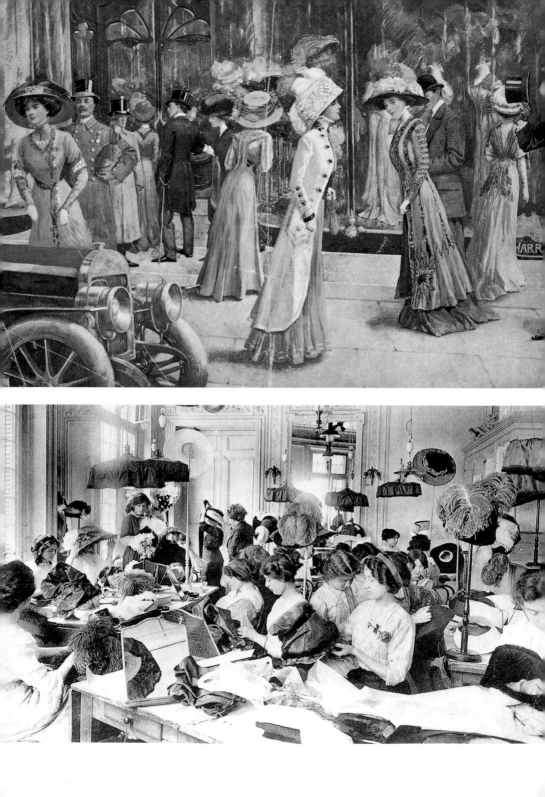

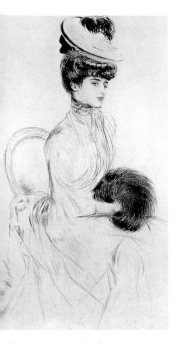

Women copied the demeanour, hairstyles and elaborate clothing of these popular heroines. Suburban photographic studios produced portraits in the form of cabinet cards. Real rather than ideal, these illustrated the 'best dress' of the less well off. The ultimate accolade was to be immortalized in oils by one of the leading artists of the day. Giovanni Boldini, Phillip de Laszlo and John Singer Sargent were society's favourite portraitists, while Paul Helleu's drawings and prints of women form a remarkable record of early 1900s high fashion.

Although she had already reached the age of fifty-eight when she was crowned Queen in 1902, Alexandra continued to exert an influence on style in both Britain and the US. With her upright posture and fine figure (sometimes retouched in photographs), she looked magnificent both in glittering, over-embellished court dress and in starkly tailored riding habits. She was famous for her fringed hairstyle and deep chokers as well as for her increasingly heavy use of cosmetics as she got older (she was often described as 'enamelled'). Edward VII's mistresses, notably Lillie Langtry and Alice Keppel, helped not only to set the fashionable tone but also to establish a vogue for the mature woman.

In the UK, much press attention was devoted to the 'American invasion' of the British peerage by New World heiresses whose considerable wealth gave the English aristocracy a much needed financial boost. On her marriage to the Duke of Marlborough in 1895, the ethereal Consuelo Vanderbilt brought a dowry estimated at two million pounds. Such marriages also introduced into the British scene a coterie of well-educated American women who were accustomed to dress at the best couturiers. The women's press was quick to feature these newcomers, and the accompanying photographs highlighted their expensive clothes. The stage also provided the aristocracy with fresh blood and glamour – at least half a dozen noblemen married actresses between 1900 and 1914, liaisons which provided ideal copy for both gossip columnists and fashion editors. One notable arrival, from America, was the actress Camille Clifford, who married Lord Aberdare's son and heir in 1906. She had achieved a certain fame in England through her portrayal on the London stage of the 'Gibson Girl', the personification of ideal womanhood created by the American illustrator Charles Dana Gibson at the turn of the century. The Gibson Girl, with her sinuously curved body, tiny waist and masses of hair piled on top of her head, was the best known of Gibson's representations of the confident young Americans who came to signify 'The New Woman'.

14. One of the richest and most famous of the New World heiresses who married into the English aristocracy around the turn of the century: Consuelo, Duchess of Marlborough (the American heiress Consuelo Vanderbilt). Entranced by the Duchess's delicate beauty, the artist Paul Helleu made numerous such studies of her in the early 1900s.

15. *Opposite*: The actress Camille Clifford, who played the 'Gibson Girl' on the London stage in 1904. The curves of her rounded hourglass figure are echoed by the circles of her bowl-shaped, feather-filled hat, huge ostrich feather fan and swirled train.

14

15

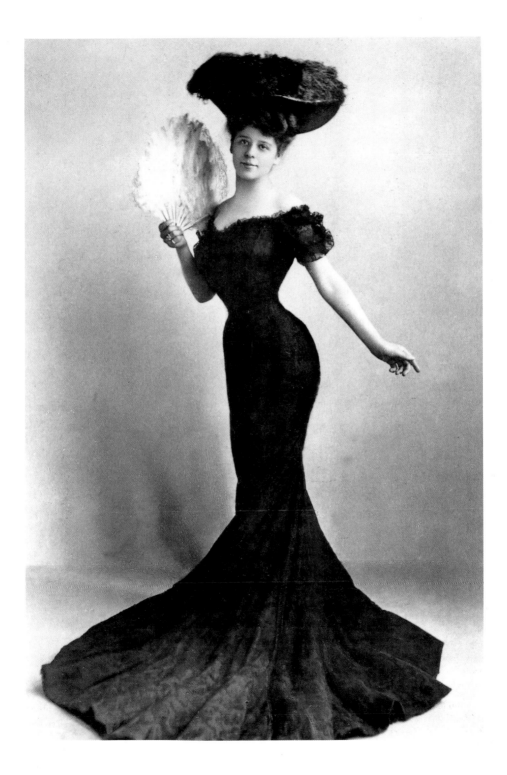

A minority of women avoided fashion's mainstream in favour of individualistic styles. These women often belonged to literary or artistic circles and schools of design such as the Souls (who straddled the nineteenth and twentieth centuries), the Wiener Werkstätte and the Bloomsbury Group. In England, the Regent Street shop Liberty was the haunt of those in search of clothes and fabrics which transcended fashion. Throughout the early 1900s its studio specialized in flowing garments based on historical costumes from various sources and periods. In 1909, in a similar spirit of independence from current trends, the theatre, textile and costume designer Mariano Fortuny, operating from the Palazzo d'Orfei in Venice, patented his famous Delphos gown. Based on the classical Greek chiton, made in fine silks dyed in glowing colours and pleated by a secret method, the Delphos gown fell in a glistening column from the shoulders to the ground. It was discreetly trimmed with Venetian glass beads and adjusted around the neck and arms by hidden drawstrings. Similarly non-restrictive garments were favoured by the liberated performers Loïe Fuller, Isadora Duncan (a Fortuny client) and Maud Allan, who danced their way into dress history wearing flimsy pseudo-classical robes and drapery.

For the first eight years of the century there were no radical changes in dress. The desire for the new was entirely satisfied by the introduction of seasonal colour ranges and novel, progressively complex overlaid decoration in which Paris couturiers – especially Callot Soeurs, Doucet, Paquin and Worth – excelled. Designers used the costliest fabrics, which had to be pliable with good draping qualities if they were to achieve the flowing lines in vogue at the time. Warmth came from furs, velvets, wools and the ubiquitous ostrich feather boa. Summer and evening clothes were made in a cornucopia of lightweight linens, cottons and silks with evocative names – *mousseline de soie*, *crêpe météore* and frosted tulle. Unpatterned fabrics were favoured and were then lavishly adorned with fine laces, crochet, embroidery and braiding. Ready-made haberdashery essentials such as boning and fastenings were obtained from specialist suppliers and ateliers in Paris, as were embroideries, beads, feathers, passementerie and artificial flowers. The fact that the mode favoured pastel colours with cream and white trimmings may have helped create the myth that the period was one long idyllic summer dominated by garden parties. Fashion commentators advocated *eau de nil*, mauve, rose pink and sky blue. Unavoidably sombre notes were introduced by the obligatory black, grey and purple of mourning and the practical, dark hues of tailored suits and tweeds.

17, 18. Two lavish ensembles from top couture houses. From 1912, lace-trimmed evening wear by Paquin (*left*), comprising a high-waisted, short-sleeved open robe with corset-like bodice draped over a slender skirt, worn with a plumed head-dress which adds extra height. From 1909, a design by Doucet (*right*), also worn with a lofty, feather-decorated hat.

To sustain a labour-intensive establishment, a top Paris couturier at this time would employ a staff of between two and six hundred. The hierarchy was rigid and the work carefully organized. Separate workrooms were devoted to one function or to the production of a particular garment. The process began with a vendeuse introducing a client to the latest designs modelled by house mannequins. Sometimes, for modesty's sake, the models were clad in black, high-necked, long-sleeved 'under' dresses which were worn even when off-the-shoulder wear was being shown. The choice of ensembles was followed by skilled cutting and construction and by lengthy fittings, on which the exclusive nature of these custom-made clothes depended. In 1902 a couture ball gown from the house of Félix in rue du Faubourg Saint-Honoré cost almost fifty times as much as a ready-made evening

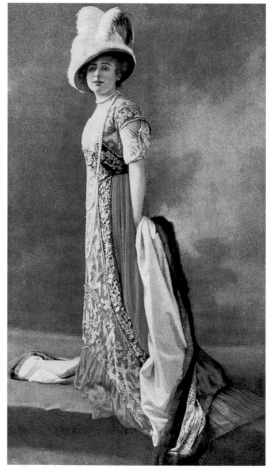

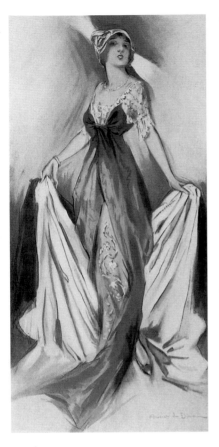
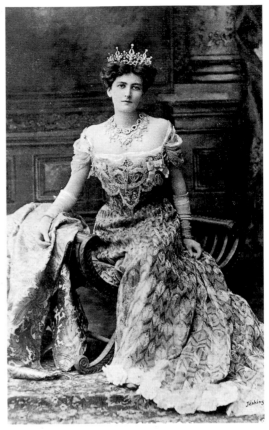

19, 20. Two designs from the House of Worth. Worth was known for extravagant, showy gowns, one of the most famous of which was the 'peacock gown' (*right*) designed by Jean-Philippe Worth, son of the founder of the house, and worn by Lady Curzon, Vicereine of India (Chicago heiress Mary Leiter) at the Dehli Durbar in 1903. The ivory coloured satin was specially embroidered in India, in silk, metal threads and iridescent beetle wings with a design of interlocking peacock feathers. The 1912 *robe du soir* (*left*) consists of an ornately beaded dress beneath a strawberry coloured, pannier-style open robe.

dress from Liberty in London. The most prestigious Paris couture house at the beginning of the century was the House of Worth – by this time in the hands of the founder's sons, Jean-Philippe and Gaston. Worth clothed a wealthy elite, among them European royalty, American heiresses and famous actresses. His early 1900s creations were conspicuously expensive and at times had an almost vulgar exuberance which announced them as Worth designs and identified their wearers as women associated with affluence and power.

19, 20

In London, where both Worth and Redfern had branches, the purchasing power of the King's circle was considerable, and though appearances at court were governed by strict sartorial regulations, they presented an opportunity for women to parade in lavish attire that revealed rank, taste and wealth. To secure such lucrative custom, establishments continued to style themselves as court dressmakers. The cognoscenti favoured Reville and

21. Cycling became an ever more popular pastime for both men and women but restrictive clothes hampered movement and could be dangerous. These American cyclists of 1902 were firmly corsetted under tailored skirts and blouses. A straw boater often provided a chic finishing touch and struck the desired sporting note.

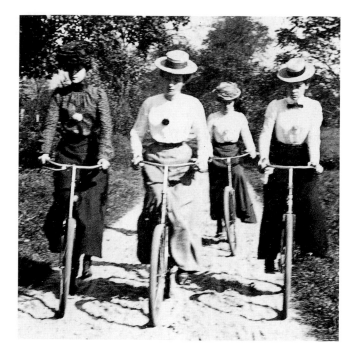

Rossiter, Mascotte, Mrs Handley-Seymour and Kate Reily, the latter specializing in insubstantial dresses which were no more than drifts of frail silk. As far as fine tailoring was concerned, London remained the international centre, meeting requirements for walking dress and riding habits. The late-nineteenth-century craze for cycling continued into the twentieth century, and tailors produced a wide range of bifurcated garments designed specifically for this activity. The number of working women increased significantly between 1900 and 1913 and a smart tailored two-piece costume with blouse (the 'Russian' blouse was a bestseller) was the perfect solution for office wear.

At this point marriage was an almost obligatory state and a young society woman began her wedded life equipped with an extensive trousseau. Intimate apparel consisted of matching sets of day and night chemises, petticoats, drawers and corset covers in the lightest of monogrammed cottons. Manuals of etiquette recommended that a dozen of each undergarment should be purchased, though American brides were occasionally cautioned not to buy too much outerwear as fashions changed so rapidly. Twelve evening gowns, two to three evening wraps, two to four street costumes, two coats, twelve hats and four to ten house dresses would be enough. It was understood that shoes and stockings

would be bought by the dozen. Additionally, if the season were to be spent out of town, country and seaside attire were necessary for society sojourns at Newport or Palm Beach.

For the *beau monde*, the daily routine demanded at least four changes – for the morning, for early afternoon, for tea time and for the evening. In the morning it was customary to wear a tailor-made costume for paying social visits and shopping. This consisted of a skirt and jacket or coat, sometimes coordinated with a blouse and belt. Wools, especially a fine facecloth, made ideal autumn and winter costumes. The skirt was singled out in fashion magazines of the time as one of the most significant elements of early 1900s fashion. Cut to emphasize a curvaceous body, skirts were pleated or gored to fit closely from the waist to the lower thighs. They then flared out to just above ground level at the front and to slight trains which swept the ground at the back. If the domed posterior was ill-defined, a bustle-like skirt improver could be tied around the waist. Blouses or shirtwaists with pouched 'pouter pigeon' fronts which hung over the waist became an important part of the wardrobe. These invariably had high, stand-up collars kept up by whalebone, celluloid or wire supports. Not a comfortable style,

22. Department stores stocked ranges of delicate, finely embroidered, beribboned undergarments for trousseaux. These demure designs and matching sets were offered by the Grands Magasins du Printemps, Paris, in their mail-order white goods catalogue of 1910.

23. *Above*: A neat hat of about 1911, with an upturned, velvet-lined brim and a high tier of nodding, white ostrich feathers. Ostrich feathers were particularly popular at this time.

they aided and abetted the no-slouching posture imposed by corsets and compelled wearers to keep their necks straight and elongated and their heads held in an arrogant chins-up position. Hats were obligatory and milliners devised ever more decorative concoctions. It was a symbol of status to incorporate feathers and even entire birds in stylish headgear, though the anti-plumage movement in Britain and the US eventually forced governments to adopt protectionist measures. Throughout the early 1900s hats were deep, and small to medium size, worn perched on the prevailing full hairstyles.

The well-connected owned a vast array of clothes. Dress was decreed by the occasion, the season and the time of day. Particularly demanding were country house weekends. Open automobiles were replacing horse-drawn carriages. The most avant-garde motored to the rural venue concealed in voluminous dustcoats, protective bonnets, veils and goggles, their trunks bulging with the necessities for a variety of both indoor and outdoor pursuits. Riding gave women an opportunity to flaunt their good (corsetted) figures in tightly tailored habits. Golfing, shooting, skating, tennis, croquet, mountaineering, archery and bathing at the level

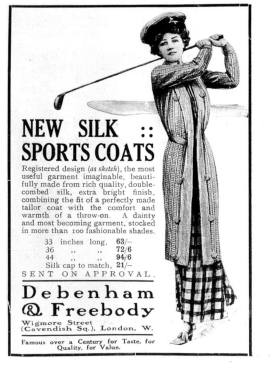

## NEW SILK :: SPORTS COATS

Registered design (*as sketch*), the most useful garment imaginable, beautifully made from rich quality, double-combed silk, extra bright finish, combining the fit of a perfectly made tailor coat with the comfort and warmth of a throw-on. A dainty and most becoming garment, stocked in more than 100 fashionable shades.

|  |  |  |  |
|---|---|---|---|
| 33 inches long, | | | 63/- |
| 36 | ,, | ,, | 72/6 |
| 44 | ,, | ,, | 94/6 |
| Silk cap to match, | | | 21/- |

SENT ON APPROVAL.

## Debenham & Freebody

Wigmore Street
(Cavendish Sq.), London, W.

Famous over a Century for Taste, for Quality, for Value.

24, 25. *Opposite below*: Sporting activities called for specialist clothing. For golfing (*left*), ready-to-wear sports wear like this long silk coat (*c*.1910) combined comfort with style. Its flexibility permitted a full swing of the club, and silk offered warmth on windy golf links. A large, mannish cap along the lines of a tam o' shanter protected the head. The new craze for motoring called for protective clothing suitable for travel in open cars, though in April 1905 the Duchess of Sutherland (President of the Ladies Automobile Club, London) dispensed with the usual gauntlet gloves, veils and goggles (*right*). She guarded her hair with a large, flat-crowned hat (its streamers firmly tied under the chin) and wore a roomy dustcoat over her daytime ensemble.

26. *Right*: Paper patterns enabled home dressmakers to create low-cost clothing, including tea gowns, wrappers and house dresses. Butterick (with branches in London, Paris and New York) offered a variety of designs to suit all tastes in their *Catalogue of Fashions*, Winter 1907–1908.

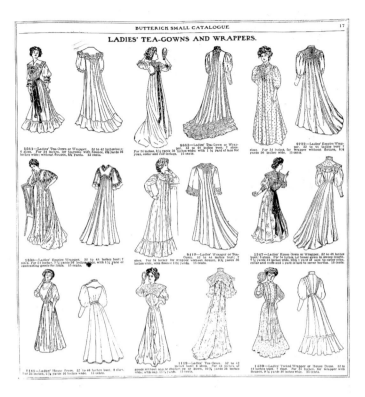

of either leisure or serious sport required specialized clothing. English designers capitalized on their reputations for high-quality tailor-made costumes and activity wear – the best came from Creed, Redfern and Burberry.

Tea gowns were essential to gracious living and fashion periodicals carried regular reviews of the latest (often ornate) designs and how they should be worn. Edwardian fiction and biographies abound with nostalgic references to these garments. Originally marking the divide between day and evening wear, they permitted women a few hours of relief from tight corsets at around five o'clock, when tea was traditionally taken. Described as picturesque, both tea gowns and wrappers (another at-home garment popular at the time) were long, flowing and sometimes voluminous, giving the body room to relax. Convention allowed women dressed in such informal gowns and lounging in their boudoirs to receive guests – a boon to budding liaisons.

Evening wear was extraordinarily flamboyant and provocative: bodices were low cut with narrow shoulder straps decorated with wisps of accordion-pleated silk. This permitted the overt

26

display of jewels – diamonds and pearls were particularly admired. Tiaras and bejeweled ornaments glittered in the hair and long pearl ropes were festooned artistically over the bodice. For those who could not afford real jewels, the market provided excellent costume jewelry. Edwardian frou-frou relied on luxurious fabrics, particularly glossy satins that would catch and reflect the light and which were inventively trimmed with pleated voiles, sequinned and beaded panels, hand-painted inserts and lace frills and flounces. Rustling taffeta petticoats beneath trained skirts completed the sensual composition. Lavish capes with cosy linings protected their extravagantly arrayed occupants from the cool evening air.

The style described variously as Empire, Directoire and Madame Récamier, with straight vertical lines and a high waist, was favoured during the early years of the century for evening dresses and tea gowns. By 1909 it had become the dominant form. The colour wheel revolved and the gentle hues of the 1900s were replaced by stronger, more assertive colours. This change was gradual, brought about by certain cultural phenomena and by the emergence of various avant-garde talents centred in Paris. In 1905, the first exhibition of the vivid paintings of the 'Fauves' had an enormous impact on the decorative arts. In 1906 the founder of the Ballets Russes, Serge Diaghilev, arranged an exhibition of Russian Art and in 1909, under his aegis, the Imperial Russian Ballet performed *Cléopâtre* with brightly coloured costumes and sets by Léon Bakst. The Ballets Russes held its inaugural performance in London in 1911, by which time the first Post-Impressionist exhibition, arranged a year earlier by the critic and painter Roger Fry, had created a furore and asserted its influence in London's artistic circles.

It is in the context of this artistic ferment that the designs of Paul Poiret came to prominence. Poiret energetically led the movement away from the full, curvilinear silhouette of early 1900s fashion towards a longer, leaner line. But the claims of this gifted self-publicist to have been personally responsible for liberating women from the tyranny of corsets and to have been the first designer to employ bright, strong colours have to be treated with caution. On the wave of a trend for orientalism, the transition from pale to violent hues was inevitable. Bakst's vivid designs for the Ballets Russes (especially for *Schéhérazade* in 1910) and Poiret's brilliantly coloured, looser clothes were received by an appreciative audience which did not need to be persuaded to abandon muted tones.

28, 29

27

28, 29. Two examples of high-waisted 'empire' line evening gowns. The look was column-like and attention centred upon skirts that were draped and gently gathered into fluid lines. A group of talented fashion illustrators sketched these romantic dresses in idealized settings: 'Nocturne', 1913 (*above*), and 'La Caresse à la Rose', 1912 (*below*), from the *Gazette du bon ton*.

30. *Opposite*: Georges de Feure captures an *élégante* (1908–1910) as she glides along in her slender ensemble. Patterned horizontal bands break the verticality of the tubular gown while her full, swept-up hair and enormous feather-topped hat create a skittle-like silhouette.

After spells with Doucet and Worth, Poiret had opened his own house in 1903. He became the most exciting couturier in the years before the First World War and fashion editors gave his exploits prominent coverage. With enormous verve and imagination he constructed a lifestyle which enhanced his dressmaking activities. His wife, Denise Boulet, was an ideal model for his tubular, high-waisted designs and he created a Paris garden which <sup>34</sup> became the perfect foil for his bevy of languid house mannequins. The garden was also the setting for Poiret's famous celebrations, including the notorious Thousand and Second Night in 1911, when all the guests had to come in exotic fancy dress.

Beneath the self-congratulatory tone of Poiret's autobiography, his dedication to the art of dress is obvious. He was a master of colour, texture and fabrics, combining the latest luxury materials with pieces from his collection of ethnological textiles. He had the panache of a theatrical costumier: it was the final impact that was paramount, rather than the fine details of construction, with the result that some clothes bearing his distinctive label with its rose logo were assembled in a decidedly crude manner. In eight years of hectic creativity Poiret opened significant new avenues for the profession. By 1911 he had introduced 'Rosine' perfumes, founded the decorative arts studio 'Atelier Martine' and in 1914 travelled Europe with his troupe of mannequins. Only the outbreak of war would curtail these groundbreaking initiatives.

Poiret's achievements may be compared to those of Lucile (Lady Duff Gordon), who had established branches in London, New York and Paris by 1912. However, Lucile's work was less radical. She issued no challenges, simply meeting the needs of her clients by producing elegant clothes for all occasions. Her particular forte was draping – the making of garments by working directly with material on the figure. By the 1910s, though a full body remained fashionable, the exaggerated curves had vanished and the effect was pillar-like. Although some advanced women discarded corsets, most did not, and corsets were merely adapted to suit the prevailing line. Lucile claimed to be a pioneer in bringing 'joy and romance' to clothes, and among her triumphs were designs for the stage, including the 1907 costumes for Lily Elsie in *The Merry Widow*. These started the vogue for huge hats which, <sup>35</sup> at their maximum, reached three feet (roughly one metre) across – secured by long hatpins rendered harmless by safety guards. Lucile remained faithful to the early 1900s sweet pea colours and, like her contemporaries, delighted in the juxtaposition of satin, chiffon, net, gilt lace and spangled panels edged with swinging

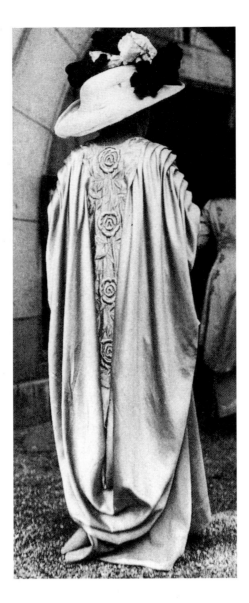

31. Teamed with an immense flower-bedecked hat, an embroidered satin cloak (in the Poiret mode) cascades to the floor in graceful folds. Worn here by a professional model (photographed by the Seeberger brothers), this cloak represented the apogee of Paris fashion in 1909.

pompons and fringes. Bodices were still intricately constructed and boned. The vertical line was usually broken around knee level by the horizontal hem of an overskirt or tunic top. Designers paid meticulous attention to these overskirts, inventing numerous variations ranging from tasselled handkerchief points to diagonal drapes secured by artificial flowers. Like Poiret, Lucile employed beautiful women to model her designs, which she described as 'gowns of emotion', endowing each with a name and 'personality'.

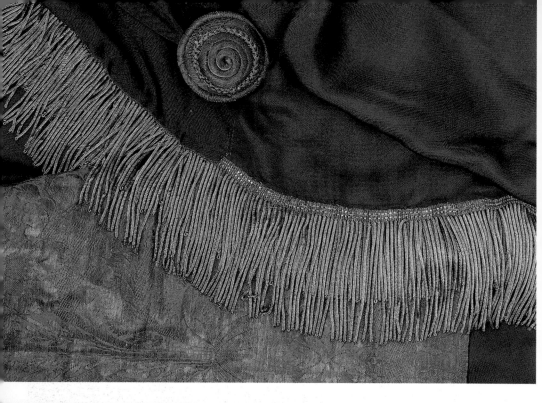

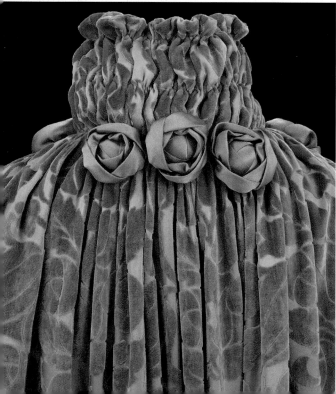

32, 33. Fine examples of pre-First World War fashion survive. Around 1912, Paul Poiret created a luxurious opera cloak in bright colours and gleaming metal threads (*above*). The colours reflect the influence of orientalism, which was having a huge impact on fashion at the time. A close-up shows silk chiffon with gold metallic fringe, matching coiled button and cloth of gold sleeves. Of a similar date and opulence, a Lucile-like rose patterned velvet evening cape (*left*) with high ruched collar decorated with plump satin roses.

34. *Opposite*: In his cover, 'Chez Poiret', for the magazine *Les Modes* (April, 1912), the illustrator George Barbier depicted two evening ensembles inspired by the exotic forms and brilliant colours of oriental costume and set them in Poiret's famous garden. Both languid mannequins wear turbans with aigrettes – the fur-edged evening coat 'Battick' on the right has a bold abstract pattern while the tunic on the left is decorated with figures taken from Egyptian art.

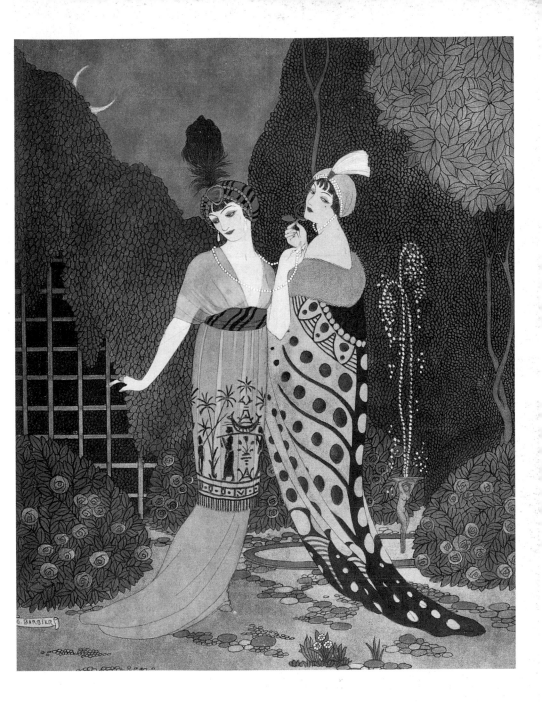

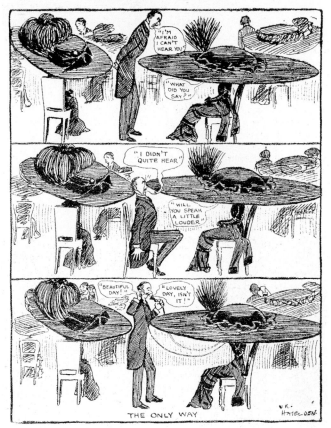

35. The extremely wide-brimmed women's hats that were popular at this time were a gift to cartoonists. In 1910 a cartoon by W. K. Haselden for the *Daily Mirror* newspaper made fun of the 'incorrigible hugeness of fashionable hats', and suggested one way of overcoming a communication problem and making conversation possible.

Her autobiography resembles Poiret's in that it is a masterpiece of self-promotion, but what both books lack in detailed chronologies they make up for in providing unique insights into the dynamics of top-level dressmaking in the first quarter of the twentieth century.

Between 1909 and 1914 many women, even the most liberated, adopted that curious fashion, which Poiret endorsed: the hobble skirt. The ungainly motion that gave the garment its name was caused by the skirt's narrow construction which clamped the knees and restricted the stride. When teamed with the colossal cartwheel hats championed by Lucile, the effect was one of pronounced top-heaviness. Though the look was lampooned, contemporary criticism was ignored. British suffragettes, wishing to further their cause rather than attract attention to their appearance,

36

eschewed unconventional reform dress and kept to mainstream fashions. Purple, white and green were adopted as the 'Votes for Women' colours and created small-scale dress and accessory manufacturing and retailing opportunities.

Society's codes became generally less rigid and young Europeans revelled in a succession of lively dances – many imported from America. The Argentine tango was particularly influential, spawning tango shoes, tango corsets and even tango perfume. The latest steps were professionally demonstrated by the famous trendsetting dancers Irene and Vernon Castle. By 1914, just before the outbreak of war, gigantic hats had been discarded and the columnar silhouette became narrower and sleeker.

Gentlemen of means and style, though not at the mercy of passing fashions, were nevertheless obliged to keep extensive

36, 37. Fashionable extremes. *Left*: Gowns are gleefully hoisted to show the restricting construction of hobble skirts, 1910. *Right*: In the years before the First World War the tango took Europe by storm and influenced many dress styles. Here the female dancer is wearing what were known as 'jupes culottes' – full culottes gathered at the ankles and worn with an overtunic. They are decidedly exotic in comparison with her partner's tails and trousers.

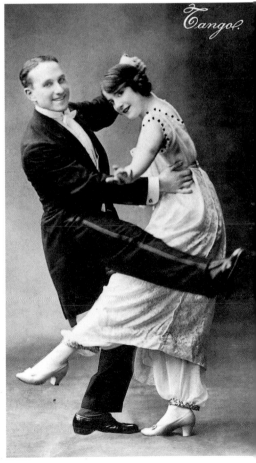

wardrobes to clothe themselves appropriately at all times. No truly revolutionary departures took place in men's dress between 1900 and 1913 but clothing gradually grew less formal and the lounge suit became dominant. Minute shifts – an extra button, slightly narrower lapels or a new collar shape – created comment and gave satisfaction. Few were brave enough to break the many early-twentieth-century sartorial rules, which incorporated a store of nineteenth-century edicts. Clothes indicated social status. At Derby Day in England in 1912, the 'notables' won praise for their black morning coats and top hats – the correct fashion for an important social function in the presence of royalty – whereas the 'ordinary' crowd came in for criticism on account of their lounge suits in greys and browns.

Though sixty-one years old at his coronation in 1902, Edward VII continued to dress with distinction and took enormous pride in his appearance. Rotund, lacking the grace of dandies such as Max Beerbohm and Boniface Comte de Castellane-Novejean,

38

he was nevertheless, as both Prince of Wales and King, a major arbiter of fashion. A stickler for correctness, he admonished his courtiers if they were improperly dressed. Edward established vogues for numerous articles of clothing, from Norfolk suits to homburg hats.

In addition to impeccable tailoring, the hallmark of male elegance was perfect grooming. Personal valets ensured that clothes were kept in pristine condition and that their masters were always immaculately turned out. Hair was short and well trimmed. Young men sometimes grew full moustaches while older men and sailors frequently sported beards. Puritanical reserve kept fragrances to a minimum – no more than a dab of eau-de-Cologne on a handkerchief passed over the hair. Barbers were party to such male secrets as hair dyeing and attempts to remedy or disguise bald patches.

British tailoring was considered the best in the world and the wealthy patronized famous, long-established tailors in Bond Street and Savile Row. Leading concerns included Gieves and Henry Poole. A royal warrant was the ultimate honour and boosted trade. The finest shoes and boots were made by hand; shoemakers such as Lobb kept wooden lasts of their prestigious clients. Footwear had oval toes and spats were popular. The best hatters provided clients with custom-made headgear, ranging from opera hats to

39. American style. Crisp shirts and high collars were considered essential even for casual wear, and stripes were ideal for the clean-cut American look. The Arrow trademark was launched in Troy, New York, before the turn of the century, but achieved widespread publicity and success from 1913 on through its lively and attractive advertisements, drawn by the artist J. C. Leyendecker.

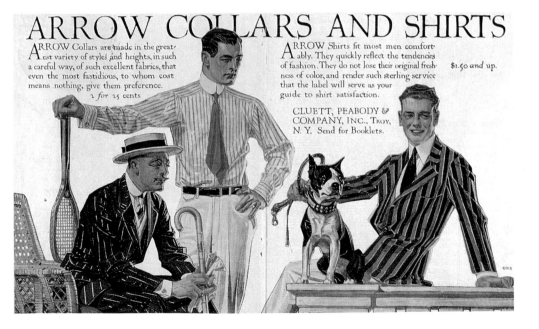

# ARROW COLLARS AND SHIRTS

ARROW Collars are made in the greatest variety of styles and heights, in such a careful way, of such excellent fabrics, that even the most fastidious, to whom cost means nothing, give them preference.

2 for 25 cents

ARROW Shirts fit most men comfortably. They quickly reflect the tendencies of fashion. They do not lose their original freshness of color, and render such sterling service that the label will serve as your guide to shirt satisfaction.

$1.50 and up.

CLUETT, PEABODY & COMPANY, INC., TROY, N. Y. Send for Booklets.

40, 41, 42. Meticulously groomed gentlemen in 1912 wore well-cut clothes which gave them a debonair appearance. *Left*: a single-breasted, two-buttoned morning coat with distinctive cut-away fronts, a flattering, slightly dipped waist seam, long tails and low angled lapels. *Centre*: that endangered species, the dignified double-breasted frock coat, with wide, steeply angled, silk-faced lapels and minimally flared skirts. Both coats were worn with top hat, gloves, cane and half boots with fabric uppers. *Right*: for evening, a black tailcoat and trousers (waistcoats could be black or white), white shirt with starched front, stiff collar and narrow bow-tie were the order of the day and feet were usually shod in glistening, patent-leather pumps decorated with tailored bows.

bowlers. This period witnessed the decline of the top hat, which, after 1914, was confined to the most formal occasions. Linen had to be faultlessly laundered. Shirts did not have button-through front fastenings and had to be pulled on over the head. Detachable stiff linen collars reached an uncomfortable three inches in height, echoing the deep, boned collars of female fashion. Difficult-to-handle double collars, anchored to shirts by studs, were customary. Some restrained decorative touches were permitted: coloured braces, striped shirts, jaunty handkerchiefs and a multiplicity of neckwear. The man-about-town was always equipped with a slender walking stick or tightly furled umbrella. Department stores and trade catalogues offered budget-priced clothing, also providing special tropical apparel for those who worked in the colonies. It was not seemly for the well-dressed man to betray undue interest in clothes and yet he had to be the epitome of style. The watchwords were 'neat', 'quiet' and 'suitable'. Gentlemen relied on their tailors and manservants for personal styling and advice about the latest trends.

Although its days were numbered, the long (just above the knee) double-breasted frock coat of fine black wool remained

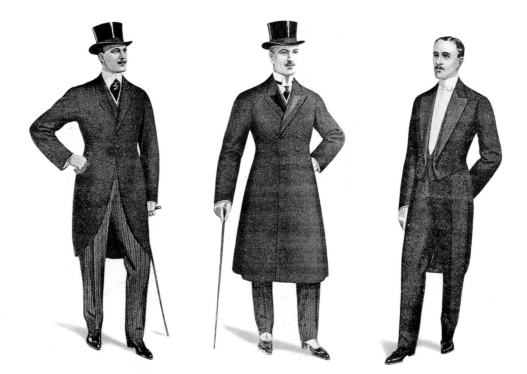

current throughout the early 1900s for formal day wear. It was often worn open over a double-breasted waistcoat, a shirt with a high stiff collar, and matching or striped trousers. A top hat completed the ensemble. Throughout the period trousers tended to be narrow, worn with or without turn-ups. Morning coats and morning coat suits became fashionable replacements for frock coats. A typical morning coat was single-breasted, with tails which reached to the back of the knees.

Gradually the unwaisted lounge jacket superseded both the frock coat and the morning coat. Lounge suits pointed the way to the business suits of the future and marked the growing informality of menswear in which North America took the lead. The English magazine the *Tailor and Cutter* acknowledged the significance of the US market and its special needs, but wrote disparagingly of 'Yankee swank' and the American preference for 'racy' clothes of the kind that an Englishman would consider suitable only for holiday or sports wear. Warned off the vulgar excesses of the 'freak American suit', Americans were advised to travel to the 'home of irreproachable clothes for men' and visit an English tailor. More seriously, the magazine reported the iniquities of

43, 44

45

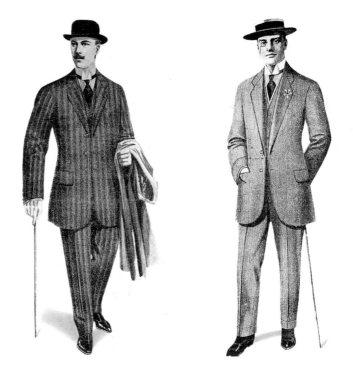

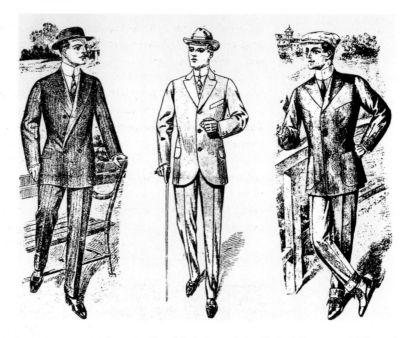

45. American lounge suits, 1912–1913, described by UK tailors as 'racy'. *Left to right*: 'The American', a bold, double-breasted jacket and trousers with deep cuffs; 'The Universal', the most popular type of lounge suit; and the more informal 'Drexel', a brash, wide-shouldered suit illustrating the fact that Americans favoured plenty of pockets and, for leisure wear, looser, easy-fitting trousers.

sweatshops in Great Britain and the United States and followed the progress of the 1912 tailoring strikes and the introduction of minimum wages.

Illustrations of 1900s evening functions record the multi-coloured froth of women's gowns punctuated by the strict black and white of their male companions. Tailcoat (with white boutonnière) and trousers were black and were worn with a white waist-coat, white cummerbund and a dress shirt with a high, winged collar. White gloves and patent-leather dance pumps were essential and some gentlemen affected monocles. The less formal dinner jacket known in the US as a tuxedo and in France as a monte carlo was initially confined to minor evening occasions but rapidly gained currency.

For town wear, the chesterfield overcoat was recommended and was available in a number of styles, the elegant variant with velvet collar and fly-front being extremely popular. Ulsters and caped overcoats were common travelling wear. New types of mack-intoshes came onto the market, advertised by manufacturers as rubber-less and therefore odour-free. The increasing numbers of motorists could purchase a variety of dustcoats to suit each season, together with the other protective necessities – caps, goggles and gauntlet gloves.

Smoking jackets were the masculine equivalents of tea gowns. In supple fabrics, especially velvet, they permitted wearers to relax

and yet look smart. Both smoking jackets and dressing gowns were often embellished with decorative frogging, which added an acceptable military touch.

Leisure wear and sporting wear were designed to meet the specific rigours of either activity. Whether for boating or playing cricket, proper attire was essential and garments were not transferable from one sport to another. A striped flannel suit or a combination of flannel trousers and a conservative dark blue coat, worn with a straw boater, served as acceptable semi-formal outfits. Long-sleeved knitted sports sweaters became commonplace and were destined to play an important role in the future. Soon, however, other more serious preoccupations took centre stage as the demands and ravages of war accelerated the demise of the 'Golden Age' and its ostentatious lifestyles and fashions.

46. 'Men's clothes are dead, but women's are alive' (a concept since challenged by dress historians) was current theory in 1904 when this cartoon set the frou-frou and curves of an Edwardian beauty against her partner's traditional white tie and black tails and trousers.

# Chapter 2:  1914–1929
## La Garçonne and the New Simplicity

The First World War brought about significant changes in fashion design, dress fabrics and methods of clothing manufacture. Radical developments were most evident in women's dress and had a particular impact on daytime and workplace clothing. When Germany declared war on France on 3 August 1914, preparations were well under way for the Paris Autumn fashion collections and these were shown, as scheduled, to a large international clientele. By late 1914, however, unstable money markets and anxieties about the effects of war began to disrupt European high society and threaten the customary financial outlay on luxurious haute-couture clothing, while shipping restrictions meant that the lucrative export trade to North America could no longer be guaranteed. As the realities of war took hold, many male couturiers signed up for service, leaving a number of the houses that remained open under the direction of women.

America did not enter the war until 1917 and during the early years of the hostilities its fashion industry made various attempts to support the French fashion houses, on which they had relied for many years for design leadership. In November 1914, for example, Edna Woolman Chase, Editor-in-Chief of American *Vogue*, organized a series of Fashion Fêtes to raise money for the national charity known as Secours National. The first show was staged at Henri Bendel's prestigious New York department store and presented the work of US designers, among them Maison Jacqueline, Tappé, Gunther, Kurzman, Mollie O'Hara and Bendel himself. However, though the programme was intended to reaffirm American dependence on French design, fears were aroused in Paris that America was seizing the opportunity provided by the war to promote domestic talent. Bendel attempted to defuse the situation by organizing a French Fashion Fête in November 1915 to publicize Parisian design. The Condé Nast organization then established a fund (known as 'Le Sou du Loyer de l'Ouvrière' [A Cent for the Rent of the Sewing Girl]) to assist those workers in the French couture who had either lost their jobs or were on reduced incomes as couture orders decreased.

47. By 1916 'simplicity' had entered the vocabulary of fashion. A European wartime couple walk in the park: she wears an understated, gently waisted day dress with the new hemline, reaching just above the ankle, to offset dainty, high-cut, laced boots. Her brimmed hat is discreetly decorated and plain gloves and a furled umbrella provide the finishing touches. For the many men engaged in the services, uniform became standard wear and was worn with great pride.

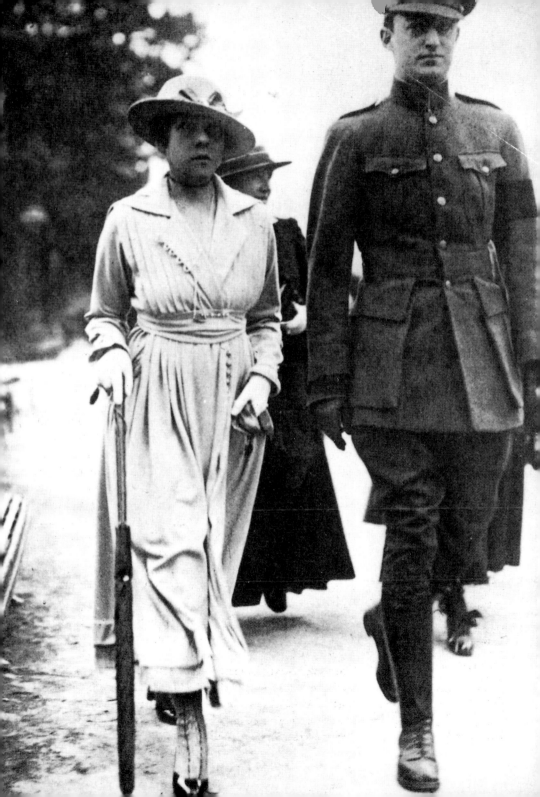

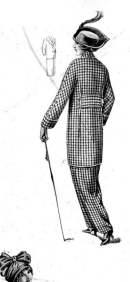

Despite wartime setbacks, the international standing of Paris fashion remained unchallenged and the couture houses continued to dictate in matters of style. The biannual shows were staged as usual, and though their audiences were smaller, they were still given coverage by the world's fashion press. News of the latest styles continued to arouse great interest and in 1916 Condé Nast launched a British edition of his influential New York-based magazine, *Vogue*.

During the first year of hostilities, high-fashion journals, such as the French *Les Modes* and the British magazine *The Queen*, barely mentioned the war. Stylistic developments were almost at a standstill and fashions still resembled those of 1910 to 1914. The silhouette remained column-like, with the vertical emphasis broken by crossover bodices, peplums, layered skirts and draperies. Notable exceptions were created by Madame Paquin, who revived mid-nineteenth-century tiered crinoline skirts for evening – designs which could be considered precursors of the 1920s *robes de style*. Trimmings remained important and many garments continued to be lavishly decorated. For evening, silver and gold metallic lace and embroidery were fashionable and all manner of fur trims adorned both day and evening clothes.

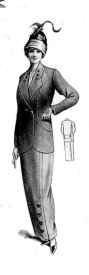

In 1915 a number of designers introduced military references into their collections, notably for day wear, and there was a vogue for the colour khaki. Sensible tailored jackets and suits, with gently waisted silhouettes, became increasingly important components of women's wardrobes. Magazines described these garments as 'the acme of smartness' and stressed the fact that they would not date. Jackets were cut wide to hip-length, with broad belts tied loosely just above the waist. For outdoor wear, three-quarter-length reefer and Norfolk-style jackets provided comfortable protection. Traditionally, fashionable dress for women rarely included pockets, but now roomy, practical patch pockets became a prominent feature, echoing functional army uniform. Military-style passementerie was *de rigueur* and braiding and frogging were used to embellish coats and suits. A forage cap offered an up-to-date alternative to more conventional millinery. Because wool was vital for uniforms, serge (a twill cloth with a warp of worsted and a woollen weft) was often used as a substitute in tailored attire and corduroy was presented as a durable fashion fabric. Trenchcoats, complete with storm cuffs, were appropriated for civilian use and British companies such as Aquascutum and Burberry offered stylish ranges.

48, 49, 50. *Opposite*: Ladies tailored costumes (also known as tailor-mades) by Foster Porter & Co. Ltd of East London for Spring/Summer 1914. Smart, practical and available ready-made, ensembles like these were worn by the growing numbers of (generally unmarried) middle-class women going out to work. Designed in the fashionable silhouette, suits were made distinctive by fabric pattern, colour and via interesting details such as satin-trimmed collars, piping, half-belted backs, button detailing and the shape of pockets and lapels. The top suit was made in black and white check; the middle design was available in 'tan, saxe, navy, purple and black serge' and the model at the bottom in 'tango, grey, purple and tan serge'. A stylish hat provided the vital finishing touch.

51. *Right*: The (remarkably similar) outfits worn by these stylish young women mark the transition period between the early post-war styles and the mid-1920s garçonne look. Skirts have become somewhat shorter, reaching midway between the knee and ankle. Both women wear brimmed hats (the one on the left decorated) and patterned blouses that still emphasize the waist. Leather strap shoes like these were fashionable day wear from the late teens through the twenties.

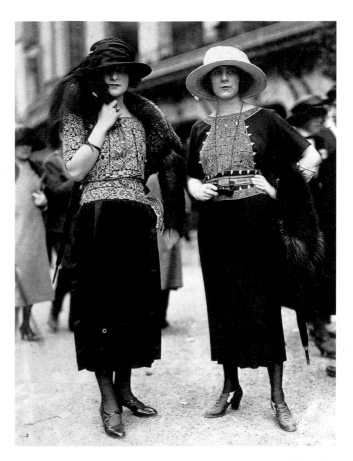

One of the most striking developments in 1914 was the shift from narrow hobble skirts to flared and bell-shaped designs, some with tiers, pleating or kilting. This new silhouette made elaborate petticoats essential once again and shops offered a variety of frilly designs, some with wide, divided legs. By 1916 hemlines had crept up to two or three inches above the ankle, making footwear more prominent. High-heeled, calf-length, buttoned or laced-up boots provided elegant protection and were manufactured at all market levels, often in two tones – usually beige or white combined with plain black or patent leather.

By 1916 the exigencies of war were affecting even the most affluent. A shortage of domestic labour meant that clothing that required elaborate cleaning, ironing and fitting soon became impractical and designs began to be modified to accommodate wartime shortages and more modest lifestyles. Evening wear played a progressively smaller part in the seasonal collections,

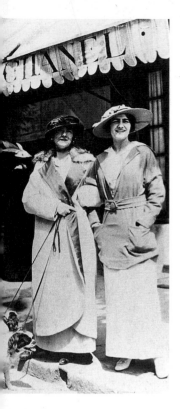

52. Gabrielle Chanel with her aunt Adrienne, standing in front of the designer's first boutique, in Deauville, in 1913. Both women exemplify the understated elegance that was to make Chanel famous.

53. *Opposite:* Chanel's 'Costumes de jersey' from *Les Elégances Parisiennes*, March 1917. Combining function and luxury, these delicately embroidered jersey ensembles consist of an open-necked blouse, loosely belted marinière and the new shorter, fuller skirt. The model on the right features a double-buckled belt derived from saddlery (Chanel was an accomplished horsewoman) and the central figure is wearing two-tone shoes, a style that has remained a house signature.

with the main demand coming from the US. Since it was no longer possible to observe the pre-1914 protocol of at least four changes of dress a day, the war years also saw the decline of the tea gown. Dark, dull colours predominated and proved entirely appropriate to the sombre times. For mourning, black continued to be worn, and crape remained the approved fabric, but the rules governing funerals and mourning etiquette were relaxed because many women working for the war effort were unable to adhere to them. It was felt, however, that even in times of mourning morale should be kept up, and fashion journals offered stylish solutions in black for the vast numbers of women who had experienced bereavement.

Changes in the styling of day wear, more than any other area of dress, paved the way for postwar fashion. From 1916 many designers focused on easy-to-wear clothing. The jumper-blouse in particular offered women a fashionable and practical garment to wear with a skirt or suit. This was an unusual piece of clothing for women in that it was pulled on over the head and had no fastenings. Worn over the skirt, rather than being tucked in, it reached just below hip level and sometimes featured a sailor collar, belt or sash. The jumper-blouse (the term had been shortened to jumper by 1919) was usually made in cotton or silk and became a major feature of 1920s fashion. Knitted cardigans were also popular, as were heavier-weight 'knitted sports coats' for outdoor wear. In addition to buying machine-made garments, many women hand-knitted items for themselves and their families. Necklines on shirts and blouses remained low, often with deep V-necks, but chemisettes or 'fill-ins' were frequently pinned in for modesty, a practice that would last throughout the 1920s.

It was the young Gabrielle Chanel who, arguably, did the most to transform the design of fashionable wartime dress by noting and developing these trends for more casual and sporty clothing. Having started her career as a milliner in Paris, Chanel opened her first dress shop, selling day wear and hats, in Deauville in 1913 and soon attracted a clientele from among the area's rich refugees, who were escaping the realities of wartime Paris. Capitalizing on the success of this shop, she opened a *maison de couture* in Biarritz in 1915 and presented her first haute-couture collection in the Autumn of 1916. Chanel's pared-down, sporty clothes were to prove ideal for the war years. Her supple, eminently wearable two-piece jersey costumes, capes and coats created a sensation by virtue of their simplicity. Jersey had previously been used mainly for men's sporting wear and underclothing, but Chanel made this prosaic textile the height of fashion. Women loved her clothes and

52

53

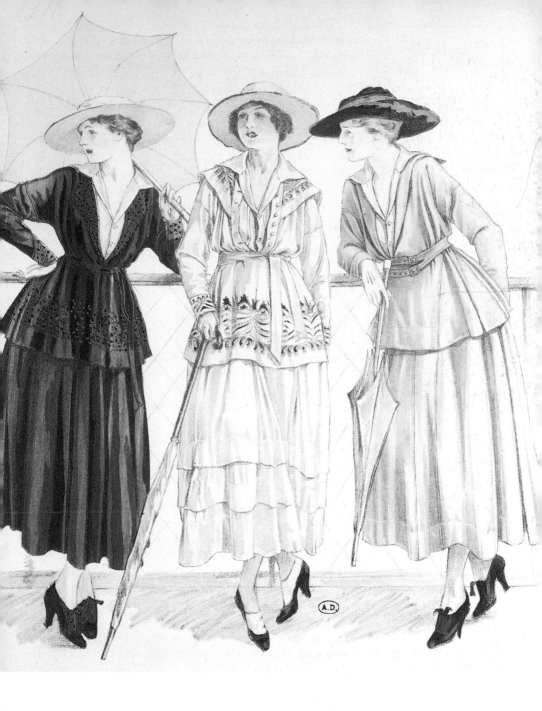

manufacturers were quick to recognize their commercial potential. In 1917 the US-based Perry, Dame & Company offered their mail-order customers, for just $2.75, 'a trim fitting middy of all wool jersey' with white worsted collar, cuffs and hem – a style that closely resembled those seen in Chanel's collections.

In 1917 a handful of Parisian designers, including Paquin, Doeuillet and Callot Soeurs, introduced the barrel skirt, but this rather extreme style, cut exaggeratedly wide over the hips, and recalling the pannier fullness of eighteenth-century dress, had little impact since more restrained designs were deemed both flattering and more appropriate to the difficult times. In addition, women's participation in the war effort made practical clothing essential.

From 1916, as increasing numbers of men joined the services, women were encouraged to enter the labour force, undertaking arduous and often highly skilled work in the munitions, transport and chemicals industries, as well as in hospitals and on the land. This led to new approaches to working dress. Long-held taboos against bifurcated garments broke down as young women in particular adopted breeches for agricultural labour and wore loose cotton trousers, boilersuits and dungarees for factory work and in the mines. A typical munitions worker dressed in a three-quarter-length, loose-fitting, thick cloth jacket, belted at the waist, ankle-

54. During the First World War, British women took on many different jobs, at home and at the front, and their work was documented by official photographers attached to the Ministry of Information. This photograph shows a member of the Women's Royal Air Force.

54

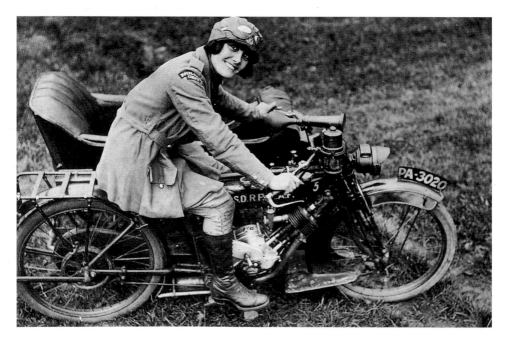

length trousers, black stockings, and low-heeled, lace-up leather shoes. Hair was often parted in the centre, tied in a loose knot at the back of the head, and covered with a protective mob cap.

Changes in the line and form of outerwear were paralleled by developments in undergarments. Although corsets continued to be worn, the emphasis shifted from moulding the body to supporting it. In the UK, the large Symington factory in Leicester introduced a compressed paper called Fibrone as an effective substitute for boning, and used buttons as fastenings instead of metal busking. In addition to conserving scarce resources, these corsets were particularly useful for munitions workers, who were not permitted to wear garments containing metal. By 1916 the brassiere had evolved from the bust bodice. (The term would not be abbreviated to bra for another twenty years.)

Throughout the war, many clothing workshops and factories were redeployed to make standardized army uniforms – a move that was to have a significant impact on the manufacture of women's clothing. Freed from the tyranny of seasonal changes of fashion, many businesses expanded their production capacity and employed a greater division of labour to achieve high-speed, quantity output. Though the majority of production units remained small (fewer than ten employees) and labour- rather than capital-intensive, some larger organizations embraced such technological developments as the band knife (introduced in the late 1850s by John Barran in Leeds, England), which cut large batches of cloth in one lay. In 1914 the Reece Machinery Company in the US invented the buttonholing machine. Used initially to finish army uniforms, this was to prove indispensable to fashion manufacturers in the postwar years. The industry as a whole also became better organized and, taking the lead from the US, the Tailor and Garment Workers Union was formed in Britain in 1915 to consolidate terms and conditions of work.

In the postwar years, Paris continued to dominate international fashion and revitalized couture houses enjoyed a booming trade. The huge demand for wedding dresses immediately after the war gave the industry a much needed boost, as did preferential pound and dollar/franc exchange rates, improved air and sea travel and increasingly sophisticated communications networks. The year 1921 saw the successful launch of French *Vogue*, which generated large domestic and overseas sales. A number of designers expanded their fashion houses, some employing up to 1,500 highly skilled craft workers in tailoring and dressmaking studios and in embroidery and accessory workshops.

55. The first brassiere, designed by Mary Phelps Jacob (Caresse Crosby) and patented by her in November 1914. Like all early bras up to the mid-1920s, it was unboned and was meant to flatten rather than emphasize the breast shape.

Businesses grew even bigger as designers started to diversify into top quality ready-to-wear clothing and sporting wear, and began to introduce highly profitable diffusion lines, such as perfume. Poiret had issued his own range of perfumes in the pre-war years, but Chanel was the first fashion designer to put her name on a scent bottle. Launched in 1921, Chanel 'No. 5' was blended by Ernest Beaux, the perfumer who was famous for his innovative use of synthetic aldehydes to enhance the smell of costly natural ingredients such as jasmine. Chanel herself designed the modernist, pharmaceutical-style bottle, prompting a trend away from precious, curvilinear scent flaçons. Other houses followed suit and perfume sales have proved highly profitable ever since.

During the first half of the 1920s fashion followed two courses – the traditionally feminine and the more modernist. In the US, Tappé; in London, Lucile; and in Paris, Paquin, Callot Soeurs, Martial et Armand and most notably Jeanne Lanvin were at the forefront of the romantic movement. These designers took delight in creating dreamy clothing in sugared-almond-coloured paper

56. *Opposite*: The transition from romantic to modern styles is revealed in this 1924 illustration by comparing the highly decorated *robes de styles* (left and centre) with the shorter and linear early garçonne model (right). *Robes de styles*, though most closely associated with Lanvin, were made by most couturiers of the time. These examples are by Patou, while the simpler garment is a Doucet design.

57. Embroidered mother-and-daughter frocks were a Jeanne Lanvin speciality. Lanvin began her career as a milliner, but was led into haute couture when she created a wardrobe for her daughter. This illustration, 'Vive Saint Cyr!' by Pierre Brissaud for the *Gazette du bon ton*, July 1914, shows the mother wearing a waisted, tiered, romantic dress, while the daughter wears the shorter boxy style that was to prevail.

58. Evening gowns by Lucile (Lady Duff Gordon). Lucile had been at the forefront of the romantic style and even in 1923, when the new, boyish look was beginning to enter women's fashion, she was still producing 'picture dresses' of the kind shown here. Her failure to move with the times may have been one of the causes of the collapse of her business in the same year. *Left to right*: blue taffeta and lace; straw-coloured faille and silver lace; ivory crepe with golden embroidery.

taffeta, organdie and organza, trimmed with ribbons, fabric flowers (often on the waistband) and lace. Designs drew on exotic and historical sources, often culminating in the *robe de style* or 'picture dress', with its boned bodice, nipped-in waist and billowing skirts, which reached just above the ankle. Beribboned shepherdess-style hats, and shoes with pointed toes laced with silk ribbons completed the look. Pastel-coloured mother-and-daughter dresses by Lanvin epitomize this style and have been immortalized in the exquisite fashion plates of Georges Lepape, Benito, André Marty and Valentine Gross, among others.

What was to dominate postwar fashion, however, was the garçonne look – the very antithesis of the romantic style. The term is said to have originated with Victor Margueritte's sensational 1922 novel, *La Garçonne*, which tells the tale of a progressive young woman who leaves her family home in pursuit of an independent life. The garçonne look was in fact aspirational rather than rooted in reality since relatively few women actually experienced radical social, economic or political freedom. In the UK, for example,

though women over the age of thirty, married women, householders and university graduates had been enfranchised in 1918, it was not until 1928 that all British women were entitled to vote. And while American women had won the right to vote in the Presidential elections by 1920, their newfound independence was curtailed after the war when they, like women in Europe, were encouraged back into the home to resume their full-time roles as wives and mothers and to make way for men returning from the war.

The garçonne or *jeune fille* look evolved during the immediate postwar years, reaching its peak in 1926 and continuing with little change until 1929. It was a youthful, boyish style which, because it demanded a pre-pubescent figure, brought about a drastic change in the desirable fashionable physique and provoked a flurry of adjectives such as 'slender', 'svelte' and 'sleek' on the fashion pages.

Hairstyles also followed the vogue for the youthful and androgynous. The more avant-garde women had their hair cut short in 1917 and by the early 1920s many others had followed suit. Brilliantine was used to keep bobbed and shingled hairstyles sleek and gleaming. Longer hair was generally worn up, decorated for

59. Cover of *La Garçonne* (1922) by Victor Margueritte, the novel from which the fashionable look of the 1920s is believed to have got its name. The illustration depicts the book's scandalous heroine, Monique Lerbier, who cut her hair short, wore a man's jacket and tie, and gave birth outside wedlock.

60. Fashionable young 'garçonne' wearing an afternoon dress in pale mauve crepe-de-chine by Welly Sœurs, c.1926.

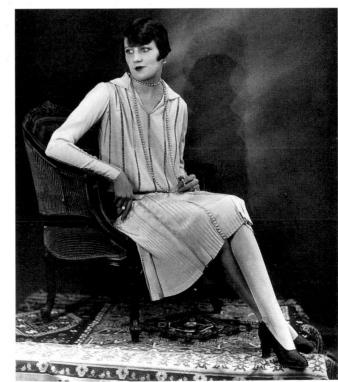

the evening with hair ornaments, such as Spanish combs with high, ornate mounts and long curving teeth. By 1926 short hairstyles became the norm, with the most daring women adopting the schoolboy haircut known as the Eton crop. Short hair was of course essential under the ubiquitous cloche hat of the period. Bell-shaped and usually made of felt, this style fitted closely to the head and was pulled deep over the brow. The face was highlighted with cosmetics, now used in greater abundance than ever before. The beauty business prospered as modish young women started to pluck their eyebrows into fine arches, highlight their eyes with dark lines of kohl and apply deep colours to their lips – sometimes even in public.

Throughout the period, professional models (usually contracted to one particular fashion house) were generally anonymous, while beautiful society women, film stars and actresses were feted in fashion magazines and were sometimes given more extensive coverage than the designers whose clothes they endorsed. The

61. *Above*: The cloche became the most popular hat design of the second half of the 1920s. This early turbanned velvet version is by Marthe Collot, 1924–25.

62, 63, 64. *Right, this page and opposite*: Designs by Jacques Doucet, 1924–25. *Left to right*: day dresses adapted from the lines of Doucet's prewar tunics; an elegant drop-waisted dress in checked material worn with a coat with matching lining and a cloche hat; an evening gown with an uneven split hem; and an evening dress worn with a dramatic high-collared theatre coat. These designs were created towards the end of Doucet's career – he died in 1929.

65. The Hollywood actress Louise Brooks, whose vivid beauty, chic, bobbed hair and vitality personify the 1920s goddess.

cinema became an especially powerful style leader. Audiences were enchanted by such vamps of the silent screen as Theda Bara, Pola Negri and Clara Bow, though it would have been inappropriate to translate their rather theatrical appearances into everyday life. Following the introduction of sound in 1927, however, there was a move towards greater realism. When such stars as Joan Crawford, Louise Brooks and Gloria Swanson were cast as fashionable 1920s flappers, they inspired millions of women to copy their clothes, hair and cosmetics, as well as their mannerisms. Fan magazines, first launched in 1911, revealed the beauty routines and wardrobes of the stars. Male actors Rudolph Valentino and Douglas Fairbanks provided new measures of style for men. Ina Claire took the Chanel look to Broadway and the lithe Gertrude Lawrence wore Molyneux's pyjama suits on stage.

The simplicity that characterized the garçonne look was evident primarily in cut rather than in fabric. The straight-cut

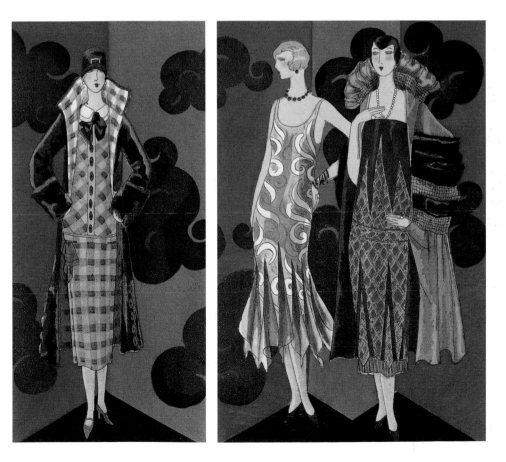

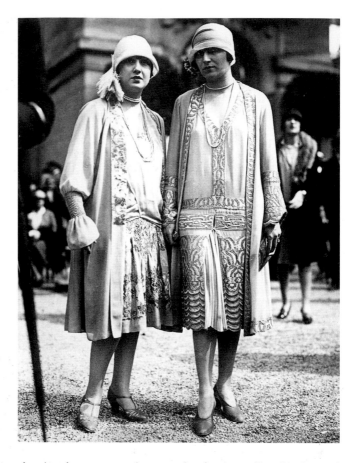

66. Dressed for a special daytime occasion, c. 1926, these fashionable young women wear cloche hats and decorated, drop-waisted dresses with matching coats. The long strings of beads were ubiquitous in this period.

chemise dress was to become the dominant line for day and evening wear. Garments hung from the shoulders, as waists dropped to hip level. Chanel and Patou were leading exponents of the garçonne style and the former, whose own appearance epitomized her fashions, was given most press coverage. Other top Paris houses included Doucet, Jenny, Lanvin, Paquin, Doeuillet, Molyneux and Louiseboulanger. Though Poiret adapted to postwar trends, he was no longer in the vanguard and the three 'Poiret' barges moored on the River Seine at the 1925 Paris Exhibition, in which he showed clothing, perfumes and food, were to be his swansong. In the US, Hattie Carnegie, Omar Kiam and Richard Heller enjoyed financial success as, from 1927, did the newly established British designer Norman Hartnell. None of these, however, was accorded the status and prestige associated with Paris.

Throughout the first half of the 1920s there was uncertainty about the future direction of the hemline. Chanel and Patou

62–64

consistently championed the shorter length, and this fashion did much to stimulate demand for stockings. Silk stockings remained the most desirable, generally knitted in plain colours – black, white and neutral shades of beige and grey were the most popular. For day and evening plain stockings were usually preferred, with decoration chiefly confined to discreet embroidered clocks. More flamboyant tartan and checked designs were worn with sporting wear. The most common footwear styles were cuban-heeled court shoes, and shoes with cross straps and T-bars. Shoe materials included plain and two-tone leathers and reptile skins for daytime, and embroidered and brocaded fabrics, silks and gilded kid for evening, sometimes with jeweled buckles and decorative inlays in the heels.

While the cut of clothing was generally pared down, fabrics were highly decorative, especially after dark. Richly coloured, naive, Slavic folk designs, introduced to Paris by Russian émigrés following the 1917 revolution, became a notable design source during the early 1920s. Following the opening of Tutankhamun's tomb late in 1922, there was also a vogue for Egyptiana, with

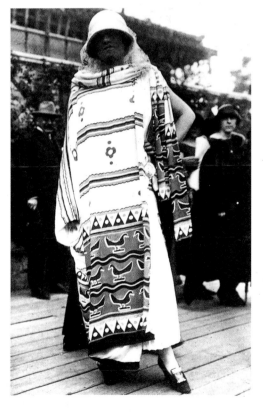

67. *Below*: *Les Tissus d'Art*'s long asymmetrical tunic with matching scarf, worn over a pleated dress, from *c*. 1923, reveals the influence of Ancient Egypt on both the cut and textile motifs of fashion garments following the discovery of Tutankhamun's tomb late in 1922.

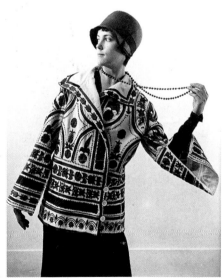

68. *Above*: Ensemble by Paul Poiret, *c*. 1925. Although fashion's mood was changing, Poiret's decorative designs retained their desirability during the early to mid-1920s. The strong black and white design on this open-sleeved jacket was perfectly in tune with the prevailing vogue for fashions revealing Russian, Egyptian, Indo-Chinese and European folk influences.

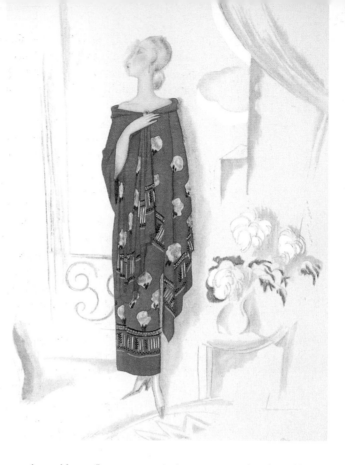

69. 'Le Chale Bleu Echarpe de Rodier', from the *Gazette du bon ton*, 1923. The shawl was a highly desirable accessory in the 1920s. It could transform a plain outfit and could be worn at any time of day and on almost any occasion. Top textile manufacturer Rodier made the fine patterned blue wool used to create this matching dress and shawl.

70. Costume jewelry by Chanel, 1929. Chanel helped make costume jewelry acceptable to the fashionable elite. The plumage, eyes and claws of the stylized bird and ostrich brooches are highlighted with red glass stones and diamanté.

scarabs and lotus flowers among the many associated motifs that inspired fashionable dress fabrics. Rich customers could select from an enormous range of patterns, from bold modern designs to repeats based on historical, often eighteenth-century, sources. A craze for Chinoiserie stimulated the production of a host of ornate and richly coloured printed and woven fabrics. Devoré printed textiles were especially popular. The cut of evening wear was straight, sometimes tabard-style with side inserts, and featured low-cut necks and backs with thin shoulder straps. Fine brocaded silks, and gold and silver lamés, conceived by major textile artists and produced in the textile mills of Lyons, were combined with exquisite embroidered and beaded decoration to demonstrate the skills of haute couture to maximum effect.

Also from Lyons came the most dramatic and sophisticated examples of the shawl – a highly popular accessory from the early 1920s to the beginning of the 1930s. Variously draped around the body, and often fringed in silk, shawls added further dimensions

69

to the pillar-like forms of the prevailing fashions. They also provided warmth and comfort over flimsy 1920s attire. In addition to brocaded shawls from Lyons, there were lavishly embroidered imports from India and China, as well as hand-painted versions by leading artists.

Some designers created frocks encrusted with glistening beaded decoration; others added beaded fringes or fringed hems which emphasized the movements of fashionable dance steps. A more restrained decorative device took the form of 'twist embroideries' – fine twists of dress fabric applied to the surface of a garment in decorative patterns or added to hems to form fancy edging. Shoes and bags were often designed to match evening wear, and bags became larger to accommodate such newly fashionable accessories as cosmetic compacts, cigarette cases and cigarette holders.

It is a myth of fashion history that women abandoned their corsets during the 1920s. A few highly publicized 'Bright Young Things' did forgo both corsets and suspenders, rolling down their stockings to just above the knee – a look much lampooned in contemporary caricatures of the modern woman – but for most women the long, cylindrical elastic corsets provided support and served to suppress feminine curves in the quest for the fashionable look. Softer corset substitutes were also adopted, such as elastic 'roll-ons' and 'step-ins', which had zip fastenings at the side. (The zip, originally known as the 'slide fastener', was invented in the 1890s and patented as the 'zipper' in 1923.) The one-piece camisole evolved from the chemise and some versions were cut extremely low at the back to wear with evening dresses. Silk and cotton were the most popular materials for underwear, and the top-selling colours were white, ivory and shades of peach. These were decorated with designs in drawn threadwork, embroidery or appliqué. More racy colours were also available and shades of lemon, mauve, sky blue, coral, green, black and pink were advertised by specialist lingerie shops and department stores.

Costume jewelry that was proudly and defiantly fake became the new fashion accessory of the 1920s. Traditionally, the function of artificial gems had been to provide deceptive copies of precious originals. Chanel, who opened her own jewelry workshops in 1924, flouted this convention by designing jewelry with paste stones and fake pearls in colours and sizes that defied nature. She believed that jewelry should be worn to decorate, rather than to flaunt wealth. Turning tradition on its head, she herself often wore, during the daytime, jewelry that would normally have been considered suitable only for evening – ropes of fake pearls

70

or her distinctive coloured-stone necklaces or brooches, inspired by Renaissance and Byzantine jewels. For evening, she frequently avoided jewelry altogether.

At the huge Exposition Internationale des Arts Décoratifs et Industriels Modernes held in Paris in 1925, highly ornate art deco objects, many of which drew on eighteenth-century revival styles, were shown alongside resolutely minimalist works. But the smooth, angular and geometric lines of modernism soon dominated both fashion and textile design. Black, white, neutral grey and beige were the most avant-garde colours, and on those rare occasions when pattern was used it tended to be linear and geometric. The artist Sonia Delaunay showed examples of her work in the applied arts in her Boutique Simultané in Paris, which she shared with the couturier and furrier Jacques Heim. Delaunay believed that the fine arts should be integrated into everyday life, and she developed textile designs from her orphic cubist paintings which explored the illusion of movement created by the juxtaposition of colours and shapes. In contrast to the prevailing vogue for neutrals, her textiles were characterized by brilliantly coloured diamond and disc patterns, which were made up into eye-catching sports clothes with matching accessories. In Russia the Constructivists, among them Varvara Stepanova, proposed dress and textile designs for the new society, combining traditional folk imagery with designs drawn from modern-day industry and technology.

By 1925 black and white photography had replaced illustration as the chief recorder and communicator of fashion expression. Clear lighting and sharp focus allowed cut, construction and fabric textures to be shown with clarity, though editorials had to provide colour details. The outstanding pioneer fashion photographers Baron de Meyer and Edward Steichen were joined by creative newcomers. Man Ray took surreal photographs of fashions from the 1925 Paris exhibition, displayed on dressmakers' dummies rather than on live models. Cecil Beaton established himself as a top society portrait photographer and George Hoyningen-Huene, who became famous for his sports wear photographs and use of classical settings, was among the first to make extensive use of male models.

The iconography of sports and the design of sports clothing became a focus for the new modernity. Couturiers opened specialist departments, and none took this aspect of clothing more seriously than Patou, who designed for professional sports people. His most famous client was the French tennis champion Suzanne Lenglen, whom he dressed both on and off court. In 1921 Lenglen had caused a sensation by playing a match in a Patou outfit which

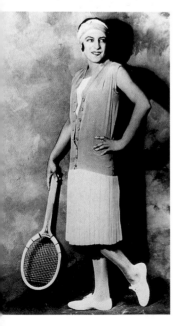

71. The tennis champion Suzanne Lenglen, who won the Wimbledon final from 1919 to 1926, had a close association with the couturier Jean Patou, who dressed her both on and off court. She is seen here in 1925 modelling a tennis outfit by Patou. Over her pleated dress she wears a sleeveless sweater, derived from a man's waistcoat, and around her head a bandeau, a style that was much copied.

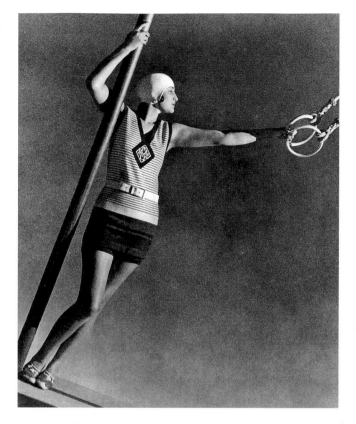

72. Knitted striped two-piece bathing costume by Patou, 1928, photographed by George Hoyningen-Huene. Patou was at the height of his success in the 1920s and was one of the largest of the fashion houses, showing up to 350 designs a season. His output of sports wear was prodigious. In 1925 he opened a specialist sports wear outlet, Coin des Sports.

consisted of a wide bandeau around her head and a just-below-the-knee, pleated shift dress which, when she ran, revealed the top of her stockings (rolled down to just above the knee). Patou also created specialist clothing for swimming, riding, golf and skiing, and his blend of ergonomic functionalism combined with fashionable styling influenced his mainline collections. In 1924 he endeared himself to the US market by importing six athletic-looking American women to model his clothes in Paris. Jane Regny, who was a sportswoman as well as a designer, brought her own experience and knowledge of sports wear to bear on her collections, and Lanvin and Lucien Lelong also excelled in this field.

The craze for professional and amateur sporting activities coincided with scientific endorsement of the health-giving properties of sunlight. For the first time a suntanned skin became fashionable, signifying leisure and the affluence required to enjoy it – ideally at cosmopolitan seaside resorts. The design of swimwear underwent dramatic changes during the postwar years, with new costumes daringly exposing the body to both public view and the

sun. Knitted one-piece bathing costumes had first appeared around 1918 and by the mid-1920s women were discarding the cumbersome tunic-and-knickers variety in favour of more minimal all-in-one designs. As the 1920s progressed, costumes became even briefer. Sleeves were eliminated and trunks shortened to mid-thigh level. Costumes for both men and women featured short overskirts which concealed the groin, but this coyness had generally been abandoned by the mid-1920s. Rubber bathing caps also became available by mid-decade, completing the sleek, streamlined look of modern swimwear. Despite an international outcry about the indecency of both sexes cavorting together so scantily clad on public beaches, attempts at legislation proved futile against the powerful tide of fashion.

The Parisian couture houses took a leading role in the creation of fashionable swimwear. Patou, Delaunay and newcomer Elsa Schiaparelli introduced striking designs using stripes and blocks of colour. These were quickly seized upon by manufacturers and made available to the mass market. Costumes were constructed either from cotton or from wool, though the latter was uncomfortably hot in summer and became heavy when wet. By 1930 the American company Jantzen, at the time the world's leading swimwear manufacturer, had produced body-moulding costumes by developing knitting machines that could make garments with elastic rib stitch on both sides to add extra stretch, though even this did not overcome the problems of heat and water retention.

The obsession with outdoor activities and the more relaxed approach towards dressing proved a potent influence on the design of men's clothing. Although traditionalists denounced the

73. Detail of a black woollen sweater with a *trompe-l'œil* white bow, by Elsa Schiaparelli, 1927. This garment launched Schiaparelli's career in fashion.

74. A group of friends pose for a seaside photographer in the late 1920s. This image captures the greater informality between the sexes, the similarity in the style of bathing costumes and the dissemination of design.

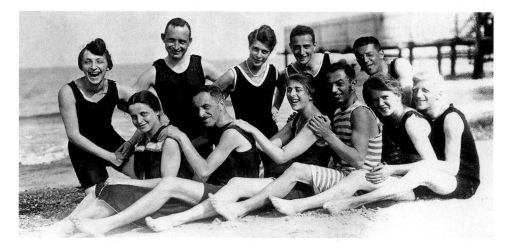

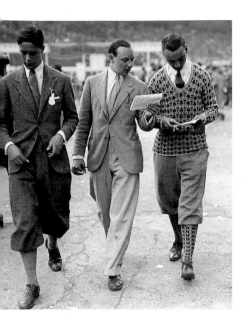

75. Top-level men's fashions, 1926. The golfing outfit (*left*) and the plus-fours and boldly patterned sweater and socks (*right*) show the influence of the Prince of Wales.

76. Chanel's designs for the Ballets Russes production of *Le Train bleu* in 1924 also drew inspiration from the Prince of Wales's sporting dress. With this production, Diaghilev brought a new modernist realism to dance: Picasso designed the programme and signed the stage curtain, which was an enlargement of his 1922 painting *Two Women Running on the Beach* (*The Race*). The Cubist sculptor Henri Laurens conceived the sets.

movement towards greater informality as 'slovenliness', it gained widespread support, finding its greatest exponent in the trend-setting Prince of Wales. Among the many fashions popularized by the Prince were plus-fours (so-called because the fabric over-hung the knee band by four inches [10 cm]), the cut-away shirt collar and the 'windsor knot', known in the US as the 'bold look tie'. He had a penchant for brogue shoes with fringed tongues, and revived the ailing Scottish knitting industry when he was pho-tographed wearing a jaunty, multicoloured, Fair-Isle sweater while playing golf at St Andrew's in 1922.

In 1924 the Prince's dapper style was to inspire Chanel's cos-tume designs for the Ballets Russes' performance of *Le Train bleu*. This ballet, named after the luxurious train which had made its maiden voyage from Paris to Deauville in 1923, was set on the Riviera and had a sporting theme. Swimming, tennis and golf were all featured and Chanel dressed the dancers in jersey bathing costumes and cardigan suits, similar to those seen in her fashion collections. Nijinska danced the leading female role (based on the tennis player Suzanne Lenglen) and the male lead, Leon Woizikovski, wore costumes directly drawn from garments popularized by the Prince of Wales.

As with womenswear, men's sports clothing became increas-ingly acceptable as casual wear and the demarcations between town and country dress and day and evening wear gradually started

75

76

77. Postcard photograph showing two stylishly dressed couples in the early to mid-1920s. Revealing the dissemination of fashionable design, the women wear relaxed *sportif* styles as promoted by Chanel and Patou. The men are dressed in the boldly striped flannel blazers, open-necked shirts, cream trousers and light coloured shoes that formed the basis of fashionable beachwear at the time.

78. In contrast to the vogue for casual day wear among younger men, these older gentlemen, attending an American Legion party in September 1923, happily accept the prescribed formality of morning dress.

to blur. Single-breasted blazers (sometimes striped) with patch pockets and gleaming metal buttons cut a dash when worn with open-necked shirts, grey flannel or white linen trousers and white lace-up shoes.

London continued to lead fashions in menswear: a made-to-measure suit from Savile Row remained the most desirable in the world. In marked contrast to the angular lines of womenswear, men's formal suits were almost shapely, with high, indented waists, accentuated shoulders and tapered trousers. More comfortable, rounder-toed shoes replaced those with narrow points, and brogues were widely worn during the day, though during the early 1920s spats were *de rigueur*.

At Oxford University a small group of 'aesthete' undergraduates adopted trousers with exceptionally wide legs (forty inches [102 cm] around the hem at their most extreme) which became popularly known as 'Oxford bags'. The most flamboyant wore shades of lavender, sand and pale green, though navy, grey, black, cream and beige were more usual. Oxford bags excited the interest of the international fashion and trade press and the craze soon spread to Ivy League colleges in the US.

Reaction against the dictates of mainstream fashion, often fuelled by issues surrounding health, politics and aesthetics, remained the prerogative of artists and the intelligentsia, and continued to find its most eccentric expression in Britain. Unlike their French counterparts, British 'bohemians' did not mix with

79. Nina Hamnett and Winifred Gill model Omega's spectacularly colourful and boldly patterned clothes, posing in front of Vanessa Bell's painted screen *Bathers in a Landscape* (late 1913). Omega artists believed that art should be spontaneous and a part of everyday life, so they created dress and interior objects that mirrored the colour and modernity found in their paintings.

80. Members of the Men's Dress Reform Party in London in July 1937. These men – all attired in MDRP-approved styles – were taking part in a dress contest, the results of which were published in the magazine *The Listener* on 14 July 1937. The man second from left won a prize for his ensemble.

fashion designers but tended to form small, exclusive colonies. One famous example is the Bloomsbury Group, whose members included the painter Vanessa Bell, a distinctive figure in her long, loose, brightly coloured clothes; the friend and patron of the group: violet-haired Lady Ottoline Morrell, with her penchant for Turkish robes; and Roger Fry. Fry, a Quaker, had been a conscientious objector during the war. He wore shapeless Jaeger homespuns with brilliantly coloured shantung ties, wide-brimmed hats and sandals – a style he retained throughout his life.

A more organized form of protest came from the Men's Dress Reform Party, founded in June 1929, which campaigned to gain acceptance of a style of clothing for men that would provide 'aesthetics, convenience and hygiene'. The MDRP suggested that stiff shirt collars, tightly knotted ties and trousers be replaced by more relaxed, decorative shirts and blouses, and shorts or breeches. They also preferred sandals to shoes. These reforms were intended to apply to all occasions. Leading forces behind the group included an eminent radiologist, members of the Sunlight League (which promoted the health-giving properties of pure air and sunshine), artists and writers. A similar organization, known as the Anti-Iron-Collar League, existed in France. Throughout the period there was much debate as to whether shirt collars should be stiff or soft, attached or detached. In the end it was the comfortable, easy-to-wear, soft attached collar that won the day, and the MDRP was disbanded in 1937.

Chanel continued to make fashion headlines throughout the latter half of the 1920s, bringing many items of men's clothing – some of which had been worn by women during the war years – into the fashionable woman's wardrobe. Blazers, shirts with cuff-links, reefer jackets, and tailored clothes in thick woollen tweed featured regularly in her collections. One of the most radical developments for women was the gradual acceptance of trousers, which were no longer considered either eccentric or strictly utilitarian. Chanel did much to accelerate this move and was often photographed during the day wearing loose, sailor-style trousers, known as 'yachting pants'. The most fashionable young women started to wear trousers for leisure pursuits, particularly on the beach, or for early evening wear at home, the latter in the form of luxurious, Chinese-style, printed silk pyjama suits. Women's trousers were loosely cut, often with elasticated or drawstring waists, and were distinguished from men's by side fastenings.

In 1926, with the launch of her legendary 'little black dress', Chanel promoted black as a colour which could be exploited purely for its elegance and its capacity to flatter. Matt fabrics such as crepe and wool were used for day wear, and silk satins and velvets were popular for evening, sometimes accented with diamanté trim. American *Vogue* likened the design of these dresses to the mass-produced, all-black Ford motor car and predicted that they would be adopted by an equally large market sector. Fashions of 1927 were characterized by uneven hemlines, featuring handkerchief points or hems that were longer at the back. Narrow, trailing scarves, sometimes attached to dresses, also served to break the hemline in a decorative manner. Knitted jersey cardigan suits continued to be the mainstay of many women's wardrobes throughout the decade. Some were made from horizontally striped fabrics, but many were plain, or simply trimmed with a contrasting colour.

During the 1920s styles were rapidly disseminated from the gilded salons of haute couture to the high streets of Europe and America. A labyrinth of copy houses encircled the Paris fashion district, including Madame Doret's establishment in rue du Faubourg Saint-Honoré, which made its name by selling cheap copies of catwalk fashions. The couture houses tried to copyright their designs to prevent pirating, but, as is still the case, the trade was ruthless and copying was rife. Many top-level manufacturers and retailers posed as potential buyers and stole designs by surreptitiously sketching and memorizing details at the shows. The more scrupulous obtained their patterns by purchasing toiles – calico copies – which designers sold expressly for reproduction.

1978     1996     2001     Blouse 1987   Skirt 2001   1937   1839    1839

Sample tailors and dressmakers cut these out into standardized sizes for manufacture. The lower end of the trade, unable to visit Paris themselves, copied the designs seen in more exclusive shops. Specialist trade literature reported on the forthcoming season's designs and fabrics and predicted future trends.

The garçonne style, with its loose, straight cut, was easy to 82, 83 make at home as well as to mass produce in standard sizes. It was economical – just two or three metres of fabric would make a dress – and since garments were generally made from lightweight material, they could be assembled using domestic sewing machines. Home dressmakers had access to designs created by top Parisian couturiers. Between 1925 and 1929 the US-based McCall Pattern Company featured designs by Chanel, Vionnet, Patou, Molyneux and Lanvin, among others. In Britain, *Weldon's Ladies Journal* published magazines which included not only free patterns, but also designs for patterns which could be ordered by post. Fashion advice was given by 'Yvette – a Woman of Fashion, rue de la Paix, Paris'. *Weldon's* also published editions specially devoted to evening dresses, hats for women and children, and fashions for medium and outsize women. Across the US and throughout Europe the fashion press proliferated at all market levels. By these various means, the design of the most elegant haute-couture evening dress filtered down to the cheapest rayon frock.

The development of rayon was one of the most significant textile breakthroughs of the inter-war years. Superficially resem-

bling the feel and appearance of natural silk, rayon became a great asset to the mass market. Since the 1880s attempts had been made to perfect a man–made fibre, but these had met with little success. Initially, viscose filaments were woven to create a material known as art (artificial) silk. This term, implying as it does that viscose was a poor substitute for silk, was abandoned in 1924 when the generic name rayon was officially adopted. At first, use of this fabric was limited to linings for cheaper ranges of clothing, lingerie and trimmings, but it was subsequently employed in huge quantities in the production of stockings. Though these had the advantage of being competitively priced, they were always less desirable than silk because they laddered easily and had an unfashionable shine. As production techniques improved, making a pleasingly dull finish available by 1926, rayon began to be used for day and evening dresses as well as for fashionable knitwear.

The major fashion feature of 1929 was the dramatic drop in hemlines in the Winter collections – a change widely credited to Patou. It has often been asserted that skirt lengths reflect the economic situation and that when times are bad, skirts are long, but this theory has to be treated with caution. The Winter 1929 collections had been designed and made well before the collapse of the Wall Street Stock Exchange on 24 October 1929, which caused the overnight bankruptcy of multi-millionaires and huge international businesses and brought the 'Roaring Twenties' to an abrupt close.

# Chapter 3: 1930–1938
# Recession and Escapism

The collapse of the New York stock market, which led to a world-wide Depression and mass unemployment, was an inauspicious start to the 1930s. For a long time the French high fashion industry had been dependent on its export trade to the United States: after the 'Crash', extant orders from department stores and private buyers were cancelled and few were placed following the December shows of the same year. In a bid to ride the Depression, designers slashed their prices – it is said that Chanel cut hers by half. They also diversified, introducing cheaper, ready-to-wear ranges, and top names raised additional revenue by endorsing fashion-related products.

During the early part of the decade, couturiers abandoned costly, labour-intensive decorative techniques, such as embroidery: Paris's master embroiderer Lesage survived the crisis by temporarily adapting his designs for cheaper printed textiles. Unemployment in the Parisian industry had been rare in the 1920s, but as demand decreased and fashion houses downsized, many thousands of skilled dressmakers, tailors, seamstresses, embroiderers and accessory makers were laid off. Despite these setbacks, however, new houses continued to open, including Alix Barton in 1933 and Balenciaga, Jacques Fath and Jean Dessès in 1937.

Although Paris still dominated international fashion, there was growing competition from designers in London and New York. In London a new generation of couturiers gradually replaced the court dressmakers. These designers operated along similar lines to their Parisian colleagues, though on a smaller scale. Molyneux (who had houses in both London and Paris) and Norman Hartnell were joined by talented newcomers, among them Victor Stiebel, who opened in 1932 and specialized in romantic day and evening wear, and Digby Morton, who established a reputation for impeccably tailored suits made in subtle, textured wools. Morton started his career at Lachasse but left in 1933 to set up on his own; he was succeeded by Hardy Amies. Giuseppe Mattli

84. A 1931 advertisement for the London firm of Aquascutum (from the Latin, meaning 'water-shield') shows racegoers wearing the company's exclusive rainwear. At this date the company served both military requirements and an affluent, style-conscious civilian market requiring functional outerwear.

76

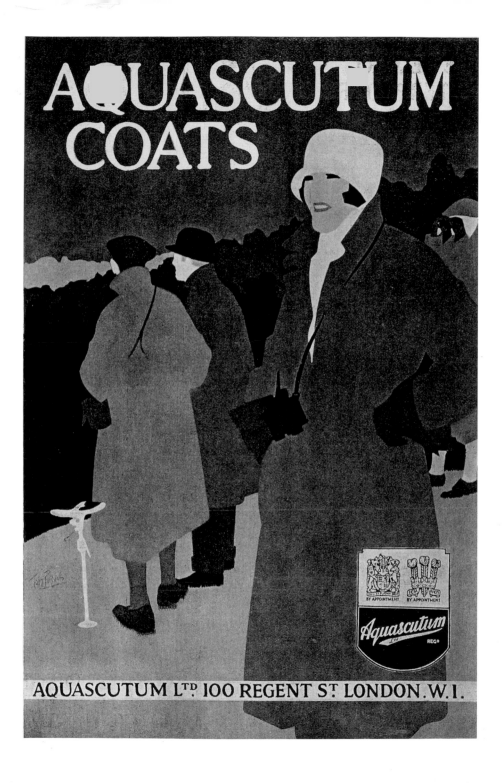

85. The Prince of Wales, 1933. When dressing for golf – his favourite sport – the Prince indulged his penchant for experimenting with colour and pattern. With great aplomb he freely mixed spots, checks and tartans, often in the loudest of colours.

and Peter Russell opened houses in the mid-1930s – the latter specializing in sports and travel wear. Also focusing on sporting wear were various specialist tailors and outfitters, including Bernard Weatherill, who supplied top-level, bespoke equestrian clothing; Pringle, which provided fine knitwear and golfing clothes, and Barbour, Aquascutum and Burberry, which sold protective, waterproofed garments.

84

While Britain excelled in tailoring and formal sports clothing, the US cornered the market in ready-to-wear fashion and leisure sports wear. By 1930, America led the world in the mass production of clothing in standardized sizes. The wholesale garment trade was the country's fourth major industry and New York's largest. At the time, however, most American ready-to-wear designers were anonymous because the US industry liked to give the impression that its products were Paris-related. Bergdorf Goodman was an exception in that it promoted its in-house designers, among them Leslie Morris. Dorothy Shaver, President of Lord & Taylor, made fashion history in 1932 when she advertised clothes by named American sports wear designers in national newspapers. Other retailers and the fashion press gradually followed her lead. One of the designers who rose slowly to prominence during this period was Claire McCardell, who was appointed head designer at Townley Frocks in 1931 and by the late 1930s was well known for using menswear detailing and fabrics in her stylish casual day and evening wear.

At the very top end of New York's fashion market were Valentina, Muriel King, Jessie Franklin, Elizabeth Hawes and Hattie Carnegie, each of whom had her own exclusive fashion house, as did leading milliner Lilly Daché. Muriel King was famous both for her interchangeable separates, which could be carried through from day into evening, and for her refined use of colour. Hattie Carnegie's neat, tailored suits were in great demand.

American fashion was given a boost when Wallis Simpson 86 chose the Paris-based American couturier Mainbocher to design the gown for her marriage in 1937 to the Duke of Windsor. The former Prince of Wales, who had been crowned King Edward VIII in 1936 and who had abdicated the same year, continued to be acknowledged as *the* international menswear style leader. During the 1930s he remained adventurous in his love of bright colour, 85 texture and bold pattern, especially for sports clothes. He went to his London tailor, Frederick Scholte, for his jackets but to New York for trousers, which he liked to wear in the American style – with belts, rather than braces. Throughout his adult life he had his

86. The Duke and Duchess of Windsor, photographed on their wedding day at Chateau de Cande, France, in 1937. The Duchess chose the American, Paris-based couturier Mainbocher, famous for his refined and elegant fashions, to design her trousseau. Her wedding ensemble, a bias-cut dress and tailored jacket in silk crepe, created a vogue for what became known as 'Wallis blue'. The famous Paris millinery house Caroline Reboux supplied a matching hat. The Duke wore a black cashmere herringbone weave tailcoat by the London tailor Scholte, a grey waistcoat; a blue and white pinstripe shirt with a white collar; a blue and white chequered silk tie; and grey striped worsted trousers with American-style waist by Forster & Son Ltd., of London.

trousers cut in the same style, with straight waistband, side pockets and creases. In 1934 he replaced the button fastenings in his trousers with zips. Though Savile Row considered belts and zipped flies to be vulgar and capable of ruining the fall of a pair of well-cut trousers, the Duke, as usual, was ahead of his day and both trends caught on after the war.

By 1930, designers of women's fashion had abandoned the linear, gamine look of the twenties in favour of softer, more sculptural clothes which accentuated feminine contours. Bodices were slightly bloused; belts emphasized the waist – now reinstated to its natural position; skirts were gently flared. Hemlines dropped and for the first time varied according to the time of day: day clothes reached around 14 inches (35 cms) from the ground; afternoon wear was two inches (5 cms) shorter and evening gowns were full-length. Short, shoulder-encircling capes and cape sleeves were fashionable on dresses for all occasions.

After years of flattening the bosom, bust bodices were replaced by shaped brassieres. Waists were controlled and emphasized by featherlight boned and laced corsets or by stretch undergarments,

87

87. *Below*: Kestos advertise their girdles and new high-line brassiere in *The Tatler*, March 1939.

88. *Bottom*: The Women's League of Health and Beauty, rehearsing for a show in London in the 1930s. The participants are dressed in modern, streamlined sports styles.

made possible by the new American elasticated rubber yarn, Lastex (later known as Latex), introduced in 1930. Pretty, bias-cut camiknickers and slips made in pastel coloured silks or cheaper rayons, with embroidery and lace inserts, were highly popular. Although the fashionable silhouette was shapely, slenderness was still desirable. As in the 1920s, purveyors of weight-reducing foam baths and electric figure-shaping treatments promised miraculous results, as did manufacturers of various pills and potions.

Throughout the 1930s, beauty became inextricably linked with health. Naturist, sports and health clubs were set up to improve both body and soul. In Britain, the Women's League of Health and Beauty, founded in 1930 by Prunella Stack, organized mass exercise classes in large public spaces. Specialist clubs were established for outdoor activities such as hiking and rambling. Shorts became acceptable wear for women, and ankle socks were sometimes worn instead of stockings. Wool and cotton bathing costumes became briefer, lower cut at the front and back and, with the help of elasticated fabrics, more figure-hugging, though problems with sagging when wet had still not been overcome. The cult of sun worship showed no signs of diminishing and mountain

88

sunbathing became the latest craze. Sunglasses were highly desirable accessories, especially those with tortoiseshell rims, and many sports and leisure clothes featured halter necklines and crossover straps which could be removed for sunbathing. White fabrics, which showed off a lightly bronzed skin to maximum effect, were ultra-fashionable.

The backless evening gown which scooped down to below the waist was a 1930s fashion innovation. Mercilessly revealing, the style permitted only minimal undergarments. Smooth textiles such as satin and charmeuse, often in shades of ivory and peach, were cut on the bias to mould the body and fall into soft drapes. The complex shaping and piecing of these garments meant that when patterned fabrics were used, designs were generally small, abstract or 'scattered', with no obvious repeat. Floral prints were especially popular and were fashionable throughout the decade. By 1934, as part of the vogue for mid- to late-nineteenth-century styles, corsetted, crinoline and bustle evening gowns were introduced.

89

Silks, fine wools and linens remained the most exclusive fash-
ion fabrics. Fur was used extensively to make and trim garments,
with flatter pelts used primarily for day wear and longer haired
furs for evening. Most desirable during the 1930s were astrakhan,
silver fox and black monkey fur. The quality of rayon was much
improved by this time, but despite valiant attempts by manufac-
turers to promote it as comparable or even superior to silk, the
latter remained in the ascendant. When rayon was used by top
designers, it was invariably combined with a natural fibre. The
introduction of more informal fabrics for evening wear made a
radical, as well as an economical fashion statement. Chanel was
invited to London to promote cottons by Ferguson Brothers
Ltd: for Spring/Summer 1931 she presented thirty-five evening
gowns in cotton piqué, lawn, muslin and organdie.

92. Illustration from *Le Petit Echo de la mode*, 11 November 1934. This fashion paper showed styles for the home dressmaker. *Left*: evening dress of green moiré silk with the corsage and bow in green satin. With its filled-in V-neck back, this design is more demure than many top couture models of the period. *Right*: a smart evening coat in supple yellow velvet with cravat neck, pleated sleeves and fur trim.

Innovative manufacturers continued to work closely with couturiers to create unique couture fabrics. This was especially true in France, where manufacturers benefitted from government subsidies. For Schiaparelli, Colcombet produced in 1934 a permanently pleated satin which resembled tree bark, as well as short runs of novelty prints, such as her musical score design of 1937. Rhodophane, a glass-like material made from cellophane and other synthetics, was developed by Colcombet in the 1920s, but did not make fashion news until 1934, when Schiaparelli's adventurous American client, Mrs Harrison Williams, wore a rose-coloured Rhodophane tunic over a taffeta gown.

Tailor-made suits and coats were widely worn in town and country. British designers excelled in classic suits, and Irish and Scottish mills served international demands for both traditional

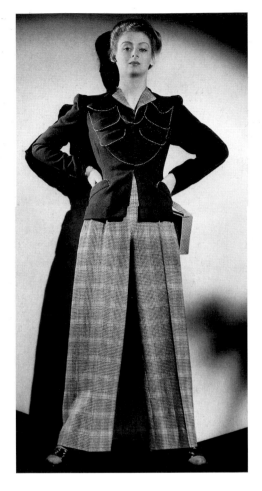

93. Tailored ensemble by Jacques Heim, late 1930s. This promotional photograph issued by the International Wool Secretariat shows a model wearing plaid flannel trousers and a bright blue tweed jacket with three pocket flaps at each side of the chest and two below the waistline.

and more overtly fashionable wools and tweeds. Skirts were either long and lean or flared, and jackets were short with nipped-in waists or longer and sinuous. Suits with full-length skirts were worn during the evening. Couturiers created the most fashionable designs; more understated styles were often made-to-measure by a tailor, while the expanding ready-to-wear trade met the demands of the middle and lower end of the market.

Accessories served to update and add distinction to what were often plain, versatile garments. Hats were still common for outdoor wear and styles were diverse, including the fez and the sailor's hat as well as berets, tricornes and pillboxes. By 1936 millinery reached dramatic new heights and the most extreme designs reflected the influence of Surrealism. As the waist was renewed as a fashion focus, belts became important accessories,

94. Clutch bags in sleek, refined designs such as this were the height of 1930s fashion. This model was made in shagreen, a term applied either to untanned leather given a granulated pebbly finish or to certain types of sharkskin. It was dyed in bright colours – usually green.

95. Strappy two-tone leather and suede high-heeled sandals, 1930s. The two-tone shoe was introduced in the 1920s, but reached the height of its popularity, for both men and women, in the 1930s. The peep-toe, first worn on the beach, had become the height of chic for everyday wear by the mid-1930s, despite concerns raised about hygiene and safety.

often designed to match the garment and sometimes featuring decorative clasps or buckles in jeweled metal or sleek plastic. Moulded plastics were also used to create modernistic handbags, while more traditional designs, with jeweled clasps and short chain handles, utilized fine skins or fabrics decorated with petit-point embroidery. Envelope-shaped clutch bags were also popular. 94 Strappy, high-heeled sandals were worn with evening gowns 95 and were often made in fabrics and leathers to match the colour of the dress. Shoes with sling-backs were fashionable and open-toed designs were introduced around 1931. The French shoe designer Roger Vivier has been credited with producing the very first platform soles in the mid-1930s and in 1936 the innovative Italian shoemaker Salvatore Ferragamo created the original 96 wedge sole.

Within the framework of these general fashion trends, designers derived much of their inspiration from historical and escapist sources: from Hollywood glamour, neoclassicism,

Victorian revivalism, Surrealism and ethnic clothing traditions. These influences were also evident in other areas of the applied arts, as well as in salon and shop window displays, fashion photography and illustration.

In addition to New York's fashion industries, the United States had the unique advantage of Hollywood, whose films exerted a strong influence on 1930s fashion. Costumes were central to a film's success and vast sums were spent on the wardrobes of female stars (though male actors often had to provide their own clothes). Manufacturers and designers seized the opportunity to produce wearable, and profit-making, fashions inspired by the screen.

For a long time, Hollywood's studios had followed and adapted Paris fashions, but they were caught unawares when longer hemlines were introduced. Thousands of reels of film were instantly rendered outmoded and obsolete. To prevent a repeat of this costly episode, scores of stylists were sent to Paris to relay up-to-the-minute fashion changes back to the studios. Samuel Goldwyn's solution seemed even better: to invite a world-famous Paris couturier to Hollywood. He chose Chanel, sure that her classic designs would retain their appeal during the year or more it took to make a film. The couturier accepted his staggering offer of one million dollars a year to design the on-and-off-screen wardrobes for Metro Goldwyn Meyer's top stars, including Greta Garbo, Gloria Swanson and Marlene Dietrich. In the event, however, Chanel worked on just three Hollywood films – *Tonight or Never* (1931), starring Gloria Swanson; *Palmy Days* (1932), starring Charlotte Greenwood; and *The Greeks Had a Word for Them* (1932), starring Ina Claire – and her costumes were either overlooked entirely or criticized for being too understated.

96, 97. Two innovative 1938 designs by the Italian master shoemaker Salvatore Ferragamo. *Left*: laced shoe with upper in patchworked suede and wedge heel in suede-covered cork. *Right*: a showy design with gold kid leather upper and a platform sole of layered cork, covered in various brightly coloured suedes. This was probably designed for the cinema or theatre.

98. Joan Crawford in the 1932 film *Letty Lynton*, wearing the famous 'Letty Lynton' dress, which became one of the most widely copied styles of the 1930s. The focal point of a film costume was often sited near the face to permit full appreciation in close-up shots and photographic stills, which is why the ruffled theme of this dress reaches maximum effect at the shoulders.

A number of international designers worked in Hollywood with varying degrees of success, but it became increasingly apparent that the design of film costumes and that of elite fashion called for different skills. From the early 1930s, therefore, the studios started to promote the talents of their own costume designers, including Adrian at MGM; Travis Banton, Walter Plunkett and Edith Head at Paramount; and Orry-Kelly at Warner Brothers. Soon these designers were not only creating costumes which fitted the storyline and expressed the personality of the characters, but were also setting new trends and endorsing existing fashions.

Possibly the most famous film costume of the decade is the white evening gown with ruffled sleeves created by Adrian for Joan Crawford in the 1932 film *Letty Lynton*: Macy's, the New York department store, is reputed to have sold half a million copies of it. The design, which emphasized Crawford's naturally broad shoulders, has been widely credited with setting the vogue for the shoulder pad, for though Marcel Rochas and Schiaparelli had already featured padded shoulders in their collections (the latter inspired by the Indo-Chinese costumes shown in the 1931 Exposition Coloniale in Paris), it was not until this style was given the seal of approval by a top Hollywood star that it really caught on. 98

Sometimes Hollywood was in advance of the couturiers. From 1933, Travis Banton designed for Marlene Dietrich loose-cut trouser suits with broad, padded shoulders, which were simultaneously mannish and feminine. (These were admired at the time, though trouser suits did not gain widespread fashion currency until Paris designer Yves Saint Laurent introduced the first of his 'le smoking' suits in 1966.) Film costumes also influenced sports and leisure wear. For her role in *The Jungle Princess* (1936), Edith Head dressed Dorothy Lamour in sarongs, and similar designs appeared in American collections for the next fifteen years.

Although it was not always appropriate to replicate entire ensembles, it was easy to copy details and accessories from film costumes for mass consumption. Garbo's influence on millinery was massive: following her role in *The Kiss* (1929), she created a vogue for berets; *Romance* (1930) prompted the fashion for the Empress Eugénie hat; *Mata Hari* (1931) popularized jeweled skullcaps; and veiled pillboxes became highly fashionable after she wore them in *The Painted Veil* in 1934. The footwear of movie stars was also influential: the late 1930s vogue for two-tone brogues, known as co-respondent shoes in the UK and spectator shoes in 99

99. Even before she was famous, Greta Garbo was ultra-stylish. This photograph was taken before she moved to Hollywood, at a time when she was earning her living soaping men's faces in a barber's shop. She wears a double-breasted tailored suit and a brimmed hat – a look she was to make world famous. During the 1930s she was widely credited with boosting America's millinery industry.

100. *Opposite*: Fashion spread from *Esquire,* June 1938. Launched in 1933, this stylish American menswear magazine featured top-level ready-to-wear, such as the relaxed, colourful and patterned leisure clothes shown here. This illustration shows the influence of both Hollywood movies and fan magazines, which often showed the rich and famous 'at play' at fashionable seaside resorts such as Newport, Palm Springs, Palm Beach and Nassau in the Bahamas.

the US, was undoubtedly boosted by their association with Fred Astaire. Carmen Miranda did much to popularize platform soles.

The profitable commercial spin-offs for manufacturers were only too obvious, and 'Miss Hollywood' and 'Studio Styles' were among the many businesses founded to manufacture Hollywood-inspired fashions. These retailed in Cinema Fashion Departments within stores throughout North America and Europe. Film fashions were also available via mail-order catalogues. Throughout the 1930s, the American company Sears, Roebuck sent out some seven million catalogues biannually, featuring film styles as well as star-endorsed fashions. International fanzines helped disseminate Hollywood style – not surprisingly, their editorials promoted Hollywood, rather than Paris, as the centre of international fashion. Many of these magazines advertised their own range of ready-made film fashions, as well as paper patterns for home dressmakers.

For the many women living on the breadline, unable to afford new clothes of any kind, it was at least possible to approximate the hairstyle and makeup of their favourite star. Garbo's bob and Claudette Colbert's bangs were widely copied and when Jean Harlow appeared as a platinum blond in the 1930 film *Hell's Angels,* sales of peroxide soared. California led the world in the field of cosmetics, with many styles originally created by or for a star: the vogue for finely arched, pencilled-in eyebrows, for example, was initiated by Marlene Dietrich. False eyelashes and nails, both

## SUMMER NOTES

At southern resorts this past season well-dressed men wore:

1—Paisley printed swimming trunks.

2—The new Jippi Jappa hat with telescope crown and India Madras half sleeve shirts.

3—Colorful corduroy slacks with crew neck half sleeve colored stripe lisle shirts, and brown and white versions of the Norwegian peasant slipper.

4—For evening wear—the bone color silk double breasted dinner jacket with one-button front, peak lapels and cocoanut straw hat with wide white puggree band.

*(For answers to all dress queries, send stamped self-addressed envelope to Esquire Fashion Staff, 366 Madison Ave., N.Y.)*

Marya

developed in the 1930s, also originated in Hollywood. Max Factor, the talented Russian wigmaker and beautician employed by the studios, became a top name in America's burgeoning beauty industry, launching his own range of cosmetics and establishing beauty salons across Europe and the US, where women could have their makeup applied by experts.

Fine grooming was important also for men, providing the finishing touch to the sleek tailoring of the period. Although Hollywood's emphasis was on women's costumes, the movie industry did much to reinforce and shape attitudes towards menswear. Just as female members of the audience studied the style of actresses, many men picked up sartorial tips from top stars like Ronald Colman, Cary Grant and Gary Cooper. British style and Savile Row tailoring in particular were presented as the ultimate in sophistication, while American leisure clothes were used to convey a more rugged image. The design of men's clothing for summer and resort wear generally became more relaxed, chiefly under the influence of America. Fashionable society congregated at Palm Beach, Monte Carlo, Cannes and other leading resorts, and stylish sun-lovers favoured blazers, teamed with loose-cut linen trousers or shorts. The vogue for soft-collared, sporty polo shirts also testified to the shift towards more informal dress.

For formal occasions men continued to wear suits, usually in dark colours and with a shirt and tie. Like women's fashions, menswear exaggerated the masculine physique to create a strong, athletic appearance. This was especially true of the 'drape' or 'London cut' suit, created by Scholte, the Duke of Windsor's tailor, which dominated the shaping of 1930s menswear and became synonymous with American styling. The jacket of the suit had broad shoulders (with minimal padding) and a breast pocket. It was nipped in at the waist and fairly close-fitting over the hips. It could be either single- or double-breasted, though the latter was particularly fashionable. The waistcoat was short, with six buttons and a V-opening. Trousers were high waisted and loose cut, with double pleats and turn-ups, and were supported by braces. Though there was some resistance at first to the loose cut, men gradually came to appreciate its comfort and ease. The most popular hat styles were the trilby and the fedora.

Though there were discernible trends in menswear, it was not subject to the diversity of influences that determined fashions in women's clothing. From 1930, the styles of classical antiquity inspired many couturiers, especially the Parisians. Fluid silk and rayon jersey, crepe, chiffon and soft velvet were pleated, draped

101. *Opposite*: Perhaps best known for its sports and rainwear, the British firm of Burberrys also sold fine tailoring, such as the single- and double-breasted suits shown here, taken from an advertisement of the 1930s. Mindful of the effect of the Depression, the company emphasized the virtues of its classic styling and high quality materials and workmanship. 'A suit with a very long life is desirable in these times. The more reason then that the suit should be one that will please and neither tire nor annoy its owner in any way.'

102. *Right*: Madame Louis Arpels is photographed in Paris in 1936 wearing an understated dress by Maggy Rouff with two clips at the neck, buttoned sleeves and a gathered waist detail. Elegant accessories complete the look: she wears high-heeled shoes, with matching long gloves, both of which complement the wide-brimmed hat by Caroline Reboux.

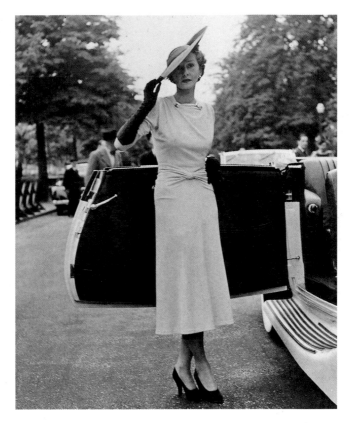

and folded, often directly onto the body, to achieve seemingly simple, but in fact highly complex, garments. These refined fashions were immortalized by top photographers such as Man Ray and George Hoyningen-Huene in settings that incorporated Corinthian columns, capitals, acanthus leaves and classical statues. Among the Paris designers who contributed to the vogue for neoclassical fashions were Alix, Vionnet, Maggy Rouff, Lucien Lelong, Robert Piguet, Jean Patou and Augustabernard.

Alix and Vionnet were at the forefront of the neoclassical style. Alix, born Germaine Krebs, had early ambitions to become a sculptor but these were thwarted by parental disapproval, with the result that she channelled her creativity into the art of dressmaking, initially making toiles and then serving an apprenticeship with the Parisian house of Premet. In 1933 she joined forces with Julie Barton, opening the house of Alix Barton: when her partner left a year later the house became known simply as Alix (in 1941 Krebs would change her name yet again, to Madame Grès). In a bid to capture some of the timeless elegance of classical sculpture,

103

103. Vionnet evening gown, photographed by George Hoyningen-Huene for *Harper's Bazaar*, 1936. Made of white rayon satin, this asymmetrical dress features a cape collar on the left shoulder balanced by a line of diamanté bows down the right side.

104. *Opposite*: Vionnet evening gown illustrated by René Gruau for *Femina* magazine, December 1938. By the 1930s photography had become the dominant form of fashion representation, but Gruau's direct and elegant illustrations perpetuated the tradition set by Art Deco fashion illustrators such as Georges Lepape.

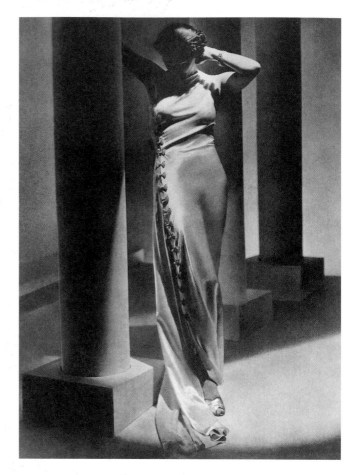

she created a number of white gowns which moulded the figure and fell into heavy draperies and folds. She worked directly onto the body and often compared her work with fabric to a sculptor's manipulation of materials.

Vionnet's label depicts a classical image of a woman poised on a column, raising the straps of her tunic above her head. From 1924, her embroidery designs were inspired by Greek vases and Egyptian frescoes and by the early 1930s she had largely abandoned her famous bias cut in favour of classical-style draping and folding. Many of her garments were ingeniously constructed in one piece, devoid of fastenings. Vionnet was exceptional in that she did not sew down her draperies, but expected her clients to perform a series of skilful manoeuvres to achieve the desired look. She generally worked in neutral colours, but also loved terracotta, deep green and black.

In 1936 the Parisian couture houses were hit by a wave of strikes organized by the CGT (La Confédération Générale de Travail), which was campaigning for better conditions for its workers. Despite these disputes, however, the fortunes of the couture houses and ancillary industries were much boosted by the craze for lavish costume balls, as well as by the demand for what became known as neo-Victorian clothing. Interest in the styles of the period from the 1850s to the late nineteenth century surfaced around 1934 and reached its peak in 1938. It was especially evident in interior design and fashion. Devotees of neo-Victorianism rejected the stripped-down purism of international modernism in favour of theatricality and ornamentation. Period Hollywood films, including *Little Women* (1933) and the epic *Gone with the Wind* (1939) fed into this vogue, as did stage plays such as *The Barretts of Wimpole Street* (1934), with costumes by Lelong. Whereas original Victorian furnishings were often used for interiors, fashion designers translated styles from the period into ultra-romantic special-occasion evening gowns and wedding dresses which used huge quantities of silk and lace and were designed to make women's figures elegantly voluptuous.

Bare-shouldered, corsetted gowns with crinoline and bustle skirts were created in diaphanous silk, rustling taffeta, velvet, tulle and fine laces, sometimes shot with glistening threads of cellophane. Fullness was achieved by skilful cutting, padding and lightweight hoops, instead of the cumbersome petticoats of stiff horsehair which had supported many nineteenth-century dresses. Designers also placed huge bows on the derriere of their gowns to create a bustle-like silhouette, and accessorized them with veils and shoulder-length, fingerless lace gloves. Designers also reintroduced fans. Even Chanel, who had so determinedly rejected frou-frou earlier in her career, revelled in the new romanticism. Though less apparent in day wear, this vogue gave rise to leg-of-mutton sleeves on tailored jackets and, in accessories, to 1860s-style muffs and crochet snoods.

Norman Hartnell was a key figure in the neo-Victorian movement. Following the accession of King George VI in 1937, Hartnell was awarded the prestigious royal warrant and was invited to design the Queen's wardrobe for her visit to Paris the following year. Inspired by the magnificent Royal Collection of paintings, which included portraits by Winterhalter, he decided to dress his client in crinolines. While the gowns were being made, however, the Countess of Strathmore died and the court was plunged into mourning, which meant that the highly coloured

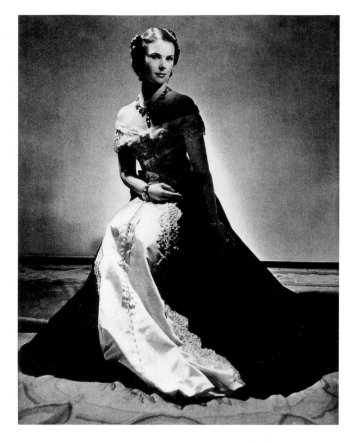

105. Lady Rosse models a 'Neo-Georgian Ball Gown' by Norman Hartnell, 1939.
A costume ball hosted at Osterley House in London, which took the 18th century as its theme, inspired Hartnell to design this *décolleté* black velvet gown with a satin panel encrusted with pearl- and diamond-studded lace.

fabrics already chosen by the Queen were no longer suitable. Hartnell, reluctant to use funereal black and purple, presented instead an acclaimed collection in white, a lesser-used colour of mourning.

In keeping with the new romantic mood, real and artificial flowers were used in abundance for corsages, posies, necklaces and wristlets, as well as to decorate evening purses and hats. For special evening events, hair was swept up, with curls caught in a comb of mixed fragrant blooms, or it was piled into a chignon which was then topped with flowers. Floral chokers were also fashionable and both precious and costume jewelry often featured floral motifs and forms.

From the mid- to late 1930s, the influence of Surrealism showed itself in fashion shoots and advertisements, as well as in shop window displays and salons. Although the movement dates back to 1924, when André Breton's first *Surrealist Manifesto* was published, it was not until major exhibitions were staged in

London, Paris and New York between 1936 and 1938 that the public became broadly aware of Surrealist imagery. Schiaparelli's designs in the second half of the decade are unrivalled in their exciting and innovative exploitation of these devices.

Schiaparelli collaborated with a number of artists, including Christian Bérard and Jean Cocteau, but her most striking fashions were created in conjunction with Salvador Dali. In many instances there are direct links between his Surrealist artwork and her witty, startling designs. In 1936 Dali completed his sculpture *Venus de Milo with Drawers*: the same year he placed a stuffed bear, dyed shocking pink (Schiaparelli's signature colour) and with drawers installed in its torso, in the window of Schiaparelli's boutique. This in turn inspired her sleek, tailored 'drawer suit', which featured true and fake pockets, expertly embroidered by Lesage in a *trompe-l'œil* design to resemble drawers.

106, 107. Salvador Dali's ideas often influenced designs by Elsa Schiaparelli. In 1936 he produced both *Venus de Milo with Drawers* and *The Anthropomorphic Cabinet* (cast 1982), shown below. The series of drawers was the inspiration for Schiaparelli's Desk Suit of the same year (*centre*). Some of the drawers in Schiaparelli's suit functioned as pockets, while others were false.

The 'Tear Dress' of 1937–38 juxtaposes violence and tatters with elite luxury. Made of silk crepe, it features a print in bruised purple and pink on a grey ground, depicting strips of torn flesh. The organza shawl, which is worn over the head, has appliquéd flaps of pink silk. This model was inspired by Dali's painting *Three Young Surrealist Women Holding in Their Arms the Skins of an Orchestra* (1936), in which one of the figures wears a skin-like dress covered with tears, which reveal the body.

Surrealism influenced the surface decoration of Schiaparelli's clothes rather than the cut, which conformed to general 1930s trends. It was millinery which provided the designer with an opportunity to explore new forms. In 1936 she presented her shoe hat, an inverted design of a high-heeled court shoe, made in plain black or black and shocking pink velvet. This extraordinary design has been seen both as a fetishistic object and as an example of Surrealist displacement: there is a famous photograph of Dali with a shoe balanced on his head. Schiaparelli teamed the shoe hat with a tailored, black cocktail suit featuring erotic, appliquéd lips around the pocket opening. She also designed a 'Lamb Chop Hat' in 1937, reflecting Dali's obsession with meat, and a quirky 'Inkpot Hat' in 1938.

108

Schiaparelli has been credited as the first designer to introduce themed collections. The first of these, for Autumn 1937, celebrated musical iconography. Subsequent collections drew inspiration from the circus, paganism, harlequins and astrology. All the collections featured stunning embroideries conceived and executed by Lesage, and the themes were reinforced by novelty buttons. Schiaparelli was also innovative in her use of the zip. Though this method of fastening had been patented as early as 1893, its use had been confined to underwear, utilitarian dress and luggage. Traditionally, refined fashion has concealed hand-worked fastenings, so it was a radical move on Schiaparelli's part to use the zip for haute-couture clothing and furthermore to emphasize it by using bright and contrasting colours. Zips first appear in Schiaparelli's designs on the pockets of her 1930 towelling beach jacket and were subsequently incorporated into her formal day and evening wear collections.

109. Jacket detail from Schiaparelli's Circus Collection, 1938. Painted cast metal acrobats seem to leap up the front of this pink silk twill jacket with woven design of prancing horses. The acrobats are pierced with brass screws connecting with fastening slide hooks.

110. Advertisement for Lightning zips, endorsed by Schiaparelli, 1935.

# Schiaparelli
### features this fashion fastener in her Autumn Collection

To fasten Scotch tweeds, finest Lyons silks, heavy Ottomans and cobweb British woollens, Schiaparelli uses either self-toning fasteners unobtrusively, with plastic teeth and tape to match, or contrasting colours—red on green, blue on red—to charm the eye with their decorative value.

She fits them cleverly on shoulders, sleeves and skirts; to front, side and back openings and to pockets: for the smooth, swift fastening of

EVENING, TOWN AND SPORTS WEAR

## 'LIGHTNING'
TRADE MARK
## PLASTIC FASTENER

Sole Manufacturers:
LIGHTNING FASTENERS LTD.
(A subsidiary company of Imperial Chemical Industries Ltd.)
KYNOCH WORKS, WITTON, BIRMINGHAM, 6.
London Sales Office: Thames House, Millbank, S.W.1. Telephone: Victoria 3828.

The Anglo-American designer Charles James was also an early advocate of the zip. The British-born James worked as a milliner and custom dressmaker in New York between 1924 and 1928, and in 1929 opened premises in London. During the early 1930s he travelled extensively between London and Paris, establishing a Paris branch by 1934. Like Schiaparelli, he was a friend of Dali's and made use of Surrealist influences in his designs.

James was fascinated by the cut of historical dress and explored innovative new forms of garment construction, such as spiral draping. Among his most important works are the taxi dress, the pneumatic padded jacket and the Sylphide gown. He updated his first 1929 'Taxi' design (so called because it was as easy to get in and out of as a taxi) in 1933–34 by spinning a zip around the torso. These dresses were sold pre-packaged in two sizes to support James's belief that a well-cut garment could fit perfectly, ready-made. His famous padded white satin evening 112 jacket of 1937 had an unusually voluminous sculptural form. Its construction was the same as that of eiderdown and in the 1970s it achieved cult status as the precursor of that decade's padded coats.

James's forte was the creation of luxurious, full-skirted evening gowns. The 'corselette' or 'Sylphide' evening gown, also of 1937, 111 is an excellent example. Made in canary yellow organza, with a pale pink shoestring halter neck, the dress had an overbodice that was pulled in by a decorative, back-lacing, yellow quilted corset. By 1938 similar corset-tops had also appeared in the collections of Balenciaga, Maggy Rouff, Lelong, Jacques Heim, Molyneux and Mainbocher, among others.

During the late 1930s Balenciaga revealed talents that would 113 make him a leading international designer in the postwar period. Already well known in Spain before he moved in 1937 to Paris, he quickly established a reputation for understated, refined tailoring, counterbalanced by elaborately decorated evening gowns.

During the 1930s ethnic clothing traditions exerted a powerful influence. From 1934, the Chinese-Deco style was especially evident in the work of Valentina, Mainbocher and Molyneux, who were inspired by the brilliant colours of Chinese porcelain and Japanese blossom prints. All three designers employed shantung silks to create dresses and suits which variously featured mandarin collars, swathed sashes, Japanese kimono or wing sleeves, and narrow tubular skirts with slits and forked trains. Bamboo buttons and coolie-style hats completed the look. Alix drew inspiration from a multiplicity of cultures, using elements from the cut of kimonos, caftans, saris and dhotis.

The mid- to late 1930s also saw the proliferation of Austrian and German peasant styles – Tyrolean hats, dirndl skirts, embroidered peasant blouses and kerchiefs tied at the neck. Though apparently innocent at the time, this vogue has subsequently been seen to have sinister overtones, coinciding as it did with Hitler's rise to power. By the late 1930s, however, it was just one of many fashion trends. Magazines advised their readers that they could choose between looking like a Greek column in jersey or a Victorian ancestor in satin or tulle. Hybrid styles brought together elements from different movements: the statuesque folds of classicism combined with the coquettish corsetry of the Victorian Revival, for example. Some designers went even further back in history: Balenciaga alternated Velazquez pannier skirts with 1880s bustles; Lelong designed eighteenth-century sack-back styles, after Watteau; Maggy Rouff acknowledged a debt to Boucher and Vionnet was inspired by Madame Récamier.

Perhaps reflecting the tumultuous political circumstances and the impending reality of war, military-style passementerie, from tassels to admiral's gold braid, featured extensively in the 1939 collections and fashionable colours took on ominous tones. Fashion magazines reported that colours were sullen: threatening blues, foggy greys, sea-storm greens and purples. On 3 September 1939, following Hitler's invasion of Poland, Britain and France declared war on Germany.

111, 112, 113. Designs by Charles James and Cristobal Balenciaga.
*Left*: Corselette' or 'Sylphide' evening dress by Charles James, 1937. The corset top of this gown provides an early example of underwear worn as outerwear, a trend that many fashion designers have exploited since the 1980s.
*Centre*: James's legendary white satin evening jacket and bias-cut evening gown of 1937. At the most extreme point the depth of the tapering arabesques on this sculptural jacket reach about 3 inches (7.6cm). To facilitate ease of movement the padding was less heavy around the neck and armholes.
*Right*: Balenciaga dinner gown from the early 1930s in pale pink silk crepe trimmed with black lace. Pink and black were a favourite colour combination of this designer. Spanish by birth – he opened his first fashion business in San Sebastián in 1919 – he drew inspiration from his native land: the influence of the bullring, for example, can be seen in both his flamboyant use of colour and his love of embroidery and jet trimmings. He gained a reputation for discreet day wear and for dramatic evening designs such as the one shown here.

# Chapter 4: 1939–1945
## Rationed Fashion and Home-Made Style

In peacetime, fashion expenditure has always been motivated by conspicuous consumption; in wartime, it is largely determined by necessity. During the Second World War, what women needed was a minimum wardrobe with maximum versatility. Despite these restraints, styles were not dull; indeed, the fashion press emphasized that garments with spirit would retain their desirability throughout the war.

During the period of the hostilities, fabric manufacture was directed to war-related purposes. Wool supplies were requisitioned for the manufacture of millions of uniforms, and silk was commandeered to make parachutes, maps and gunpowder bags. To eke out supplies, cloth for civilian clothing was often made from viscose and rayon. Throughout the 1930s, the US textile giant Du Pont researched the manufacture of a new synthetic fibre made entirely from mineral sources. In October 1938 the company announced, in a full-page advertisement in the *New York Herald Tribune*, the introduction of nylon. Initially, the major contribution of this fibre was to hosiery – nylon stockings were introduced to the American public in May 1940 – and, after supplying wartime needs (it was primarily used as parachute material), it was developed as an easy-care underwear and dress fabric.

Within weeks of the declaration of war, designers in Paris and London introduced models that emphasized practicality. Molyneux and Piguet presented coats with snug hoods, teamed with pyjamas in satin or wool 'for sheltering'. Schiaparelli's suits, with large 'slouch' pockets, were worn over corduroy bloomers for additional warmth. Digby Morton showed zipped and hooded 'siren suits' in tartan Viyella, which could be swiftly slipped on over nightclothes during air raids. Parisian milliner Agnès created 'night-cap' jersey turbans; bags were roomy enough to accommodate gas masks and footwear was produced in practical, chunky styles with snub toes and relatively low heels.

During the initial period of the 'Phoney War', the French government granted two weeks leave to designers engaged in war

114. *Vogue* (October 1942) praised these 'distinguished, functional and simple' Utility models by the Incorporated Society of London Fashion Designers. *Left to right*: a severely tailored coat in nut-brown wool with three buttons and shaped pockets; a check suit with collarless, cut-away jacket and gored skirt; and a double-breasted cavalry red wool twill coat with a half-belted back. Photo by Lee Miller.

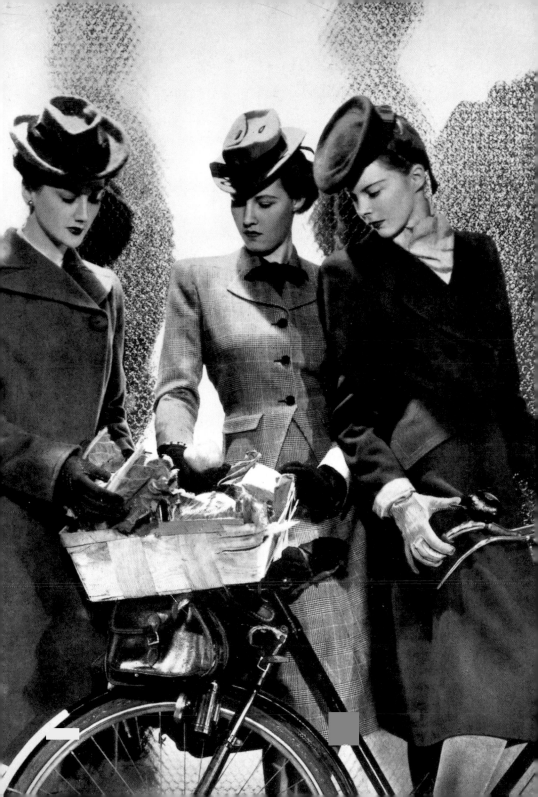

work, to allow them to prepare their Autumn 1940 collections. Both Britain and France exploited the skills of their high-fashion designers to create luxurious collections for export, especially to the United States, to raise dollar revenue. Designs for wartime markets included culottes for cycling, sturdy tweed suits, and evening dresses with long sleeves and high necks, in sensible wool and jersey fabrics. The more elaborate models shown, including décolleté, polonaise-style gowns in rustling silks, were chiefly intended for export.

In June 1940 German forces occupied Paris and brought its dominance of international fashion to an abrupt halt. Styles continued to evolve, but news of the latest creations was no longer instantly communicated to the outside world. Many non-French designers left Paris: Schiaparelli embarked on a lecture tour of America, but kept her house open; Creed and Molyneux returned to London and Mainbocher and Charles James re-established themselves in New York. Chanel closed her fashion salon and spent the duration living in the Ritz Hotel with her Nazi lover, while Jacques Heim, who was Jewish, went into hiding.

As part of his bid to transform Berlin into the cultural capital of the world, Adolf Hitler planned to move Paris's prestigious fashion industry to the German capital. It was only after lengthy discussions with Lucien Lelong, President of the Chambre Syndicale, that he became convinced that this would not be practicable. Instead, it was agreed that the couture would remain in Paris and serve a Nazi-approved Franco-German clientele. More than one hundred houses stayed open, including Paquin, Jeanne Lanvin, Worth, Pierre Balmain, Marcel Rochas, Nina Ricci, Lelong, Jacques Fath and Balenciaga, thus securing the livelihood of some twelve thousand workers. When Madame Grès presented a defiant collection in the colours of the French flag, her business was temporarily closed down by the Germans.

Because massive quantities of luxury goods were exported from France for German consumption, top quality fabrics and accessories were highly prized and Parisian haute-couture prices soared. Despite the shortages, styles were extravagant. Lavishly decorated garments were full-cut and generously draped. Shoulders were rounded; extra-wide bishop or batwing sleeves were caught into tight wristlet bands; full bodices were nipped into slender, moulded waists and skirts were full. Reflecting the cultural concerns of the Nazi occupiers, some fashion and textile designs were inspired by romanticized notions of peasant and medieval costume. Rejecting as decadent the slender silhouette which epitomized

Parisian elegance, the Nazis portrayed an ideal of womanhood that
was buxom and athletic – suited to working the land and child-bearing. From the mid-1930s and during the war years, modest 'peasant' styles, promoted through Nazi-approved artworks, were in favour, and their influence can be seen in high fashion in the vogue for embroidered blouses, neckerchiefs, shooting suits with embroidered braces, and loden capes, as well as in more overtly glamorous evening gowns made from fabrics with, for example, designs of meadow flowers and wheatsheaves.

By 1941 French stocks of leather, which were required for boots for the forces, were virtually exhausted and civilian shoes were among the precious commodities that were traded illicitly on the thriving black market. To conserve leather, huge quantities of women's shoes were made with chunky wooden wedge soles. This rather masculine heaviness in footwear was offset by towering, lavishly decorated hats. When felt, feathers and tulle ran out, milliners turned to such unconventional materials as cellophane, wood shavings and braided paper for both construction and decoration.

Although fashions were on a grand scale, the Nazi administration ruled that designers must limit collections to one hundred models; this was further reduced to sixty in 1944, when shortages of material reached crisis point. Potential haute-couture clients had to apply for special dispensation passes – during the four years

115, 116. In the 1930s, German fashion emphasized the healthy, buxom young woman, often placing her in a pastoral setting. *Left*: For the cover of a 1937 issue of *Mode und Heim* (Fashion and Home), the model is shown holding a bunch of daisies and wearing a flowered sundress with a sash waist. By her side is a straw hat trimmed with a bow and flowers. An advertisement for textiles *c.* 1940 (*right*) shows a similarly flower-bedecked young woman, also in a country setting.

of Occupation a staggering twenty thousand of these were issued to wealthy French women, collaborators and the wives and mistresses of German officers.

Most of the population suffered appalling deprivations because of the scarcity of foodstuffs and other vital goods, including clothes. Numerous clothing factories run by Jewish families were closed down and their owners sent to their deaths in concentration camps. Menswear was especially difficult to obtain as much of the trade was redirected towards supplying the Germans with both uniforms and civilian clothing. For the French, the second-hand clothes market became a vital means of supplementing meagre wardrobes. Resourceful and style-conscious women remade old clothes into new styles: in 1942 there was a vogue for 'la robe à mille morceaux' – a multicoloured dress which combined pieces taken from several old garments.

From February 1941, clothing consumption in France was rigorously controlled by various rationing measures and from July of the same year coupons were issued. Each item of clothing was accorded a coupon value, and coupons had to be surrendered with cash when new clothes were purchased. Initially, one hundred coupons were allocated to each person, thirty of which were immediately usable. It was a woefully inadequate allowance, permitting those who could afford new clothes to purchase little more than a coat or suit, or a few smaller items each year. The regulation of knitting yarn was especially resented: special coupons were granted only to pregnant women and those with children under three years of age. By April 1942 the design of clothes was also regulated. Strict yardage limits were given for specific garments and extraneous details were outlawed. The effect on men's clothing was that suits could no longer be made with double-breasted jackets, and pleated or darted pockets on coats and jackets were banned. Trousers were limited to a single hip pocket; turn-ups were not permitted and hems were narrowed.

Isolated from the outside world, Paris lost its position as the epicentre of fashion. After initial anxieties, designers in London and New York recognized that this provided them with the opportunity to assert their own design talents, even in the face of shortages and restrictions. In Britain, with the onset of war, imported raw materials and foodstuffs could no longer be relied on. It became vital to conserve existing stocks while at the same time releasing labour, raw materials and factory space for the war effort. To ensure the best use of clothing resources, the Board of Trade controlled supplies, restricted demand and imposed design

regulations. Initial measures included the Cotton, Linen and Rayon Order (April 1940) and the Limitation of Supplies (Miscellaneous) Order (June 1940), which reduced retail fabric stocks. The Concentration Schemes, augmented in July 1942, cut down the number of clothing factories and prevented newcomers entering the industry.

In order to reduce demand and ensure a fair distribution of goods, the first Consumer Rationing Order was introduced on 1 June 1941 (and lasted until March 1949). During the first year of rationing, sixty-six coupons were issued to each man, woman and child – an allowance estimated to provide about half the clothing bought during peacetime.

With his coupon allocation a man could purchase little more than the clothes he stood up in: an overcoat required 16 coupons; a jacket or blazer 13; a waistcoat or sweater 5; trousers 8 (other than fustian or corduroy, which were 5); a shirt 5; a tie 1; woollen vest and underpants 8; socks 3 and shoes 7. A woman could select an overcoat for 14 coupons; a woollen dress with long sleeves for 11; a blouse and cardigan or jumper (sweater) which were each 5 coupons ; a skirt for 7; a pair of shoes for 5; two brassieres and a suspender belt for one coupon each and a petticoat, combination or camiknickers for 4 coupons. The remaining 12 coupons could be used to purchase just six pairs of stockings.

Many women had been accustomed to buying a new pair of stockings each week – at the pre-war rate, stocking consumption alone would have required 104 coupons. To save precious sheer stockings, many women wore woollen stockings during winter and went bare-legged in warm weather and at home. When the use of silk was banned for civilian clothing in 1941, rayon became the less desirable substitute. From 1942, US servicemen stationed in Britain brought with them supplies of highly desirable nylon stockings. Nylon was marketed as the new miracle fibre, one which looked similar to silk but was more durable. (Nylons were not manufactured in Britain until 1946.) Special cosmetics were produced to tan bare legs, though gravy browning and cocoa served as cheaper alternatives. Once the legs were stained, a mock seam was painstakingly painted up the back of the calf. Many younger women chose the less laborious alternative of wearing ankle socks.

The second year of rationing saw the coupon allocation temporarily reduced to forty-eight and the value of certain items adjusted. In a bid to conserve leather, shoes with wooden soles were re-rated at just two coupons. Initial loopholes in the system

117. In 1940, in response to wartime shortages, Max Factor introduced a coloured preparation that dyed the legs to give the impression of stockings. Painting a mock seam up the back of the leg – the finishing touch – required a steady hand and was extremely difficult to perform on oneself.

were also closed: unrationed industrial overalls and furnishing fabrics were allotted a coupon value when it became apparent that they were being used to supplement clothing allowances. However, blackout material remained unrationed for the duration of the war and was often used illicitly to make clothes. As always, home dress-making and knitting provided an opportunity for individuality and financial savings, as well as offering a means of conserving coupons. A skirt could be made at home using three-quarters of a yard (68 cm) of fabric for only three and a half coupons; ready-made, it required twice as many.

Although hats were unrationed – to allow women at least one fashion statement – designs were small-scale. Veiled pillboxes were popular, as were berets, caps which moulded the head and miniature hats with tiny brims – these were all worn at a jaunty angle. Popular trimmings included plumage – ranging from single feathers to entire birds – and pert, tailored ribbons. For summer,

118
119

glazed straw models were decorated with fabric flowers. Despite the lack of regulation, hat sales did not show any appreciable increase during the war. Many women found the prices prohibitive; others considered hats frivolous and irrelevant in wartime and preferred the more practical nets, turbans, snoods and headscarves, which covered the hair and were therefore safe for factory work, as well as being suitable for wear both indoors and out.

An alliance between enterprising cloth merchants and talented artists led to the production of patriotic wartime textile designs as well as designs inspired by the fine arts. For their range of cheerful headscarves, Jacqmar made use of allied emblems and slogans such as the propagandist design by *Punch* cartoonist Fougasse entitled 'Careless Talk Costs Lives'. The Manchester-based Cotton Board's Design and Style Centre and the London textile company Ascher commissioned leading artists and designers, including Henry Moore and Graham Sutherland, to conceive distinctive, modern textile prints. To avoid wastage when cutting, woven and printed pattern repeats were kept small.

The Utility scheme was introduced by the Board of Trade in 1941 to ensure that low- and medium-quality consumer goods were produced to the highest possible standards at 'reasonable' prices, consistent with the restrictions on raw materials and

120

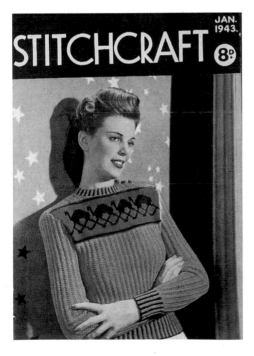

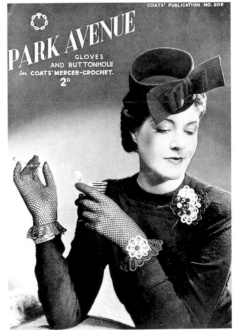

labour. The word 'Utility' was applied to garments made from Utility cloth, which was defined in terms of minimum quality levels (weight and fibre content per square yard) and maximum permitted retail prices. Utility clothes were identified by the distinctive double crescent CC41 (Civilian Clothing 1941) label. After manufacturers had met their Utility quotas – about 85 per cent of the total production – they were permitted to make clothes using non-Utility cloth, but were obliged to follow the same style regulations. To further economize on diminishing resources, the Making of Civilian Clothing (Restrictions Orders) was passed in 1942. This forbade wasteful cutting and set out a list of restraints within which dressmakers, tailors and manufacturers were compelled to work. A dress, for example, could have no more than two pockets, five buttons, six seams in the skirt, two inverted or box pleats or four knife pleats, and 160 inches (4 metres) of stitching. No superfluous decoration was allowed.

To demonstrate that the limitations of Utility did not rule out style or result in standardized clothing, the Board of Trade recruited London's leading fashion designers to create a prototype collection. Working under the auspices of the newly founded Incorporated Society of London Fashion Designers, Hardy Amies, Digby Morton, Bianca Mosca, Peter Russell, Worth (London) Ltd, Victor Stiebel, Creed and Edward Molyneux were commissioned to design a year-round wardrobe comprising an overcoat, suit (with shirt or blouse) and day dress. Templates in graded sizes were made of thirty-two of these designs and they became available to manufacturers for a small fee from October 1942. That month, *Vogue* praised the fact that clothes conceived by top designers were now widely available and that negative style restrictions had been turned into positive triumphs.

With the focus on cut and line, the collection was distinguished by its elegant simplicity. Though few women could hope to equal the sophistication depicted in *Vogue*, these designs established the lines of British wartime dress. The silhouette was narrow and tailored, with pronounced shoulders and a nipped-in waist. Jackets were cut short and boxy or long and lean. Hips were accentuated with tunic lines, drapery, and slanting and patch pockets. Skirts were straight with kick or inverted pleats or gently flared panels to facilitate movement. Hemlines reached eighteen inches from the ground – generally just below the knee. Additional surface interest was created by the imaginative design and placement of buttons, such as those patriotically featuring the CC41 motif. Military details were apparent in the use of belts, breast pockets,

120. British textile designs from October 1943. *Top to bottom*: 'Peace and Plenty' design on a red background with black and white figures; stripe with a counter-stripe and an off-register print.

121. *Opposite*: A group of young women munitions workers wearing the ubiquitous overalls attend a display of Utility clothes in Croydon, England, in 1942.

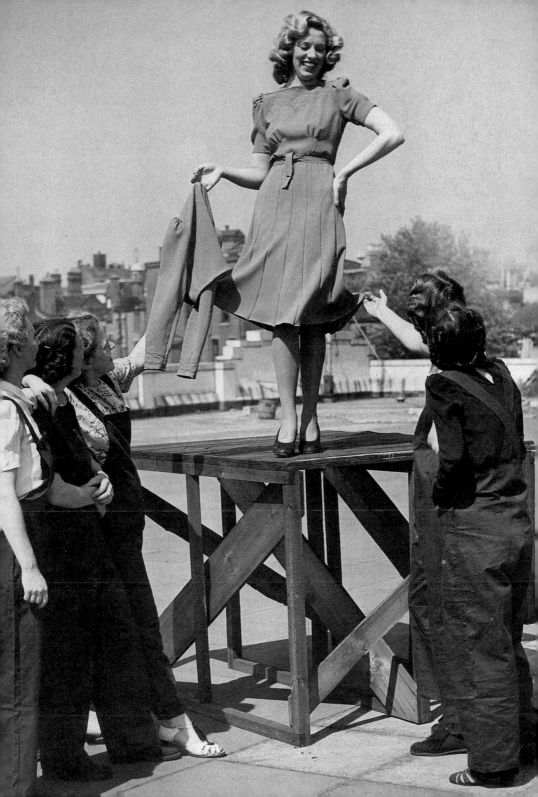

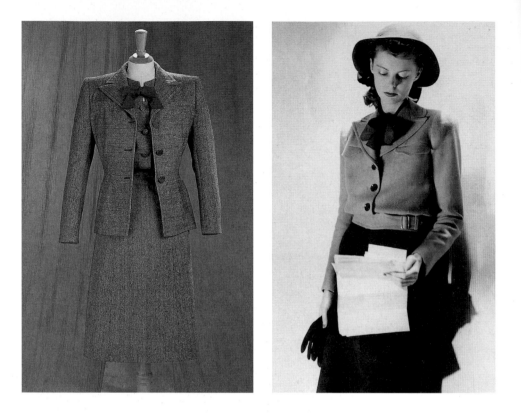

high-cut necks and small collars, and a touch of gaiety was achieved through the use of bright and contrasting colours.

Shoe designs for women were chunky and sturdy, with wedge soles or heels rarely more than 2 inches (5 cm) high. Open toes were banned as unsafe and impractical. Despite leather shortages, shoe uppers were generally made from calf or suede, though raffia and felt proved to be economical and novel alternatives. Men's shoes adhered to a long established formula, dominated by conservative, hard-wearing oxfords and brogued lace-ups.

While many men spent the war years in uniform, civilian styles became less formal: open-necked shirts and pullovers, worn with flannels or corduroy trousers, were often preferred to suits, collars and ties. Styles were also pared down under Utility rulings. The chief economies were the abolition of the waistcoat – making all suits two-piece – and the elimination of pocket flaps, turn-ups on trousers, and braces. Critics of these measures pointed out that demand for pullovers would inevitably increase to compensate for the absence of waistcoats, that pocket flaps were important to conceal bagginess due to excessive use, that turn-ups made it

122. *Opposite left*: Utility ensemble in grey herringbone tweed with fine red stripe, grosgrain ribbon and three CC41 buttons. Although it was agreed that designs should be anonymous, swing tags marked with the designers' initials were found on some garments when the collection was donated to the Victoria & Albert Museum in 1942, and this outfit has been attributed to Digby Morton. By making blouse, jacket and skirt in the same fabric, this versatile three-piece could be worn as a suit or as a dress. It was made in all quality levels.

123. *Opposite right*: Utility ensemble of flecked pale blue jacket and navy-blue wool skirt, attributed to Victor Stiebel. The buckled, single-breasted jacket with square padded shoulders, deep revers and two flap pockets closely resembles the battle dress top of army uniform. It is worn with a slender skirt with gently flared panels set into a yoke.

easier to effect repairs, and that braces were essential for suits which no longer fitted perfectly; but the Board's decision was final. Accessories could be used to bring variety to reduced wardrobes: by alternating a conservative black homburg and a more casual snap brim hat, for example, a man could wear the same suit for both business and leisure.

Although rationing controlled civilian consumption, UK menswear manufacturers such as Hepworths and Burton were fully occupied throughout the war fulfilling government demand for uniforms. Business was also steady in Savile Row as both orders for uniforms and orders from overseas boosted sales. Numerous American officers serving in Britain ordered suits for their return home and by the end of the war there were lengthy waiting lists for Savile Row's exclusive, handcrafted product.

A government-organized campaign known as 'Make-do and Mend' was put into effect by 1943 to ensure that people made their

127

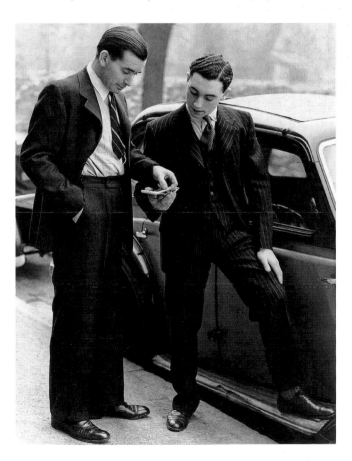

124. A young man wearing a standard Utility suit offers a cigarette to an older man dressed in a suit by Simpson's, an exclusive London department store, *c.* 1942. This image was presumably intended to document the superficial similarity between the two outfits.

existing clothes last as long as possible and then recycled them. Poorer families had always been resourceful, but now the better-off were encouraged to follow suit. The press supported the campaign by advising readers how to look good on a shoestring and how to create new clothes from old. Women were even advised to reuse the thread from worn-out stockings to make knitted tea cosies and slipper tops, while those in need of a swimming costume were shown how to run one up using five dusters. The most adventurous of all were given instructions on how to design natty jewelry from bottle tops, corks and film spools.

Throughout the war, women were under pressure to look good at all times, especially for men home from the front, while at the same time caring for their families and undertaking war work that was often arduous and potentially dangerous. For factory work, anything that might catch in machinery was eliminated or concealed: long hair was covered and clothes stripped of strings, laces and loops. Fastenings were sited down the back or on the shoulders, pockets were on the seat, belts fastened from behind and shoes pulled on.

Because clothing and accessories were in short supply, special emphasis was placed on hairstyles and makeup, though the manufacture of cosmetics was also severely curtailed. Staple ingredients including castor oil, glycerin, talcum powder and alcohol were required for war purposes, as were packaging materials such as plastics. Production was also diverted to cater for special non-fashion requirements, such as face creams to help prevent munitions workers from absorbing toxic substances. Nonetheless, the various ideals of beauty projected by Hollywood stars Rita Hayworth, Betty Grable, Bette Davis, Joan Crawford and Barbara Stanwyck continued to be avidly copied by their female fans.

Beauty journalists suggested women buff their nails instead of varnishing them because varnishes were scarce and, furthermore, impractical for wartime life. Likewise they were encouraged to shine their hair by brushing rather than by the use of brilliantine. Early in the war, shorter hairstyles were fashionable, but from 1942 onwards shoulder-length styles became popular and Hollywood star Veronica Lake inspired countless women to part their hair at the side and wear it in page-boy style. For special occasions, hair was worn long and curled or swept up.

In Italy, as elsewhere, shortages were severe and the fashionable silhouette for women was similar to that created in Britain, with square-shouldered, fairly close-fitting garments which reached just below the knee. However, Italian style tended to be more 'dressy'

## COMBINING GARMENTS

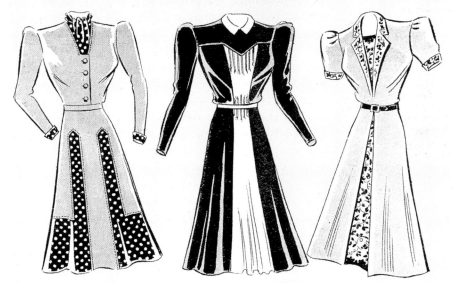

THREE WAYS IN WHICH TWO OLD FROCKS MAY BE COMBINED

than the rather masculine, tailored lines of Utility. Designers such as Maria Antonelli, Sorelle Fontana, Schuberth and furrier Jole Veneziani continued to answer the needs of the aristocracy, industrial millionaires and leading actresses. Leather shortages were especially pronounced and perhaps worst affected were Italy's internationally renowned accessory makers. Faced with severe leather restrictions, the influential and ingenious Florence-based shoemaker Salvatore Ferragamo created masterpieces of invention. He used synthetic resins and cork to produce ultra-stylish wedge-soled shoes, but most distinctive of all were his futuristic soles made both from rhodoid, which looked like glass, and from Bakelite. From 1940, when the use of leather was reserved exclusively for soldiers' boots, Ferragamo's colourful shoes, often featuring oriental upturned toes, utilized such diverse materials as hemp, felt, raffia and crocheted and plaited cellophane.

Between June 1940 and December 1941 American designers created stylish collections, free from wartime constraints. At the very top end of New York's fashion market, Valentina created draped silk evening dresses, some with a medieval feel, and full-skirted ballerina styles; Charles James designed sculptural coats and gowns in unusual colourways and Hattie Carnegie tailored body-moulding suits in blazing colours. For winter 1941 Carnegie teamed a mustard jacket with a fuchsia skirt and designed a dashing, tomato-red wool suit with a blue lining that could be glimpsed through slitted shoulders and pockets.

128. 'It's her duty to face the future calm and unruffled,' reads the text of this early 1940s Elizabeth Arden advertisement for face creams. This kind of patriotism found its way into many cosmetics advertisements.

129. American tailored fashions, 1945: the model in the foreground wears a boxy, double-breasted design in tweed by Kraus while the model with the umbrella wears a wool suit with a nipped-in waist by Hattie Carnegie.

The United States entered the war in December 1941. Although shortages of materials were less acute there than in Europe, in 1942 the US War Production Board issued General Limitation Order L-85, which forbade non-essential details and outlawed certain garments (the order would remain in force until 1946). Designers and manufacturers were forbidden to make woollen wraps or full evening dresses or to use bias-cut or dolman sleeves. Jackets could not exceed 25 inches (63.5 cms) in length; cuffs and overskirts were banned and belts could be no wider than 2 inches (5 cms). As in Britain, manufacturers were compelled to produce a certain number of cheaper lines to counteract the wartime tendency to focus on more profitable, higher-priced ranges.

During the war, Hollywood moved away from the extravaganzas characteristic of the 1930s. Adrian, realizing that his heyday as a film costume designer had passed, re-established himself as a custom dress designer, presenting his first fashion collection in January 1942. His suits were especially distinctive, featuring

broad, padded shoulders and eye-catching fabric inserts. As there was no shortage of skilled labour, American designers could employ complex techniques to create desirable couture garments, which complied with fabric-saving regulations.

While New York's custom designers were highly acclaimed, it was in the field of understated separates and sports wear that America was to make its fashion mark. Pauline Trigère, Norman Norell, Philip Mangone and Nettie Rosenstein were among the top ready-to-wear designers whose designs were sold throughout the US. Consistently reworked was the classic shirtwaist dress made in utilitarian fabrics for day wear and in more luxurious fabrics, with decorative accessories, for evening. Full-circle dirndl skirts were forbidden under L-85 regulations, so slimmer-skirted dresses were designed in stripes or solid colours, with patch pockets, cap sleeves and square or back-baring halter necks. Throughout wartorn Europe and in America, it was widely acceptable for women to wear trousers for utilitarian purposes, in the country, on the beach and in the form of dressy evening slacks. For all other occasions the rule of thumb was: if in doubt, wear a skirt.

130

The talents of Californian designers were also acknowledged during the war. Specializing in separates and play clothes, they were acclaimed for their lively use both of colour and of ethnic clothing sources. Alice Evans of Sante Fe fastened her blue denim suits with silver buttons, handmade by Native Americans.

American-produced cotton was used in abundance by designers and manufacturers, many of whom had hitherto imported ultra-sophisticated French fabrics. Slacks, culottes and shorts (worn at 'soldier-in-the-tropics' length), dresses, skirts, shirts and blouses were all made in crisp cottons. Wedge-soled shoes were covered in gingham plaid; cotton webbing was used to make belts; crisp, pleated piqué was used to trim clothes, and berets were made in sailcloth. For beachwear, sanforized (pre-shrunk) cotton and rayon were printed with brilliantly coloured designs of tropical flowers, awning stripes or polka dots and made into modified ballerina-style skirts.

From summer 1942 the styles, patternings and colourings of Guatemala, Peru and Chile were interpreted for North American markets. Skirts were designed with deep flounces, and embroidered 'peasant' blouses with puff sleeves and deep scoop necks were popular. The fashion focus was on the midriff, which was bared in day dresses as well as in beachwear. Magazines suggested that women invest in a simple dress, a beach blouse-and-skirt and a bathing costume to make full use of that unrationed commodity –

sun. Beach blouses were often cut low at the back and sarong-style trunks or shorts were worn with bra tops in floral-printed rayon jersey. Complementary accessories included thong sandals in velvety suede, multi-strand necklaces, dangling earrings, upper arm bangles and gilt coin bracelets worn around the ankles.

Among the leading New York-based sports wear designers, who included Tina Leser, Vera Maxwell, Bonnie Cashin and Clare Potter, the most famous was Claire McCardell. From 1927 to 1929 she studied at Parsons School of Design in New York and Paris and subsequently worked within the industry. During the war, her talents were fully exploited and recognized. Using heavy-duty fabrics such as denim, chambray, mattress ticking, cotton seersucker, gingham and jersey, she created a versatile capsule wardrobe of interchangeable blouses, trousers and skirts. Breaking with tradition, McCardell left metal fastenings exposed and emphasized her signature double seaming – a strengthening technique traditionally used on work wear – by using contrasting coloured thread.

In 1944 McCardell persuaded the shoe manufacturer Capezio to make unrationed ballet pumps in fabrics which matched her clothes, with sturdier soles for outdoor wear. She also introduced a long-legged leotard in wool jersey, to provide a warm and elegant layer underneath her skirts and dresses. Though these sports wear garments did not appeal to wartime markets, similar styles were to cause a fashion revolution in the 1970s.

Of all the women serving in the forces, those in the US were considered to have the most glamorous uniforms, many of which had been designed by top fashion talents. Mainbocher was especially praised for blending functionality with femininity: the stylish uniforms he created in 1942 for the WAVES (Women Accepted for Voluntary Emergency Service) were also adopted by the SPARS (the Women's Reserve of the Coast Guard). The uniforms worn by the Women's Auxiliary Corps were designed by Philip Mangone, who subsequently made much use of military detailing on his tailored day wear. Although Elizabeth Hawes had retired

131. *Right*: Three members of the WACs model the new uniforms of the auxiliary army. *Left to right*: officer's winter and summer uniforms and the basic uniform. Note the similarity between these outfits and the tailored suits worn off-duty and by civilians.

132, 133. *Opposite*: Bootleg tailors made the flamboyant zoot suits worn – and fully accessorized – by these two young African-American men (*left*) and the separate checked jacket and sharply tapered trousers, worn with distinctive looped watch chain by the young Mexican-American (*right*), 1943.

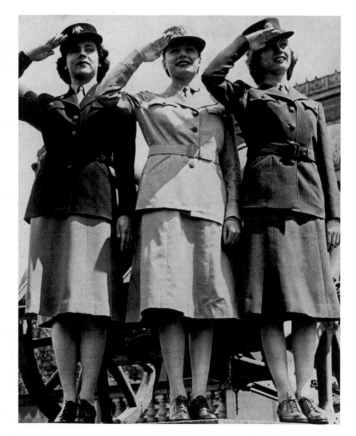

from fashion to concentrate on writing (her most famous book, *Fashion Is Spinach*, was published in 1938), she agreed in 1942 to design a uniform for Red Cross volunteers.

For men, a radical and controversial alternative to uniforms and wartime fashions was the zoot suit, which emerged in the mid-1930s but made its greatest impact during the war when it was worn by African-American and Mexican-American youths as an emblem of their ethnic pride and alienation from mainstream society. The zoot suit was distinguished by its exaggerated styling: exceptionally long, waisted jackets featured extra-broad padded shoulders, while ballooning, ultra-high-waisted trousers tapered to narrow turn-ups. Fabrics were brightly coloured, boldly striped or loudly checked; ties were showy, and two-tone, co-respondent shoes were popular. The crucial finishing touch was a long, looping watch chain. Young women also wore the jacket and chain with great aplomb, teamed with a tight skirt, fishnet stockings and high-heeled shoes. High profile 'zoot suiters' included the jazz

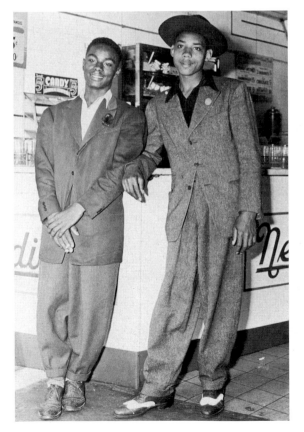
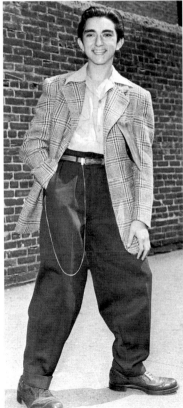

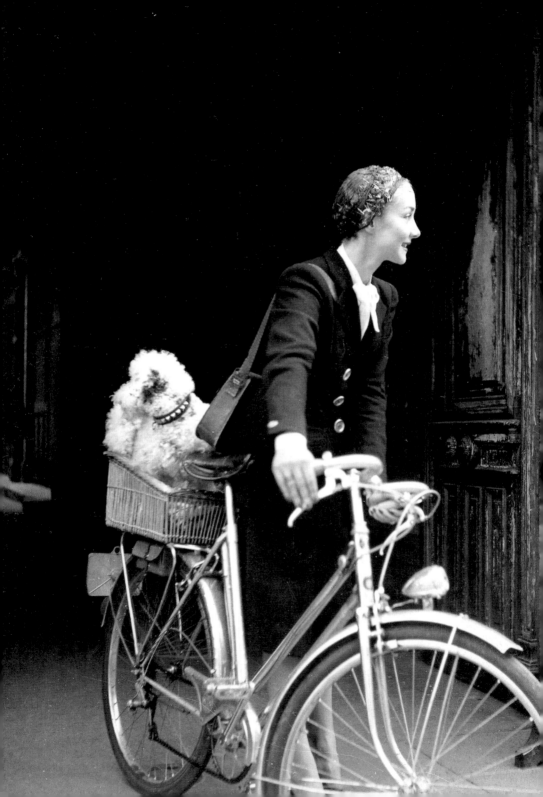

musicians Dizzy Gillespie and Louis Armstrong, as well as the young Malcolm X.

At a time of widespread patriotic economy, the wearing of the rather extravagant zoot suit aroused much hostility, which culminated in the famous Zoot Suit Riots in 1943 when 'zoot suiters' clashed with servicemen and the police. The zoot suit continued to be worn throughout the war and later influenced the dress of defiant and narcissistic swing fans in Nazi-occupied Paris, who became known as Zazous, as well as that of the black market 'spiv'.

After the Liberation of France in August 1944, news of both the hardships and the hedonism of the occupied capital reached the outside world. Among the first to arrive in Paris was Lee Miller, who photographed the prevailing fashions for *Vogue*. Occupation styles could also be seen in *Album de la mode*, a clandestine document compiled by Michel de Brunhoff, the former editor of French *Vogue*, which had ceased publication in the summer of 1940, following the Nazi invasion.

134

Inevitably, investigations were made into the role played by the couture industry during the Occupation and the patriotism of the designers was called into question. Some explained that they had deliberately used massive quantities of fabrics in order to waste enemy resources and that their preposterous wartime styles had been created expressly to ridicule their clientele. Others claimed that by making women look beautiful they were maintaining a veneer of normality and in so doing were cocking a snook at the Nazis.

After the Liberation, designers in Paris stepped in line with the savings in materials made elsewhere. Collections were reduced to just forty models and styles were discreet and economical. By 1945 magazines were reporting a 'new femininity' in fashion: skilfully cut garments gave an impression of greater fullness; shoulders were softened and deep oval and sweetheart necklines were popular. Japan and China also provided inspiration for clothes featuring kimono sleeves, frogged fastenings and vibrant colour combinations. Fashion reports were international and the prospect of Paris regaining its former fashion supremacy looked, for a brief period, uncertain.

134. 'Leaving the Pierre et René hairdressing salon with wet curls', photograph by Lee Miller, Paris 1944. With the liberation of the French capital, Lee Miller (who also documented the horror of war from the front-line) photographed most of the collections for *Vogue*. Known for the honesty and accessibility of her work, she also captured 'behind the scenes' fashion shots of models, and street scenes.

# Chapter 5:    1946–1956
# Femininity and Conformity

After the devastation of war, the economies of all the participating European countries were exhausted, many to the point of bankruptcy. Recovery was slow as populations adapted to the climate of peace and the armed forces returned to civilian life. In the UK the immediate postwar period was dubbed 'The Age of Austerity' – money and commodities were in short supply and rationing continued to slow the development of the fashion industry. The US, relatively unscathed and affluent, made its economic and political power felt in the Marshall Plan of 1947, which distributed financial aid to support European recovery. Fashion reflected the gradual growth in prosperity. The pace of the fashion industries' revival varied across Europe, while the manufacture of ready-to-wear went from strength to strength in the US. Ex-servicemen were glad to get out of uniform and, in Britain, were keen to find substitutes for the ill-fitting demob suits with which they had been issued at the end of the war. Many women, after their participation in the war effort, returned to the home as full-time housewives and mothers.

136

The end of the war brought the gradual resumption of weekend activities and holidays. While Europe took some time to reactivate its leisure wear industry, US manufacturers with experience in sports clothing were quick to produce new lines. One of the most newsworthy items of beachwear created in the postwar period was the bikini, launched in 1946 by the French designer Louis Réard shortly after the US tested an atom bomb in the Bikini Atoll in the Pacific. Two-piece swimsuits were far from new, but the diminutive size of Réard's version provoked controversy. This venture could be said to mark the beginning of the leisure and sports wear revolution that would eventually harness the potential of synthetic fibres to produce ever more effective and sophisticated activity clothes as the century progressed.

Following its liberation from the German Occupation, Paris quickly regained its position at the summit of world fashion. In 1945 the Théâtre de la Mode, a travelling exhibition of miniature wire-frame dolls dressed in couture clothing, spread the news that

137
138

135. Two years after the end of the war, in February 1947, Christian Dior's first and revolutionary collection, the 'New Look', re-established Paris as the centre of the fashion world. The keynote outfit of the collection, the 'Bar' suit, consisted of a tightly fitted natural shantung jacket and a full, knife-pleated, fine wool skirt. Below the tiny waist (achieved by a short corset), the jacket was gently padded to curve over the hips. The immensely heavy skirt was supported and shaped by a layered silk and tulle petticoat.

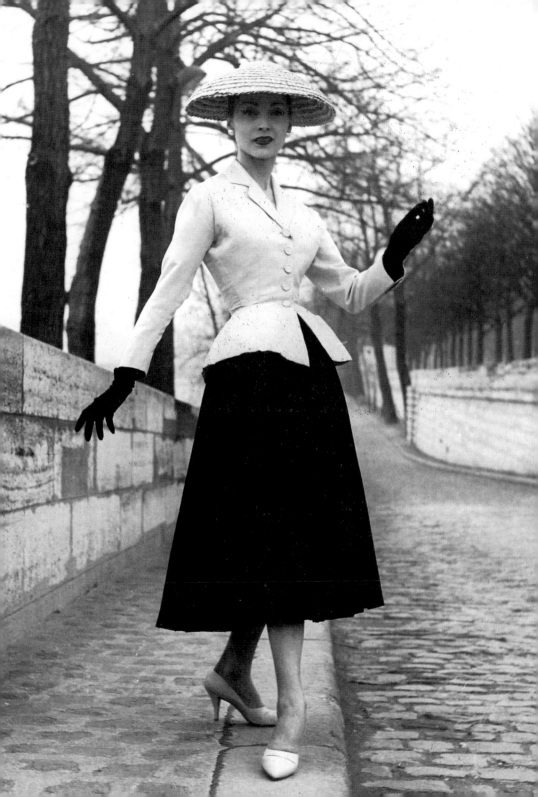

136. Government-issue demob suits displayed to British soldiers in Egypt in the mid-1940s at an ENSA (Entertainments National Service Association) show at the Garrison Theatre, Cairo. Making the best of these regulation, wide-lapelled clothes, the line-up sported jaunty handkerchiefs in breast pockets and cheerfully raised their hats to peacetime.

137, 138. *Opposite*: Two miniature mannequins from the Théâtre de la Mode, an exhibition organized by the Chambre Syndicale de la Couture Parisienne and sent around Europe and America in 1945 and 1946 to raise the profile of French fashion. The exhibition consisted of more than 150 wire-frame dolls (68.5 cms/27 inches tall) dressed in couture clothing. Over 50 French couture houses participated. As well as the meticulously constructed outfits, miniature wigs and accessories were specially made for each figure – *left*, a turquoise and white spotted chiffon summer dress by Lucien Lelong (president of the Chambre) and straw hat by Legroux; and *right*, a black wool ensemble with huge fringed hip sash by Balenciaga.

Paris fashion was in the ascendant. A few of the outfits revived romantic styles that had been present in the 1938–39 collections, indicating that designers understood the psychological need for change and were beginning to move away from the boxy wartime profile towards softer, longer lines. Two couturiers were dominant forces in this period: Christian Dior and Cristobal Balenciaga.

With the financial backing of the millionaire textile manufacturer Marcel Boussac, Dior opened his couture house at the end of 1946. On 12 February 1947 he launched his first – and now legendary – Spring collection, comprising two lines: the 'Corolle' and the '8'. Nicknamed 'the New Look' by Carmel Snow, editor of *Harper's Bazaar*, it immediately established Dior as a leader in the field. The collection was remarkable in its lack of compromise – shoulders were narrow, with gentle, sloping profiles; waists were tiny, pulled in by an undergarment known as a waspie or guêpière; skirts were enormously full and reached low down the calves. Most fashion commentators gave these lavish, romantic clothes an ecstatic welcome. Despite its name, however, the look was far from new. It revisited the minuscule waists and spreading skirts of historical dress, especially dress of the mid-nineteenth century; it also somewhat resembled ballet costume; but in its total rejection of wartime styles and its defiant challenge to rationing restrictions, it was eminently newsworthy and therefore desirable. The press debated the pros and cons of this costly splendour, which required vast quantities of fabric at a time when materials were in short supply. Officialdom in Britain, led by the then-President of the Board of Trade, Sir Stafford Cripps, was sanctimonious in its

135

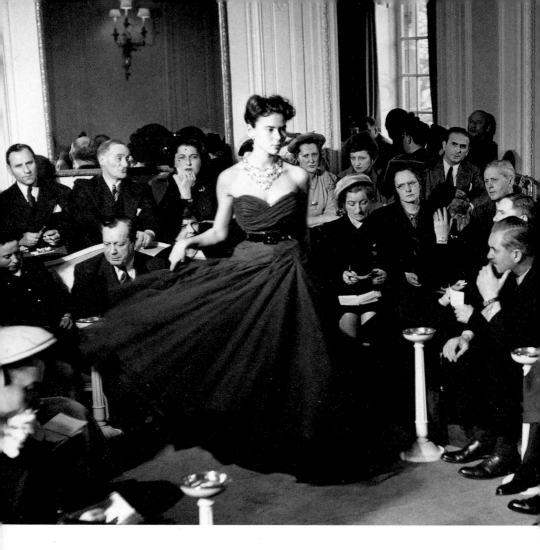

139. Postwar collections were shown in the relative calm of the couturier's salon and were sedate affairs compared with the razzmatazz that would begin at the end of the 1950s. At Dior in 1948, there was no raised catwalk and the mannequin is shown here swirling the full skirt of her evening gown over the front row of spectators and dangerously close to the elegant pillar ashtrays.

condemnation. The profligate New Look was criticized as an inappropriate and irresponsible attempt to curtail women's freedom. Those in fashion's vanguard quickly acquired versions of the style but it took a year to penetrate mass markets. Pockets of resistance and protest made news also in the US, where the anti-New Look 'Little Below the Knee' clubs attracted 3,000 members throughout the country before the fuss eventually died down. The New Look's commercial possibilities were recognized and enthusiastically exploited in America. The style boosted not only the textile industry but also the manufacturers of the numerous accessories that went with it. In recognition of his achievement, Dior was awarded the prestigious Neiman Marcus Fashion Award in Dallas in 1947.

The fashion output of the late 1940s was marked by frantic creativity, but two silhouettes dominated until the arrival of the H-line and the sack in the mid-1950s. The first comprised a fitted bodice which accentuated and clearly defined the breasts, a natural shoulderline, a tight (often belted) waist, and an immensely full mid-calf to ankle-length skirt (sustained by multilayered petticoats). The second differed only in that the skirt was pencil slim, with a long back vent or pleat to permit movement. For ten years, Dior rang the changes, showing his elite clientele two hundred models each season. Although privately a shy man, he understood and exploited the promotional value of press coverage as well as the financial rewards of export deals and licensing contracts. Giving names to collections and individual designs was not a new concept but Dior's titles were awaited as eagerly as the silhouettes they described, becoming headline news and fodder for copyists. The litany of Dior's lines includes the Zig-Zag (1948), Vertical (1950), Tulip (1953) and the famous H-, A- and Y-lines of 1954–55. The last collection before his untimely death in October 1957 was the Spindle Line. Custom-made garments by Dior were intricately crafted by a skilled workforce. A succession of eye-catching shapes was achieved by complex and sometimes over-elaborate construction. Outer layers depended on form-making foundations. Ornate, strapless evening gowns relied on rigidly boned understructures with tiered tulle petticoats. The security of a rich backer together with the rapid success of the New Look gave Dior a head start and his name is the one that is most popularly associated with 1950s fashion.

Whereas Dior nourished women's escapist yearnings for romance, Cristobal Balenciaga's work came to have a strictly modern appeal. Often called the designer's designer, Balenciaga opened in Paris in 1937 and was responsible for numerous forward-looking styles, achieving his pre-eminent position in French couture after the war. A master of refined, tailored garments which skimmed the body's contours, he was famous for his rigorous approach to every facet of couture. Fabric, colour, cut, construction and finish had to blend perfectly. He designed elegant, often dramatic clothes in which a complicated construction produced an appearance of simplicity. A talented colourist, he used black, white, grey and vibrant pinks to great effect. It has been claimed that his sense of colour and drama stemmed from his Spanish roots and he undoubtedly drew inspiration from paintings by Velazquez and Goya, as well as from the spectacle of bullfights and flamenco and the rituals of the Roman Catholic Church.

141

140

140, 141. *Following pages*: Gala evening gowns designed by Christian Dior in 1951 illustrate the two silhouettes that dominated the 1950s – *left*, the lean sheath, and *right*, full-skirted opulence. Both have tight, strapless bodices. The dress on the right is worn with a stole, an accessory that added verve to fashion photographs and became a favourite for evening wear.

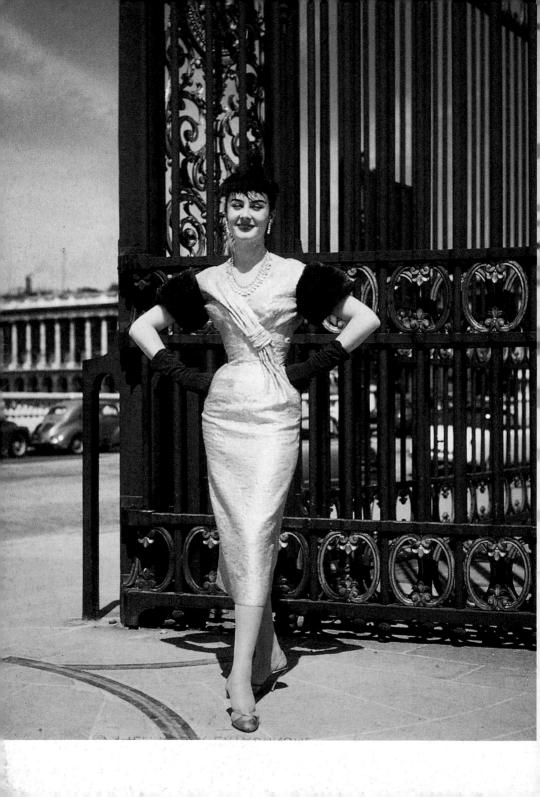

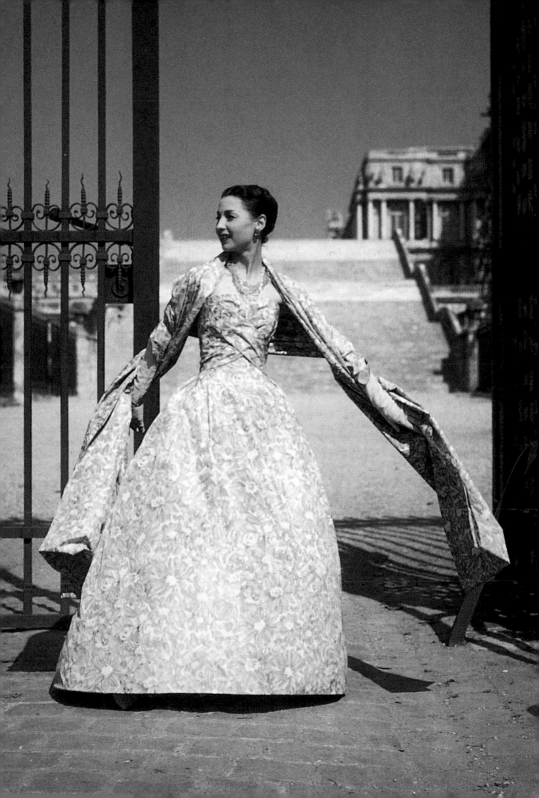

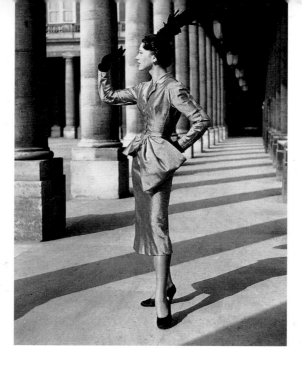

142. Balenciaga enlivened a tailored, single-breasted outfit of 1950 with an enormous sash set on the left hip. Immaculately groomed, the mannequin adopted a mannered pose that typified fashion reportage in this period.

Balenciaga did not limit himself to the pencil-thin mannequins employed by fellow couturiers, but chose house models with more average looks and his designs accommodated women of all shapes and sizes. For Carmel Snow he created what she described as 'the great suit of our time'. This outfit, which became a classic and appeared with modifications in most of Balenciaga's collections, consisted of a semi-fitted jacket with a collar that stood away from the neck, and a simple skirt, either straight or with two or four slightly flared panels. A master of illusion, Balenciaga also made a feature of collarless necklines which revealed the clavicles, making necks appear long and slender. He preferred raglan sleeves, which allowed movement and swept smoothly to a becoming seven-eighths length, revealing slender wrists. He pitched waistlines just above natural level to make wearers seem taller, and often gave his skirts flattering, minimally flared lines. Pockets, buttonholes and fastenings were streamlined and meticulously hand-finished to meet Balenciaga's exacting standards. Lined with the finest China silk, garments slipped on with ease and most included that luxurious finishing touch: tiny, silk-covered press-studs. Day wear for cold weather was made in his favourite navy, grey or black, in plain or checked wools and tweeds. Linen featured frequently in summer collections in shades of blue, sand and orange. For his dramatic evening wear Balenciaga manipulated bold planes of

heavyweight silk in solid colours or constructed sumptuous evening tunics from staggeringly heavy, encrusted embroideries, many commissioned from Lesage. Black or white lace juxtaposed with plain silk was an often repeated combination for special-occasion gowns. Balenciaga was not at his best when draping soft materials, but in all other cases his empathy with fabrics ensured a successful match of concept and material.

Postwar Paris was a fashion mecca. Designers who had established their reputations in the 1930s, including Schiaparelli and Molyneux, maintained their positions and were joined by gifted newcomers. Women with money could choose from a range of talented couturiers, many of whom were members of the powerful professional body, the Chambre Syndicale de la Couture Parisienne. Fifty-four Paris-based couture houses were registered with the Chambre in 1956. Throughout the 1950s they supplied an increasingly affluent clientele with impeccable clothes. Jacques Fath became a leading force after the war. He excelled in designing for tall, slender women who had the necessary panache to carry off his form-fitting sheath dresses with fly-away panels and sharply pointed

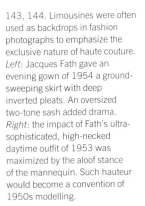

143, 144. Limousines were often used as backdrops in fashion photographs to emphasize the exclusive nature of haute couture. *Left*: Jacques Fath gave an evening gown of 1954 a ground-sweeping skirt with deep inverted pleats. An oversized two-tone sash added drama. *Right*: the impact of Fath's ultra-sophisticated, high-necked daytime outfit of 1953 was maximized by the aloof stance of the mannequin. Such hauteur would become a convention of 1950s modelling.

143
144

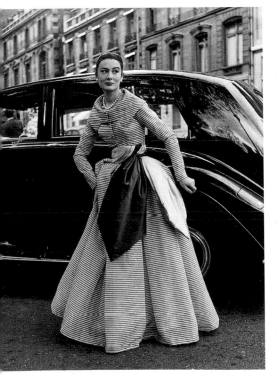

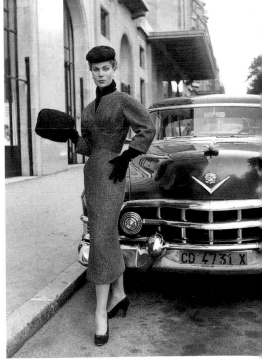

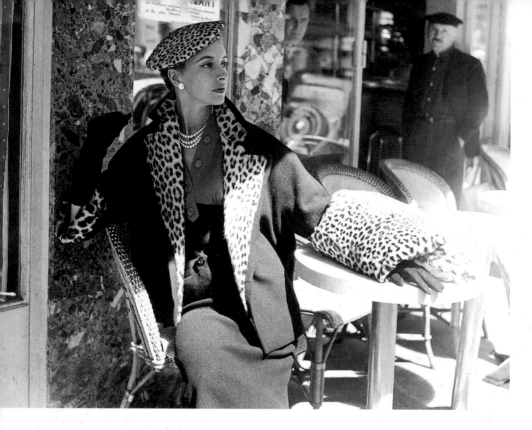

145. Balmain was fond of using expensive fur such as leopard-skin for accessories (especially muffs and hats) and to trim tailored ensembles. In 1954 passersby showed their curiosity as the haughty, Balmain-clad mannequin posed in a Paris bistro.

146. *Opposite*: Full-skirted evening dresses by Balmain were masterpieces of construction, often with painfully tight, firmly boned, strapless bodices that permitted the maximum exposure of costly jewelry. In 1955 a delicate fan helped create the romantic mood for which Balmain was famous.

collars. Fath's work was always strong and he achieved striking results by using extra high, peep-over collars, and bold asymmetrical features such as obliquely positioned gigantic bows. Like Poiret in his heyday, Fath adored fancy-dress balls and gathered socialites at his Chateau de Corbeville for themed parties – the 'Square Dance', 'Tableaux Vivants' and 'Carnaval à Rio'. At the peak of his career, he fell victim to leukaemia and died in November 1954.

Pierre Balmain opened his house in 1945 and became noted for ultra-feminine, sophisticated clothes, a tone that he emphasized between 1952 and 1957 by calling his collections 'Jolie Madame' (Pretty Woman). Like other leading couturiers, Balmain acquired a faithful clientele which included royalty and film stars, among them the Queen of Thailand, Lady Diana Cooper, Vivien Leigh and Marlene Dietrich. Though sharply tailored day wear with crisp, angular details was part of his repertoire, the house of Balmain was best known for glamorous evening attire. This included short cocktail dresses frequently in embroidered satin or velvet, and, for gala evenings, dresses with tight bodices and long, sweeping skirts in organza or satin embroidered by Rébé, Lesage

146

136

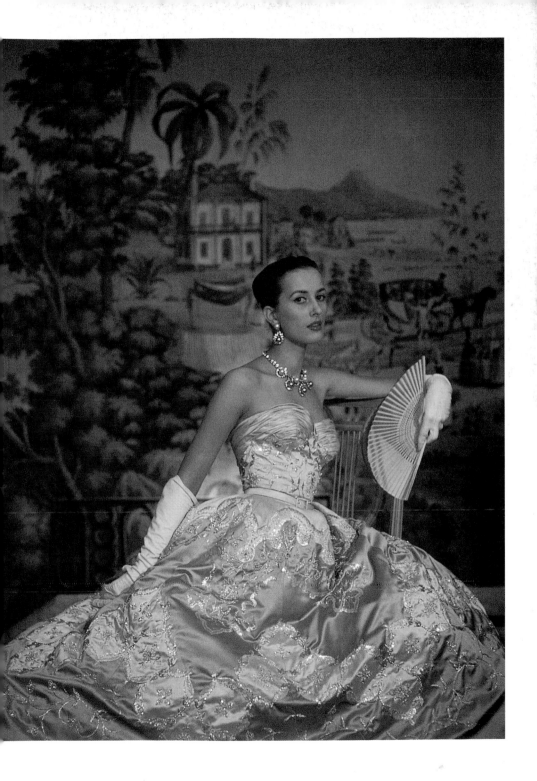

147. Gabrielle Chanel, photographed by Robert Doisneau on the mirrored staircase of her headquarters at 31 rue Cambon in Paris on the eve of her comeback collection in February 1954. Pin neat, she wore a severely tailored outfit with a gently flared skirt and cropped black jacket over a white blouse. Costume jewelry of her own design added highlights.

or Dufour which were reminiscent of the most lavish eighteenth- and nineteenth-century costumes. Form-hugging, draped and minutely pleated chiffon dresses were also popular. Like many couturiers, Balmain also designed for the cinema – between 1947 and 1969 the house was involved in more than seventy films.

Chanel relaunched her operations in 1954 and did nothing to disguise her dislike of the prevailing taste for highly structured, constricting clothes. She reworked her classic designs, such as the supple cardigan suit, giving them a contemporary look, but only American *Vogue* showed any enthusiasm for her work. It took a couple of years before the validity of her timeless designs was properly acknowledged and she was welcomed back into the realm of high fashion.

148

Although haute couture with a Paris label remained the privilege of a moneyed elite, the dissemination of each season's designs was rapid and took place at a number of levels. Good Paris copies were the next best thing to couture. In return for an agreement to purchase toiles, paid for in advance as part of the entry ticket, buyers attended the collections and selected designs to put into production. Americans were the major customers and high-quality copies were available in the US from Henri Bendel and Marshall Field. Rembrandt provided the UK with excellent Paris copies. The Chambre was responsible for timetabling the shows and enforcing strict rules governing publicity and reproduction. Photography and sketching were forbidden. Memoirs of designers and journalists provide fascinating insights into the world of fashion at this time. They indicate that espionage techniques had not changed. As in the past, clandestine notes and sketches were made, a photographic memory was a huge asset and pirating was a fact of life. Official press photographs and drawings of selected garments were permitted as soon as the audience had left but were stamped with instructions for use and release dates (usually a month after the show). To ignore these meant expulsion from the collections. At the cheaper end of the market, mass manufacturers relied on published sources, including the increasing number of fashion forecasting journals. Fashion magazines relayed the highlights of the Paris collections to an international audience. Even

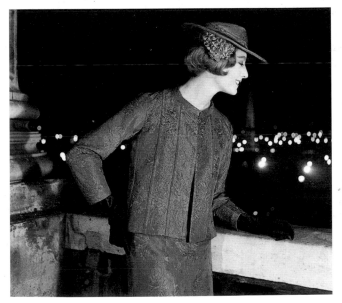

148. Chanel remained faithful to the cardigan suit formula she had so successfully devised in the 1920s. This late 1950s version was the epitome of uncluttered simplicity, combining a collarless, straight-line jacket with edge-to-edge fastening and a matching slimline skirt.

the most mundane of British homemaker magazines had its fashion column, and editors whipped up interest in the biannual collections by informing their readership that they absolutely must get the latest Paris look. The tradition of home dressmaking was widespread, and paper pattern manufacturers such as McCall, Butterick and Simplicity updated their ranges twice a year. *Vogue* Pattern Service carried the most avant-garde designs and continued to produce its expensive series of Paris couturier patterns.

Conditions in postwar Britain were not conducive to large-scale improvements in the fashion industry. The restrictions imposed by rationing remained in force until 1949 and the Utility Clothing Scheme was not wound up until 1952. In an attempt to improve the export trade, encourage 'good' design and boost morale, the Council for Industrial Design organized an exhibition of British products entitled 'Britain Can Make It' at the Victoria and Albert Museum in September 1946. The show drew crowds of eager would-be consumers keen to buy new goods, but as most of the products displayed were prototypes or marked 'for export only' the exhibition was soon renamed 'Britain Can't Have It'. Eminent fashion journalists Ernestine Carter, Anne Scott James and Audrey Withers were members of the fashion and accessories committee. The Fashion Hall featured a white display tower showing the work of fifteen top London designers, mainly the members of the Incorporated Society of London Fashion Designers (founded in 1942), who were continuing their sterling efforts to encourage capital investment and to establish an official structure for their profession. This group wished to safeguard their common interests and bring top-quality British products to international attention. Though the ISLFD could not hope to rival the long-established, government-supported French organizations, it made a strong showing in the 1950s. Its members were the cream of British and Irish designers, and included Hardy Amies, Norman Hartnell, Edward Molyneux, Digby Morton, Victor Stiebel, Peter Russell, Bianca Mosca, John Cavanagh and Michael Sherard. Together they succeeded in reviving interest in UK fashion and in attracting buyers to the London collections, held just before the Paris shows.

British royalty was not overtly fashion conscious but its presence at fashion events was an enormous asset, as was the endorsement of a royal warrant. Members of the royal family and a coterie of aristocrats patronized the two leading postwar couture houses – Norman Hartnell and Hardy Amies. Princess Elizabeth's wedding in 1947 attracted widespread media attention and led to a flurry of clothes shopping in establishment circles. Her embroi-

149. Horrockses cotton dresses were quintessentially British, expressing an optimistic note with their breezy simplicity and fresh colours. In the mid-1950s, they invariably had a fitted bodice and a very full, gathered skirt. This flower-striped design was created for Spring/Summer, 1957.

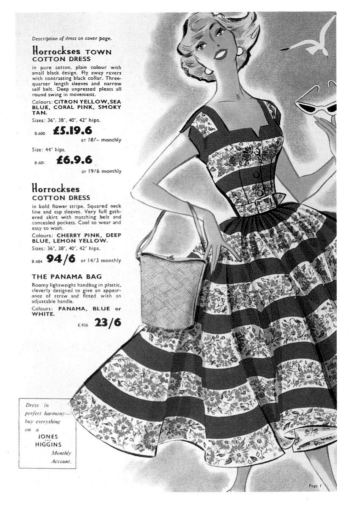

*Description of dress on cover page.*

## Horrockses TOWN COTTON DRESS

in pure cotton, plain colour with small black design. Fly away revers with contrasting black collar. Three-quarter length sleeves and narrow self belt. Deep unpressed pleats all round swing in movement.
Colours: **CITRON YELLOW, SEA BLUE, CORAL PINK, SMOKY TAN.**
Sizes: 36", 38", 40", 42" hips.
B.600 **£5.19.6** or 18/– monthly
Size: 44" hips.
B.601 **£6.9.6** or 19/6 monthly

## Horrockses COTTON DRESS

in bold flower stripe. Squared neck line and cap sleeves. Very full gathered skirt with matching belt and concealed pockets. Cool to wear and easy to wash.
Colours: **CHERRY PINK, DEEP BLUE, LEMON YELLOW.**
Sizes: 36", 38", 40", 42" hips.
B.604 **94/6** or 14/3 monthly

### THE PANAMA BAG

Roomy lightweight handbag in plastic, cleverly designed to give an appearance of straw and fitted with an adjustable handle.
Colours: **PANAMA, BLUE or WHITE.**
E.926 **23/6**

*Dress in perfect harmony— buy everything on a* JONES AND HIGGINS *Monthly Account.*

*Page 1*

dered gown, by Norman Hartnell, was not ration-free and required 100 coupons. The dress was much admired and so efficient was the Seventh Avenue copying network that a replica was ready eight weeks before the wedding, though in the interests of international harmony it was not put on sale until the day itself. Throughout the 1950s Hartnell created spectacular state gowns for the Queen Mother and for Queen Elizabeth II. In 1953 he designed the latter's magnificently embroidered coronation gown which was seen by millions of first-time television owners. These official gowns were 'showstoppers' and deliberately distanced from fashion of the day.

In 1947 the tradition of presentation at court was resumed, signalling a return to the debutante round and to the 'Season',

151

150. *Below*: Clothes for British social events featured regularly in the fashion press. Top British model Barbara Goalen displayed accessories available from Harvey Nichols and recommended for Ascot in 1945. The picture hat was trimmed with curled ostrich feathers while grosgrain shoes, bag and suede gloves were available in matching navy or black.

151. *Right*: Norman Hartnell's sketch of Princess Elizabeth's embroidered white satin wedding gown for her marriage to Lieutenant Philip Mountbatten RN on 20 November 1947. It took Hartnell's workrooms almost three months to make up the romantic design, with its sweetheart neckline, flared skirt and long train.

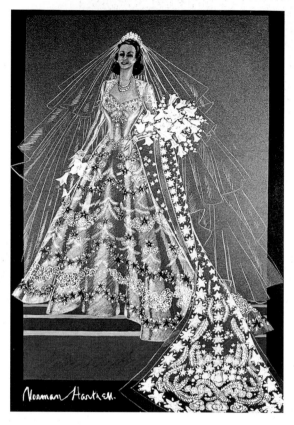

152. *Opposite*: A smartly tailored coat dress by Hardy Amies in a black silk from Ascher, 1954, was teamed with a flying saucer hat, gloves and court shoes. Pearl earrings and necklace provided the perfect finishing touches.

which included quintessentially English events ranging from the races at Ascot to the Henley Regatta. All these occasions demanded appropriate attire, which inevitably meant good business for a whole spectrum of fashion makers, tailors and retailers, mainly based in London.

150

Hardy Amies played a central role in British high fashion at this time. After a training at Lachasse, he opened his couture house in Savile Row in 1946 and throughout the late 1940s and 1950s produced both tailored city clothes and clothes for the country weekend. He was also known for his evening gowns and for special-occasion gowns for debutante balls and presentations at court. His evening styles for the younger woman were made with firmly boned, fitted bodices which were either strapless or held up by spaghetti straps. Skirts were bouffant and frothy, made in tulle or organza, shimmering with embroidery. For his dresses for mature clients, which were similar in form, Amies often used heavy satin or ribbed silk, with embroidered panels. He was patronized by the

152

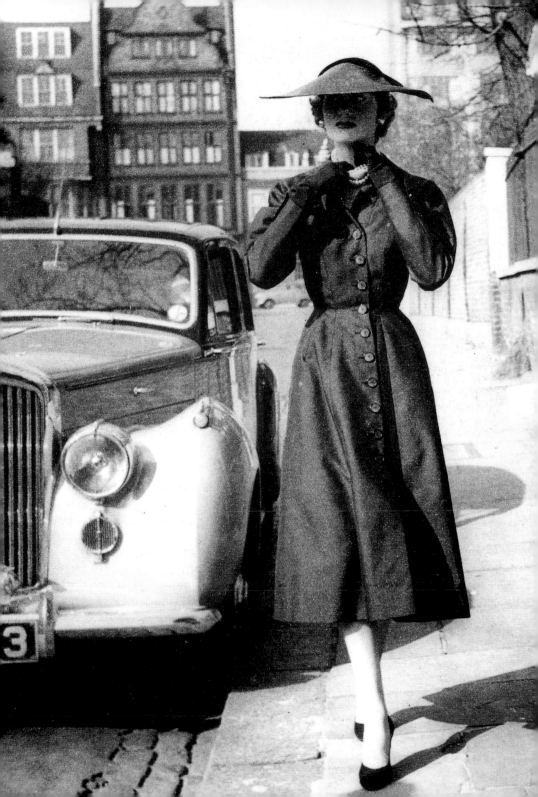

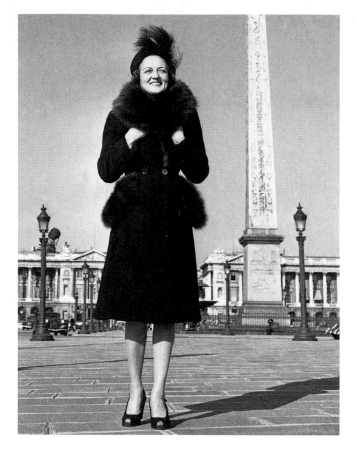

153. Marking the transition between wartime Utility clothes and New Look extravaganzas, this 1946 suit by Edward Molyneux had the short skirt typical of the war years but its jacket featured the nipped-in waist and softer lines that heralded the New Look revolution of 1947.

royal family and in 1950 designed Princess Elizabeth's clothes for her state visit to Canada. In the early 1950s, aware of the need to satisfy discriminating customers who could not afford the high costs of haute couture, he introduced a ready-to-wear boutique.

Charles Creed, who came from a long line of famous Paris-based couturiers, returned to London from the French capital at the outbreak of war and when the war was over he set up his own business. A tailor *par excellence*, Creed concentrated on the production of elegant, well-cut coats and suits which brought a comparatively daring spirit to the sometimes staid world of British fashion. Victor Stiebel, Edward Molyneux, John Cavanagh and Digby Morton, though all capable of extrovert gestures, were best known for high quality, tasteful, classic clothes.

In Italy, new forces emerged. After the war a group of designers, many of them from the aristocracy, became important style-setters, making highly individual statements with brightly coloured,

153

boldly patterned clothes that had a vibrant, youthful appeal. These designers, who excelled in the creation of holiday and sports wear, received widespread publicity and attracted American buyers. One of their number, Simonetta, opened in 1946 and became known for her young, chic collections. Simonetta married the couturier Alberto Fabiani, who specialized in streamlined tailoring, and in the 1950s the couple achieved a professional harmony by showing their collections separately.

The rise of Italian designers was celebrated in 1951 with a group show organized by the fashion entrepreneur Giovanni Battista Giorgini in his Villa Torregiani, Florence. Ten top designers from Rome and Milan participated, together with four boutiques. Giorgini invited American buyers and the press – *Life* magazine is on record as declaring that the event challenged Paris. These presentations continued on a biannual basis and in 1952–53 were transferred to the Pitti Palace, placing Italy firmly on the international fashion circuit. In 1951 the twenty-one-year-old Roberto Capucci made his debut and went on to produce outstanding collections which converted architectural and geometric concepts into wearable clothes. In a different vein, the Neapolitan aristocrat Emilio Pucci captured attention with sports clothes and casual wear which emphasized the shape of athletic bodies and featured his now famous silks printed with swirling designs in singing colours. A Pucci pants and shirt ensemble became an essential component of resort wear for the international smart set.

While Paris resumed its position as world leader of haute couture, the US boasted the most efficient manufacturers of ready-to-wear clothing. American production lines, research and development units and retailing processes – relatively uninterrupted by war – returned to streamlined, profitable operations. Demand for quality rather than variety ensured that the industry stabilized and prospered. Throughout the late 1940s and 1950s, American companies welcomed visits from European colleagues and potential competitors who wished to study their advanced systems. The industry allowed itself to be thoroughly scrutinized – a detailed analysis was published in 1947, and in 1956 the US Department of Labour compiled a report specifically intended for European production managers on the manufacture of women's dresses.

Although the American press and buyers returned enthusiastically to Paris, they no longer ignored domestic talents. On the contrary, American designers found themselves in the spotlight, and their innovative approaches, combined with national manufacturing skills, ensured that New York's Seventh Avenue continued

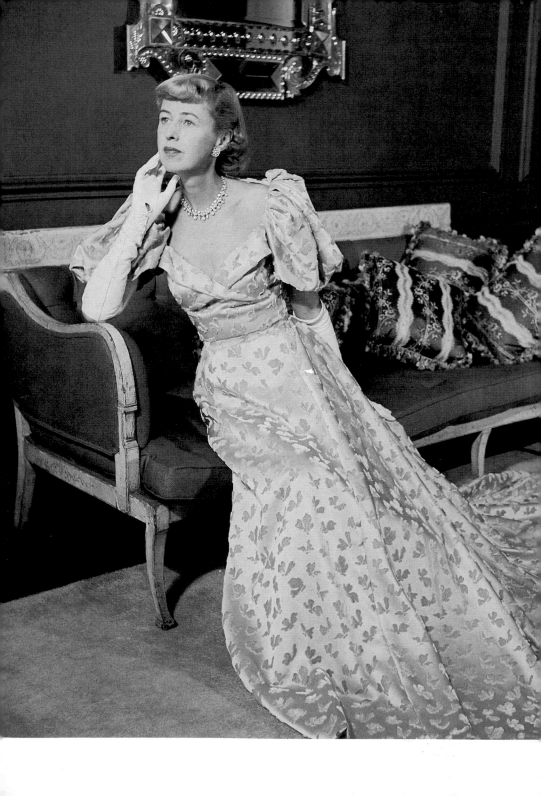

as a major force. In such a vast country decentralization was inevitable and many local fashion centres flourished. Dallas, Florida and California (mainly Los Angeles) specialized in beachwear and sports clothes while Chicago and New York produced a wide range of garments. Mail-order catalogues advertised good-quality ready-made clothing. The entire trade was kept informed of fashion news on a worldwide basis each working day by Fairchild Publications' influential paper, *Women's Wear Daily*. American designers, with their special understanding of the lifestyles and requirements of the home market, consciously resisted the pull of Paris, and though glossy fashion journals continued to report on collections in the French capital and to photograph the best Paris copies, this was balanced by coverage of home-produced fashion. Relatively well-off, stylish Americans spent a considerable amount of money on clothes and stimulated trade. American manufacturers also pinpointed the teenage market and made 'young look' clothes specifically for this age group.

In high-fashion circles, designers established in or before the 1940s continued to satisfy wealthy customers. Foremost among these were Norman Norell, Mainbocher, Hattie Carnegie and Pauline Trigère in New York and former Hollywood costume designers Adrian, Howard Greer and Irene in California. The maverick Charles James, who had returned to New York in 1939, went on inventing and reworking toiles and constructing extraordinary clothes in lavish fabrics for a devoted clientele, including Mrs William Randolph Hearst, Mrs William S. Paley and Mrs Cornelius Vanderbilt Whitney. These women tolerated James's erratic behaviour because they knew that he would provide them with clothes that would be the highlight of any occasion. His evening wear explored contrasts of volume, often perching dangerously tight bodices above perfectly balanced, massive skirts in heavy satins dyed in pellucid colours. The dramatic black and white lobed 'Four-leaf Clover' or 'Abstract' ball gown of 1953 was considered by some to be James's most spectacular gown. Though his day wear was made in eminently practical flannels and tweeds, it played with unusual shapes, such as the 'Cocoon' coat (1949), the 'Gothic' coat (1954) and the forward jutting 'Pagoda'

154

155

154. Mrs Vincent Astor (wife of a descendant of the wealthy American merchant and financier John Jacob Astor) in a trained evening gown by Mainbocher, New York, 1948. Supple satin was ideal for the large, gathered sleeves (reminiscent of the 1890s) and the gown's soft, flowing contours.

155. Charles James was known for his magnificent ball gowns. He was commissioned to design the spectacular 'Four-leaf Clover' or 'Abstract' gown for Mrs William Randolph Hearst, Jr., to wear at the Eisenhower inaugural ball in 1953. James subsequently made a number of copies. This version is in cream satin duchesse and black velvet. A complex substructure (the gown is constructed from thirty pattern pieces) provides the framework for the glistening satin and wide lobes of lustrous velvet.

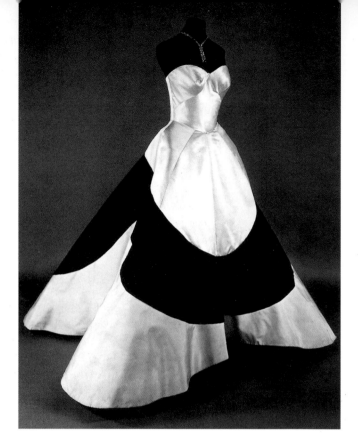

suit (1955). James opened a custom salon in Madison Avenue in 1945 and dabbled with wholesale manufacturing in the mid-1950s, but was a catastrophically bad businessman and eventually retired bankrupt in 1958. Despite his rather precarious career, he was greatly admired by his peers: Balenciaga described him as the only couturier who has 'raised haute couture from an applied art form to a pure art form'.

The work of Claire McCardell and Norman Norell points up two dynamics that were central to the American industry in the postwar period. The first was resolutely American while the second was in harmony with Paris couture. McCardell was already highly respected as the innovative designer for Townley Frocks. Her forte was functional, elegant day wear and sporting clothes which were affordable and available off-the-peg. She used unpretentious fabrics, especially cotton and wool jersey, and avoided applied decoration and ornamental devices. Her strong, timeless designs have pared-down, practical shapes. In the 1950s she extended themes introduced in the 1940s — unwaisted dresses

156
157

with optional belts, cropped halter tops teamed with bermuda shorts, and strongly coloured shirtwaisters with circular skirts. McCardell, whose creativity was cut short by cancer in 1958, provided the active American woman with the ideal versatile wardrobe.

Though their work was to follow different creative paths, McCardell and Norell had both designed for Hattie Carnegie. Norell and Carnegie visited the Paris collections together, and Norell became intimate with French haute couture. He left Carnegie in 1940 and the following year joined the manufacturer Anthony Traina. Throughout the 1950s Norell catered for wealthy women, creating expensive ready-to-wear which was artistically independent of Paris but which harnessed the techniques and chic of the French couture tradition. In 1952 Norell declared, 'I don't like over-designed anything,' and, true to this tenet, his day wear was characterized by pared-down lines with a minimum of trimmings. He regularly returned to favourites such as understated wool jersey dresses, sharply tailored suits and – his speciality – 'little overcoats' (chic interpretations of the humble pea jacket). He preferred simplicity – unfussy collars or unadorned, round necklines; plain court shoes; and stripes, checks and spots rather than ostentatious floral patterns. For summer he was particularly fond of neat sailor dresses in clean-cut navy and white. Though he created ultra-romantic evening gowns to meet customer demand, he was at his best with uncluttered ideas such as the famous 'mermaid'

158

156, 157. Throughout the late 1940s, until her untimely death in 1958, Claire McCardell designed (for Townley Frocks) leisure and activity clothes that combined elegance with practicality. She liked to enliven simple designs such as the easy-to-wear cap-sleeved shirtwaister (*left*) with interesting belts, and she made no-nonsense gingham into attractive swimwear (*right*).

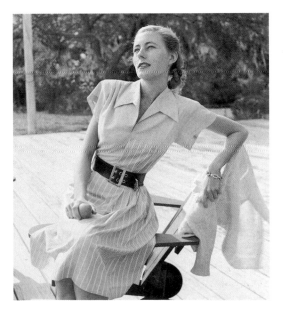

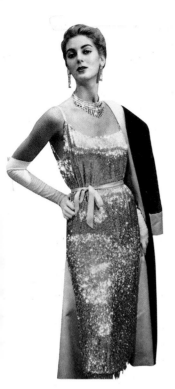

158. A signature Norman Norell design: narrow chemise dress with simple tie belt, given glamour by the all-over crystal bead embroidery. Norell cultivated this super-elegant refined look. He created this dress in 1950 for Traina-Norell.

dresses – glimmering sheaths embellished with sequins applied in the all-over fishscale technique. To match his disciplined designs, he used mannequins with the looks, chignons and deportment of prima ballerinas.

While the world of women's fashion was preoccupied with the ramifications of Dior's New Look, demobilized men either returned to their pre-war wardrobes or, in the UK, wore unappealing demob suits. This situation improved as the men's tailoring industries responded to changing economic circumstances and the gradual growth of purchasing power. In Britain, class divisions were as rigid as ever. Coupons permitting, gentlemen patronized Savile Row and its environs for bespoke clothing and accessories, while the less well-off shopped for ready-made garments at menswear chains such as Cecil Gee and Burton's, as well as at department stores. Affluent clients from abroad returned to their London tailors, which included the renowned Gieves, Henry Poole and Anderson & Sheppard. The belief that it was unmasculine for men to be preoccupied with dress ensured the survival of conservative menswear. This tended to be drab, confined to black in the evening and grey, navy and black during the day, though touches of muted colour were acceptable in sports and leisure wear. Most respectable salaried men indicated their social position and reliability by sticking to safe, predictable basics. Work demanded a well-cut, often pin-striped suit with the usual accessories, plus an overcoat and bowler hat; a lounge suit served for semi-formal, at-home occasions; evening dress might include a set of tails, and it was vital to have the correct top-to-toe attire for one's chosen sport. The British trade journal *The Tailor and Cutter* documented weekly developments, spotted coming trends and, through the late 1940s and 1950s, sent out its 'wandering' cameraman to capture the well-dressed and not so well-dressed British male at work and at play. Conventional men's attire permits only the smallest changes in details; thus wider, longer lapels, slightly slanting pockets and the depth of turn-ups became critical, copy-worthy features.

Just after the war, a group of elegant men-about-town (some were ex-Guards officers) began to have their clothes styled along Edwardian lines. Though this tendency had dandy overtones, it was applauded by the establishment because it looked upper-class and was typically British – in fact, it resembled officers' undress wear. The neo-Edwardian look consisted of a long, lean, single-breasted jacket with sloping shoulders and high-set buttons; narrow trousers (often without turn-ups); an elaborate waistcoat; and a slimline Chesterfield-style overcoat with a velvet collar. The

outfit was completed by a bowler hat, a furled umbrella or silver-topped cane and a pair of highly polished oxfords.

Such an ultra-refined style, based (like Dior's New Look) on historical dress, represented a complete contrast to postwar American menswear. The British found it difficult to accept mainstream sartorial developments from the US, perhaps because American clothing, with its leisure-wear bias, was larger and brasher than European. In 1948 America's Custom Tailor's Foundation set out to win international sales and attract skilled European tailors to its workshops – an effort that was supported by a well-organized publicity campaign involving menswear shows and media coverage. At times, the British trade revealed an ungenerous attitude towards the American Look (described by the men's magazine *Esquire* as the 'Bold Dominant Male Look'). The British psyche found it hard to accommodate the over-confident way in which the US promoted its products, and though the components of menswear were the same in America as in Europe, national interpretations and sizings were very different. American jackets had a boxy, loose cut with broad lapels; trousers were wide-legged. Americans tended to wear their clothes with a hearty bravura which was alien to Europeans. A homburg in London was generally worn with the brim straight or angled down whereas in New York it was frequently tipped up at a jaunty slant. American ex-servicemen were keen to retain the best elements of their comfortable and functional uniforms which the industry obligingly translated into casual slacks and pullovers. *Esquire* captured the vagaries of American menswear, presenting the idealized lifestyles of get-ahead modern executives, wearing clothes which exuded success.

The postwar revival of menswear production in France and Italy initially took inspiration from British tailoring and American styling, but by the later 1940s lines had emerged which were designed specifically to meet the needs of the home markets. Italy had a tradition of local tailoring, with leading menswear firms situated in Rome, Naples and Milan. Lightweight Italian suits and three-quarter-length car and scooter coats became market leaders in the mid-1950s and were soon to prove influential, particularly in the US and Britain where they were retailed as avant-garde 'continental' styles. At their most extreme, suits had short, fitted, single-breasted jackets with narrow lapels and slightly curved, cut-away fronts. Trousers were tapered without turn-ups and were worn with narrow, pointed shoes. Like the neo-Edwardian look, these Italian imports were to assert a powerful influence on subcultural youth styles. Menswear fashion shows

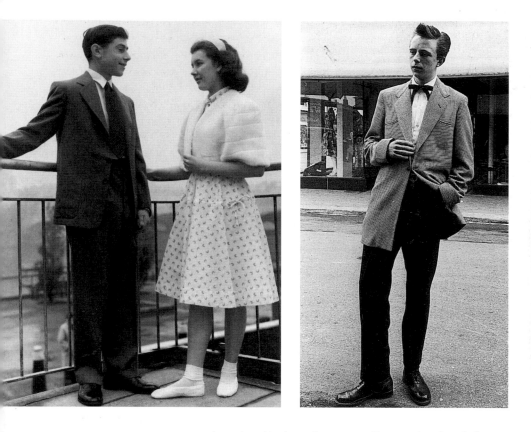

were introduced in the early 1950s and international trade forums such as the annual World Congress for Tailors enabled professionals to meet and exchange ideas. Above all, this period saw the acceptance of informality. Although suits were still obligatory for white-collar professionals, these men could relax in their off-duty hours in slacks and cardigans. In summer, the most adventurous even wore the American straight-cut leisure shirt.

As mainstream fashion flourished, groups of young people drawn together by shared ideologies and passions (ranging from popular music to motor bikes) developed unorthodox styles of their own. The picture is diverse, with pockets of anti-establishment youth emerging in Europe and the US. There is a certain irony in the fact that although rebellious attitudes were deliberately anti-fashion, these groups developed visual identities and 'uniforms' which made powerful style statements at the time and in later years fed back into top-level fashion. Disaffected youth rejected the disciplined cleanliness and conformism of their parent's generation and cultivated a scruffy appearance. The American Beats,

following Jack Kerouac's lead, wore chinos and air force surplus flying jackets. In the cellar bars of Paris, young men and women inspired by existentialism indicated their seriousness by encasing themselves in black. Women put roomy sweaters over skirts or tight trousers while men favoured pullovers and corduroy trousers. In Britain, the 1950s Beatnik phenomenon mixed the American Beat and Left-Bank existentialist look – young Beatnik women adopted sloppy joe sweaters and cropped skintight jeans, worn with ballet pumps, sandals or bare feet. In Britain, the neo-Edwardian style, formerly confined to an elite group, and made to order by Savile Row tailors, had been appropriated by the ready-to-wear by 1951 and a year later appeared in an even livelier and showier guise in London's East End, where streetwise young men, known as Teddy Boys or Teds, reworked the style, adding elements from zoot suits (long draped jackets), American cowboy wear (bootlace ties) and the rock 'n' roll look epitomized by Elvis Presley. The shiny oxfords of the neo-Edwardians gave way to crepe-soled shoes ('brothel-creepers'), and a further signifier of belonging was a Brylcreemed hairstyle with a large quiff. By the mid-1950s another subculture had also surfaced in Britain. Taking the lead from the 1954 film *The Wild One*, starring Marlon Brando, clubs of bikers began to be formed. Their members, known as Ton-Up Boys, made Brando's black leather jacket central to their tough look. These minority subcultural units, though they challenged fashion's mainstream, remained marginal and were never powerful enough to subvert its course.

160

After the war the manufacture of underwear increased dramatically. It was revolutionized by the availability of the synthetic fibre nylon, which, since its launch by Du Pont in 1938, had been restricted in the UK to the war effort. When nylon was introduced onto the open market, manufacturers combined it with elasticated panels and decorative insets to produce pretty undergarments. Its advantages were that it was drip-dry and lightweight, though some were put off by its tendency to stiffen and turn yellow or grey after regular washing. Utilitarian wartime underwear was gradually replaced by delicate lingerie and major firms such as the Anglo-American Kayser Bondor mounted sophisticated advertising campaigns. While mature women remained faithful to firmly boned corsets fastened with laces or hooks, their daughters wore simple, back-fastening suspender belts or lighter-weight, pull-on pantie-girdles. In addition to holding up stockings, girdles flattened the stomach and posterior, providing the svelte line that was essential under 1950s sheath dresses and slender tailored suits.

159, 160. Teenage alternatives. *Opposite left*: 1 November 1954. Conventional young styles were modelled at a London clothing fair preview. The boy's single-breasted suit was made of Terylene. The girl wore ballet pumps, short white socks, spotted nylon party dress, and nylon Furleen cape, which gave her an American teenage look. *Opposite right*: Also in London in 1954, a far less conventional look was photographed outside the Mecca Dance Hall in Tottenham. The Teddy Boy, with his long, draped jacket and drainpipe trousers was the UK's first postwar subcultural style.

161. *Above*: Another anti-establishment icon from 1954: the black leather jacket of the biker, worn by Marlon Brando as Johnny in *The Wild One*.

Fashion leaders forced themselves into boned, eight-inch deep, waist-restricting waspies. Nylon stockings became increasingly available and the most popular colours were flesh tones or tan; pastel ranges were introduced but failed to become a widespread success. To achieve the fashionable breast shape of the period – prominent, separated and pointed – brassieres were constructed with conical cups (sometimes padded), kept rigid by machine-stitched concentric circles. Foam rubber falsies which could be slipped into bras aided the less well endowed. It was customary (and wise) to wear long-line, boned brassieres underneath strapless dresses.

In the field of cosmetics, postwar expansion of the industry resulted in a wealth of new products from companies such as Helena Rubinstein, Gala, Elizabeth Arden and Revlon. In the late 1940s lips were all-important and deep-red lipsticks were advocated by beauty columnists. By the very end of the decade the emphasis had shifted to the eyes. On the Left Bank in Paris, the singer Juliette Greco set the pace with her soulful, doe-eyed look, achieved by pencilling around the eyes in black and extending the lines in upward flicks at the outer corners. Sales of eye makeup rocketed. Out of school, teenage girls were openly using makeup and the industry realized the financial potential of this burgeoning market. New releases were promoted by lavish advertising. Revlon led from its New York vantage point with sophisticated

162. The ploy of commissioning celebrities to advertise cosmetics, perfume and clothes endured. In 1954, Hollywood star Ann Blyth endorsed Max Factor's neatly packaged, non-spill Pan-Stik (a solid cream) that fitted easily into a handbag. It was extremely popular in the 1950s but was heavy in comparison with the light makeup developed in the late 1960s.

163. Suzy Parker modelling an embroidered tulle evening gown designed around 1950 by Adrian (Gilbert Adrian). In an unusual pose (revealing her underarms), she adjusted an earring, thus showing the strapless, full-skirted dress to its best advantage.

double-page colour spreads in the fashion glossies heralding the biannual release of 'non-smear' lipstick and matching 'chipless' nail polish. Cosmetics became available in a vast range of shades. Advertising copywriters invented catchy names for Revlon products, including 'Cherries in the Snow', 'Love that Red', 'Queen of Diamonds' and 'Red Tape'. In addition to lipsticks and nail polish there was a plethora of creams, moisturizers and cleansers. A fashionable mask-like appearance was achieved by the use of thick foundations, such as Max Factor's all-concealing Pan-Stik.    162

The hard, painted look was popularized by professional fashion mannequins who, for the first time, became celebrities in their own right. In Britain, Barbara Goalen and Anne Gunning stared    150 out haughtily from the pages of magazines. American image makers made the red-haired Suzy Parker a fashion icon, while Bettina    163 achieved fame as France's leading 1950s model. Top couturiers hired their favourites, who understood the clothes and made them come alive on the catwalk. Top-to-toe perfection was the goal. It was essential to be immaculately groomed and pin-neat – an effect

that cost a great deal of time and effort. The most aloof beauties drew their hair back into chignons, though in France the actress and dancer Zizi Jeanmaire popularized the cropped, gamine look, a style which became known in Britain as the urchin cut. Women now had time to pamper themselves and indulge in beauty and hair treatments. Hairdressers received star billing and practised their art internationally. The London hairdresser Raymond (Mr Teasie Weasie) was constantly in the news, and Antoine was equally famous as a coiffeur to the rich and famous of both Paris and New York. The cinema-going public was huge and their 1940s and 1950s Hollywood film-star idols ranged in appearance from the girl-next-door (Doris Day) to the more curvaceous glamour goddess (Jane Russell, Marilyn Monroe, Gina Lollobrigida and Elizabeth Taylor). The glacially elegant Grace Kelly and the elfin Audrey Hepburn set different canons of beauty. In 1957 Brigitte Bardot appeared in *And God Created Woman*, encouraging a wave of provocatively dressed, pouting lookalikes.

'Smart' was the watchword and it was vital that the correct accessories were chosen to accompany each ensemble. Fashion magazines usually recommended that shoes, bags, hats and gloves

164. In the late 1940s, Paris milliner Claude Saint-Cyr created this wide-brimmed, low-angled, triangular hat (popularly known as a coolie) and decorated it with an enormous bow. Long hat pins and elastic hat stays helped anchor such large hats to the head.

165. The milliner Simone Mirman was French-born but made her home in London, providing royalty and high society with inventive, often amusing hats. 'Horizon' (Spring, 1952) had a diminutive crown resembling a skullcap and an enormous transparent brim.

should match. Belts were popular, to emphasize trim waistlines; they ranged from deep elasticated 'waspie' belts with interlocking clasps to kid leather sashes. Since fashionable women were rarely seen without gloves and hats, milliners flourished. The most inventive issued seasonal ranges which encompassed impressively large cartwheel or flying saucer hats as well as minuscule cocktail concoctions. In France it was chic to patronize Paulette, Claude Saint-Cyr and Svend. In London, Aage Thaarup, Simone Mirman and Otto Lucas made names for themselves and Ladies Day at the Ascot races perpetuated the tradition of the eye-catching Ascot hat. In America, the milliner Lilly Daché continued to produce her custom-designed model hats. Italian craftsmen made superlative leather goods, including shoes. The ever ingenious and experimental Salvatore Ferragamo is credited with introducing the reinforcing steel bar that gave rise to stiletto heels. In France, Louis Jourdan and Roger Vivier produced de luxe shoes. Lobbs of London had a reputation for the world's best handmade men's shoes and Rayne sold quality, ready-to-wear women's shoes in up-to-the-minute designs. Each centre of fashion had its satellite of accessory makers and purveyors of trimmings and haberdashery who supplied designers and manufacturers. In the mid-1950s, highly mannered styles for mature customers still held sway. But a shift was on its way. The power of youth would shortly bring about significant and irreversible changes in both fashion design and fashion retailing.

164
165

# Chapter 6:  1957–1967
## Affluence and the Teenage Challenge

By 1957 Europe had emerged from the shortages and deprivations of the immediate postwar years. On both sides of the Atlantic, statistics recorded a growing teenage market with a large disposable income – a development that was to have a dramatic impact on fashion manufacturing and marketing. This growing prosperity led to the emergence of the 1960s throwaway, consumer society. Short-lived fads became the norm, clothes were disposed of long before they were worn out and a youthful image was suddenly desirable. Bringing the US closer to Europe, transatlantic non-stop flights gave birth to the 'jet set' and prompted the rapid dissemination of fashion trends.

By the mid-1960s the international fashionable pace was being set not by Paris couturiers but by a talented group of designers in London. The most significant aspect of this change was that fashion's cutting edge began to focus on the average young man and woman in the street rather than on a select, wealthy few. The threat to the pre-eminence of Paris was averted only by the rapid growth of prêt-à-porter and by futuristic innovations by Pierre Cardin, André Courrèges and Emanuel Ungaro, and mould-breaking designs by Yves Saint Laurent.

The garment that symbolizes the 1960s is the thigh-high mini skirt, which would remain current, along with little-girl looks, geometric haircuts and skinny rib sweaters, until stylistic changes took place around 1967. But the mini did not in fact start to take hold until 1965, and from 1957 to the early 1960s mainstream fashion was still dominated by the elegant attire and conventional looks of mature men and women. During this period, though a grass roots challenge was already being mounted across the Channel, Paris remained at the hub of fashion, and established Paris houses such as Nina Ricci, Grès and Patou continued to provide affluent clients with superbly made clothes which maintained the high standards and dignity of the *grands couturiers* and avoided any revolutionary stylistic gestures. Gradually, however, the business of haute couture went into decline as the cost of labour-intensive

166. An elegantly poised mannequin with a modified version of the popular beehive hairstyle wears a straight line evening gown and cape by Nina Ricci (1960). Illustrating the perennial versatility of pleats, the dress was set effectively against a cape with pure, undecorated planes. Long, ladylike, white kid gloves remained an essential for gala events and plain, pointed shoes completed the refined look.

166
167

167. Two short evening dresses for Spring/Summer 1959 from Patou, flanking a dapper single-breasted suit. 'Crazy Horse' (left) was an understated design eminently suitable for cocktail parties, while the inflated 'Ballon d'Essai' (right) was more appropriate for late evening appearances. Throughout the 1950s designers experimented with similarly extreme puff-ball shapes. This image shows fashion photography gradually becoming less static as mannequins are encouraged to act informally and simulate movement.

168. *Opposite*: After his famous Trapeze collection for Christian Dior, Yves Saint Laurent created variations on the successful wedge silhouette such as this bouffant evening dress 'Barbaresque' for Autumn/Winter, 1958–59. It demonstrates how Saint Laurent added youthful appeal to the Dior tradition of gracious style.

custom design escalated and its coterie of wealthy clients shrank. In order to survive, the haute couture houses started to expand both their ready-to-wear operations and the major profitmaking options of perfume and makeup.

Christian Dior had been credited with securing the future of Paris fashion with his 1947 collection and, to mark ten momentous years at the top, he was featured on the cover of *Time* magazine in March 1957. Just over seven months later he died suddenly at the age of fifty-two, leaving a legacy of the world's most prestigious fashion house, with a vast export business and an annual turnover of five million pounds. Dior's assistant, the twenty-one-year-old Yves Saint Laurent, was appointed artistic director and for nearly three years steered the house towards more youthful styles. His talent had been apparent in Dior's final collections, especially in the Spindle Line (1957) which featured narrow, unwaisted garments. Other designers, notably Balenciaga, had been working along the same lines, perfecting the lean, waistless sheath dress which eventually penetrated down to the mass market and was nicknamed 'the sack' by disapproving journalists, who were also unimpressed by crude, home-made versions taken from paper patterns.

169. The sudden death of Christian Dior in 1957 precipitated Saint Laurent's first solo collection for the house (January 1958), featuring the Trapeze look. It was a triumph. Saint Laurent was hailed as the saviour of Paris couture (Dior accounted for almost half of French fashion exports at this time). Sketched by Yves Saint Laurent, this simple, flared coat dress in grey wool bouclé was the most photographed design in the show. It was easy to wear yet smart and captured the headlines because it was young and innocent looking.

Saint Laurent's first solo collection for the House of Dior was the 'Trapeze', featuring an undecorated, wedge-shaped silhouette. The following year he experimented with puffball shapes, prompting accusations of fancy dress and lamentations about the loss of Dior's guiding hand. His final collection for Dior, in 1960, was the equally controversial Left Bank 'Beat' collection in which he reinterpreted the clothes of Bikers and Beats in glove leather, crocodile skins, mink and expensive wools for an haute-couture market. Dior's clientele was not yet ready for such a radical approach. When Saint Laurent was drafted into the army the same year, he was replaced at Dior by Marc Bohan.

In 1961, with business partner Pierre Bergé, Saint Laurent founded his own house, showing his first independent collection in 1962. Throughout the 1960s, though he avoided the singularly modern route taken by Courrèges and Ungaro, his designs were always diverse and stimulating. He brought a number of classics from work wear and special-occasion wear into his repertoire, where they became YSL standards. Between 1962 and 1968 he revived the pea jacket, the trenchcoat, the Little Lord Fauntleroy knickerbocker suit and the safari suit. Most famously, in 1966, he borrowed from men's formal evening wear to create his *le smoking*, variations of which continued to appear from time to time in his subsequent collections. In 1965 paintings by Mondrian inspired heavy silk shifts which are now among the icons of the 1960s. The Mondrian dresses were immediately translated into cheap copies in man-made fabrics, as were Saint Laurent's bold Op Art dresses of 1966–67. By launching his first Rive Gauche prêt-à-porter boutique in 1966, the designer acknowledged the economic necessity of making less expensive clothes which would attract a wider clientele.

Like Saint Laurent, Hubert de Givenchy was at his best designing for elegant young women and by the late 1950s was firmly established in the upper ranks of Paris couture. A fervent admirer and eventual friend of Balenciaga, he suffered one of his gravest disappointments when he failed to be appointed Balenciaga's assistant in 1945. Before establishing his own house in 1952, he worked for Fath, Piguet, Lelong and Schiaparelli. Firmly rooted in the de luxe tradition, Givenchy studiously avoided populist gestures and perfected a classic, refined style. Film star Audrey Hepburn was captivated by his work and after meeting him in 1953 became his most loyal client. His sleek, meticulously constructed designs suited her slender gamine looks and she wore his clothes both on and off the screen. He designed for sixteen of

169

170

171
205

172

173

Tricot

Crocodile
with
mink
1960

Trench Coat
Black
c 20'
1962

170, 171, 172. Sketches of three key 1960s works by Yves Saint Laurent. The crocodile leather jacket trimmed with mink (*above left*) was part of his last Dior show (July 1960) – the audacious Beat collection. Far too daring for Dior's cautious customers, it received a cool reception. For his own couture house in 1962 Saint Laurent revived the functional trenchcoat (*above right*) but gave it new proportions and made it in radical black ciré. Offering women a revolutionary alternative to the grand evening gown, in 1966 he invaded male territory and cut a feminine version of the tuxedo complete with trousers (*right*) – his famous *le smoking*. Throughout his career he created variations on this chic formula.

173. For Autumn/Winter 1965, Yves Saint Laurent treated slender tubular shifts like canvases or flags to pay homage to abstract paintings by the Dutch De Stijl artist Piet Mondrian. This bold 'window pane' dress in heavy silk crepe is composed of meticulously pieced bands in black, separating brilliantly coloured and white panels. The 'Mondrian' concept was immediately appropriated by manufacturers who made cheap copies for the mass market.

174

174. Audrey Hepburn, posing with her co-star George Peppard, in one of her famous black dresses by Hubert de Givenchy in *Breakfast at Tiffany's* (1961). Givenchy, Edith Head and Pauline Trigère made the costumes for the film. Hepburn was the perfect vehicle for Givenchy's understated designs. Here, her natural elegance was compounded by the high chignon hairstyle, sleek black gloves and extra-long cigarette holder.

her film appearances between 1953 and 1979 – most famously for her role as Holly Golightly in *Breakfast at Tiffany's* (1961).

Balenciaga continued to make ultra-refined clothes and, for showstopping evening wear, he experimented with exaggerated geometric shapes executed in the stiff silk, gazar. His studio nurtured both Courrèges and Ungaro, who were destined to revitalize 1960s French couture. Courrèges joined Balenciaga in 1950 and spent a decade in the master's atelier before starting his own label in 1961. It took him three years to break away from Balenciaga's stylistic hold but in Autumn 1964 he astounded the fashion world with a resolutely modern collection shown in a tiny, all-white showroom to the insistent beat of drums. The show received wide press coverage and Courrèges' minimalist approach earned him the sobriquet 'the Le Corbusier of fashion' in *Women's Wear Daily*.

Courrèges chose as his mannequins young, athletic women who suited his clean-cut designs. Central to his output were short, flared shift dresses and skirts worn with cropped jackets. He created numerous variations on the triangular shift shape, introducing curved inlays or breaking stark lines with pocket flaps and welts. Of the many trouser suits making an appearance on the Paris runways at this time, those by Courrèges were the most avant-garde. Depending on precision cutting and construction, they had cigarette-slim trousers which were slit over the insteps and reached almost to floor level – the effect was to make the leg look very long. Seductive hipsters were teamed with svelte tunics or double-breasted jackets and were available in wool for daywear and in sequinned or embroidered silk for evening.

Courrèges' designs looked best on women who adopted the total look. They were demanding to wear, and the right attitude was as essential as the right accessories. Shoes had to be flat: he introduced white boots with impractical sliced-off toes and bar shoes (mary janes). His white eclipse glasses with slits for the eyes were rarely seen off the catwalk but his neat white gloves, popularly known as 'shorties', were accepted into a wider market. Courrèges' palette was strict. Inspired by sports wear, as well as by astronauts' survival suits and spacecraft, he had a passion for white and silver. For him, white signified youth and optimism – he liked the fact that it had to be kept scrupulously clean. Sugar almond pastels and a few strong colours, especially flame orange, were also typically used. For all seasons he preferred plain fabrics, sometimes relieved by stripes, checks and piping, and for summer he used daisy-strewn fabrics embroidered to order in Switzerland.

Hugely popular with women in the forefront of fashion who could afford couture, Courrèges had an impressive list of clients who included Princess Lee Radziwill (Jacqueline Kennedy's sister) and the French pop singer Françoise Hardy. His designs were so successful that they were widely plagiarized, often in crude copies, machine-made in cheap, foam-backed fabrics. This practice disheartened the designer who felt that top-quality fabrics and fine craftsmanship were crucial to his concept; it was one of the reasons for his withdrawal from the market in 1965. He closed, with a full order book, for almost two years, selling only to his private clientele. By the time he reopened, in 1967, he was out of sympathy with fashion's transition to softer, flowing lines.

Emanuel Ungaro also played an important role in the rejuvenation of Paris fashion. He left Balenciaga to join Courrèges in 1964 and when this partnership failed he began to design indepen-

175

176

dently, showing his first collection in 1965. Like Courrèges, Ungaro sculpted hard-edge clothes in heavy worsted fabrics, often using Nattier, an Italian manufacturer, who wove deep, smooth-faced textiles including triple gaberdines that retained the angular shapes of mid-1960s fashions so perfectly that the clothes almost stood up by themselves. Both Ungaro and Courrèges remained true to the discipline learned at Balenciaga and produced techni-cally brilliant work. Their designs at this period are similar, particularly those for precision-made mini dresses with simple, collarless necklines, yoked bodices, half belts and chunky, self-coloured buttons, but Ungaro differed from Courrèges in his use of organic pattern and loud colour combinations. He collaborated

with the textile designer Sonia Knapp, who provided a succession of powerful prints which almost overwhelmed the line of the clothes.

Pierre Cardin, hailed as the bright young star of Paris couture, established his own company in 1950 and by 1957 had consolidated his position with collections of strong, uncluttered designs. Trained as a tailor, he remained true to the principle that an ensemble should never be overloaded with ideas. His signature features included asymmetrical necklines, scalloped and rolled edges and enormous, face-framing collars, all of which were revamped to suit the mood of each season. He also investigated spherical shapes: in 1958 he made a balloon coat dress whose shape was achieved by the use of a drawstring threaded through the hem, and in 1960 he created tight sheath dresses with puffball panniers which sat over the hips. In the same year he showed undecorated, trapezium-shaped coats topped by towering sugarloaf hats which extended the line almost eighteen inches above the head. By licensing a ready-to-wear line in 1959, Cardin flouted the laws of the Chambre Syndicale de la Couture and for a time was denied membership of this elite group, though his originality won him the first *Sunday Times* Fashion Award in 1963. In 1964 Cardin's experiments with ultramodern designs placed him firmly in fashion's futuristic movement, together with Courrèges and Ungaro.

He brought the diminutive, doll-like Hiroko (Matsumoto) from Tokyo to Paris to act as his muse and to model his most outlandish designs. Links with Pop and Op Art were established in a series of shifts patterned with geometric inlays in a combination of black and vibrant colours. Cardin further emphasized the geometric look by perching rectangular pillboxes on neatly coiffured heads.

179

The space race pervaded 1960s culture, and fashion was not immune. Cardin was fascinated by interplanetary exploration and the first space walk by astronaut Major Ed White prompted his 1965 Cosmos collection. This practical, unisex range consisted of a tunic or pinafore over a body-fitting ribbed sweater, and tights or trousers. Headgear of peaked caps and felt domes completed the cosmonaut look. It was a functional design which united fashion

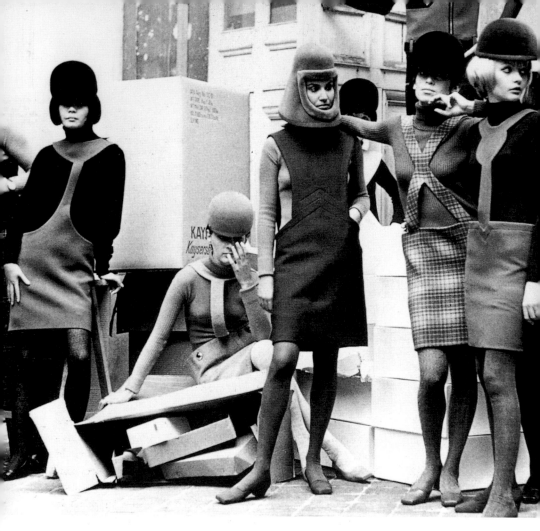

with comfort and mobility, and versions were available for the entire family. However, despite the fact that copies of the mini-pinafores reached a mass audience, the look as a whole proved too advanced for widespread consumption. Cardin was one of the first designers to avoid the exposure of flesh-pink legs under the short skirts of the 1960s by offering heavy-denier coloured tights (often made to his own designs) for cold weather wear and dense white or patterned tights for summer. He also introduced daring thigh-length boots and frequently streamlined the body in black sweater, tights and close-fitting hat to act as a foil to the main outfit.

Whereas the work of Cardin, Courrèges and Ungaro is part of the tailoring tradition, Paco Rabanne's designs developed from the costume jeweler's craft. Rabanne created entire garments by

180. Paco Rabanne's unusual dressmaking technique avoided the convention of cutting fabric and assembling clothes by sewing. He is shown here in 1966, adjusting the shoulder of one of his plastic disc and split metal ring dresses with a pair of pliers.

179. Cardin's influential pinafore dresses of 1966 in heavy worsted were worn over skinny polo-neck sweaters. Domed peach-bloom felt helmets and square-toed, low-heeled shoes completed the futuristic look. On the left, top mannequin Hiroko (Cardin's muse), with her hair in a chin-length, blunt-edged bob, wore a pinafore with a curved T-shaped bib.

linking together small plastic and metal components. Sparkling paillettes and metal discs were joined by split metal rings for evening wear, while day dresses were composed of leather segments secured at the corners with brass rivets. The shaping in these garments was rudimentary – Rabanne used cutters and pliers in their construction – and comfort was a minor consideration. To give the appearance of nudity, the clothes were worn over flesh-coloured bodystockings. Rabanne's designs achieved cult status in the later 1960s when they were modelled by Peggy Moffitt and Donyale Luna.

Throughout the late 1950s and early 1960s, Italian couturiers maintained their international standing with sophisticated collections – womenswear was characterized by powerful shapes in bright 'Mediterranean' colours. In Rome, Roberto Capucci continued to fill his notebooks with sculptural images which resulted in strong, dramatic garments – a talent he refined for the next thirty years. The 1958–59 season was dominated by a boxy silhouette; fascinated by its possibilities, Capucci repeated the geometric theme even in hats and oversize buttons. Amused by the squared-off look, which also inspired Carosa (Princess Giovanna Caracciolo) and Alberto Fabiani, journalists tagged it the box or 'paper bag' line. London-based textile producer and converter Zika Ascher provided Italian couturiers with neon-coloured mohairs and sumptuous chenilles which were ideal for their 1950s and 1960s tailoring experiments.

At the beginning of the 1950s, after working in the Paris trade, Alberto Fabiani took over his family's long-established dressmaking concern in Rome. Fabiani's output, until the house closed in the 1970s, was acknowledged to be classic but unconventional and was praised for its inventive cut. After his marriage, he spent the

180

181

181. Roberto Capucci's fascination with the possibilities of geometry led him to explore the potential of the 'paper bag' or box line which resulted in square-cut garments. In 1958 he used a mohair (by Ascher) to soften the edges of this rectangular coat, and echoed the theme in a squared-off half-cape, enormous square buttons, and a cube-shaped hat with tailored bow.

early 1960s in Paris with his wife and fellow designer Simonetta (Visconti). Designs by Simonetta always made strong statements and had to be worn with great aplomb. She used sumptuous and eye-catching fabrics to create unusual evening gowns incorporating bubble and cocoon shapes. For town wear she devised chic tailored suits and coats – each design had a distinctive feature, such as an extra-large collar or fly-away back panel which made it stand out in the crowd.

Emilio Pucci, whose vibrantly coloured, swirling, printed silks gained new validity in the psychedelic 1960s, also opened a Paris outlet. Pucci's comfortable, light leisure wear was popular with Americans, including the film stars Marilyn Monroe, Elizabeth Taylor and Lauren Bacall, who relished its chic appeal and instantly recognizable designer signature. Pucci blouses, scarves and body-skimming little dresses were constants to which the designer returned with new ideas each season. In 1960 he launched 'capsulas' – skintight, stretch nylon and silk one-piece bodysuits (precursors of the Lycra leotards and exercise garments

of the 1980s). Pucci's pliant, printed silk-jersey fabric perfectly suited the long, flowing capes and harem styles of his late 1960s collections.

Italy's major triumph from the mid-1950s to the early 1960s was menswear – Italian tailoring was the ultimate in cutting-edge style. Naples and Milan were centres for male fashion, but Rome became the most important style centre, partly because of its prestigious tailoring school, the Accademia dei Sartori, and because top tailoring firms such as Brioni, Domenico Caraceni, Duetti and Tornato were based there. It was also the location for 'hip' movies like *La Dolce Vita* (1960), which brought Italian modernity – including 'sharp' suits, the Vespa motor scooter and coffee bar culture – to international audiences. The fashionable Italian suit of the period was typically made of smooth-faced worsted and consisted of a short jacket with sloping shoulders and narrow,

182. Emilio Pucci's first designs were for ski clothes and the aerodynamics of sports wear often informed his subsequent collections. In many ways, his sleek 1960 long–sleeved bodysuit was ahead of its time, offering maximum mobility as well as the pretty appeal of a Pucci print and matching bootees and cap.

183. Winklepicker shoes were fashionable during the 1950s and lasted until the early 1960s. They were sometimes a feature of 'Mod' dress.

straight-cut trousers without pleats and usually without turn-ups. It was worn with a pristine shirt, narrow tie and either 'winklepicker' shoes or loafers. In the US and the rest of Europe, the neat, clean-cut Italian look was widespread among men in the vanguard of fashion. The chief purveyor of the look in Britain was the London entrepreneur John Stephen, who stocked his first menswear boutiques with highly desirable, youthful clothes in the Italian idiom.

Stephen's clothes were especially popular with a group of young men and women, who surfaced in London around 1958 and called themselves Modernists because of their love of modern jazz. Avid in their appreciation of continental culture, especially French films, they were obsessive about clothes and fastidious in their taste for ultra-neat tailoring and immaculate grooming. By 1960, the group was no longer metropolitan-exclusive and the name had been abbreviated to 'Mod'. The most fashionable and high-profile Mods were known as 'faces' and supported Mod pop groups such as The Who.

Men's growing preoccupation with their appearance showed itself in booming sales in both menswear and male toiletries. Tailoring trade fairs continued to be lively, well-attended events. In 1964 the British tailoring chain Hepworths acknowledged the 'importance of Male Fashion in contemporary life' by sponsoring a new course in men's fashion design at the Royal College of Art. The following year Carnaby Street retailers made a witty attack on Establishment styles by forming a group called 'the ban the bowler brigade' which exemplified the tension between the exponents of cheap, 'switched-on' ready-to-wear and the tradition of exclusive bespoke tailoring. The sartorial battle between Carnaby Street (mecca of the Mod generation) and Savile Row (bastion of male sobriety) was typified by a 1966 television programme *A Tale of Two Streets*, which saw the two streets as epitomizing an international phenomenon – the dual state of men's fashions.

America was alert to European developments (including the Carnaby Street phenomenon) and from 1956 the big question was:

Will the Ivy League look be ousted by the Continental look? In fact, both survived; the Ivy League style was updated and the Italian suit adapted to accommodate the often taller, more athletic American physique. American dress throughout the early 1960s tended to be conservative and Brooks Brothers suits were still the safest option during working hours. Leisure wear, on the other hand, verged on the garish. Loose sports shirts in vividly coloured prints remained popular and the American love of plaids showed itself in mid-decade in an upsurge of sports jackets, slacks, bermuda shorts and sports wear (especially for golf) in dazzling checks. As the decade progressed, the 'peacock revolution' gradually took hold and Americans began to feel free to experiment with jackets with shaped waistlines and wider lapels, flowery shirts with white, blunt-ended collars, and tighter, lower-waisted trousers.

During this period, two designers – Pierre Cardin and Hardy Amies – exerted an immense influence on international menswear. In 1959 Amies designed a prototype menswear collection for Hepworths, marking the beginning of a long association (over twenty years) with this national chain. The use of his name gave the suits what Amies described as a 'semi-couture status' and with

184. The Mod pop music group 'The Small Faces' (so called because, as well as being Mods, or 'faces', all of its member were short) started in 1965 and had numerous hit records in the years 1966–67. They epitomized the clean-cut look cultivated by Mods. Fans admired not only their music but also their sartorial innovations. Lead singer and guitarist Steve Marriott (far right) was the group's mainstay. He is shown here wearing narrow, boldly checked trousers with a polo-neck sweater and button-down jacket. The group's fringed haircuts were slightly backcombed on top.

it enormous customer appeal. Overseas interest resulted in a contract to design for the American corporation Genesco, which had stores in New York, menswear factories and a chain of menswear shops. He provided unostentatious clothes which combined traditional tailoring with new-wave touches and which appealed to the somewhat less adventurous young man. Pierre Cardin, on the other hand, was the champion of nonconformists. He introduced his menswear collections in 1959 and frequently modelled his own designs. Interviewed by *Jardin des modes* in 1959, he proposed a new dandyism which rejected the rigidity of establishment dressing in favour of comfort combined with elegance. His collarless, round-necked jacket was a major contribution to the liberation of menswear, though it would never become a universal fashion. Cardin's influence spread rapidly (aided by licensing contracts). After a trip to India he introduced Nehru suits, and these were adopted by the salesmen in his Paris boutique, Adam. Soon style-setters were photographed about town in jackets based on the original long-line, single-breasted Indian garment with stand-up collar.

185

Although Cardin's Cosmos styles for men were, like the women's styles, too avant-garde for mass consumption, some features from these mid-1960s collections did enter the mainstream, including sleeveless, side-zipped jerkins, turtle-necked sweaters (replacing shirts and ties) and chunky, square-toed boots. Commenting on Cardin's futuristic 'day after tomorrow' designs, the *Tailor and Cutter* also noted in March 1967 that fellow progressive designers such as Tom Gilbey and Ruben Torres united modernity and functionalism with good workmanship and fine materials. When Cardin designed the costumes (made in London) for the character John Steed, played by Patrick Macnee, in the British television series *The Avengers*, British city suits and country clothes were given a French chic. Such was their success that a group of UK manufacturers made a retail collection based on the originals.

In keeping with the new menswear trends, the Mersey pop group The Beatles abandoned the leather jackets and T-shirts of their Hamburg period in favour of the smart look. In 1962 (the year they released their top-selling album *Love Me Do*) the band adopted Mod suits in the Cardin idiom, consisting of round-necked, short boxy jackets and tapered trousers without turn-ups, worn with crisp cotton shirts with Edwardian-style collars. Their tailor was Dougie Millings, who also made stagewear for forty other British hit parade groups. The Mersey look had a profound influence on young men's appearance, from neat, fringed haircuts to cuban-heeled chelsea boots.

186

185. Pierre Cardin envisaged modern suits for men stripped of fossilized features such as lapels and turn-ups – details that men had come to accept as sacrosanct. In the late 1950s and early 1960s he designed innovatory single-breasted jackets with high, round, collarless necks worn with slim trousers.

186. The cultural impact of The Beatles was huge and their early look (as well as their later Hippie personae) influenced many thousands of young people. For their performance at the London Palladium in October 1963 they wore dapper suits with tapered trousers and collarless jackets over shirts with high, Mod-style collars. Here they are shown backstage inspecting an insignia beetle perched on Ringo Starr's nose. All aspects of their appearance, from glossy basin haircuts to cuban-heeled boots, were much copied. To satisfy their vast following of teenage girls, a range of clothes was produced (including stockings), emblazoned with portraits of the Fab Four.

By the early 1960s a new generation of British fashion design-ers had emerged who were to challenge the dominance of Parisian haute couture. Mainly educated in the fashion and textile depart-ments of the state's art schools and encouraged by enthusiastic teachers, these newcomers were refreshingly unorthodox. Mary Quant led the way. In 1955, in partnership with her husband, Alexander Plunket Greene, and business manager Archie McNair, she opened her first shop, Bazaar, in Chelsea's King's Road. Determined to sell clothes which pleased young shoppers, but in despair at the matronliness of available stock (elaborate, tightly waisted, calf-length clothes which were complicated by an array of ladylike gloves, hats and costume jewelry), Quant started to make up her own designs. Her clothes were instantly successful, putting enormous pressure on her to increase production. Her designs for 1956–57 featured unfussy garments based on simple, slightly flared shift shapes and tubular lines. She pitched waists at a low level; used horizontal bands and triangular insets of pleats at the hemline to permit movement; kept accessories to the minimum; and, most significantly, shortened skirts.

Quant's autobiography, *Quant by Quant* (1966), captures the hard work, excitement and intense pleasure of her early 1960s successes. She took elements from mundane British classics and subjected them to dramatic reinterpretations. The conventional grey flannel suit became a short, sleeveless shift over knicker-bockers edged with piecrust frills. Pinstriped wools customarily reserved for the city gent were transformed into saucy pina-fores with braces. Her collections, which eventually embraced

187, 188. Mary Quant's 'Ginger Group' clothes were hugely successful and signalled the fact that their wearers were in fashion's vanguard. A football kit inspired the bold, striped bonded wool jersey mini-dress of 1967 (*left*). Quant designed the complete look, launching in August 1967 her footwear collection 'Quant Afoot' (*right*). The neat ankle boots of clear PVC were made with linings of bright cotton jersey which absorbed perspiration and provided colour.

accessories and underwear to provide the total look, were in the forefront of fashion and in 1962 she secured a lucrative contract with the giant US chainstore J. C. Penney. In 1963 she went into mass production with the Ginger Group range. Quant took ideas from unusual sources and reworked them into a series of fast-moving looks. She enjoyed materials that were new to fashion, making brightly coloured macs in PVC, and mini-skirted gymslips which promoted the man-made fibre Tricel. She even explored the potential of Crimplene, and the humble knitting pattern was given a boost when she created a series of mini-dresses for Courtelle's new 4-ply yarn. Quant made fun, easy-to-wear, classless clothes, rejecting all that was starchy, hidebound and unnecessarily formal

– characteristics she associated with the staid British establishment. The names she gave to some of her garments reveal her lighthearted, unstuffy attitude: 'The Bank of England' (a chalk stripe tunic), 'Booby Traps' (a bra) and 'Quant Afoot' (a collection of boots).

188

On 15 April 1966 *Time* magazine splashed 'London, the Swinging City' on its cover and, accurate or not, the description stuck. The article revealed an enthusiasm for London's youth-orientated attractions. In the mid-1960s British teenagers had money to spend on entertainment (chiefly pop music), clothes and cosmetics. In London, the place for the young to meet, hang out and exchange their weekly wages for reasonably priced ready-to-

189, 190. On Saturdays Carnaby Street (described as the teenager's play street) was crowded with young people parading in their latest clothes, searching the boutiques and examining each other for new ideas. To keep ahead, it was essential to buy a new outfit weekly. Lord John (*left*), opened by brothers Warren and David Gold, sold trendy menswear 'not exactly built to last a lifetime' but colourful, and cut to enhance lean, youthful figures. By the mid-1960s, Carnaby Street rivalled Buckingham Palace as a tourist attraction. Girlswear boutiques (small, intimate and with exciting stock) had joined menswear outlets, offering low-priced clothes for 'switched-on girls'. Lady Jane (*right*), owned by Harry Fox, sold quick-changing styles – from diminutive mini-skirts to trousers suits – to young women avid for novelty.

wear clothing was Carnaby Street in Soho. The already mentioned John Stephen was a major force in the establishment of this street as the main rendezvous for international youth. Before forming his own business in 1957, Stephen worked briefly at Vince, a menswear shop off Carnaby Street which sold unusually flamboyant clothing and sophisticated leisure wear to a predominantly gay and artistic clientele.

An astute businessman, Stephen recognized the fact that traditional tailors and multiple stores were not catering for teenagers. Specifically for this market he introduced adventurous, body-conscious, boldly coloured clothing made from tactile fabrics such as velvet, suede, leather, satin, corduroy and mohair. The popularity of Stephen's clothes was such that by the early 1960s he owned one third of Carnaby Street's premises. A menswear outlet, Lord John, was paired with a womenswear boutique, Lady Jane, which opened in 1966 with a live window display consisting of two young women dressing and undressing in the shop's stock.

Boutiques for both sexes proliferated in the 1960s and satisfied the appetite for the latest fads with a rapid turnover of merchandise. Often owned and run by young people who were in tune with their target audience, they sold short runs of up-to-the-minute clothes and employed relaxed assistants who welcomed browsers without exerting sales pressure. Decorated in vivid, fairground colours, these shops attracted customers through enticing window displays, gimmicky interiors and non-stop pop music.

189
190

Relatively inexpensive clothes with the right look filled rails in small boutiques such as Jeff Banks's Clobber and Lee Bender's Bus Stop. The place to be, however, was Barbara Hulanicki's crowded and noisy boutique, Biba. The Biba shop was set up in 191 1964, on the strength of a successful mail-order business established by Hulanicki a year earlier. Biba's retro Art Nouveau interiors, communal changing rooms, bentwood coat stands (replacing conventional dress rails) and charged atmosphere are legendary. In harmony with the moment, Biba clothes and makeup in sludgy colours were snapped up as soon as stocks arrived and were instant and profitable hits. More expensive ready-to-wear labels included Jean Muir, John Bates (famous for the actor Diana Rigg's costumes in season four of the 1960s television series *The Avengers*) and Foale & Tuffin, who had introduced their label in 1961 and in 1965 opened a boutique off Carnaby Street. New fashion magazines, particularly *Petticoat* (subtitled 'The New Young 192

191. Barbara Hulanicki opened the first Biba shop in Kensington's Abingdon Road in 1964. With navy-blue walls and black lampshades, and with the stock arranged on bentwood coat stands, it established the Biba formula of moody informality. Biba clothes worn by Cathy McGowan on TV's *Ready Steady Go* attracted thousands to the shop, including celebrity customers such as Sonny and Cher, Julie Christie and Cilla Black.

Woman') and *Honey* (advertised as 'young, gay and get ahead'), fed youthful readers a diet of the latest fashions. The *Sunday Times* launched its first colour supplement in 1962 with a cover photo by David Bailey showing the model Jean Shrimpton in a Mary Quant grey flannel shift.

Echoing developments in London, a group of young Paris *créateurs de mode* also opened successful boutiques, offering lively designs which bridged the gap between haute-couture products and department-store clothing. Known as the yé-yé designers (after the Beatles refrain), they married French chic to youthful styling. In the early 1960s Emanuelle Khanh attracted a cult following for pale crepe dresses and suits whose pure lines were relieved by her signature droopy collars and scoop necklines. Jacqueline and Elie Jacobson led the way with their boutique, Dorothée Bis, which stocked the work of new designers; in 1965

192. Cover of teenager magazine *Petticoat*, 27 April 1968. The baby-doll look of the period was captured in the childlike pose, with feet turned in. The mannequin wore a white jacket and skirt made from a McCall's 'groovipattern' with bright red bar shoes from Gamba and matching heavy denier tights and beret by Mary Quant.

193. Betsey Johnson's see-through plastic mini slip dress, 1965. Like many of Johnson's 'wacky' clothes, this design was intended to amuse or shock, and to have a limited existence. It came with a set of brightly coloured stick-on shapes which the owner could position wherever she felt they were needed.

Jacqueline created her own first clothing range, centring on mix-and-match separates and distinctive knitted garments.

America's baby boomers were coming to adulthood and their desire for outrageous 'look at me' fashions was also met by boutiques, which sprang up in all the big cities. New York boasted the most up-to-the-minute shops: Paraphernalia, opened by fashion businessman Paul Young in 1965, set the pace. Betsey Johnson (New York's answer to Mary Quant) joined Paraphernalia in 1965. Johnson's career had started at *Mademoiselle*, a magazine which, like *Seventeen* in the UK, was aimed at girls in their teens. At Paraphernalia she enhanced the shop's lively reputation with low-cost fun clothes – those with built-in obsolescence, such as bonded fibre dresses which, when watered, sprouted real seedlings, were christened 'throwaways'. Exhibitionist yearnings were satisfied with see-through plastic dresses, paper dresses, silvered biker outfits, and light-up disco clothes. The fragile, white-blonde 'Superstar' Edie Sedgwick, who was part of the Andy Warhol

193

194. Jacqueline Kennedy, acknowledging the crowd on a visit to London in 1962. Her claret-coloured wool tailored dress and jacket (with her favourite minimalist lines) was by Oleg Cassini and consisted of a gently flared dress and neat jacket with collarless neck, three-quarter-length sleeves and single button fastening. Spotless white gloves completed the outfit.

group known as the Factory, became Johnson's house model for the designer's most outrageous creations.

Compared with Europe, and in particular with London, adventurous spirits willing to wear outlandish fashions were relatively rare in the US, where conservative, functional clothes had always had the widest appeal. This is not to say that the US was immune to international trends. Some up-to-the-minute Americans had been prepared to risk the no-waist chemise imported from the Paris salons in 1957, and America's top designers had interpreted the line in an elegant manner well-suited to tall, extra-slender American figures. Even Marilyn Monroe had eased her curves into a sack dress. A transitional empire-line phase was then completely ousted in the US by another French import – the trapeze, a line that was particularly favoured by Jacqueline Kennedy. Kennedy became America's First Lady in 1960 and immediately assumed a high-profile role as an international fashion leader. She was extraordinarily photogenic, with striking good looks and a refined stylishness. Responding to the special requirements of her position, she assembled an extensive and impressive wardrobe, the enormous cost of which was gleefully estimated by the world's press. For three years Kennedy topped America's best-dressed list, setting a trend for clothes with clean, uncluttered lines in plain, pure colours. When her predilection for Paris designers drew adverse publicity, she began to patronize home-grown talents. Oleg Cassini was appointed her personal designer and he skilfully translated her rigorous requirements into American-made garments with a French gloss. Kennedy was highly fashion literate and knew exactly what suited her for both leisure activities and formal First Lady occasions. The widespread publicity surrounding her every appearance gave the industry an enormous boost and sparked off numerous popular trends – among them sleeveless A-line dresses, pillbox hats and chunky sunglasses. The complete, streamlined 'Jackie Look' was much copied, from the dark bouffant hairstyle to the low-heeled court shoes. Jacqueline Kennedy's influence declined during her period of mourning after her husband's assassination, but had returned in force by the summer of 1964.

Affluent young American socialites emulated Kennedy's sophisticated simplicity, and in New York (still the heart of US fashion) a huge choice was available to them, from off-the-peg ranges in stores such as Saks Fifth Avenue, Bergdorf Goodman, Bonwit Teller and Henri Bendel, to custom-made models from Norman Norell, Oleg Cassini, Ben Zuckerman and Oscar de la Renta at Elizabeth Arden. This same clientele was also served by

194

the excellent Paris copies made by Chez Ninon (Jacqueline Kennedy was a customer) and Ohrbach. The importance of the fashion industry in the US was marked in 1962 by the founding of the Council of Fashion Designers of America – a body responsible for the promotion of American design.

American designers made a speciality of easy-to-wear, stylish dressing and in the 1960s the work of two designers of long experience came to the fore. Though their signatures were very different, Bonnie Cashin and Geoffrey Beene shared a common-sense, practical and innovative approach to design. Cashin was a costume designer for Twentieth Century-Fox in the 1940s and then designed for the sports wear firm Adler & Adler before setting up her own company in 1953. In the 1960s she continued to refine her designs for separates, usually in wool, cotton and leather, which were worn with comfortable woollen sweaters with distinctive necks or hoods. Many of her concepts were ahead of their time: her streamlined hooded dresses and capes in particular would not come into their own until the 1970s.

Geoffrey Beene, who had trained at the Chambre Syndicale, worked for various ready-to-wear manufacturers, including Teal Traina, before launching his own label in 1962. His guiding principle was to make clothes which allowed movement and freedom. Beene was a confirmed modernist and though his collections accommodated the latest trends, including high-waisted little-girl dresses and later the long, ribbon-trimmed ethnic look, he was happiest making lightweight, simple dresses in wool jersey with a minimum of seams and details. By the 1970s his costly ready-to-wear collection had been joined by less expensive lines, including the amusingly named Beene Bag.

In 1967 the journalist Marilyn Bender of the *New York Times* offered the following explanation for the American fashion cornucopia: 'American designers come in infinite varieties addressing themselves to different audiences.' Los Angeles-based James Galanos and Rudi Gernreich were singled out by Bender as significant inventors who represented two extremes of American 1960s style. After apprenticeships with Hattie Carnegie in New York, Jean Louis in Hollywood and Robert Piguet in Paris, Galanos launched Galanos Originals in Los Angeles in 1951. The elegance and sophistication of his work was reinforced by his choice of haughty-looking mannequins (his favourite was Pat Jones) who gave every appearance of being rich women. His precisely tailored day wear and spectacular evening gowns (minutely pleated chiffon was a speciality) won him wealthy customers – Mrs Charles

Revson (wife of the Revlon Chairman), Betsy Bloomingdale and Nancy Reagan, who wore a Galanos gown at the ball marking the inauguration of Ronald Reagan as Governor of California in 1967.

Austrian-born Rudi Gernreich operated in an entirely different sphere. After studying art and spending a decade as a modern dancer, he began by designing form-fitting jersey swimwear (without structured linings) and achieved international notoriety when he released the topless bathing suit in 1964 – modelled by his muse Peggy Moffitt. The mid-1960s vogue for nude-look underwear was advanced by Gernreich's flesh-coloured, insubstantial 'No-Bra' bra (for Exquisite Form) which came in a novel plastic wallet together with a card advertising its qualities. Gernreich enjoyed experimenting with plastics and synthetics, often combining brightly patterned jersey knits with transparent or coloured vinyl strips for decorative effect. He felt that fashion should be inexpensive and targeted a youthful and daring clientele wanting easy-to-wear clothes that made strong statements. His background as a dancer made him keenly aware of the advantages of a fit and healthy body and of the merits of garments with simple lines that allowed freedom of movement. In 1969 he withdrew briefly from fashion, returning in the 1970s as a strong contributor to the unisex trend: he produced long caftans, jumpsuits and bell-bottomed trousers that could be worn by either sex.

The triumph of informality made it no longer essential to wear a full set of coordinated accessories. The millinery trade suffered a dip in sales, though the tradition of special-occasion hats – for Ascot, Longchamps, royal garden parties and weddings – as well as short-lived fads for novelty hats such as fake fur 'baby' bonnets and PVC souwesters aided its survival. By 1964 uncomfortable pointed shoes with high heels were démodé and fashionable footwear was low-heeled and wide, with pronounced square toes. In Britain, Rayne made ultra-modern shoes with broad toes and bold buckles, in reflective patent leathers in many colours. It was considered trendy to wear specialist dance and theatrical shoes and boots by London's Anello & Davide. Roger Vivier and Charles Jourdan in France were responsible for inventive shoes in costly leathers and decorative materials. Courrèges established the vogue for flat white boots which were widely copied by mass manufacturers.

To be part of the 'in crowd', youth had to be on the move. A frenetic pace was encouraged by films such as *The Knack* and *Darling* (both released in 1965) as well as by live TV pop music programmes including *Ready Steady Go* and *Top of the Pops* in the UK and *Salut les copains* and *Discorama* in France. As the influence

197

195
196

195, 196. *Below*: One of the most inventive shoe designers of the 20th century, Roger Vivier collaborated with numerous Paris couturiers to create shoes for their collections. He was famous for fantasy evening shoes. *Top*: 1963 design in satin and tulle, with embroideries of mother-of-pearl spangles and 'comma' heel. *Bottom*: Green brocade shoe with slightly rounded toe and Regency heel, 1963–64.

197. *Right*: Peggy Moffitt, in thigh-high ciré boots and a menacingly tinted visor, modelling a simple one-piece bathing suit by Rudy Gernreich in 1965.

of Hollywood film stars waned, teenagers came to idolize pop musicians, sports personalities, disc jockeys, fashion photographers and models. Ideals of beauty were set by a group of young models who, in tandem with leading streetwise photographers such as David Bailey, Antony Armstrong-Jones (later the Earl of Snowdon) and Terence Donovan, introduced a new vigour into fashion photography. A glamorized version of their activities was

captured in Michelangelo Antonioni's film *Blow-Up* (1966), starring David Hemmings and featuring top mannequin Veruschka. The hero was based on David Bailey, whose photographs of Jean Shrimpton ('The Shrimp') appeared in most upmarket magazines. With enormous eyes, long, tousled hair, sensuous mouth and long legs, Shrimpton had a chameleon-like quality that rendered her the perfect vehicle for a wide range of 1960s styles. The ideal model for Mod fashions was Lesley Hornby ('Twiggy'), whose adolescent body, boyish side-parted hair and elfin aura found favour with teenage magazines of the period – she was named 'Face of the Year' in 1966. 'The Twig' was frequently teamed with 'The Tree' (Penelope Tree), one of the sixties' more unconventional-looking models, who further enlarged her already enormous eyes by adding painted-on eyelashes.

198

199

200. Vidal Sassoon revolutionized hairstyling for the young in the early 1960s with precisely cut bobs. One of his most popular innovations, in 1963, was the 'Nancy Kwan', a bob cut extremely short into the nape of the neck and angled to swing forward around the face at chin level. He is shown here in 1964, shaping Mary Quant's gleaming hair into his famous geometric 'Five-point Cut', devised the same year.

198. *Opposite, left*: The model Jean Shrimpton at the Melbourne Races in 1965, looking the height of elegance in a neatly tailored double-breasted suit and halo-like breton hat. The previous day she had been castigated for attending the races (on a promotion for Orlon) in a sleeveless white mini, barelegged, and without either hat or gloves.

199. *Opposite, right*: Twiggy, wearing an outfit from her own range of clothes, created with Pam Procter and Paul Babb for Leonard Bloomberg, and launched in 1967. Like this shirt dress with long, pointed collar, the collection (catsuits, jumpsuits, shorts, culottes and 'baby-doll' smocks) was overtly girlish, aimed at a teenage market.

Heavy black eye makeup was a prerequisite of 1960s fashion; to create contrast, lips and skin were kept pale. In 1966 Mary Quant introduced a palette of daring colours for both lipstick and eye shadow (made by Gala). She also produced false eyelashes in long strips which could be cut to custom-fit the eyes – these were promoted by witty advertisements (such as 'Bring Back the Lash') and by distinctive silver and black packaging bearing Quant's famous daisy logo. Hairstyles at the beginning of the period varied from formal, mature coiffures (including home perms), held rigidly in shape by sticky setting lotion and sprays, to youthful beehive, pony-tail and urchin styles. These were all rendered instantly démodé in 1963 when Vidal Sassoon produced his angled geometric bobs, first demonstrated on the model Nancy Kwan. Always ahead of her time, Mary Quant set the pace by having her own dark hair cut by Sassoon himself in an asymmetrical shape which often swung seductively over one eye. Those whose hair refused to conform to clean-cut geometry wore wigs (Sassoon's were the market leaders) styled in the latest bob. Men grew their hair long and experimented with moustaches, sideburns and beards.

200

With increased momentum, the textile industry continued to research and develop man-made fabrics, blends and special finishes. International competition was fierce as firms vied with each other in the production, branding and marketing of each new product. Scientists aimed to provide the entire family with easy-care, wash-and-wear fabrics which were durable, dirt- and crease-resistant and comfortable. It was estimated that every American male had at least one wash-and-wear suit.

For two or three years in the mid-sixties, manufacturers experimented with the fashion potential of bonded fibre (paper), a material which had transformed medical work wear, and paper dresses and panties became the ultimate symbols of disposability.

201. The craze for throwaway 'paper' clothing was short-lived, lasting only from about 1966 to 1968. In 1966, as a publicity stunt for the Scott Paper Company, a paper dress was offered for one dollar twenty-five cents. In less than six months half-a-million dresses were sold. Amusing though it was, manufacturers soon discovered that costs were not substantially less than conventional dress production. Here, against a torn paper backdrop, in an energetic pose, the mannequin wore a popular butcher's boy cap and a simple (paper did not respond to complex construction) striped paper T-shirt mini-dress.

In 1966, as an advertising gimmick to promote a new line of table napkins, Scott Paper Co. in the US offered readers a paper dress. 201 The firm was inundated with orders. At the height of the fashion, Mars Manufacturing Corporation (America's leading producer of paper dresses) used the 'new wonder fabric' Kaycel, which was both fire and water resistant, for clothes that bore the label 'Waste Basket Boutique'. In London, the enterprising firm Dispo sold psychedelically printed paper garments. Although marketed as 'throwaway', these could in fact withstand three washes and could be ironed.

So prolific were the manufacturers of man-made fabrics that handbooks were compiled as guides to the many hundreds of fibres, fabrics and their makers. Trade names tended to be short and catchy and included Ban-Lon, Dralon, Acrilan and Orlon. The polyester fabric Terylene played a key role in the men's ready-to-wear tailoring sector. Major producers of man-made yarns were Du Pont in the US and Courtaulds and ICI in the UK. Top designers, including Mary Quant, Pierre Cardin and Lanvin, were contracted to make special collections which would promote the latest synthetics and raise their status. But despite attempts to go upmarket, man-made fabrics remained the mainstay of cheap, mass-manufactured garments. Their most notable impact was on the development of underwear and sports clothes. The introduction of new elastics (especially Lycra in 1959) and light but strong fabrics with stretch-and-recovery qualities enabled the underwear industries to produce minimal, gentle-control garments. Suspender belts were made almost redundant when, for decorum's sake, tights replaced stockings under mini-skirts. Pantie-girdles in decorative stretch nets matched briefly cut bras, and underwired bra slips became popular. Stocking manufacturers experimented with fishnets, lace patterns and heavy deniers. Under ever-briefer skirts the young and 'with it' wore brightly coloured stockings and tights designed by Mary Quant and first issued in 1965.

The seeds of the next major stylistic shift were sown in the mid-1960s when long coats (maxi-coats) were placed over minis and the film *Dr Zhivago* (1965) inspired a spate of full-length flared overcoats with military overtones. Two years later the gangster movie *Bonnie and Clyde*, with its calf-length, 1930s-style costumes, accelerated the move to long, flowing, sinuous lines. Textile manufacturers faced an economic and technological challenge when solid fabrics which held short, stiff triangular shapes were rendered obsolete by demands for soft, pliable materials.

# Chapter 7:  1968–1975
# Eclecticism and Ecology

Taking its lead from youth, fashion became increasingly diverse and by the mid-1970s had resolved itself into two broad areas – classic, easy-to-wear clothes, and fantasy garments. Two factors were of major importance in womenswear: the replacement of the mini's rigid, triangular silhouette by the long, svelte lines of the midi and maxi; and women's increasing dependence on trousers. Meanwhile, men's preoccupation with style continued.

Although Paris remained at the centre of the fashion world, Milan and New York went on asserting their considerable fashion strengths. The industry worldwide had to contend with inflation and the economic crisis brought about by the 70 percent rise in the price of oil in 1973 which, for a short time, imposed the damaging three-day working week on British manufacturers. The same year also saw the end of the Vietnam War, but violent conflicts continued, including race riots and student protests in America and Europe and a worldwide escalation of terrorist attacks. In the 'anything goes' climate of the 1970s, designers in search of new sources found inspiration even in these grim events. They also explored retro high fashion with a quick-moving series of 1930s and 1940s looks as well as styles based on occupational attire from cowboy gear to milkmaid dress. On the whole, however, fashion had become less a matter of designer diktat and more a question of personal choice – in fact it could be asserted that the mini was the last universal fashion.

In the late 1960s and early 1970s members of the burgeoning Women's Liberation Movement tended to be anti-fashion. Nevertheless, liberationist literature, such as Betty Friedan's *The Feminine Mystique* (1963) and, in 1970, Germaine Greer's *The Female Eunuch* and Kate Millett's *Sexual Politics*, had a formative influence on many fashion-conscious and socially aware young women: the little girl look was abandoned in favour of more 'grown up' styles. Anti-authoritarian and protest dress took the form of the stereotypical Hippie outfit or the boilersuit beloved of some feminists. The year 1968 saw the opening of *Hair*, advertised as the American Tribal Love-Rock musical. This celebrated not only long hair – the most obvious sign of rebellious youth – but also the

202. Yves Saint Laurent adapted men's tailoring techniques to create desirable mannish trouser suits for women. This suit of the mid-1970s was made in anthracite wool and worn with a blouse of pearl-grey marocain crepe. The padded shoulders gave it a sharp profile, and the flared, almost floor-level trousers were elongated over platform shoes. The short, slicked-back hairstyle, hand in side pocket, and particularly masculine way in which the cigarette is held all added to the sense of androgyny. Photo by Helmut Newton.

permissiveness of the Hippie movement with its liberal attitudes towards sex and drugs. The musical's anti-authoritiarian stance and anti-war sentiments were backed by a deafening beat and psychedelic lighting effects. A corollary of Hippie culture was the rejection of urban corporate values, which involved the adulation of and return to nature. This back-to-the-earth spirit nourished the growing ecological movement and was one of the starting points for a major resurgence of crafts in both the US and the UK. Appliquéd, crocheted and knitted garments began to appear in many ready-to-wear and even in some couture collections. As society became increasingly multicultural, designers also turned for inspiration to non-Western clothing concepts. Package tours and cheap air travel (jumbo jets were introduced in 1970) brought exotic places, customs and dress within reach; all were rich sources of inspiration for designers. Natural beauty products and health foods were viewed as the wholesome alternative to chemically based products and coincided with the keep-fit culture.

In 1968, at the age of seventy-three, Balenciaga closed his Paris house, having declared haute couture to be at an end. In 1971 the death of Chanel marked yet another stage in couture's decline. Nevertheless, though the elite clientele for custom-made couturier clothes had dwindled to approximately three thousand, the financial, political and creative forces underpinning haute couture ensured that it adapted to suit the prevailing climate. The tradition of bi-seasonal collections was maintained and the couture shows were used to herald the big business of the prêt-à-porter collections. This period proved to be a difficult time for Paris as the leading names attempted to come to terms with the threats to their dominance in an increasingly eclectic climate. Yves Saint Laurent remained at the forefront, with collections that were given star billing by fashion editors. His constant search for fresh ideas led him to a wide range of sources, including peasant, national, occupational, historical, film and ceremonial dress. His designs for the theatre also enriched his collections and he showed great skill at selecting elements from extravagant costume to rework into eye-catching yet practical day wear. His partnership with the astute businessman Pierre Bergé continued and by the early 1970s more than twenty YSL ready-to-wear boutiques were operating worldwide. Though Saint Laurent's health suffered from the pressure of maintaining both a rapidly expanding empire and a hectic social life – his glamorous entourage included his muse Loulou de la Falaise, the French film star Catherine Deneuve, Andy Warhol, Rudolf Nureyev and Paloma Picasso – his collections still grabbed

the headlines. Many of his styles were deliberately ostentatious and sensational – his see-through garments of 1968–69, for example – but they were shown alongside elegant, classic designs. Through his restless creativity, Saint Laurent opened avenues that others would follow in the 1980s and 1990s. In 1969 he introduced body sculptures by Claude Lalanne which reproduced the torso and were worn like glistening gladiatorial armour over crepe-georgette evening gowns. Alert and in tune with youth culture, he was not immune to short-lived trends and fads, to which he gave a special Parisian allure. At a time when the craft of patchwork was being revived in Europe and the US, Saint Laurent took the technique upmarket, creating not only sophisticated patchwork evening wear but also a wedding dress in a patchwork of expensive silks and satins. At another level he used humble, undyed calico and printed cottons for layered smocks and gypsy styles.

In 1971 Saint Laurent's passion for 1940s fashions became apparent in a collection which hugely exaggerated the characteristics of wartime clothes. Fox fur coats (one dyed brilliant green) with immense shoulders were worn with big turbans and saucy platform shoes. A skilled colourist with a highly tuned decorative sense, he produced designs that were remarkable for their

205. Yves Saint Laurent brought high Parisian chic to the traditional safari suit, 1968.

interplay of hues and textures. Throughout this period he also remained faithful to his standard repertoire, updating the lines as necessary. Trouser suits appeared in numerous forms for both day and evening, along with all-in-one jumpsuits in jersey and, in 1971, pinstriped suits for women.

Saint Laurent's major rival, Pierre Cardin, continued to diversify and build his empire by expanding his licensing operations, accumulating real estate and using couture as the flagship for his name. He was one of the first designers to put maxi coats over mini dresses, thereby offering women the advantage of both lengths. An even more provocative solution to the changing hemline involved long skirts composed of fringes of narrow panels terminating in pompons or discs. When the wearer moved, the mobile-like panels swirled apart to reveal the legs. For some of his evening dresses, Cardin linked concentric circles of fabric which fell from the shoulders over black or white bodysuits. Using heavy jersey knit in plain colours he created strong geometric shapes for tunics, dresses and trouser suits. High, choker-collared dresses were given handkerchief hemlines (again producing a mix of long and short), while in 1971 trousers ended in circles which were slit over chukka boots. Cardin remained true to the tailoring tradition with

206. With great ingenuity, Pierre Cardin solved the dilemma of the transition from mini- to midi- and maxi-length clothes by attaching long skirts of broad 'fringes' to slender, hip-length bodices. Made in a pliable double jersey, this dress of 1970 had 'fringes' ending in circular discs. The mannequin spun around to reveal the advantages of this two-in-one design.

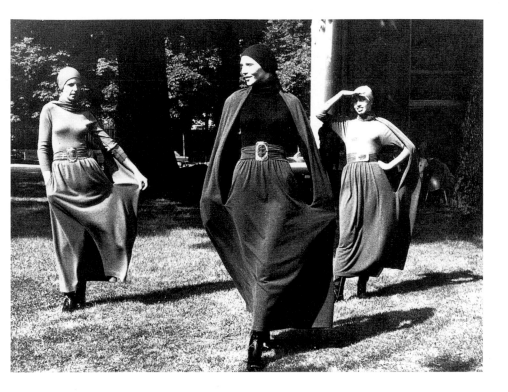

207. Adapting readily to the softer lines of the 1970s, Cardin created a series of fluid dresses combining clinging sweater tops with long gathered skirts (with integral capes) in fine wool and angora jersey knits. The headhugging pull-on hats which matched and unified each ensemble were typical Cardin touches.

its emphasis on perfect cut and high-quality fabrics, spurning both the currently popular ethnic look and the influence of historical costume. In the 1970s he turned to fashionable soft fabrics, focusing on angora jersey. He also experimented with shift dresses in bright jersey, the skirts of which were held out by descending rows of hoops. Though these looked striking on slender models, they were often difficult to wear and were not commercially successful. In the mid-1970s Cardin draped and gathered soft jersey knits into sophisticated jumpsuits and unusual dresses whose flowing lines incorporated looped back panels and integral floating capes. In 1977 he launched his new prêt-à-couture range, midway between haute couture and prêt-à-porter.

Away from the *grands salons*, the group of ready-to-wear *créateurs de mode* in Paris became an increasingly important force. These were new designers, distinct from the great couturiers, who created young styles for their own labels. Sonia Rykiel opened her boutique in 1968. A serious designer with philosophical leanings, she was and remains deeply committed to easy-to-wear, versatile clothes with flattering lines which sweep over the body. She rejected fussy embellishments and favoured luxurious jersey knits in fine wool

207

208, 209. Designers enjoyed lighter moments when creating fun clothes for the young. In 1972, using her favourite stripes, Sonia Rykiel made a button-through skinny cardigan to go over an even tighter sweater (*left*) shown alongside a cropped, edge-to-edge cardigan with a tactile curled texture and chunky tie belt (*right*). Knitted caps, pulled over the forehead, were trimmed with imitation floral sprays.

In a similarly carefree mood for Autumn/Winter 1971 (*opposite*), Kenzo conceived a pair of youthful, zany outfits of fluffy short coats with matching huge, floppy, feather-trimmed berets, polo necks and pantomime-like stripy tights. The models wore high, platform-soled mules – dangerously elevated footwear such as this caused many ankle injuries at this time.

and cotton for interchangeable separates with classic overtones. As a woman designing for women, her attitudes and sensible approach can be compared to those of Jean Muir. The views of these two designers could be considered almost anti-fashion, since they both believed that clothes should not be mere seasonal whims but should last for years. Sonia Rykiel's muted palette was sometimes enlivened with her hallmark stripes. Black was central to her output, supplemented by subdued greys, browns, sludge blues and terracotta, with off-whites and apricot for summer clothes. She occasionally used bright red and blue with considerable verve. Rykiel gained the respect of fellow designers and in 1973 was elected Vice-President of the Chambre Syndicale du Prêt-à-Porter des Couturiers et des Créateurs de Mode.

The German-born Karl Lagerfeld began working with the team of designers at Chloé in 1963 and by the early 1970s his powerful vision prevailed. His designs were informed by many factors, including his training at the Chambre Syndicale, his period at Balmain, his detailed knowledge of the history of art and dress and his pronounced sense of fun. Lagerfeld was aware that the invigorated prêt-à-porter was all-important in fulfilling the needs of young clients who found haute couture dull and expensive and

208

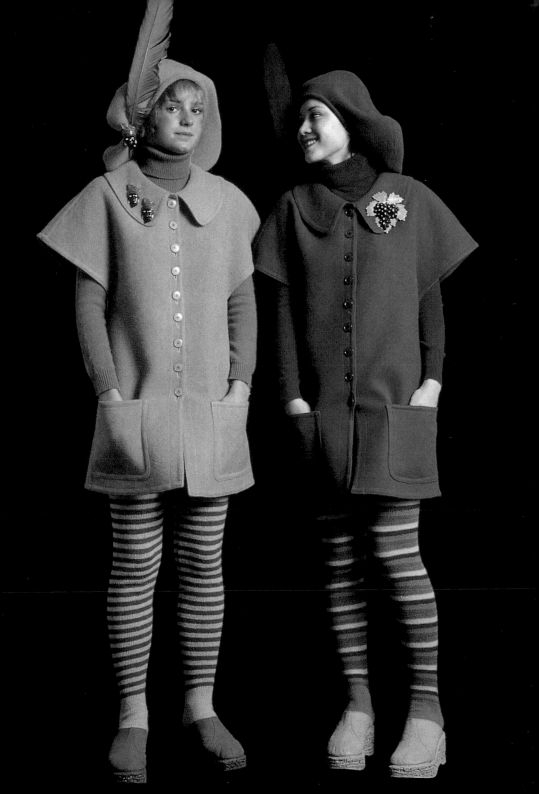

considered mass-produced clothes cheap and nasty. He captured the spirit of the early 1970s by using boldly designed, brightly coloured fabrics. Wholeheartedly embracing the retro movement, he produced amusing parodies of 1930s and 1940s styles, making the news in 1971 with his adaptations of Art Deco graphics in primary colours on black silk backgrounds.

Presenting her collections in Paris from the mid-1960s, Hanae Mori became a trailblazer for Japanese fashion talent. While Mori incorporated Japanese textiles and design motifs into her classic and elegant collections, subsequent designers who followed in her footsteps by showing in Paris combined the cut of Japanese clothing with a modern East/West aesthetic. Kenzo Takada, Kansai Yamamoto and Issey Miyake created loose, layered styles, often in vibrantly patterned fabrics and textured weaves, introducing a radical new look to Western fashion.

Kenzo Takada was one of the first of the new wave of Japanese designers, arriving in Paris in 1965. By 1970 he was designing his own label, Jungle JAP. From his studies at Tokyo's Bunka College of Fashion he had gained a thorough knowledge of production methods. His designs – informal, loose-cut and layered, in clashing colours and patterns – drew inspiration from ethnographical costume and textiles and demonstrated his close familiarity with traditional Japanese fabrics, ceremonial dress and work wear.

Kansai Yamamoto, also a graduate of the Bunka College of Fashion, established his own label in 1971. His dramatic clothes in vivid colours had a powerful graphic appeal and, like Kenzo's, made reference to traditional Japanese attire. The strong shapes and volume of these costumes (secular and military, as well as theatrical) were starting points for garments with a bravura and exoticism that attracted a following in Europe and the US. Richard Martin of the Metropolitan Museum, New York, pinpointed the fact that Kansai Yamamoto's work combined the pop sensibilities of the West with the highly formal conventions of Japan. His exuberant collections were especially popular in the 1970s, when he evolved an extravagant form of figurative appliqué featuring glossy satins and leathers.

Issey Miyake graduated in graphic design at Tokyo's Tama University in 1964 and then went to work with Guy Laroche, Givenchy and Geoffrey Beene. In 1970 he founded the Miyake Design Studio in Tokyo and the following year established Issey Miyake Inc. Initially, Miyake showed in New York but from 1973 he presented his collections in Paris. Many of his designs have been inspired by samurai armour, as well as by the volume and

209

210

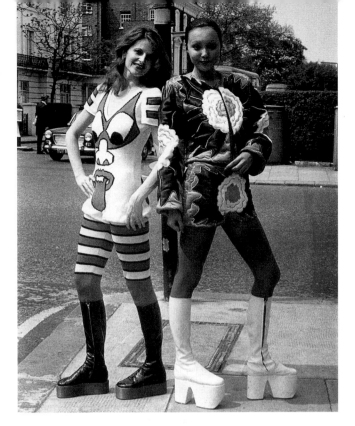

210. Kansai Yamamoto wanted people to feel happy and energetic when wearing his designs which, at their most dramatic, drew on Kabuki theatrical costume. An extraordinary knitted all-in-one bodysuit of 1971 (*left*) had a powerful graphic face (with tongue stuck out) placed suggestively over the torso, while deck-chair striped tights completed the bold look. Enormous appliquéd flowers gave a quilted hot-pants suit (*right*) a slightly more subdued decorative appeal. The huge, platform-soled boots resembled those worn on stage by pop stars such as Elton John and members of Abba.

straight cut of the traditional Japanese kimono and the functionalism of workclothes.

By the mid-1970s the Italian fashion industry was flourishing. With its excellent business and manufacturing techniques, it posed a real threat to the might of Paris. The competition between Rome, Florence and the latecomer Milan to become Italy's major fashion centre was eventually won by Milan, chiefly because of its air links, large hotels and spacious commercial premises. The Italians had the advantage of home-manufactured de luxe silks, linens and wools and world-famous leathers, for which fashion provided a showcase. Mills and printworks produced runs for individual designers to use exclusively in their collections. It was a fertile period, during which established names like Valentino and Mila Schön were joined by Giorgio Armani and Gianni Versace, the rising stars who were to dominate Italian fashion in the 1980s. In 1975 the National Chamber of Commerce of Italian Fashion organized the first major ready-to-wear events in Milan and the city's fashion week subsequently became a fixture for international buyers and the press.

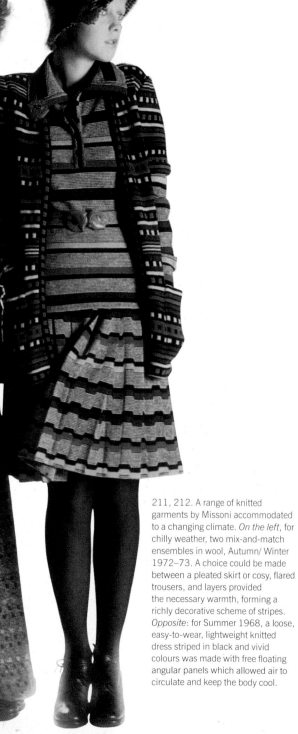

211, 212. A range of knitted garments by Missoni accommodated to a changing climate. *On the left*, for chilly weather, two mix-and-match ensembles in wool, Autumn/ Winter 1972–73. A choice could be made between a pleated skirt or cosy, flared trousers, and layers provided the necessary warmth, forming a richly decorative scheme of stripes. *Opposite*: for Summer 1968, a loose, easy-to-wear, lightweight knitted dress striped in black and vivid colours was made with free floating angular panels which allowed air to circulate and keep the body cool.

213. Legs were all-important in the early 1970s, encouraging the exploration of the long-with-short formula. For Spring/Summer 1971, Valentino designed this black and white layered ensemble consisting of a demure polka-dotted crepe, high-necked blouse (beneath a singlet) and not quite so demure matching shorts. A long, open-fronted skirt offered a covered-up option when a more modest look was necessary.

Italian designers built on their country's long-established craft traditions, bringing fresh spirit to international fashion. In 1973 the knitwear designers Rosita and Ottavio Missoni received the Neiman Marcus Fashion Award for their innovations in machine knitwear. Their introduction of stripy rainbow colours, textured yarns and intricate patterns ranging from flame designs to interlocking chevrons had raised the status of knitwear to an art form. Like many Italian concerns, the Missoni firm employed the complementary talents of the entire Missoni family. At Fendi, too, the leatherware and furs were the product of the combined efforts of the five Fendi sisters – the daughters of the founder – and their families. Established in 1925 in Rome as a small leather goods boutique, the firm supplied a private clientele until 1962, at which point it began to expand rapidly, making imaginative leather products and fur collections which catered for the couture and ready-to-wear. During the early 1960s, in a spirit of innovation, Fendi commissioned fashion designer Karl Lagerfeld to create special lines for its exclusive furs. In a break with traditional high-status furs, Lagerfeld used squirrel, mole and ferret, cutting and dyeing in new and unorthodox ways and dispensing with the usual cumbersome linings and interlinings to create versatile, lightweight fashion statements.

Overtly glamorous clothes were an important feature of Italian design. Valentino was hailed as the master of this genre. After studying in Paris and working for Jean Dessès and Guy Laroche, he established his atelier in Rome in 1959 and came to international prominence with his spectacular white collection of 1968. Throughout the 1960s and 1970s his ultra-sophisticated, extravagant designs attracted high-profile customers such as Jacqueline Onassis, Elizabeth Taylor and the Empress of Iran. His ready-to-wear boutiques, the first of which he had opened in 1969, quickly spread to the rest of Europe, to the US and eventually to Japan. American customers in particular were attracted to his soft tailoring and lavish evening gowns.

Two other Italian designers, working in different idioms, achieved success with designs which matched comfort with style. Laura Biagiotti introduced her first collection in 1972 and, after the acquisition of a cashmere firm, began to make practical, low maintenance, cashmere knit dresses that almost eliminated the problem of sizing. She also designed a trans-seasonal capsule wardrobe made up of easy-to-wear classic separates. In 1968 Mariuccia Mandelli, founder of Krizia, added knitwear designs to her initial range of skirts and dresses. Her sweaters decorated with

211
212

213

animal motifs were so popular that she subsequently introduced a new creature to her fashion 'zoo' each season. Krizia also specialized in intricately pleated evening wear inspired by the pleating techniques traditionally practised in Italy's convents.

New York remained the hub of the American fashion industry and, like the Italians, US designers demonstrated a new confidence. Leading names continued to make clothes in the refined, European mode but they were now joined by designers who developed a distinctive American style. The long look of the late 1960s was not immediately successful in America: women rejected it as dowdy, ageing and unappealing. In an attempt to overcome this resistance, designers introduced maxis and midis with long slits up the front and side to show the legs. In 1970 a last bid was made for above-the-knee fashions with the introduction of extremely brief shorts. Made with or without bibs or straps in durable denim, leather and wool for daytime wear and in velvet and satin for evening, these were worn chiefly by the young and daring. They originated in the Paris ready-to-wear collections and looked their best over heavy-denier coloured tights. (As an indication of the relaxation of dress codes, it should be noted that these shorts were permitted in the Royal Enclosure at Ascot in 1971 if their 'general effect' was satisfactory.) They achieved notoriety when they were christened 'hot-pants' by *Women's Wear Daily*. This publication was transformed in the 1960s by John B. Fairchild (grandson of the founder) into a paper carrying up-to-the-minute fashion information and gossip about society and its trendsetters (known as the Beautiful People). International in its scope, it was essential reading for anyone in the business. In 1973 Fairchild added a full-colour sister title, *W*, which surveyed fashion in conjunction with the lifestyles of 'people who make things happen'. The London-based magazine *Nova* (1965–1975) played a part in widening perspectives on the relationship between fashion and gender. Its talented team put together original and compelling articles with avant-garde fashion photographs by Helmut Newton, Deborah Turbeville and Harri Peccinotti.

Casual yet elegant separates remained central to American fashion and in the 1970s they were updated by designers such as Calvin Klein, Geoffrey Beene and Halston. After graduating from the Fashion Institute of Technology in 1962, Klein worked for various ready-to-wear firms before establishing his own company in 1968. He created mix-and-match collections of understated, casually elegant, classic garments that were ideally suited to the professional working woman. He favoured natural materials such

214. Hot-pants grew shorter and shorter before they went out of fashion. They were not for the coy and required a well-toned figure. In 1971 Krizia teamed a tiny pair of brashly checked hot-pants with forties revival, strappy, platform-soled sandals.

214

as cashmere, suede and fine wools, and preferred the subtle appeal of earth tones and neutrals, adopting brown as his signature colour. Klein's work soon attracted an international clientele and by the mid-1970s his name was synonymous with contemporary American style.

The designs of Halston (Roy Halston Frowick) were similarly simple and classic. Halston abandoned a successful career in millinery to become a dress designer in the late 1960s. By 1972 he was offering both ready-to-wear and custom-made ranges and his clothes were capturing the limelight in the society pages – his customers included Jacqueline Onassis and Liza Minnelli. Specializing in fluid, soft-line garments that were both chic and comfortable, he perfected a trouser and tunic combination that was made for both

215. Infinitely versatile, blue denim was given a popular bleached treatment in 1971 for a safari suit (by Aljack Sportswear of Montreal) consisting of flared trousers and a long belted jacket with cuffed sleeves, tan buttons and four flap pockets.

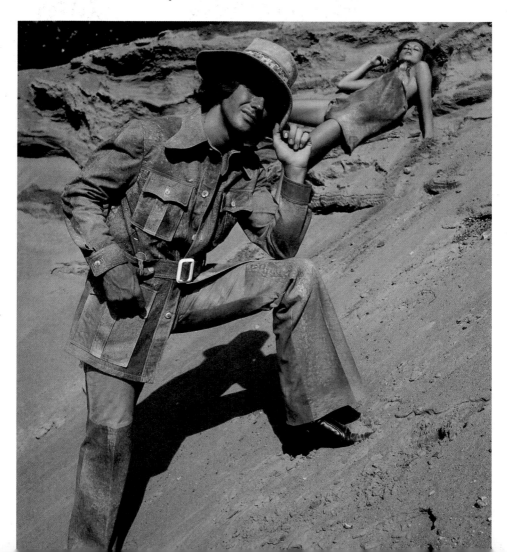

216. A characteristically sophisticated and body-conscious ensemble designed by Halston in 1972 combined a svelte silk jersey jumpsuit (with a revealingly low halter neck) with an Ultrasuede (a Halston hallmark) trenchcoat thrown nonchalantly around the mannequin's shoulders. Dark glasses, complete assurance and a cigarette held confidently aloft created the perfect mood for this simple but elegant evening outfit with overtones of 1930s styles.

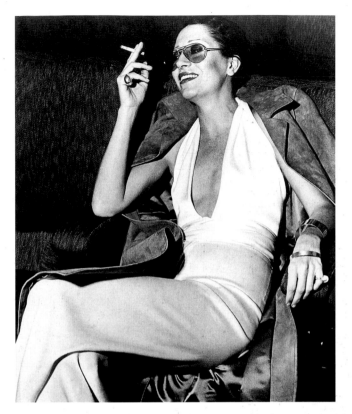

day and evening wear. Complex fastenings and nonfunctional details were kept to a minimum in close-fitting jersey T-shirt dresses, long cashmere sweaters, body-skimming silk caftans and wraparound skirts and dresses. Bold, abstract jewelry by Elsa Peretti often complemented Halston's streamlined designs.

While Calvin Klein and Halston are fashion minimalists, Ralph Lauren has reinvented traditionalism. In the early 1970s he took the kind of clothes that are normally associated with the life of the British landed gentry and reinterpreted them, adding an element of sophistication which made them attractive to the American market. With no formal design training, Lauren gained experience working for the exclusive menswear store Brooks Brothers in New York, and as a tie salesman, before starting his Polo Fashions as a division of Beau Brummell Neckwear in 1967. The following year he established Polo Fashions as a separate menswear company catering for the total look. Lauren's choice of the word Polo – with its associations of gentlemanly exclusiveness, rural tweediness and sporting dash – was one of the starting points for

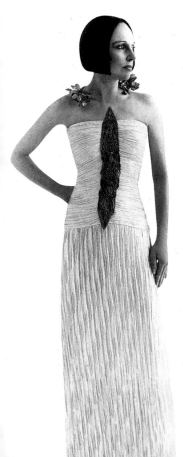

the marketing of a complete lifestyle. In 1971 he introduced men's-style shirts for women, complete with the polo player logo, and their success prompted his top-to-toe womenswear collections. His clothes often made references to 1920s and 1930s fashions as shown in photographs, magazines and films, so he was the obvious choice as designer of the male wardrobe for the 1974 film *The Great Gatsby*. Three years later Diane Keaton wore his designs in *Annie Hall*, so popularizing a mannish style consisting of extra-large shirts, trousers and jackets, often worn with a tie and waistcoat.

Whereas Ralph Lauren looked to the English country gentleman for inspiration, Mary McFadden, a widely travelled, former fashion editor at American *Vogue*, turned to the clothing styles of ancient civilizations and exotic cultures. McFadden started showing her collections in 1973 and during the next two years developed the designs for her hallmark permanently pleated polyester satin. For Fortuny-like evening wear, she often combined this fabric with beadwork and elaborate fastenings. The material was ideal for travelling: it resisted creases and sprang back into shape as soon as the garment was unpacked. It could be dressed down with a cotton or wool sweater for daytime wear or given extra glamour in the evening by the addition of pleated or embroidered tops.

The youthful, zanier side of American fashion was represented by Stephen Burrows, Scott Barrie and Betsey Johnson. In 1970 the trendiest place to shop in New York was Stephen Burrows World, inside the department store Henri Bendel. Burrows trained at the Fashion Institute of Technology and for his initial collections took inspiration from biker gear and his own African-American culture. Aiming at a youthful market, he was known for studded, pieced and fringed leather and suede garments, and liked to create eye-catching clothes in gaudily coloured patchworks of different materials. He also made simple, classic styles for both men and women in supple jersey knits which skimmed the body's contours. His vibrant, occasionally iconoclastic designs were closer in spirit to those of young European designers than to the work of his American contemporaries. Unconventional in his approach, he turned seams to the outside, highlighting them with bright zig-zag lines of top stitching, and preferred prominent press studs and lacing to discreetly concealed button fastenings.

By the late 1960s blue jeans had become an almost universal uniform for those in their teens and twenties, prompting journalists to bemoan the 'seas of denim'. In 1973 the Neiman Marcus Fashion Award was presented to Levi Strauss for 'the single most important American contribution to worldwide fashion'. For

many young men and women across the world it was crucial to sport the right label, be it Levi, Lee or Wrangler, and to have the correct type of jeans – stone-washed, shrunk, faded, bleached or brushed denim. Jeans were slit open and gussets inserted to make patched denim skirts. Older people chose denim for its sheer comfort and practicality, while chic New Yorkers wore their immaculately laundered, sharply creased jeans with tailored designer jackets or navy-blue blazers. Denim art came into its own when jeans and jackets were customized by their owners: embroidered, studded, painted, slashed and appliquéd with an array of decorative motifs or names and slogans. Unisex styles prevailed. Initially, top designers remained aloof from this youthful trend but the more adventurous soon introduced denim jeans into their collections. Among the most desirable were Gloria Vanderbilt's in white, Elio Fiorucci's in khaki and Ralph Lauren's in traditional indigo – all worn with the labels clearly visible. Mass manufacturers copied the famous work wear brands and also produced jeans with the fashionable hipster cut, with or without bell bottoms. Dangerously high clumpy platforms, which kept flares as well as long dresses off the ground, became one of the most evocative fashion icons of the 1970s.

215

Flares were a vital component of the fashionable male wardrobe. The prevailing youthful silhouette featured a tightly clad torso and 'second skin' trousers or jeans which hugged the legs to just beyond the knees and then flared out to wide hems. Fashion's limelight belonged to young men who wore audacious colours and styles in an increasingly extrovert manner. Especially popular for casual wear was the combination of a short-waisted, rainbow-coloured, knitted tank top or blouson over a psychedelically patterned shirt with a large pointed or teardrop collar, worn with velvet or corduroy bell bottoms. White-collar workers were obliged to observe a formal dress code, but though older men remained faithful to suits of a conservative cut, their younger counterparts wore suits with waisted jackets, wide lapels and flared trousers. As the decade advanced, trouser hems grew ever wider until, in the mid-1970s, flares went out of fashion.

The pop scene was a major fashion force, especially for menswear. Ideas borrowed from the costumes of pop musicians appeared in the high street with only a few modifications. In 1969 style-setter Mick Jagger caused a stir by performing at a free pop concert in London's Hyde Park in an unashamedly feminine, frilled tunic top, white flares and a studded leather choker. The leading exponents of Glam Rock – Gary Glitter (strutting on

217. Designer Mary McFadden wore one of her own pleated evening gowns for this 1970s photograph. Inspired by historical and ethnographic costume and adornments, she offset the stark white strapless columnar dress with craftsman jewelry – a crescent-shaped neckpiece and, bisecting the tubular bodice, a long, leaf-like 'shield'.

218. David Bowie achieved star status in the UK by 1969 and in the US by 1972. He was a gifted image manipulator and enhanced his stage performance by cross-dressing, wearing heavy makeup and making constant changes to his stage persona. His early 1970s Ziggy Stardust phase, when he dyed his distinctively spiked hair a range of bright colours, had an enormous influence on young fans.

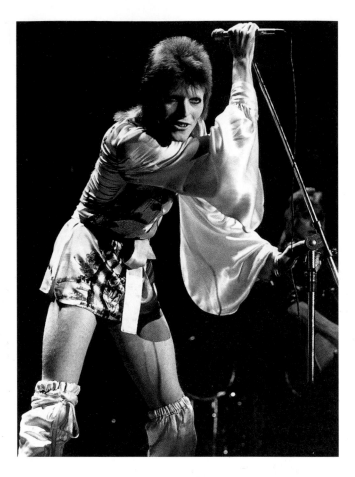

perilously high platform shoes) and Marc Bolan – took elements previously confined to women's evening wear and reworked them into sexually ambiguous costumes in Lurex, satin, and sequinned stretch fabrics. Though still shocking to some, androgynous styles were no longer taboo. Marc Bolan wore his dark, curly hair long and emphasized his prettiness with obvious makeup. Like David Bowie, he adopted the feather boa as a stage accessory. For his Ziggy Stardust persona, Bowie created a flamboyant transexual look achieved through attention to detail, from immaculately applied makeup and sharp hairstyles to carefully accessorized, meticulously crafted stage costumes. Described as an 'androgyne chameleon', he delighted his fans and made a significant impact on 1970s styles with his rapid and radical transformations of his image.

American anti-establishment styles continued to have a dramatic influence internationally, affecting both the dress of

21

students and the leisure wear of young professionals with Hippie leanings. The film of the massive Woodstock pop concert in 1969 familiarized European youth with a variety of anti-fashion clothes: collarless 'grandad' shirts, cheesecloth or printed Indian cotton dresses, headbands, and strings of ethnic beads. Later in 1969, thousands of pop fans in a kaleidoscope of tie-dye and floral prints besieged the Isle of Wight's festival of music to hear rock and folk 219 stars, including Bob Dylan. In the same year, Dennis Hopper and Peter Fonda played two quintessential, motorbike-riding Hippie dropouts in the film *Easy Rider*. Fonda's Captain America look, 220 complete with stars and stripes, and Hopper's jeans and fringed leather jacket, long hair and droopy moustache were to have an influence not only in the US but also in Europe.

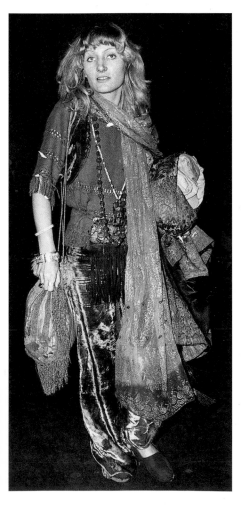

219. *Left*: A young Hippie, in baggy velvet trousers and fringed loose top, with flowing silk scarf, drawstring bag and long bead necklaces, returning from a pop concert on the Isle of Wight in 1970.

220. *Above*: Peter Fonda in the guise of Captain America, with the American flag on the back of his leather jacket, in a scene from *Easy Rider*. A widely influential movie, which became a cult among the young, *Easy Rider* followed two counter-cultural heroes as they biked their way across the US. Film critics at the time – it was 1969 – commented adversely on the length of Fonda's hair.

The widespread adoption of non-traditional clothing by young men in the UK had serious implications for Savile Row's eminent tailors. While rents rose steeply, the elite customer base dwindled, and when workers retired their skills were not replaced, since apprenticeships in the trade were considered untrendy. One ray of light was the opening of Tommy Nutter's establishment, in which modern styling was combined with excellent construction techniques. In 1969 John Lennon and Yoko Ono bought their unisex white wedding suits from Tommy Nutter, and Bianca Jagger was a regular customer for sophisticated trouser suits which she accessorized with elegant walking canes. Nutter broke many tailoring conventions by using adventurous materials in mix-and-match combinations. Most of his suits had his hallmark braid-trimmed, extra-wide lapels and generally exaggerated styling.

Bryan Ferry and his Roxy Music group, usually dressed by Antony Price, revived slick interwar styles and helped to popularize retro looks. At a time of economic depression and growing unemployment following the oil crisis of the early 1970s, the fashion for retro styles endorsed the practice of hunting for second-hand clothes in flea markets as well as in charity and thrift shops.

By the mid-1970s the lines of men's fashion began to show subtle changes. Jackets lost their pronounced waists and, as flares went out of fashion, tight trousers gradually gave way to roomier garments with pleats and softer lines. Italy's Giorgio Armani played an important role in this period of transition. After a spell with the chainstore La Rinascente, he worked at first for Nino Cerruti (designing the Hitman range) and then as an independent, showing his first ready-to-wear menswear collection in 1974. The groundwork was in place for the move later in the decade to a new, unstructured look.

Though the trend in clothing was towards a more relaxed silhouette, it was imperative that the body inside be lithe and well toned. The vogue for fitness and health clubs which began in the US spread rapidly. The movement was promoted by ideologues who believed that a trim, healthy body meant a better, more productive life – a philosophy supported by keep-fit videos, television programmes and fashion magazines. Sports and leisure wear manufacturers were swift to supply exercise wear that emphasized fashionable appeal rather than sporting practicality. Lycra, with its excellent stretch-and-recovery and fast-drying qualities, came into its own. Combined with other fibres, it was used for leggings and leotards which migrated from the dance studio and gym to become prototypes for fashion statements on the disco floor and at

the exercise club. Lycra also made possible the gossamer-fine, virtually seamless underwear of the late 1960s and 1970s. The craze for jogging and skating, which also originated in the US, called for new lines in coordinated tracksuits, shorts, bodysuits and even legwarmers and sweatbands. Top professional sports people not only backed these developments but also signed deals to endorse specialist equipment and clothes. The 1972 Olympics featured the performance-enhancing 'second skin' swimsuits which led to similar styles in high street stores.

The ideal beauty regime began with exercise. Models radiating good health abandoned the *faux naïf* child image of the later 1960s in favour of an assured sophistication best exemplified in photographs of Jerry Hall, Marie Helvin and Iman. The Black is Beautiful movement brought an increasing number of black mannequins – among them Beverly Johnson, Princess Elizabeth of Toro and Mounia Orhozemane – into magazines and onto the catwalk. Other 1970s role models included Bianca Jagger, Jane Fonda, Farrah Fawcett-Majors and Angela Davis. Makeup was either underplayed in natural colours, applied so as to produce the white-purple pallid face of Biba fame, or heavily painted in bright, clown-like hues. Favourite hairstyles included the afro, long tousled 'Californian' locks and crinkled Pre-Raphaelite tresses.

London designers were quick to endorse the new longer lines in pliant fabrics. By the early 1970s Jean Muir, Zandra Rhodes, Bill Gibb, Gina Fratini, Foale & Tuffin and Ossie Clark had realized their early promise. With the exception of Jean Muir, they shared a predilection for fantasy and romance – possibly deriving from the liberal atmosphere of British art schools, which was less formal than the couture and trade-focused training in France, the US and Italy.

Ossie Clark graduated from the Royal College of Art in 1964 and soon became the *enfant terrible* of London fashion, scoring an instant success with his early Op Art-influenced designs. Clark played a key role in the young London scene and enjoyed the company of pop musicians and painters. He started his career designing for Alice Pollock's boutique Quorum, and his work was a magnet for celebrities such as Bianca Jagger, Marianne Faithfull and Patti Boyd. While avoiding vulgarity, he used peep-holes at the midriff and shoulder tops, and strategically placed slit seams, to expose tantalizing parts of the female anatomy. By the late 1960s he had discovered his true forte, which was to cut pliable, difficult-to-handle moss-crepe, satin and silk chiffon into seductive styles which flowed over the body. Married to the printed-textile designer

221

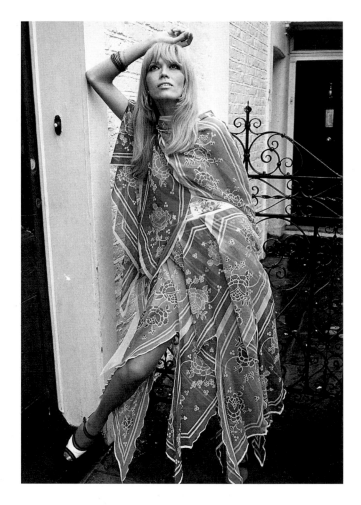

221. This floating ensemble was part of the late 1960s movement away from short, structured clothes in stiff fabrics. Ossie Clark designed it in 1968 using frail chiffon printed with a lyrical pattern by Celia Birtwell. Set on the bias, handkerchief points rippled becomingly around the body, permitting glimpses of the legs in this period of transition from thigh-high to ankle-length fashions.

Celia Birtwell, he used her dress fabrics to maximum effect. Her patterns had a fluid quality that was a perfect match for his concepts. The manufacturer Radley commissioned designs from Clark, which were mass-manufactured in moss-crepe in a range of soft pastels as well as in black and white.

Lyrical design was also central to the output of Zandra Rhodes. After graduating in printed textiles from the Royal College of Art in 1964, she spent a period as a freelancer and entered into partnership with dress designer Sylvia Ayton before producing her first independent collection in 1969. An unconventional and prolific talent, Rhodes created distinctive prints which she used to make special-occasion gowns – these immediately attracted buyers in America and the UK. Her 1969 evening

dresses and coats were made with immense circular skirts which acted as silk chiffon and felt backgrounds for startling screen prints inspired by eighteenth- and nineteenth-century knitting and embroidery stitches. Subsequently, each collection was linked to a theme stemming from her research into historical dress and textiles and her trips around the world – all documented in lively sketches. Rhodes's use of sources was never one of slavish imitation; they functioned as springboards for her designs. Acknowledging the lyrical nature of her work, she referred to her creations as 'butterflies'. Between 1970 and 1976, her collections – 'The Ukraine and Chevron Shawl', 'New York and Indian Feathers', 'Paris, Frills and Button Flowers', 'Japan and Lovely Lilies' and 'Mexico, Sombreros and Fans', among others – were stimulated by a wealth of images and places. The printed pattern was the controlling factor – a garment's constructional and decorative details were designed to highlight the nature of the print. Crenellated and handkerchief hems – some with icicle-like extensions – were finished with beads or real feathers; seams were ostentatiously placed on the outside of garments and their edges

222. Photographed flat, Zandra Rhodes's reversible quilted coat printed in a design called 'Chevron Shawl' (1970) was cut to the shape of the print, giving it a serrated edge. Max Tilke's costume books with their clear illustrations of ethnographic garments provided inspiration for the cut of this coat, and the idea for the decorative screen print came from a tasselled Victorian shawl. This particular coat was a favourite of the designer herself, who often wore it with baggy trousers tucked into high Biba boots.

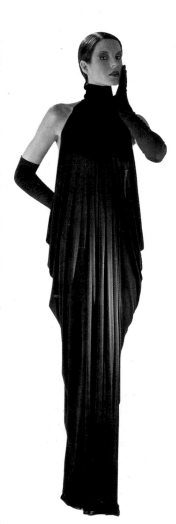

were pinked or lettuce-frilled; silk and jersey dresses had hand-rolled edges and were often made with pipings, panels or deep cummerbunds in reflective satin. The laborious techniques of appliqué, quilting and knife pleating emphasized Rhodes's crafts-manship. With its aura of romance, her work was greatly in demand for high-profile portraits, such as Princess Anne's engagement photographs of 1973.

The Scottish-born Bill Gibb trained at St Martin's School of Art. With the painter and knitter Kaffe Fassett, he introduced the influential design technique of 'mix-and-match pattern on pat-tern' in a group of swirling tartans and intricate knits which won him *Vogue*'s Designer of the Year Award in 1970. The following year he started his own label and embarked on a series of extrava-gant collections inspired by folk, medieval and Renaissance cos-tume as well as by Highland dress. By using contrasting, highly decorative fabrics enhanced by ornate trimmings, Gibb produced striking designs which found favour with media personalities who needed dramatic outfits for public appearances. In 1971 Twiggy commissioned dresses for the premieres of the film *The Boyfriend*. Gibb's full-skirted evening and wedding dresses came with typical Gibb touches such as piped seams and braid streamers, and his clothes often carried his bee (B for Bill) insignia in the form of embroidered motifs, tiny enamel buttons or buckles. Though he excelled in romantic and fantasy clothes, Gibb also designed prac-tical day wear in Scottish tweeds and tartans, such as long, plaid skirts based on the traditional kilt. Especially successful were his coordinated knitwear ensembles (with up to ten pieces in one out-fit) which were made in heavyweight wool for winter and in light bouclé for summer. His career peaked in the mid-1970s with a Bill Gibb room in Harrods and a shop in Bond Street.

Jean Muir, by contrast, avoided any nostalgic reworking of past styles. Muir had no formal training but worked at Liberty, Jacqmar, Jaeger and the ready-to-wear manufacturer Jane & Jane, before launching her own label in 1966. She rapidly found her own vocab-ulary and rarely deviated from it. At her Bruton Street premises she showed refined, understated designs that were flattering as well as authoritative. Her streamlined clothes proved ideal for high-profile professional women, combining feminine grace with 'no nonsense' elements. They were easy to put on, unfussy and usually had practical, roomy pockets. Unpatterned matt jersey, woollen crepe and supple suede and leathers dyed in subtle ranges (invariably including navy-blue and black) became her signature materials. The strength and integrity of her work derived from its

simplicity and austerity. Decorative accents were created by pin-tucking and top-stitching, as well as through the use of handmade buttons and buckles commissioned from young craftspeople.

Yuki (Gunyuki Torimaru) also worked in a pure idiom. Born in Japan, he trained as a textile engineer before moving to Europe, studying at the London College of Fashion and gaining design experience at various leading houses, including Hartnell and Cardin. He established his own label in London in 1972 and quickly built an international reputation for his fluid, draped jersey garments. Unlike those of other Japanese-born designers working in the West, Yuki's designs have always been body-conscious. He draped on the torso, gathering soft folds of fabric into ring and halter necks from which the jersey cascaded sensuously over the body. He was admired both for his craftsmanship and for the fact that his work suited larger as well as smaller women. His flowing 'Grecian' dresses in Du Pont's Qiana jersey (a washable polyamide) have a timeless grace which sets them apart from mainstream 1970s styles.

223

In the early 1970s young customers could select looks of the moment at reasonable prices from the London boutiques Mr Freedom, Biba and Laura Ashley. For a couple of years before the oil crisis plunged fashion into restrained browns and beiges, Tommy Roberts stocked his shop, Mr Freedom, with a riot of brightly coloured, witty clothes which drew inspiration from American sporting wear, comics and glam rock. The launch of the huge Biba emporium in Kensington High Street can be seen as the last fling of London's swinging sixties. The Biba label had gone from strength to strength throughout the late 1960s, and in 1973 Barbara Hulanicki and Stephen Fitz-Simon took over an entire department store (formerly Derry & Toms) to sell the complete Biba lifestyle – fashions and accessories for the whole family as well as food and interior decorations. The 1930s building was refurbished in pastiche Art Nouveau and Art Deco with an overlay of Hollywood glamour. The clothes that had made Biba a cult were displayed in low light on bentwood coat racks, as they had been in the first Biba boutiques. Designed by Barbara Hulanicki and her team, styles were body-conscious, usually ankle length, in typical Biba colours: sludgy blues, plums and pinks. The dark Biba make-up range remained popular and was widely imitated. Yet the Big Biba store survived for only two years. Apart from stock control problems, it also suffered from the fact that it attracted many who came for the experience (or to shoplift) rather than to buy. In any case, financial difficulties forced it to close in 1975.

223. An elegant, pillar-like evening gown by Yuki (1974). Fluid jersey was minutely pleated into a high collar from which it draped around the body and cascaded to the feet. Yuki perfected a technique which employed an entire piece of fabric rather than the cut-out, shaped panels of conventional tailoring. He composed gowns on a dressmaker's dummy, painstakingly pinning each minute pleat into position.

224. *Opposite*: Maxi coats became widespread in the late 1960s. Taking a masculine garment into the female arena, Barbara Hulanicki made a best-selling design inspired by double-breasted army great coats. She customized the maxi to suit Biba's young customers by curving it in at the waist, after which it flared out to almost touch the ground. Enormous rounded lapels were the latest thing. The coat came in wool as well as mackintosh dyed in Biba colours – a sludgy airforce blue was especially popular.

225. *Right*: In the early 1970s Laura Ashley shops were packed with young women snapping up inexpensive cotton garments. Demand was so great that rails were tightly crammed and a considerable amount of space was devoted to plain white dresses and blouses. Late nineteenth- and early twentieth-century nightdresses and undergarments were the starting points for these nostalgic clothes, made in a fairly coarse, soft cotton, sometimes with decorative insertions of machine lace. The firm used innocent looking young women in their advertising campaigns, which were usually set in the countryside to create an impression of wholesome rural life.

225

In contrast to Biba's decadent look, Laura Ashley offered cotton print dresses which conjured up images of innocence and country living. Founded in 1953, the company released its first clothing range in the late 1960s. Tiered dresses and skirts in fresh sprigged cottons were soon sweeping grimy city streets and satisfying yearnings for a rural utopia. In response to demand, the company built up a worldwide chain of outlets. The Laura Ashley formula involved variations on floor-length dresses and pinafores with fitted bodices and features reminiscent of Victorian and Edwardian dress – flounces, ruffles, puff sleeves and high necks. The garments were made in inexpensive cottons and corduroys which were dyed in deep colours or printed with diminutive patterns taken directly from historical textiles. The look endured for almost fifteen years before going out of fashion at the end of the 1970s. By that time, such lighthearted escapism had given way to darker stylistic fantasies constructed around images of violence and anarchy and summed up in one word – Punk.

# Chapter 8: 1976–1988
## Sedition and Consumerism

While the mid- to late 1970s are generally characterized as a period of continuing economic decline, political upheaval and social fragmentation, the 1980s were for many people – at least up to the stock market crash of October 1987 – optimistic, prosperous times. These two very different climates saw the rise of equally distinctive fashions. The earlier period was in many respects one of cultural conservatism – a time of nostalgia, when all that was old or 'traditional' was considered desirable. Disenchantment with the present and a general distrust of modern innovation were reflected in many of the international fashion collections, which offered 'safe' classics or retro styles. Conversely, the more negative aspects of the period provided the stimulus for radical cultural developments, including the rise of Punk.

Born in London in the summer of 1976, Punk first manifested itself among groups of unemployed young people and students, many from the capital's art schools, who congregated around Vivienne Westwood and Malcolm McLaren's famous boutique in the King's Road, Chelsea. Known at this point as 'Seditionaries', the boutique had previously assumed other identities: in 1971, as 'Let It Rock', it sold 1950s Teddy-Boy-inspired attire; as 'Too Young to Live, Too Fast to Die' (1972), it stocked designs based on zoot suits and Rockers' leather jackets; and as 'SEX' (1974), it offered fetishistic leather and rubber bondage styles. 226

Punk identity was shaped by various factors: the styling of the Punks themselves, the designs of Westwood and McLaren, and McLaren's formation and management of the seminal Punk band, The Sex Pistols. Although Punk is primarily associated with Britain, similar developments were taking shape at the same time in New York's clubs and on the US music scene, among singers like Iggy Pop and Lou Reed and bands such as Television and the New York Dolls. Gradually Punk spread throughout the US and Europe, and into the Far East, notably Japan.

Punk was an anarchic, nihilistic style which deliberately set out to shock. In stark contrast to the naturalistic, colourful garments worn by the generally utopian Hippies, Punk clothing was almost entirely black and consciously menacing. Often home-

226. Seditionaries bondage outfit in black cotton sateen by Vivienne Westwood and Malcolm McLaren, 1976. Deriving elements from army combat gear, the motorcyclist's supplier Belstaff and the fetish clothes sold in SEX, this genderless outfit has 'hobble' straps; a detachable black towelling 'bumflap' (emulating a loincloth); metal D-rings, springlinks, and zips – including a zippered seam under the crotch. Defying traditional notions of feminine beauty, the model has short, spiky bleached hair, wears chunky workboots and swaggers down the catwalk.

made, or bought from second-hand or army-surplus shops, garments were frequently slashed, and worn in dishevelled layers. Clothes for both sexes included tight black trousers teamed with mohair sweaters, leather jackets customized with paint, chains and metal studs, and Doctor Marten boots. Variations included – for female Punks – miniskirts, black fishnet tights and stiletto-heeled shoes and – for both sexes – bondage trousers joined with straps from knee to knee, and heavy crepe-soled shoes. Jackets and T-shirts often featured obscene or disturbing words or images, including Nazi iconography. Fetishistic leather, rubber and PVC were favourite Punk materials, as were washed-out cottons and shining or sparkling synthetics. Garments were festooned with chains, zips, safety-pins and razor blades. Many ready-made Punk styles were on sale at 'Seditionaries', where they were bought by the better-off Punks.

Hairstyles, makeup and jewelry also played their part in the Punk look. Hair was dyed in Day-glo colours and shaved and gelled to create Mohican spikes; makeup was used to produce an unhealthy pallor and to blacken eyelids and lips; multiple earrings were popular and the most extreme Punks also pierced their cheeks and noses. Though public reaction to Punks was initially one of dismay and fear, as the decade progressed aspects of the style began to be commercialized and upgraded until they eventually filtered into both mass-market fashion and high fashion. In 1977 Zandra Rhodes created a Conceptual Chic collection featuring slashed rayon jersey dresses decorated with beaded safety-pins, ball-link chains and random diamantés. Ultimately, Punk had an energizing effect on British fashion, and helped re-establish London's reputation for innovative youth style. It also challenged both masculine stereotypes and long-held ideals of feminine beauty.

In the field of high fashion, the late 1970s produced three discernible trends. In the US, designers excelled in the creation of classic day wear and sporty leisure clothes; in Europe, glamorous fairytale evening wear vied with other escapist modes drawing on ethnic, rustic and retro styles; and in Paris, Japanese designers began to show collections which concentrated on layering and wrapping the body in loose, unstructured clothing.

Although designers continued to present head-to-toe looks, there was also a vogue for constructing a more individualistic appearance by combining high fashion clothes with original ethnic or period dress bought from specialist dealers. For less wealthy consumers, the growing number of low-cost ethnic boutiques and second-hand emporia provided endless style possibilities.

227

227. Zandra Rhodes, Conceptual Chic evening dress, 1977. Juxtaposing tradition with a Punk aesthetic, Zandra Rhodes safety-pinned a tattered jersey skirt to a conventional silk bodice. This garment was always intended as elite fashion, so the holes in the skirt are sited to reveal seductive glimpses of leg and are meticulously finished with zig-zag stitching. The immaculately groomed model wears perfect, unladdered tights and conventional strappy stiletto sandals. Photo by Clive Arrowsmith.

With the 1980s, however, came a shift towards far more expensive, ostentatious fashions, which reflected a more money-obsessed, image-conscious era. It became chic to signal one's wealth by wearing high-cost designer clothes and accessories. Logos proliferated. Louis Vuitton's luggage and bags with their all-over patterns, Moschino's large belt buckles and buttons, Chanel's jewelry and handbags became highly desirable accessories. Filofax personal organizers, Mont Blanc pens and Rolex watches emerged as coveted status symbols. Finance was big news, and the media glorified the lifestyles and huge salaries of young stockbrokers of both sexes. Style guru Peter York invented

228

228. Moschino's fashion shows were theatrical occasions on which the designer sprang surprises on his audience, sometimes mocking both fashion victims and the mechanics of the entire fashion industry. For Autumn/Winter 1986–87 he cheered up a black jacket with one of his unashamedly giant signature gilt belts and, for good measure, added an immense stetson hat.

229. This typically pin-neat mid-1980s power suit for the ambitious female executive was meant to indicate efficiency and drive. In the boardroom it was the equivalent of the masculine city suit. Big, padded shoulders helped to boost confidence while a nipped-in waist and a short skirt emphasized a good figure. The power look was completed by shades and a tidy, swept back bobbed hairstyle.

the word that would be used throughout the decade to describe this competitive breed – Yuppie (young, urban professional). The demand for designer menswear increased and top designers, including Thierry Mugler (1980) and Kenzo (1983), began to add menswear to their collections, a development that was paralleled by the expansion of the specialized male fashion press. For women, who entered the workforce in greater numbers than ever during the eighties, the big-shouldered power suit became a potent symbol and acted both as a protective shield and as a statement of authority. 229

By 1980 London had once again become the centre of the club scene and youth style, with feisty designers creating amusing and challenging fashions for a clientele unhampered by sartorial convention, and new style magazines *The Face* and *i-D* blurring the boundaries between club culture, street fashion and designer fashion. In 1981 Vivienne Westwood and Malcolm McLaren renamed their shop 'World's End' and in the same year Westwood showed her first, highly influential collection, 'Pirate', consisting of asymmetrical T-shirts, pirate shirts, breeches and baggy, flat-heeled 230

boots. This attracted high fashion buyers as well as subcultural fans and fuelled the New Romantic identity of pop stars like Adam Ant, David Bowie and Boy George.

Westwood's Buffalo collection for Autumn/Winter 1982–83 featured large satin bras worn over sweatshirts – an early example of the trend for underwear as outerwear which would have a huge impact on international fashion. In 1982 Westwood and McLaren opened a second shop, 'Nostalgia of Mud', whose closure the following year coincided with the end of their collaboration. From March 1983, when Westwood began to show in Paris, she assumed a new fashion identity, closer to couture than to street style, often reworking historical styles in a contemporary idiom.

In 1983 John Galliano graduated from St Martin's School of Art in London. His much praised final-year collection, 'Les Incroyables', was immediately bought up by Browns, one of London's leading fashion shops. The following year Galliano started his own label with a collection entitled 'Afghanistan Repudiates Western Ideals', which combined Western tailoring with Eastern fabrics and styling. Throughout the 1980s he enjoyed mounting acclaim for supremely elegant and iconoclastic designs, which displayed both his fascination with historical dress – in particular with the styles of the early twentieth century – and

231

233

230. Cover of *i - D* magazine, September 1986. *i - D* was conceived, edited and published by former *Vogue* Art Director Terry Jones. From the outset (the first issue was August 1980) it attracted cutting-edge photographers, journalists, graphic artists, designers and stylists and was revolutionary in featuring 'real people', often in a street setting. Photograph by Barry Lategan.

231, 232. *Left:* Vivienne Westwood's 'Buffalo' Collection, Autumn/Winter 1982–83. This outfit stole the limelight of this highly influential collection: the brown satin bra was worn over a sweatshirt and teamed with a full, layered skirt and leggings.
*Right:* Vivienne Westwood's 'Witches' collection, Autumn/ Winter 1983–84. Inspired by the New York street scene, this collection included sweatshirt and leather garments embellished with graffiti motifs by Keith Haring.

233. *Opposite:* John Galliano for Autumn/Winter 1985–86. Called the Ludic Game – the Ludi were Roman games played to appease the gods – this was Galliano's first professional runway show. He presented jackets that could be worn as trousers or skirts and garments cut on a complete circle – a style that became a hallmark.

his exceptionally complex cut and skilful manipulation of fabric. Another St Martin's graduate, Rifat Ozbek, was also to command international respect with designs inspired by his native Turkish dress, dance wear and the London club scene.

Many of the London collections were textiles-led, and print and knitwear were especially strong. Scott Crolla used ornate floral and multipatterned prints in his foppish menswear, while Vivienne Westwood incorporated graphic designs by New York graffiti artist Keith Haring into her 'Witches' collection for Autumn/ Winter 1983–84. Betty Jackson employed the talents of Timney Fowler and Brian Bolger of The Cloth to create bold, modern prints for her relaxed, stylish clothes, and English Eccentrics established a reputation for eclectic, extrovert prints. Catering for the most adventurous youth market, Body Map's ruffled, tubular garments were made both in monochrome and in lurid coloured knits. Edina Ronay and Marion Foale knitted nostalgic retro-designs and Martin Kidman, Design Director of Joseph Tricot, created influential ranges, including chunky sweaters featuring cherubs and swags.

Accessories were a key component of these exuberant trends. Emma Hope's sculptural shoes with elongated lines perfectly complemented the vogue for dressing-up, and the Canadian-born Patrick Cox launched his shoemaking career with radical designs for Body Map, Vivienne Westwood and John Galliano. Manolo Blahnik's supremely elegant, handcrafted footwear served international fashion markets. Stephen Jones established himself as a cutting-edge milliner, combining the finest craft skills with an avant-garde and often witty aesthetic, and Kirsten Woodward exploited surreal devices for designs commissioned by Karl Lagerfeld for Chanel.

While many British designers were drawn to fantasy and escapism, others actively confronted contemporary issues. Katharine Hamnett brought world peace and environmental issues into the fashion arena with her Autumn/Winter 1983–84 'Choose Life' collection, which featured T-shirts emblazoned with slogans such as '58% Don't Want Pershing' – a design she famously wore to meet Prime Minister Margaret Thatcher. Her decontamination-style bodysuits and fatigues in crumpled, wash-and-wear silks, as well as her more overtly sexy clothes from this period, were all highly influential. Georgina Godley also took a political stance, producing clothes which challenged prevailing ideals of feminine beauty. Her 1986 Lumps and Bumps collection included sculptural undergarments with padded stomachs, hips and bottoms.

One of the leading players in 1980s menswear was the Nottingham-born designer Paul Smith, whose classic, eminently wearable clothes were made distinctive by his hallmark twists,

such as unusually bold colours and quirky patterns. He opened his first shop in his home town in 1970, moved to London's Covent Garden in 1979 and by the late 1980s owned shops worldwide. His was, and remains, a quintessentially British look. Margaret Howell is also attracted to British style and has interpreted for women a variety of typically English garments such as school sports wear and country clothes.

In the 1980s British fashion received a boost from a most unexpected source – the British royal family. When the tall, gauche, nineteen-year-old nursery-school assistant Lady Diana Spencer was photographed by the press in 1980 with the sun streaming through her ordinary print skirt and revealing her long legs to the entire world, few realized that she was destined to become one of the most potent fashion icons of the 1980s and 1990s and a champion

234. *Opposite below*: Martin Kidman for Joseph, Spring/Summer 1986. The painted cherubic decoration of a Meissen plate inspired this hand-knitted and embroidered cardigan. Exploiting the heavenly theme for the catwalk, leading stylist Michael Roberts devised a subversive choirboy look, dressing the models in white robes (at a time when men in skirts were hitting the headlines) and putting wings in their hair. He tempered the angelic look with unlaced, black leather Doctor Marten boots.

235, 236. *Opposite above and right*: Katharine Hamnett can be lighthearted and witty as well as serious and political, as is evident from her hat and matching neckpiece for Autumn/Winter 1984–85 (*opposite*). *Right*: In the same collection, crumpled cottons and silks were teamed with sloganned T-shirts – the model in the foreground wears a 'WORLDWIDE NUCLEAR BAN NOW' design. All profits from T-shirt sales went to Hamnett's charity, Tomorrow Ltd.

of top-level British fashion. Before her marriage in 1981 to Charles, Prince of Wales, Lady Diana inclined towards the style known as 'Sloane Ranger'. Coined by Peter York in 1975, this term was used to describe the appearance of a coterie of young, often titled young women who lived around Sloane Street in West London. For town wear, this group favoured practical separates – frilly-necked blouses, longish skirts over pale tights, good quality sweaters or cardigans, knotted neckerchiefs and padded jackets, all set off by the Sloane's hallmark single row of pearls.

Princess Diana's royal status was to preclude any genuinely avant-garde fashion statements, but her impeccably groomed style proved to have mass appeal. The safe, matronly look of her blue off-the-peg suit in her 1981 engagement photo-call was almost immediately put in the shade by her public appearance in a revealingly low-cut, strapless black evening gown. The designers

237. Lady Diana Spencer, a tall, gauche 19-year-old kindergarten assistant, was caught by a photographer in 1980 tending two of her charges with the sun streaming through her ordinary print skirt. She was a typical 'Sloane Ranger' when this photo was taken.

238, 239. *Left*: Lady Diana moved rapidly out of her 'Sloane Ranger' phase and on her first official engagement with Prince Charles in March 1981 astounded everyone in a daring black taffeta gown by the Emanuels. Though provided with a matching ruffle-edged shawl, Lady Diana was not inclined to conceal her fine shoulders and low décolletage. *Right*: Just two years later, a slimmer Diana, Princess of Wales, chose a one-sleeved, beaded, pale cream chiffon columnar dress by the London-based Japanese designer Hachi for the last evening of the 1983 tour of Australia. It represented a new style, ultra-sophisticated Princess. In June 1997 it was one of the items in the Princess's charity auction in New York.

of this gown, Elizabeth and David Emanuel, went on to create her romantic wedding dress, with its dramatically full skirt, immense train and tight bodice. Copies of this dress went on sale within a week and by the time of her marriage the 'Lady Di' look had been transmitted worldwide by television and the press. For the next sixteen years, acting as a figurehead for the British industry, Diana exerted an immense influence on mainstream fashion, commissioning a circle of designers – including Bellville Sassoon, Caroline Charles and Arabella Pollen – to create 'working' clothes for royal tours or to make showstopping gowns for high-profile occasions. Because most royal events were governed by strict protocol and required hats to be worn, milliners also benefitted from the Princess's patronage. Her hats were custom-made by leading designers, in particular by John Boyd and Graham Smith. In the early 1980s she favoured small, head-hugging styles but as she gained in confidence she began to wear wider brimmed, more dramatic designs. Her growing assurance and sophistication were also reflected in her taste for body-conscious evening gowns and streamlined, brightly coloured day wear. One-shouldered, clinging sheath dresses were created for her by Bruce Oldfield, Hachi and Catherine Walker, while Jasper Conran provided authoritative tailored suits.

239

Although British fashion was admired for the diversity of its designers' talents, the domestic industry was not advanced enough to provide the necessary infrastructure, such as support in launching and marketing the collections of fledgling designers, and as a result many experienced commercial failure. Others chose to show in Paris, where they could draw on a more sophisticated communications set-up, orchestrated by the Syndicale de la Couture, which attracts worldwide attention from the trade, as well as from private clients and the media.

The booming international economies of the early to mid-1980s did much to ensure the survival of the haute-couture industry, though couture clients still numbered no more than two to three thousand women worldwide. Of these, only six or seven hundred bought on a regular basis. Nevertheless, their expenditure was considerable. Business in Paris was greatly boosted by wealthy Americans (who benefitted from the strength of the US dollar), by the expansion of the Japanese market for European luxury goods, and by a new, oil-rich Arab clientele. At this time the five dominant houses in Paris were Christian Dior, Chanel, Yves Saint Laurent, Ungaro and Givenchy.

Couture garments often cost more than many people earn in a year, but the profits made on them are minimal; indeed, the fashion industry usually loses money on haute-couture clothing sales. However, couture collections continue to be designed, staged and publicized – at enormous expense – because they create the prestige which sells not only the clothes themselves but also, and more importantly, highly lucrative licensed goods. Most houses have commercial links with manufacturers who use the name of the house to increase the status, desirability and ultimately the price of their own products. This practice was not new in the early 1980s, but it was at that time that labels became a cult, and licensing took off on an unprecedented scale.

Designer-name perfumes are the most profitable of all licensed goods and form the chief revenue of many Paris houses, so major capital is invested in launching and advertising them. Some designers work closely with manufacturers to ensure the quality and visual identity of products such as luggage, hosiery and sunglasses, but often a company simply buys the right to use the designer's name. To protect future transactions, fashion houses have to retain the all-important exclusivity of their label. If a house is considered to be cheapening the image of the industry, it will be struck off the register of the Chambre Syndicale, the organization which monitors these activities. Chanel and Hermès are

among the very few houses which have remained private companies and have never franchised their names.

Although, compared to Paris, the high fashion industries in the US and Italy are relatively new, their designers were not slow to recognize the commercial potential of producing more accessible diffusion lines. In New York, Ralph Lauren, Calvin Klein and Donna Karan rapidly evolved from being individual fashion designers to heading huge, international diffusion organizations. The top Italian companies – Armani, Fendi, Valentino and Versace – also exploited the success of their designers by developing and exporting diffusion lines worldwide.

It was during the 1980s that a new generation of Japanese designers became key players in the international arena. From 1981 Rei Kawakubo, working under the label Comme des Garçons (Like the Boys), and Yohji Yamamoto began to present their collections in Paris. Along with the already-established Issey Miyake, they formed a new school of avant-garde fashion.

240
241

During the 1970s, Miyake used fabrics made predominantly from natural fibres, often in ikat weaves or handprinted with blocks, but by 1980 he had embraced a more modernistic vision and had developed innovative new materials and garment forms. For Autumn/Winter 1981–82 he teamed zipped silicone bustiers with inflatable, polyurethane-coated polyester jersey pants; for Spring/Summer 1983 wakame (seaweed)-inspired tunics and stoles were created from unevenly pleated synthetic combined with metallic yarn. Padded nylon trousers were shown in 1984 and for Spring/Summer 1988, in collaboration with Maria Blaisse, Miyake created sculptural hats made from moulded polyurethane foam sheeting. Miyake also experiments with natural fabrics and has developed unusual weaves and fibre combinations such as the double-woven silk and Shetland wools, inspired by mushiro (straw matting), from which he created over-vests for his collection of Autumn/Winter 1984–85. Although some of his designs encase the body and restrict movement, Miyake is best known for flowing, organic garments which combine practicality with comfort. 'I do not create a fashionable aesthetic,' he has said. 'I create a style based on life.'

For such a radical, visionary designer, Miyake has been enormously successful. He introduced his Plantation diffusion line in 1981; Issey Miyake Permanente, which features his classic designs, in 1985; and a menswear range in 1986. His work has been exhibited in museums and galleries worldwide and from 1986 has been further publicized and recorded through his collaboration with photographer Irving Penn.

240. *Below*: Comme des Garçons for Autumn/Winter 1984–85. Challenging the sterile uniformity of mass-produced textiles, Rei Kawakubo utilized hand-crafted techniques (or the very latest technology) to create unique fabrics, often designed in-house. For this oversize coat she exploited the inherent qualities of the loosely woven cloth by using the full loom width and making a feature of both the reverse and face sides.

241. *Opposite*: Yohji Yamamoto for Autumn/Winter 1986–87. Yamamoto subverts both Western and Japanese clothing conventions – blurring notions of nation, culture and history – yet acknowledging that fashion is shaped by each. This striking ensemble of long coat of black broadcloth worn over a bright red tulle 1880s-style bustle, photographed in silhouette by Nick Knight, resembles a bird with exotic plumage.

Before forming the Comme des Garçons label in 1969, Rei Kawakubo worked as a stylist in the advertising industry, which perhaps explains her meticulous control over the visual identity of her work, on the catwalk, within retail environments and in the company's many publications. She once famously stated that she designed in three shades of black, and her early collections, inspired by Japanese work wear, were dominated by black and indigo garments, which permitted her to focus on form and shape. Her later works were more radical. In March 1983 she presented a subversive collection which included coat dresses, cut big and square with no recognizable line, form or silhouette. Many were cut 'dis-symmetrically', with misplaced lapels, buttons and sleeves, misshapen cowl necklines and mismatched fabrics. More calculated disarray was created by knotting, tearing and slashing fabrics, which were crinkled, creased and woven in unusual textures. Footwear consisted of paddy slippers or square-toed rubber shoes. The models showing this collection had rag-tied hair, and appeared to be entirely devoid of makeup apart from a disturbing bruised blue on their lower lips. These challenging cosmetics, and the fact that the clothes entirely concealed the body, led to Kawakubo's work being interpreted as an expression of feminism. The fashion press named it the 'Post Hiroshima Look', seeing it as a political comment. Kawakubo's only response has been the statement that she designs for strong women who attract men with their minds rather than their bodies.

Like Kawakubo, Yohji Yamamoto is acclaimed for his radical vision and for his outstanding skill as a cutter. He too made his name in Paris in the early 1980s, though he had worked as a custom designer in Tokyo since 1970 and had established his own studio in Tokyo as early as 1972. Yamamoto is an intellectual design purist who is interested in blurring gender categories. Oversized, layered and draped garments are ingeniously cut to swathe the body, rather than to fall two-dimensionally in the style that characterizes most Western dress. Yamamoto dislikes neat and tidy conformity: his supremely elegant clothes feature asymmetrical hemlines, collars and pockets, lapels that flow to form shawls, and unusually placed darts. He is relentless in his use of black and makes much use of experimental textiles. During the early 1980s, both he and Rei Kawakubo accessorized their clothes with black leather Doc Marten shoes, giving a new fashion cachet to a company previously associated only with utilitarian and subcultural footwear.

While the avant-garde Japanese designers were pushing back the boundaries of fashion, the established Paris houses continued

242. Jean-Paul Gaultier for Spring/Summer 1985. For this collection Gaultier presented a range of cosmopolitan, androgynous – yet body-revealing – designs. The women models wear the *basque*-style berets (with the band showing) that have become one of the designer's signatures.

to specialize in classic tailoring and full-skirted evening gowns. But by the early eighties some newly established French designers – and famous names in new guises – had begun to challenge Parisian high chic. Jean-Paul Gaultier worked with Pierre Cardin and at Patou before presenting his first collections in 1976. Quickly dubbed the *enfant terrible* of Paris fashion, he created post-modern designs that took inspiration from Dada, 1950s glamour, the male peacock and London's club scene. His more daring male clients wore post-Punk Doc Marten boots, leggings and tutus, while even his classic tailoring incorporated touches of impudence, such as naked, cut-away backs. Gaultier's Spring/Summer 1985 collection featured what at first glance appeared to be skirts for men. Tailored in respectable city pinstripes, these headline-grabbing garments were in fact apron-fronted trousers; nonetheless, they proved too extreme for most male consumers. For women he designed body-moulding, conical-bra dresses and bondage styles. He also combined masculine tailored suits with

242

ultra-glamorous corsets and bra tops to create a powerful yet sexy look which was later promoted by pop star Madonna on her 1990 World Tour. Gaultier makes extensive use of man-made fibres, including mock leather, fake fur, nylon, metal and rubber. His work explores sexual transgression and he has consistently used models who challenge conventional notions of beauty.

By the early 1980s Thierry Mugler had brought a buzz of excitement to the Paris collections and had established a reputation for an uncompromising modernity which drew on futuristic and technological imagery. His hard-edged garments exaggerated femininity, whereas Azzedine Alaïa's celebrated natural feminine contours. Affectionately described by the fashion press as 'the king of cling', Alaïa created body-conscious dresses and suits

243. Thierry Mugler for Autumn/ Winter 1983–84. Mugler's seductive and provocative collections draw on a heady cocktail of influences – here 1950s Hollywood glamour queen meets android comic woman. Always serving the curvaceous figure, the designer consistently cuts a broad-shouldered silhouette. He has said that he tries to bring out the goddess in every woman.

244. Claude Montana for
Autumn/Winter 1986–87.
Renowned for his sense of drama
and for providing modern day
armour via his formidable
silhouette, Montana clads his
models in tailored leather
trousers, high-necked sweaters,
ultra-broad-shouldered coats with
cinched-in, leather-belted waists,
and spike-heeled shoes.

in matt black stretch Lycra and leather, with provocative seaming
and an inventive use of zips. Emanuel Ungaro's mid-eighties
shirred, pleated and draped dresses in bold prints were showy and
sensual, while Claude Montana's broad-shouldered garments,     244
including leather greatcoats inspired by military uniform, made
a more aggressively powerful statement. Yves Saint Laurent     245
remained a lead player in the 1980s with collections that paid trib-
ute to fine art and to the exotic elements of non-Western cultures,
and featured his meticulous tailoring, including variations on his
famous 'smoking' tuxedo suits.

In 1983, with the appointment of Karl Lagerfeld as Design
Consultant, the House of Chanel shed the rather fusty image it had

245. The designs of Yves Saint Laurent were synonymous with glamour and in the later 1980s he created seductive suits featuring decorative jackets with impressive shoulders, worn with very short skirts. Dating from 1988, this ensemble has a fitted jacket with an arresting floral and foliate pattern and a plain skirt. Impeccable accessories – high-heeled court shoes, gloves and a flower trimmed boater complete the refined look.

acquired during the twelve years following the founder's death. From the outset Lagerfeld reworked Chanel's designs in an utterly contemporary idiom and, as the decade progressed, allowed his renditions of Chanel style to become increasingly irreverent. With great aplomb, he brought humour and modernity to the house, while at the same time satisfying some of its clients' more classic tastes. In 1984, in addition to designing for Chanel and Fendi, Lagerfeld also began to work under his own name.

The new couture house of Christian Lacroix opened in 1987, with backing from Bernard Arnault, owner of Financier Agache and chairman of the French luxury goods conglomerate LMVH (Louis Vuitton Moët Hennessy). Lacroix, who had taken degree

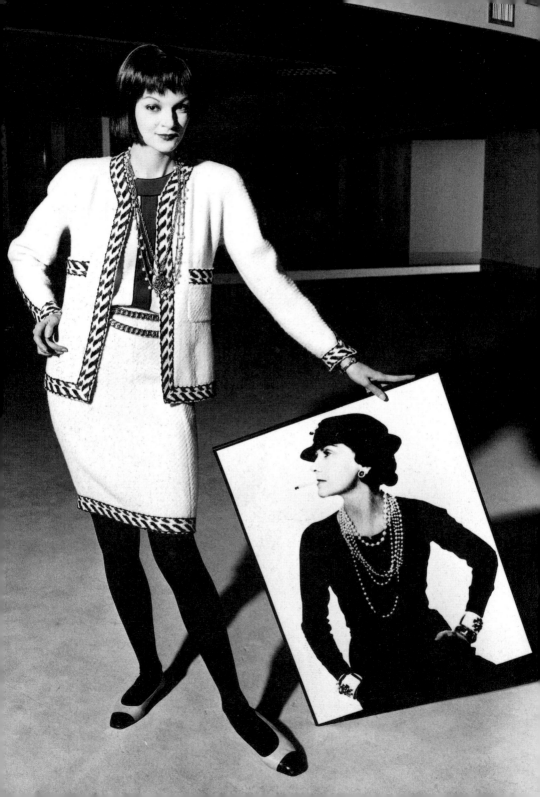

246. *Opposite*: Karl Lagerfeld for Chanel, 'Chanel-Chanel' haute couture collection for Autumn/Winter 1986. Lagerfeld reworked Chanel's signature cardigan-style suit in ivory tweed with double-width braid, a chain belt and an abundance of costume jewelry.

247. *Below*: Christian Lacroix haute couture for Autumn/Winter 1987–88. Dress with a red satin shawl-line bodice over black lace and a short, crinoline-style striped skirt, inspired by the 18th century and by French regional fashion.

courses in both art history and museum studies, was employed initially as a fashion sketcher, then as assistant at Hermès and Guy Paulin, and from 1981 as Artistic Director and Designer at Patou. He presented his first couture show under his own name in July 1987 and introduced a ready-to-wear line in March 1988. Lacroix works in the grand tradition, creating intricately cut garments in luxurious fabrics embellished with handworked beading, tassels, braids, fabric flowers, laces and embroideries, and thereby investing in and supporting ancillary, and in some cases dying, crafts. His exuberant designs are drawn from an eclectic range of sources, including his Provençal childhood, historical costume and London street-styles.

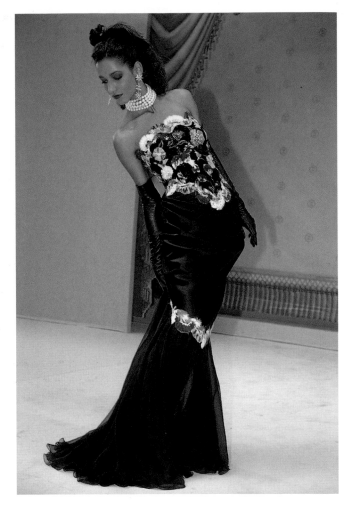

248. Chanel Couture, Autumn/
Winter 1986–87. This refined,
full-length evening gown with
embroidered bodice, worn with
long gloves, is reminiscent of
Chanel's 1930s designs. With
the 1980s penchant for historical
revivals it is perfectly adapted for
a formal evening event.

In the early 1980s Australia produced a wave of talented
designers. Designs by Adele Palmer, and by Stephen Bennett and
Jane Parker for Country Road bore some relation to trends in
Europe but were given a more relaxed styling. Less orthodox
looks were available from a group of artist–designers, including
Linda Jackson, who used colourfully printed cloth in bold shapes,
and Jennie Kee, who made layered knitwear with powerful,
abstract patterns in vivid hues. Australia's long, tropical summers
and endless beaches created key market sectors for leisure and spe-
cialist sports wear. Speedo secured an international market in New
South Wales for streamlined swimwear and spin-off beach and
keep-fit separates in dazzling colours. Young surfers and wind-
surfers customized their clothing and initiated trends in beach-

wear. Protective bush clothes, including the stockman's uniform of tough moleskin trousers and shirts, worn with kangaroo-hide hats and boots, also influenced urban fashion. R. M. Williams manufactured sturdy occupational garments under the slogan 'The Original Bushman's Outfitters', and their 'Drizabone' oilskin coat, with its distinctive shoulder cape designed specifically to resist the climactic and physical ravages of the outback, was adopted as a fashion garment in London, Paris and New York. National events including the Melbourne Cup supported inventive millinery boutiques.

In Italy the fashion boom continued at all levels. While top designers set the stylistic pace in Milan, Italian manufacturers were contracted to make ready-to-wear for the rest of Europe, including many eminent Paris houses and London-based designers. Fashion is Italy's third largest industry, and powerful fashion companies such as Basile, Complice and MaxMara met the growing market for the Italian look by commissioning designs from established names and by hiring fresh talents (many from British art schools). By the mid-1980s a select band of *alta moda* multimillionaires were feted as celebrities. Foremost among these were Gianni Versace and Giorgio Armani, who came to represent the two faces of Italian fashion – Armani advocating classic, understated styles and Versace exploring glamorous, body-conscious designs.

Armani began his career designing menswear for Nino Cerruti. With his first independent collection in 1975 he indicated that his primary aim was to create elegant clothes for an affluent clientele. Central to Armani's design concept, for both men and women, were loosely tailored, roomy jackets which achieved their soft, relaxed shapes by dispensing as much as possible with interfacings and linings. The typical and much copied Armani draped jacket had wide shoulders and long lapels that fastened at or just below the waist with a single button. From his time with Cerruti, Armani brought a highly tuned appreciation of fine textiles. He introduced textured wools and mixtures of contrasting yarns and persuaded men out of the unrelenting charcoal grey, black and blue of city suits into softer brown and beige. Richard Gere helped bring Armani's chic but casual designs before an international audience in the 1980 film *American Gigolo*. Armani avoided gimmicks and refused to pander to the whims of a teenage market – his only concession to younger customers was to sell slightly more affordable lines in Emporio Armani outlets, launched in 1981. At the same time he created Armani jeans and a year later Armani fragrances. In 1983, believing that the razzmatazz of fashion shows,

249

250

249. Top quality wools and silks were crucial to Giorgio Armani's soft line separates, including impeccably made, unstructured jackets. He had a preference for woven stripes, checks and subtle textures in subdued colours. The label became associated with big look, man-styled city suits for women as well as with more leisurely, country-ready ensembles such as this generously sized, wide-shouldered jacket worn over a simple round-necked silk blouse and a gathered skirt in a window-pane check. Spring/Summer, 1986.

with their emphasis on supermodels, threatened to alienate buyers, he took the risk of showing his collections as static displays rather than on the catwalk. Along with Versace and Gianfranco Ferre, Armani was a prime mover in the mid-1980s trend, shared by both sexes, for linen suits.

After working for five years as a freelance designer, Gianni Versace went into business with his sister, Donatella, and brother, Santo, and launched his first collection in 1978. He soon established a reputation for overtly sexy, glitzy evening wear which appealed to socialites and actresses. Each season brought new notes of daring and ostentation. These theatrical and occasionally vulgar statements often eclipsed his more restrained day wear designs, which included, throughout the 1980s, executive-type suits in supple glove leathers and lightweight wools. Versace was fascinated by technology and in the early 1980s he experimented with an aluminium mesh made to his specifications which he

251

suits a casual elegance that was
welcomed by young executives.
Though retaining metropolitan
formality and traditional banker's
stripes, this suit (Autumn/Winter
1987–88), with Armani's famous
long, wide, plunging lapels
(reminiscent of the later 1930s)
had an easy look.

draped close to the body's contours in glistening evening gowns. He investigated the possibilities of using lasers to weld seams and of producing knitwear by computer aided design.

The Missonis continued to produce their signature knitwear. Though demand had peaked by the early 1970s, a decade later their designs were acknowledged to be classics and their research and development set an example to emergent designers.

While Armani and Versace catered for dedicated sophisticates, a new talent, Franco Moschino, was beginning to create clothes that poked fun at the whole idea of high fashion. Moschino started as an illustrator and then joined the Italian clothing company Cadette before presenting his first independent collection in 1983.

252

251. At the beginning of the 1980s Gianni Versace was fascinated with dress made from untailored lengths of fabric – often merely gently twisted and tied round the torso. His investigations culminated in the 'Nonchalance de Luxe' Spring/Summer collection of 1981. Browns and greens were taken from natural colours of earth and plants while softly wrapped, pleated and gathered freedom-giving shapes were inspired by traditional Indian and Turkish costume. Hips wrapped with narrow scarves under tasselled belts united the designs. The juxtaposition of materials – leather, silk, cotton and gold thread was characteristically Versace.

Taking his lead from the Surrealists, he mastered the art of turning an apparently innocuous outfit into a walking commentary debunking the industry. He pilloried fashion victims and mocked famous logos. Moschino's jokes, like his powerful advertisements, were always well executed and the clothes bearing his label were expensive and immaculately made. Ever the businessman, he ensured that his name was emblazoned across most of his designs. His refreshing irreverence earned him the title of 'the bad boy of Italian fashion' but it also punctured the more sanctimonious aspects of that decade's styles.

In contrast to Moschino's impudent, 'upfront' clothes, Romeo Gigli's designs were opulent and romantic, incorporating subtle references to historical styles. Trained as an architect, Gigli showed his first collection in 1983. His palette ranged from opalescent hues to rich, deep shades and he employed a variety of man-made

228

textiles featuring new textured finishes as well as natural fabrics to achieve sensually shaped garments. An exponent of soft lines, he made a feature of high-waisted garments with draped, crossover bodices and asymmetrically constructed, cocoon-like skirts which tapered towards the hems. His work offered young professionals a pretty alternative to the hard-edged executive look which had begun to emerge in the second half of the 1970s.

For women in the highly competitive eighties, the equivalent of the executive look was 'power dressing'. The archetypal big-shouldered profile of the decade had its most enthusiastic support-ers among the Italians and the Americans. Jackets were often double-breasted and though trousers gradually became more acceptable wear in the workplace, the skirted suit remained the safest option. The American soap operas *Dallas* and *Dynasty* made the wide-shouldered, heavily made-up, dominant female into a cult.

252. Missoni for Autumn/Winter 1983–84. Displaying the designers' masterful synthesis of pattern, texture and above all colour, this collection took the theme of 'man the hunter'. Deriving elements from Central European folk dress, the oversize, almost androgynous designs worn in layers were perfectly in tune with current trends. Illustration by Antonio.

Although sometimes accused of sobriety, American designers were justifiably proud of their skill in making appropriate clothes for the ever increasing number of women working outside the home. These designers excelled in creating durable, classic garments which could be interchanged to achieve stylistic variations. Separates were central to the approach and diversity was introduced by varying the silhouette, skirt length and fabrics. In *W*, Calvin Klein gave advice on a 'career chic' wardrobe which involved just three jackets, three sweaters, two skirts and one dress, but these had to be made of expensive cashmere, silk and leather to give 'the woman in authority and power a sense of quality and style'. The emphasis in general was on non-restrictive comfort combined with elegance – the final impact relied on good grooming and a healthy, streamlined physique. The US fashion press recommended that American women should buy Japanese or European imports if they wanted to make overtly theatrical statements.

253

Ralph Lauren and Calvin Klein held to the design formulae that had brought them success. Always insisting on a purity of line, Klein usually made only subtle changes each season to cut, colour, length and proportion, though in his Spring/Summer 1983 collection he abandoned the svelte American image in favour of clothes with pronounced European overtones. Precisely tailored, they featured nipped-in waists and jutting peplums. In the same year he introduced what was to become a phenomenally successful underwear range. Undergarments for women were designed along the lines of men's and included briefs with thick, boldly labelled, elasticated waistbands and boxer shorts with flies. Klein's sexually suggestive advertising campaigns for both men's and women's underwear were both controversial and commercially effective.

Ralph Lauren remained faithful to his best-selling aristocratic 254 English look but extended his sources to embrace American Ivy League and folklore. Particularly influential was the 'New West' style which grew out of his impressions of New Mexico. Also known as 'Indian reservation chic', it comprised boldly patterned 'Santa Fe' hand-knitted sweaters belted over long chamois skirts below which frilled white cotton petticoats were visible. Lauren's aim was to give men and women clothes that announced their success, and to this end he created an entire Ralph Lauren world and philosophy, packaging a style for both home and family from his flagship store in the Rhinelander Mansion, New York, which opened in 1986.

Two women designers based in New York, Donna Karan and Norma Kamali, came to prominence in the 1980s. Trained at Parsons School of Design, Donna Karan began her career as

253. *Opposite*: Calvin Klein favoured a classical minimalism, making clothes that fitted many occasions. His 1980s designs were chic, practical, easy-to-wear and made in exclusive materials. A sweater with an extra large polo neck was teamed with trousers; and, completing the assured look, a wide-shouldered, double-breasted top coat updated the standard camel-hair coat.

254. Throughout the late 1970s and 1980s, Ralph Lauren favoured the American preppy image as well as the English aristocrat at ease look. He was a great believer in the efficacy of pristine white blouses (this one had a ruffled collar) and liked to team them with good tweeds and knitted woollen sweaters. A Fair Isle slipover, matching cardigan, hung nonchalantly on the chair; sensible pleated skirt and 'granny' shoes finished the picture of privilege and good breeding.

assistant to Anne Klein, taking over when Klein died in 1974. Joined by design partner Louis Dell'Olio, she established a reputation for good New York style – mix-and-match classics that were ideal for the office and chic enough to be worn into the evening. Karan produced her first own-label collection in 1985. She understood the requirements of busy professional women and offered them 'big city sophistication' combined with practical features. There were roomy coats that wrapped over suits, adjustable scarf skirts and bloused bodysuits that did not ride up. She aimed to cater to women who had little time to shop by presenting them with lines in standard black, white and neutrals with optional notes of bright colour. From the outset, she included accessories in her head-to-toe approach, declaring that 'my whole collection is based on options and flexibility'.

Norma Kamali's designs had a zanier and more youthful appeal. After graduating from the Fashion Institute of Technology, she opened a boutique in New York with her husband in 1968. Their divorce in 1977 prompted the name of her next boutique, OMO (On My Own), which was noted for its concrete interior and spectacular window displays. From this base she sold extrovert designs which attracted a celebrity clientele. Her work was adventurous; she produced the first hot-pants in New York and became known for her quilted down 'sleeping bag' coats. In 1981, for the Jones Apparel Group, Kamali took the humble cotton fleece tracksuit into high fashion with her influential range of 'sweats' in black, grey, pink and powder blue. She made curvaceous tops with saucy peplums and huge shoulder pads, and teamed them with tiny rah-rah skirts inspired by cheerleader outfits or with leggings cut like jodhpurs with long welts which reached to the knees. Such designs were easy and cheap to copy and soon high street chains were selling mass-produced versions in pretty pastel shades and the top seller, grey. This activity wear was personalized by layering cotton tops which were allowed to fall nonchalantly off the shoulders but were secured by deep leather belts. The success of Kamali's leisure lines came near to eclipsing the rest of her work, which ranged from sophisticated evening gowns to provocative swimwear.

256

A similar youthful energy marked the work of Perry Ellis, known as the Mr Pop of American fashion. Ellis entered the industry through retail and produced his first solo collection in 1978. His aim was to make bold, offbeat statements that appealed to young clients, and he made his name through his oversize jackets and trousers, voluminous skirts and big sweaters. Knitwear played a key role in his output, ranging from tight bustiers to chunky, long-line sweater dresses. Ellis sold knitting kits and had a notable success in 1984 with a knitted collection inspired by Sonia Delaunay's vivid geometric paintings and designs. His career was cut short by his premature death in 1986.

255

In addition to America's big names, New York and California nurtured a wave of small-scale designers who were free from the financial dictates of large corporations and could afford to take risks with unconventional concepts and labour-intensive craft techniques. In New York, Marc Jacobs and Stephen Sprouse were foremost in this group of inventive and at times iconoclastic designers. Though California was not on the international collections circuit, it supported an important mainstream garment industry, with manufacturers in San Francisco and Los Angeles specializing in leisure and sports wear. In addition to major high

fashion figures such as James Galanos, and innovative ready-to-wear companies like Esprit, the West Coast environment provided inspiration for artist–craftsmen making limited addition garments and accessories. A sophisticated extension of the wearable art movement which began in the 1970s, its exponents sold exclusive pieces ranging from intricate multicoloured shoes by Gazaboen to Ina Kozel's resist-printed silk kimonos. While the East Coast fostered links with the European industry, California – on the Pacific Rim – exploited the Tokyo/Hong Kong cultural axis. World economies were shaken by the stock market crash on Black Monday, 19 October 1987. This brought about a financial downturn in the fashion trade and had significant stylistic repercussions in fashion design.

255. *Opposite*: Perry Ellis made leisure wear his speciality, often employing bold, figurative, eye-catching images to make young, fun knits. In 1985 he used a Queen of Hearts playing card design to create an amusing sleeveless summer sweater. Plain, slightly cropped tapered pants and simple slip-on shoes kept the attention focused on the powerful graphic design.

256. Norma Kamali created sports wear that was defiantly high fashion but was also practical and easy to move in. This vivacious outfit from her famous and much copied 'Sweats' collection of Spring 1981 has many of her hallmarks – shoulders extended on huge pads, a pretty little peplum skirt gathered into a dropped waist, and voluminous pants gathered into below-the-knee bands. Absorbent fleecebacked cotton knit was the standby of all sports practitioners but Kamali added a new dimension to the word tracksuit.

# Chapter 9: 1989–1999
## Fashion Goes Global

During the recessionary years of the early 1990s, there was a reaction against the conspicuous consumption that had characterized the previous decade. The term 'designer' began to be used pejoratively, to encapsulate all that was brash about the 1980s. As social life became more restrained and ailing economies restricted disposable incomes, sales of high fashion apparel fell. The fortunes of the fashion houses were further hit by the Gulf War, which halted the lucrative trade with Arab Emirate countries and also led to a drop in duty-free perfume sales. As in the crisis period of the late 1960s, clothing design began to reflect a general interest in ecology and spirituality and many designers looked for inspiration to communities whose garments and bodily adornment were not shaped by international fashion trends. Authenticity became the new buzzword and subcultural style and ethnic clothing traditions entered fashion as major influences.

It has long been accepted that styles trickle down from the catwalks into mainstream fashion, but for many years there has also been increasing evidence of the reverse process. Echoes of 'the street' had already been apparent in high fashion throughout the 1970s and 1980s, but during the early to mid-1990s collections began to brim with references to an eclectic range of subcultures, past and present. These included Hippie style by Dolce & Gabbana, B-Boy and Surf by Karl Lagerfeld for Chanel, Rasta from Rifat Ozbek, Ragga by Calvin Klein, Teddy Boys and Mods from Paul Smith and hybrid ethnic-subcultural styles from Jean-Paul Gaultier. Tattooing and facial and body piercing also became part of mainstream fashion.

In the very early 1990s Punk and Hippie style combined to form the Grunge look. Grunge was a colourful, dishevelled style in which clothes that were homemade, customized or second-hand were worn in layers and accessorized (for both sexes) with heavy ex-army boots. It had its roots in the Seattle pop groups Nirvana and Pearl Jam and was in many respects a reaction against the 'go-getting' society of the 1980s. Grunge was particularly influential in the US, where the look was interpreted for a youthful market by Anna Sui and Marc Jacobs, and given more classic spin-offs by

257. Illustration from Jean-Paul Gaultier's Spring/Summer 1991 collection. Gaultier continually challenges and blurs orthodox conceptions of gendered dress (he introduced his menswear line in 1984). Note the similarity in design of these outfits, which reveal influences from subcultural rockers, city tailoring and ethnographic dress.

257

Donna Karan and Ralph Lauren. In Britain – the home of negli-
gent chic – Grunge elements merged with New Age Traveller
dress, both on the street and within the fashion industry. Neither
of these styles was particularly successful with high fashion con-
sumers, whose lifestyle required more formal attire, and who – not
surprisingly – refused to pay catwalk prices for a thrift-store look.

Interpretations of non-Western clothing traditions took many
forms in the 1990s. Chinese and Japanese sources inspired the cut
and decoration of designs by Valentino, Alexander McQueen and
John Galliano. Versace adapted the sari; Romeo Gigli created

258. *Opposite left*: Inspired by dance and classical dress, Romeo Gigli created this sensuous gown for Autumn/Winter 1989–90. It features an asymmetric bodice that wraps the body and a fluid skirt.

259. *Opposite right*: Calvin Klein Spring/Summer 1993. Klein presents his own brand of elite anti-fashion, the antithesis of 1980s power dressing. Kate Moss is 'grunge'-styled, with dishevelled hair, headscarf and apparently makeup-less face, but, ever the commercial genius, Klein has produced eminently wearable separates which capture the vogue for sheer and floaty fabrics.

oriental fantasies in the manner of the Ballets Russes, and Rifat Ozbek produced romantic interpretations of his native Turkish dress. From the mid-1990s, several designers brought out their own versions of the shalwar kameez, the traditional dress of men and women in parts of Pakistan, which consists of a long shirt and trousers gathered at the ankle. Various cultural observers suggested that the marketing of authentic ethnic clothing in the West reduced non-Western cultures to little more than the latest style statement. But some designers, notably Issey Miyake, Iranian-born Shirin Guild, and the Indian-born designer Asha Sarabhai, managed to avoid pastiche or nostalgia by reworking their own cultural clothing traditions in a reductionist aesthetic which resulted in modern, functional clothes that were in many respects transcultural.

260
262

260. Issey Miyake, Spring/Summer 1994. Miyake's featherlight, machine washable, non-crease polyester 'Pleats Please' line, introduced in 1993, was an instant success and proved to be ideal for travelling. Though a familiar Western dress shape, this cylindrical garment is sculpted around the body and dispenses with the traditional back and front form. In rainbow-bright colours, it suggests paper lanterns and origami folds.

261. *Left*: Rifat Ozbek celebrated the new decade with his all-white New Age collection for Spring/Summer 1990 (his last London show), which displayed Turquerie, club, street and sports wear influences.

262. *Right*: Shirin Guild for Spring/Summer 1996. Inspired by the cut of Iranian menswear and utilizing the finest British fabrics, Shirin Guild created a look that could be described as ethnic minimalism. Here the Abba coat, a holy garment worn by men in Iran, and Kurdish pants have been translated in brown wool and teamed with a square waistcoat and pale blue cotton shirt to create a modern urban suit for inclement summer days.

In keeping with the more dressed-down mood of the 1990s, many men (often portrayed by the media as 'new men' – sensitive and caring) discarded their broad-shouldered and boxy 'power' suits in favour of softer, more subtly tailored garments with sloping shoulders and a long, lean fit. Single-breasted jackets dominated and the more informal Nehru style also became fashionable. In the UK, a number of cutting-edge tailors entered the bespoke trade, leading to a marked increase in the demand for custom-made suits among young, fashion-conscious men. Conversely, the US led the trend for 'dress-down' days in the workplace and some companies adopted a permanent dress-down policy, which allowed smart casual wear to replace the executive suit.

Rifat Ozbek's enormously influential all-white New Age collection of 1990 epitomized the desire for spiritual enlightenment. Other designers actively embraced eco-issues: Katharine Hamnett endorsed environmentally friendly fabrics and processes and in 1992 Helen Storey advocated recycling at a high fashion level. For her Second Life collection, Storey customized thrift-store clothes and sold them alongside her own eclectic designs. Natural fibres and nature-inspired textile designs were popular throughout the decade and the cultivation of hemp – decriminalized for textile purposes – provided designers with an additional option for fabric and yarn. Comfortable and sturdy footwear – including cork-soled Birkenstock sandals, chunky walking boots and various styles made from leather substitutes – formed an important component of eco-fashion. Picking up on these trends, the cosmetics industry developed a host of natural and 'botanical' products.

Concerns about global issues were matched by anxieties regarding personal welfare and safety. The Italian company Superga created bullet-proof clothes, with built-in air pollution masks, acid rain protection and infrared, night-vision goggles. Lucy Orta, a Paris-based conceptual designer, addressed world conflict and the destruction of urban life. Her Refuge Wear range, introduced in 1992, featured multifunctional survival clothes which adapted to form tents and sleeping bags.

From the early 1990s the anti-fur movement, led by proactive pressure groups and supported by high-profile public figures, lost some of its foothold when many designers used real pelts in their collections. Fake fur remained popular, though those with the strongest anti-fur convictions believed that realistic imitations of fur should also be banned, since they could signify a desire to wear the 'real thing'. In response to criticism, the fur industry pointed out that synthetic fur is inflammable, not biodegradable and not as

261

warm as real fur. Less controversial were sustained winter trends for modernistic quilted and padded outerwear.

In the early to mid-1990s technological developments and a fascination with the future gave rise to what became known as cyber fashions. These were inspired by Punk, science fiction, virtual reality, cult films such as *Mad Max* (1979, 1981, 1985) and new genre adult comic characters. Industrial and futuristic clothing was constructed from materials that had never before been used in fashion, notably neoprene, polar fleece and high performance micro-fibres. Cyber fashions also took inspiration from the rubber, PVC and leather beloved of the fetishist, as well as from specialist sports clothes and footwear. All these materials and styles fed into both mainstream and high fashion.

One of the most significant fashion phenomena of the 1990s was the active promotion of 'supermodels'. The fame of Linda Evangelista (who 'wouldn't get out of bed for less than $10,000 a day'), Christy Turlington, Cindy Crawford, Claudia Schiffer, Naomi Campbell, Kate Moss, Stella Tennant and Honor Fraser, rivals that of top film and pop stars and has done much to retain public interest in high fashion. However, the early to mid-1990s vogue for ultra-thin 'super waif' models provoked criticism of the industry when it was linked to a rise in eating disorders. The use of models in photographs which were styled so as to suggest that such extreme thinness was due to drug-taking was also condemned. In 1997 and 1998, fashion's preoccupation with pre-pubescent models generated additional concern.

264
259

Late-twentieth-century fashion remained a labour- rather than a capital-intensive industry. At the most exclusive end of the market, couturiers demanded the most refined, intricate and time-consuming handworked craft skills in the creation of their product. Technological developments such as computer-aided design (CAD) and computer-aided manufacturing (CAM) were a major boon to the mass-production and large-scale designer level industries. However, even bulk orders were often split and subcontracted to small manufacturing units and outworkers, who continued to provide a cheap and flexible source of production to a notoriously volatile trade. Although legislation has undoubtedly been improved since the early twentieth century, the highly competitive fashion and clothing industries were still, at the century's end, partly supported worldwide by a vulnerable and exploited labour force.

In periods of recession consumers become highly discerning and top quality 'investment' goods generally sell well, irrespective

263. Fendi for Spring/Summer 1992. Already known for their fur and luggage designs, Fendi introduced a ready-to-wear collection in 1977, followed, during the prosperous 1980s, by ranges of gloves, ties, stationery, jeans, furnishings, perfume and a junior line, Fendissime. Here, Claudia Schiffer models a chic summer two-piece ensemble with a 1950s feel.

264. Dolce & Gabbana for Spring/Summer 1992, modelled by Cindy Crawford. Part of the vocabulary of twentieth century fashion (and fine art) was the annexation of text. Known for their ironic stance, the design duo used a collage aesthetic to exploit the fashion fetish for designer names and romantic cliché.

of price. Although in 1990 a couture gown could cost as much as a sports car and a tailored suit as much as a transatlantic flight by Concorde, some women continued to demand luxurious and prestigious clothing. During the early 1990s, however, haute-couture clients were at an all-time low, numbering little more than two thousand. Nevertheless, these often high-profile figures sustained the industry by appearing at key events wearing clothes that promoted a particular designer.

Gianni Versace maintained his position as dresser to the world's wealthiest and most glamorous men and women – his fetishistic and homoerotic fashions and advertising campaigns were enormously influential. In July 1997, the designer was murdered outside his Miami home and his sister and muse, Donatella, took over the design helm. Three years previously, Moschino had also died; in 1993, a year before his death, 'Ten Years of Chaos', a retrospective exhibition held in Milan, captured a decade of his witty output. Giorgio Armani continued to enjoy acclaim for his understated, stylish designs. Dolce & Gabbana – design duo Domenico Dolce and Stefano Gabbana – brought new energy to Milanese fashion with their glamorous, sexy designs. They have been greatly influenced by the sultry romance of southern Italy and imagery from films by Roberto Rossellini and Luchino

264

265. Giorgio Armani menswear 1996, photographed by Peter Lindbergh. With consummate ease, Armani made the transition from 1980s styling to the pared-down look of the 1990s. This model wears sunglasses (a top-selling designer spin-off) and softly tailored separates in subtly contrasting colours and textured fabrics. The scarf adds a nonchalant touch.

266, 267. *Opposite*: Dolce & Gabbana menswear for Spring/Summer 1994. The design duo often stated that they liked to explore the feminine side of the man and the masculine side of the woman. This collection of sarongs, white ribbed vests, linen knitwear and layered, patterned linens – with waistcoats worn over untucked shirts – was modelled both barefoot and with biblical-style sandals. D&G were designing for a new male client, whom they defined as a traveller of the soul, looking inside himself to find the answer.

Visconti, as well as by subcultural styles and religious attire: for Spring/Summer 1994 their menswear collection paid homage to Hare Krishna followers, featuring sarongs teamed with white cotton singlets. Missoni's colourful geometric knits once again made top fashion news in the late 1990s. 266 267

From the early 1990s, Paris enjoyed an influx of international fashion talent, including a coterie of radical new Belgian designers trained at the Royal Academy of Fine Arts in Antwerp. Perhaps best known of these is Martin Margiela, who worked as design assistant to Jean-Paul Gaultier from 1984 to 1987 and showed his first Paris collection in 1988 for Spring/Summer 1989. Margiela combines fine tailoring and meticulous finish with a look of contrived disarray: garments appear to have had their sleeves ripped off and often feature meticulously created frayed edgings, external seaming and exposed linings. Ann Demeulemeester began showing in Paris in 1992 and, like Margiela, favours a monochrome palette. Her layered, flowing clothes are made in high quality fabrics, sometimes with unusual textures and an antique patina. Known since 1986 for his innovative menswear, Dirk Bikkembergs emphasized the versatility of his designs by showing a collection

268. Dries van Noten for Spring/Summer 1997. Late 1990s fashion teemed with international references, and Asian styles motivated many of van Noten's designs. Here, using a multiracial group of models, he combines spare tailored jackets, shirts and sleeveless tops with ornate, sheer fabric skirts, many worn over trousers in a style evocative of the shalwar kameez.

268

of unisex clothes in Winter 1995. Dries van Noten made his name with men's and womenswear collections which reveal 'urban ethnic' influences.

Austrian designer Helmut Lang presented his womenswear in Paris from 1986 until 1998 (his Autumn/Winter collection for 1998 was shown in New York) and his menswear from 1987. What he calls his 'non-referential fashion' consists of downbeat, enduring and elegant designs, which are also uncompromisingly contemporary. Another modernist is Jil Sander, who had already established an international business for her men's and women's fashions, eyewear, fragrance and cosmetics in Germany before she began to show her authoritatively chic, tailored clothes in Paris in 1993.

Vivienne Westwood continues to rework British sartorial traditions and historical styles with a combination of irreverence and sophistication. Her exclusive Gold Label, which is described as

269

demi-couture and which offers an individual service almost to haute-couture standards, is presented in Paris, where Westwood has shown since 1982. Her diffusion, ready-to-wear Red Label is shown in London. In March 1998 she introduced the Anglomania label – a cheaper range of her most successful designs since the 1970s – which she showed in Milan. The platform-soled shoes famously presented by Westwood as part of her Mini-Crini collection for Spring/Summer 1986 – and which were virtually laughed off the catwalk – became a key 1990s fashion footwear statement.

From the mid-1990s the couture trade picked up in Paris, a result largely of improving economies and of Bernard Arnault's shrewd employment of maverick young designers to revitalize

269. Vivienne Westwood's 'Anglomania' collection for Autumn/Winter 1993–94. From punk anarchy to elite couture, Westwood has consistently exploited tartan fabrics and has been instrumental in establishing the 1990s vogue for handcrafted and traditional textiles. Linda Evangelista wears a tartan mohair jacket with a contrasting tartan shirt, tie and mini kilt-cum-polonaise skirt. Argyle stockings and Westwood's notorious black patent-leather platforms complete the outfit.

270. Alexander McQueen for Autumn/Winter 1995–96. Shown on a heather and bracken catwalk, the 'Highland Rape' collection featured see-through, torn and apparently devastated clothes, many in tartan fabrics. The show was a comment on what the designer perceived as England's rape of Scotland during the Highland clearances, though it was misinterpreted by many critics, who understood it to be a reference to the rape of women.

271. Staged in the authentic working-class setting of London's Borough Fruit Market, Alexander McQueen's Autumn/Winter 1997 collection, 'It's a Jungle Out There' (styled by Simon Costin), portrayed the models 'as urban warriors with animal instincts', wearing body-moulding leather garments punctuated with curly ram's horns.

long-established houses. In 1996 Arnault appointed John Galliano as creative director of the house of Givenchy, where the designer wooed a new, young clientele with his fantasy fashions. The following year Arnault moved Galliano to Dior, recognizing that the British designer's feminine and romantic creations were a natural evolution from the designs of the house's founder. After much speculation, Arnault announced that Alexander McQueen, the trailblazer of 1990s British fashion talent, would replace Galliano at Givenchy.

Before forming his own label, McQueen studied at Central Saint Martins College of Art and Design and gained experience within the industry, working for Romeo Gigli and Koji Tatsuno, as well as for Savile Row tailors Anderson & Sheppard and Gieves & Hawkes. In February 1993 McQueen's first commercial collection (for Autumn/Winter 1993–94) was presented in a static format at London's Ritz Hotel. Photographic stills from the film *Taxi Driver* were printed onto duchesse satin frock coats and circular skirts which were teamed with black chiffon shirts with sleeves four foot long. From the outset, McQueen revealed both his superb tailoring skills and his entirely original, sometimes shocking, fashion vision. His Highland Rape collection of Autumn/Winter 1995–96 – a comment on the Scottish Highland clearances of the

270

eighteenth century – featured ripped bodices and T-bar connecting chains between the front and back of the skirts. 'Bumster' trousers (cut low at the back to reveal the cleavage of the bottom), dashing frock coats, swaggering military-style coats, lace dresses and body-moulding, tailored jackets with crescent moon shoulder peaks are among his many powerful, feminine styles.

McQueen's first haute-couture collection for Givenchy, presented in January 1997, was inspired by Greek mythology and featured exquisite chiffon goddess gowns, and gladiator dresses in shiny gold leather. Later collections included skintight dresses in PVC, lace and leather, and full-length coats in dyed snakeskin. McQueen designs five collections each season: haute couture, ready-to-wear and a pre-collection (featuring classic pieces) for Givenchy, plus his own-label men's and womenswear, which he stages with great panache in London. For each, he successfully combines his unique creative flair with technical expertise and commercial appeal.

Other top houses have also headhunted British art-school-trained designers. The house of Chanel employed knitwear designer Julien MacDonald while he was still a student at London's Royal

272. Chloé for Spring/Summer 1998. Stella McCartney's homage to Chloé's heyday in the late 1960s and early 1970s – a heady combination of floaty dresses and rock-chic – caught the late 1990s fashion mood for haute-bohemia. This model wears a fitted, open-necked shirt beneath a corset top, and a provocative, unbuttoned fitted skirt.

College of Art. After graduating, MacDonald launched his own line of ingenious cobwebby knits. The Irish-born milliner Philip Treacy, who also trained at the Royal College of Art, in addition to his own bespoke and diffusion lines, designs for both Chanel and Givenchy. His extraordinarily innovative and stylish creations revitalized hat-wearing in the 1990s. In 1997 the house of Chloé appointed St Martin's graduate Stella McCartney, daughter of Sir Paul and Linda McCartney, as their new designer. McCartney's romantic, fluid designs are at once utterly contemporary and perfectly in tune with the Chloé house style. Alexander McQueen and Julien MacDonald have both accessorized their collections with sculptural, modernistic, sometimes fierce-looking accessories and millinery by ex-ceramicist Dai Rees, who launched his own label in 1998. American designers also exerted a strong presence in Paris, with Michael Kors at Céline, Narciso Rodriguez at Loewe, Alber Elbaz first at Guy Laroche and from 1999 at Yves Saint Laurent, Peter Speliopoulos at Cerruti and Marc Jacobs at Louis Vuitton.

272

Despite the raised profile in the mid-1990s of cutting-edge couture, it is the ready-to-wear collections – once the poor relation of haute couture – that are being used today, more than ever, to publicize licensed goods. In turn, cheaper diffusion lines, which were little advertised in the 1980s, now feature on the catwalks. The US industry has been particularly quick to recognize and respond to the shifting nature of the market and has been enormously successful in producing a number of diffusion ranges and in adapting existing lines to suit current circumstances. Ralph Lauren creates more than twenty clothing lines, Donna Karan's DKNY line – originally devoted to informal and leisure clothes – has expanded to embrace more formal attire, and Calvin Klein has enjoyed huge success with his young, minimal and sporty designs and fragrances, while at the same time retaining a loyal clientele for his more luxurious, pared-down fashions. Tommy Hilfiger's clean-cut sports wear achieved an enviable, almost anti-fashion status when it was endorsed by city gangs of homeboys. In 1994 Hilfiger introduced a range of tailored menswear and later launched two scents – Tommy (1996) and Tommy Girl (1997).

273

Accessories made top fashion news throughout the 1990s, with bags commanding special importance. Long-established companies revamped their images; a number of specialist designers entered the market, and fashion designers launched their own ranges. Storage design was also extended into garments, notably in the Autumn/Winter 1992–93 collections, when Isaac Mizrahi presented black leather jackets with two snap-fastening bags in

place of front pockets, Chanel showed quilted bumbags suspended from belts, and John Richmond introduced riding-style jackets with no fewer than ten buttoned pockets, placed in two symmetrical rows down each front.

The Italian designer Miuccia Prada transformed the Prada label (founded in 1913 and previously known for leather accessories) with her sleek, understated clothes and her minimalist range of nylon bags and rucksacks. The latter became the ultimate high-status but suitably low-key accessories of the 1990s. American fashion designer Tom Ford brought modernity and a penchant for black to the Gucci label, while the innovative Martin Margiela was appointed designer at Hermès. Marc Jacobs added new zest to Louis Vuitton's bags and luggage and introduced a clothing line. Contributing to the vogue for bags as part of the fashionable

273. The patronage of high profile rappers, including Grand Puba, Coolio and Snoop Doggy Snoop, helped promote Tommy Hilfiger's sports wear. Harnessing this street credibility – he already enjoyed an extensive market for his classic designs – Hilfiger's advertisements showed B-Boys adorned in chunky gold jewelry wearing garments emblazoned with his name.

274. *Left*: DKNY, for Spring/Summer, 1994. At all market levels, sports wear styles in comfortable stretch fabrics and training shoes were popular items of leisure wear for the 1990s. For her diffusion range, DKNY, Donna Karan adapted the design of American baseball clothes to create this zip-fronted dress, with flattering dark-coloured side panels and signature scoop neck.

275. *Above*: Isaac Mizrahi for Autumn/Winter 1992–93. Since forming his own company in 1987, Mizrahi has gained a reputation for strong shapes, luxurious materials and functional designs, punctuated by the occasional visual joke – such as the snap-fastening bags which double up as pockets on this otherwise classic leather jacket.

wardrobe, Isaac Mizrahi, Richard Tyler, Ann Demeulemeester and Helmut Lang all announced in 1998 that they were launching their own ranges.

Despite the fact that handbags generally increased in size as the twentieth century progressed – reflecting the changing needs of women – a number of 1990s designers specialized in small, special-occasion bags. Working in this vein were American designer Judith Leiber, renowned for her exotic daytime bags made from reptile and ostrich skins, and for her delicate, rhinestone-patterned *minaudière*-style evening bags; Italian Emanuele Pantanella, who crafted refined evening bags from precious woods; and London-based Lulu Guinness, who created a range based on flower baskets. 276

During the final decade of the twentieth century, fashion revivals almost caught up with themselves. In the early 1990s the styles of the late 1960s and early 1970s were inspirational and by the mid-1990s aspects of 1980s fashions were already being recalled – notably accentuated shoulders, which were given contemporary appeal when combined with subtle, pared-down tailoring. Although fashion was pluralistic, distinctive seasonal trends in cut, colour, cloth and decoration could still be identified on the international catwalks and these were presented by the press as prevailing themes.

Key looks from the collections for Autumn/Winter 1998–99 included minimal, precision-cut clothing; modernistic, sculptural designs, predominantly in neutral hues, especially grey; and, in complete contrast, vividly coloured, fluid bohemian styles. All three were united in their emphasis on ultra-luxurious (primarily natural) materials, including super-fine suede and leather, cashmere, real and fake fur, exotic feathers, hand-felted wool, and embroidered and beaded tweeds. In particular, cashmere was used in abundance and with versatility: in the US Donna Karan showed cashmere shell suits, Michael Kors created long-line cardigans and Ralph Lauren presented the tiniest cashmere item – a G-string! Also in vogue were fine lace, cobweb knits and organza and chiffon garments, often worn in layers. In an altogether different mood, paying homage both to Joan of Arc and to the futuristic works of Paco Rabanne, chain-mail weaves and metallic fabrics were shown by McQueen, Versace and Ferre.

The vogue for spare, body-skimming designs brought with it minimalist interpretations of army fatigues and sports wear: garments with quilting, hoods and zipped or Velcro fastenings could be seen in collections by Jean Colonna, Mark Eisen, Jil Sander, Martine Sitbon, Calvin Klein, DKNY and Nicole Farhi. The refined, 274
understated tailoring of 1950s Parisian haute couture, especially

276. Lulu Guinness handbag, 'Florist's basket', 1996. This whimsical, chic design in black silk satin with red velvet roses has contributed to the vogue for small, special-occasion bags.

designs by Balenciaga and Jacques Fath, provided inspiration for Martine Sitbon, Mark Eisen, Sportmax and Nicolas Ghesquiere (at Balenciaga), all of whom featured 1950s-style caped shoulders and sleek lines.

Junya Watanabe, Yohji Yamamoto, Tse N.Y. and Atsuro Tayama layered and manipulated fabrics to construct exquisitely cut garments that owed a debt to various sources, including Picasso and Braque's Cubist works, the architecture of the Modern Movement, and the origami clothing forms of early 1980s Japanese designers. The Cubist influence also revealed itself in the vibrant textiles used by Romeo Gigli, Jean-Paul Gaultier, Martine Sitbon, Givenchy and Comme des Garçons.

Those with a love of ornate fashion were well served by the embroidery and sequins used in abundance in fashions at all market levels, and most lavishly at the John Galliano for House of Dior haute couture show. For the latter, Lesage produced its most costly embroidered outfit, which took two thousand hours to execute.

Etro, Lainey Keogh, Marni, Chloé, Julien MacDonald, Clements 277 Ribeiro and Rifat Ozbek led the vogue for de luxe bohemian styles, 278 producing long-line, layered clothes in brocades, deep pile velvets, and patchworked and fringed fabrics, all in a rich palette of amber, terracotta, moss green, deep purple and gold which recalled the work of the Pre-Raphaelite painters. Patterns were bold – some inspired by turn-of-the-century Art Nouveau designs.

By October 1998 the fashion press reported that the shows for Spring/Summer 1999 were marked by a new sobriety. As a direct result of the Asian financial crisis, many fashion houses saw profits fall. Consumers in Hong Kong, Japan and Korea had become more discerning about price, were generally less in awe of European and American labels and market trends revealed a growing confidence in Asia's own increasingly sophisticated high-fashion industries. Thus, in a bid to lure back this key market sector (Asian and Pacific buyers had accounted for about half of all French luxury goods sales) many designers focused upon wearability, quality and value.

At this point it was timely for Australia's burgeoning high-fashion industry to assume a more important profile. By 1998 – four years after Sydney Fashion Week had joined the international circuit of Spring/Summer shows – the world's press and buyers enthused about the relaxed elegance of the Australian collections. Particularly applauded were Collette Dinnigan's beaded and embroidered chiffon dresses and sari skirts in opulent shades of pink and green; Akira Isogawa's delicately embroidered georgette and organza shift dresses; and Saba's sleek, urban collection of

277. Julien MacDonald evening dress, Spring/Summer 1996. V-neck T-shirts and 1930s bias-cut gowns inspired this intricately machine- and hand-knitted viscose and Lurex dress with a semi-circular train. Modelled by Honor Fraser.

278. Clements Ribeiro for Autumn/Winter 1997. Fun-to-wear, rainbow-coloured and featherlight (one-ply) cashmere sweaters for men and women in bold diamonds, squares and striped patterns were Suzanne Clements and Inacio Ribeiro's trademark. Their highly desirable designs disseminated to all market levels: they widened their market by signing with the British high street fashion chain Dorothy Perkins to create special collections.

slim pants, tunic tops and pencil skirts in grey and khaki. Furthermore, in light of international currency fluctuations, Australian designers benefitted from competitive pricing overseas and the decreasing importation of exclusive fashion.

In spite of these trends, in the final years of the twentieth century, Paris, Milan, New York and London remained the world's major fashion capitals, to which designers continued to migrate in order to make their mark. However, though Paris remained the most popular location, the industry itself was no longer dominated by the French: the capital hosted shows by designers from around the world, as well as engaging international talents to create for its own long-established houses.

In 1999 high fashion remained – as in the previous century – one of the most immediate forms of cultural production, and embodied and reflected socio-economic and technological developments. The Internet facilitated the lightning-speed communications so vital to the fashion industry and, along with television channels, provided a twenty-four-hour home shopping service. Revolutionary textile developments, many initiated by the sports wear industries, fed into and broadened the boundaries of fashion colour, textures and construction. Engineered textiles combined natural fabrics with glass, metal and carbon dioxide to create

279. *Opposite*: Designed to dazzle: Christian Dior haute couture for Spring/Summer 1997. Recalling the cut of 1930s evening gowns, the elaborately worked fabric of this design draws inspiration from paintings by Gustav Klimt and Sonia Delaunay.

280. *Right*: Yohji Yamamoto, Autumn/Winter 1991–92. Picking up on womenswear trends for bright colour and exotic prints, this season's designers – including Versace, Moschino, Ferre and Yamamoto – showed bold pattern and Pop Art designs for their menswear collections. With post-modern irony, Yamamoto emblazoned a photographic print of a 'Hollywood style' Asian beauty on the back of a Western tailored jacket.

lightweight hybrids; new coatings included silicone finishes (conceived to speed swimmers through the water) and holographic laminates. Ceramic fibres were employed to utilize solar power and micro-fibres were produced with anti-bacterial, self-cleaning and perfume-releasing qualities.

The role performed by fashion designers within society was held in higher regard than ever before, not only because of their potential to enrich lives with both functional and fantastical products, but also because fashion generated trade and employment. Many high street retailers and mail-order companies catering for the mass market recognized that it made good business sense to commission leading talents to individualize and promote their product. Thus, at the close of the twentieth century, fashions bearing the hallmark of top international designers were not restricted to the wealthy few, as they had been at the beginning of the century, but had become available to a broad section of society.

# Bibliography

## General fashion reference

Adburgham, Alison, *Shops and Shopping 1800–1914*, Allen & Unwin, London, 1964

— , *View of Fashion*, Allen & Unwin, London, 1966

Arnold, Janet, *A Handbook of Costume*, Macmillan, London, 1973

Barwick, Sandra, *A Century of Style*, Allen & Unwin, London, 1984

Beaton, Cecil, *The Glass of Fashion*, Weidenfeld & Nicolson, London, 1954

— , *Fashion: An Anthology by Cecil Beaton*, exhibition catalogue, HMSO, London, 1971

Bertin, Célia, *Paris à la mode*, Victor Gollancz, London, 1956

Birks, Beverley, *Haute Couture 1870–1970*, Asahi Shimbun, Tokyo, 1993

Birnbach, Lisa (ed.), *The Official Preppy Handbook*, Workman Publishing, New York, 1980

Boucher, François, *A History of Costume in the West*, rev. ed., Thames & Hudson, London, 1996

Brady, James, *Superchic*, Little, Brown; Boston, Mass., 1974

Braun-Ronsdorf, Margarete, *Mirror of Fashion: A History of European Costume 1789–1929*, McGraw-Hill, New York and Toronto, 1964

Brogden, Joanna, *Fashion Design*, Studio Vista, London, 1971

Bullis, Douglas, *California Fashion Designers*, Gibbs Smith, Salt Lake City, Utah, 1987

Byrde, Penelope, *A Visual History of Costume: The Twentieth Century*, B. T. Batsford, London, 1986

Carter, Ernestine, *Twentieth Century Fashion. A Scrapbook, 1900 to Today*, Eyre Methuen, London, 1975

— , *The Changing World of Fashion*, Weidenfeld & Nicolson, London, 1977

— , *Magic Names of Fashion*, Weidenfeld & Nicolson, London, 1980

Chillingworth, J. and H. Busby, *Fashion*, Lutterworth Press, Cambridge, 1961

De Marly, Diana, *The History of Couture 1850–1950*, B. T. Batsford, London, 1980

Deslandres, Yvonne and F. Müller, *Histoire de la mode au XXe siècle*, Somogy Editions d'Art, Paris, 1986

Dorner, Jane, *The Changing Shape of Fashion*, Octopus Books, London, 1974

Evans, Caroline and Minna Thornton, *Women and Fashion: A New Look*, Quartet Books, London and New York, 1989

Ewing, Elizabeth, *History of Twentieth Century Fashion*, B. T. Batsford, London, 1974

— , *Women in Uniform*, B. T. Batsford, London, 1975

— , *Fur in Dress*, B. T. Batsford, London, 1981

Fairchild, John, *Chic Savages: The New Rich, the Old Rich and the World They Inhabit*, Simon & Schuster, New York, 1989

Fairley, Roma, *A Bomb in the Collection: Fashion with the Lid Off*, Clifton Books, Brighton, Sussex, 1969

Fraser, Kennedy, *Scenes from the Fashionable World*, Alfred A. Knopf, New York, 1987

Garland, Madge, *Fashion*, Penguin, Harmondsworth, Middx, 1962

— , *The Changing Form of Fashion*, J. M. Dent, London, 1970

— and J. Anderson Black, *A History of Fashion*, Orbis Publishing, London, 1975

Giacomoni, Silvia, *The Italian Look Reflected*, Mazzotta, Milan, 1984

Glynn, Prudence, *In Fashion: Dress in the Twentieth Century*, Allen & Unwin, London, 1978

Grumbach, Didier, *Histoires de la mode*, Editions du Seuil, Paris, 1993

Hall, Lee, *Common Threads: A Parade of American Clothing*, Little, Brown; Boston, Mass., 1992

Halliday, Leonard, *The Fashion Makers*, Hodder & Stoughton, London, 1966

Hartman, R., *Birds of Paradise: An Intimate View of the New York Fashion World*, Delta, New York, 1980

Haye, Amy de la, *The Fashion Source Book*, MacDonald Orbis, London, 1988

— (ed.), *The Cutting Edge: 50 Years of British Fashion: 1947–1997*, Victoria and Albert Museum Publications, London, 1997

Hayward Gallery, *Addressing the Century: 100 Years of Art & Fashion*, exhibition catalogue, Hayward Gallery Publishing, London, 1998

Hinchcliffe, Frances and Valerie Mendes, *Ascher – Fabric, Art, Fashion*, Victoria and Albert Museum Publications, London, 1987

Howell, Georgina, *In Vogue: Six Decades of Fashion*, Allen Lane, London, 1975

— , *Sultans of Style: Thirty Years of Fashion and Passion*, Ebury Press, London, 1990

Ironside, Janey, *Fashion as a Career*, Museum Press, London, 1962

Jarnow, A. J. and B. Judelle, *Inside the Fashion Business*, John Wiley & Sons, New York, 1965

Join-Diéterle, Catherine *et al.*, *Robes du soir*, exhibition catalogue, Musée de la Mode et du Costume de la Ville de Paris, Palais Galliéra, Paris, 1990

Kidwell, C. and Valerie Steele (eds), *Men and Women: Dressing the Part*, Smithsonian Institution, Washington D.C., 1989

Koren, Leonard, *New Fashion Japan*, Kodansha International, Tokyo, 1984

Lansdell, Avril, *Wedding Fashions, 1860–1980*, Shire Publications, Princes Risborough, Bucks, 1983

Latour, Amy, *Kings of Fashion*, Weidenfeld & Nicolson, London, 1958

Laver, James, *Style in Costume*, London, 1949

— , *Costume through the Ages*, Thames & Hudson, London, 1964

— and Amy de la Haye, *Costume and Fashion: A Concise History*, rev. ed., Thames & Hudson, London and New York, 1995

Lee, Sarah Tomerlin, *American Fashion*, André Deutsch, London, 1975

Links, J. G., *The Book of Fur*, James Barrie, London, 1956

Lynam, Ruth (ed.), *Paris Fashion*, Michael Joseph, London, 1972

McCrum, Elizabeth, *Fabric and Form: Irish Fashion since 1950*, Sutton Publishing, Stroud, Gloucestershire; Ulster Museum, Belfast, 1996

Mansfield, Alan and Phyllis Cunnington, *Handbook of English Costume in the 20th Century, 1900–1950*, Faber and Faber, London, 1973

Martin, Richard, *Fashion and Surrealism*, Thames & Hudson, London, 1997; Rizzoli, New York, 1998

— and Harold Koda, *Orientalism: Visions of the East in Western Dress*, Metropolitan Museum, New York, 1994

Metropolitan Museum of Art, The Costume Institute, *American Women of Style*, exhibition catalogue, New York, 1972

—, *Vanity Fair*, exhibition catalogue, New York, 1977

Milbank, Caroline Rennolds, *Couture*, Thames & Hudson, London; Stewart, Tabori and Chang, New York, 1985

—, *New York Fashion*, Abrams, New York, 1989

Mulvagh, Jane, *Vogue History of 20th Century Fashion*, Viking, London, 1988

Musée de la Mode et du Costume de la Ville de Paris, Palais Galliéra, *1945–1975 Elégance et création*, exhibition catalogue, Paris, 1977

—, *Hommage aux donateurs*, exhibition catalogue, Paris, 1980

Museo Poldi Pezzoli, *1922–1943: Vent'anni di moda Italiana*, exhibition catalogue, Centro Di, Florence, 1980

Peacock, John, *The Chronicle of Western Costume*, Thames & Hudson, London; Abrams, New York, 1991

—, *20th Century Fashion: The Complete Sourcebook*, Thames & Hudson, London and New York, 1993

—, *Costume 1066–1990s*, Thames & Hudson, London and New York, 1994

Phizacklea, Annie, *Unpacking the Fashion Industry: Gender, Racism and Class in Production*, Routledge, London, 1990

Probert, Christina, *Brides in Vogue since 1910*, Thames & Hudson, London; Abbeville Press, New York, 1984

Remaury, Bruno, *Fashion and Textile Landmarks: 1996*, Institut Français de la Mode, Paris, 1996

Richards, F., *The Ready-to-Wear Industry 1900–1950*, Fairchild Publications, New York, 1951

Roscho, Bernard, *The Rag Race*, Funk & Wagnalls Co., New York, 1963

Roselle, Bruno du, *La Mode*, Imprimerie Nationale, Paris, 1980

— and I. Forestier, *Les Métiers de la mode et de l'habillement*, Marcel Valtat, Paris, 1980

Rothstein, N. (ed.), *Four Hundred Years of Fashion*, Victoria and Albert Museum Publications, London, 1984

Schmiechen, J. A., *Sweated Industries and Sweated Labor: The London Clothing Trades 1860–1914*, Croom Helm, London, 1984

Scott-James, Anne, *In the Mink*, Michael Joseph, London, 1952

Société des Expositions du Palais des Beaux Arts, *Mode et art 1960–1990*, exhibition catalogue, Brussels, 1995

Squire, Geoffrey, *Dress and Society 1560–1970*, Studio Vista, London, 1974

Steele, Valerie, *Paris Fashion: A Cultural History*, Oxford University Press, Oxford and New York, 1988

—, *Women of Fashion: Twentieth Century Designers*, Rizzoli, New York, 1991

—, *Fifty Years of Fashion*, Yale University Press, London and New Haven, 1997

Stevenson, Pauline, *Bridal Fashions*, Ian Allan, Addlesdown, Surrey, 1978

Taylor, Lou, *Mourning Dress*, Allen & Unwin, London, 1983

Torrens, D., *Fashion Illustrated: A Review of Women's Dress 1920–1950*, Studio Vista, London, 1974

Tucker, Andrew, *The London Fashion Book*, Thames & Hudson, London; Rizzoli, New York, 1998

Vecchio, W. and R. Riley, *The Fashion Makers*, Crown, New York, 1968

Vergani, Guido, *The Sala Bianca: The Birth of Italian Fashion*, Electa, Milan, 1992

Waugh, Norah, *The Cut of Women's Clothes 1600–1930*, Faber and Faber, London, 1968

Williams, Beryl, *Fashion Is Our Business*, John Gifford, London, 1948

Wills, G. and D. Midgley (eds), *Fashion Marketing*, Allen & Unwin, London, 1973

Wilson, Elizabeth and Lou Taylor, *Through the Looking Glass*, BBC Books, London, 1989

— and J. Ash (eds), *Chic Thrills: A Fashion Reader*, Pandora Press, London, 1992

Wray, M., *The Women's Outerwear Industry*, Gerald Duckworth & Co., London, 1957

### Chronological fashion history

#### 1900s–1930s

Battersby, Martin, *Art Deco Fashion*, Academy Editions, London, 1974

Caffrey, Kate, *The 1900s Lady*, Gordon & Cremonesi, London, 1976

Coleman, Elizabeth Ann, *The Opulent Era: Fashions of Worth, Doucet and Pingat*, Brooklyn Museum with Thames & Hudson, New York and London, 1989

Dorner, Jane, *Fashion in the Twenties and Thirties*, Ian Allan, Addlesdown, Surrey, 1973

*French Fashion Plates in Full Colour from the 'Gazette du Bon Ton', 1912–1925*, Dover Publications, New York, 1979

Ginsburg, Madeleine, *The Art Deco Style of the 1920s*, Bracken Books, London, 1989

Herald, Jacqueline, *Fashions of a Decade: The 1920s*, B. T. Batsford, London, 1991

Laver, James, *Women's Dress in the Jazz Age*, Hamish Hamilton, London, 1975

Musée de la Mode et du Costume de la Ville de Paris, Palais Galliéra, *Grand Couturiers Parisiens 1910–1929*, exhibition catalogue, Paris, 1970

—, *Paris Couture – années trente*, exhibition catalogue, Paris, 1987

Olian, Joanne (ed.), *Authentic French Fashions of the Twenties: 413 Costume Designs from 'L'Art et la mode'*, Dover Publications, New York, 1990

Peacock, John, *Fashion Sourcebooks: The 1920s*, Thames & Hudson, London and New York, 1997

—, *Fashion Sourcebooks: The 1930s*, Thames & Hudson, London and New York, 1997

Penn, Irving and Diana Vreeland, *Inventive Paris Clothes, 1900–1939*, Thames & Hudson, London, 1977

Robinson, Julian, *The Golden Age of Style*, Orbis Publishing, London, 1976

—, *Fashion in the 30s*, Oresko Books, London, 1978

Stevenson, Pauline, *Edwardian Fashion*, Ian Allan, Addlesdown, Surrey, 1980

Victoria and Albert Museum and Scottish Arts Council, *Fashion, 1900–1939*, exhibition catalogue, Idea Books, London, 1975

Zaletova, L. *et al.*, *Costume Revolution: Textiles, Clothing and Costume of the Soviet Union in the Twenties*, Trefoil Books, London, 1989

#### 1940s–1950s

Baker, P., *Fashions of a Decade: The 1950s*, B. T. Batsford, London, 1991

Cawthorne, Nigel, *The New Look*, Hamlyn, London, 1996

Charles-Roux, Edmonde *et al.*, *Théâtre de la mode*, Rizzoli, New York, 1991

Disher, M. L., *American Factory Production of Women's Clothing*, Devereaux, London, 1947

Dorner, Jane, *Fashion in the Forties and Fifties*, Ian Allan, Addlesdown, Surrey, 1975

Drake, Nicholas, *The Fifties in Vogue*, Heinemann, London, 1987

Geffrye Museum, *Utility Fashion and Furniture 1941–1951*, exhibition catalogue, London, 1974

Laboissonnière, W., *Blueprints of Fashion: Home Sewing Patterns of the 1940s*, Schiffer Publishing, Atglen, Pa., 1997

McDowell, Colin, *Fashion and the New Look*, Bloomsbury Publishing, London, 1997

Merriam, Eve, *Figleaf: The Business of Being in Fashion*, Lippincott, New York, 1960

Peacock, John, *Fashion Sourcebooks: The 1940s*, Thames & Hudson, London and New York, 1998

—, *Fashion Sourcebooks: The 1950s*, Thames & Hudson, London and New York, 1997

Robinson, Julian, *Fashion in the 40s*, Academy Editions, London, 1976

Sheridan, Dorothy (ed.), *Wartime Women: A Mass Observation Anthology*, Mandarin, London, 1991

Sladen, Christopher, *The Conscription of Fashion*, Scolar Press, Aldershot, Hants, 1995

Veillon, Dominique, *La Mode sous l'occupation*, Editions Payot et Rivages, Paris, 1990

Waller, Jane, *A Stitch in Time: Knitting and Crochet Patterns of the 1920s, 1930s and 1940s*, Gerald Duckworth & Co., London, 1972

Wood, Maggie, *We Wore What We'd Got: Women's Clothes in World War II*, Warwickshire Books, Exeter, 1989

#### 1960s

Bender, Marilyn, *The Beautiful People*, Coward-McCann, New York, 1967

Bernard, Barbara, *Fashion in the 60s*, Academy Editions, London, 1978

Cawthorne, Nigel, *Sixties Source Book*, Virgin Publishing, London, 1989

Coleridge, Nicholas and Stephen Quinn (eds), *The Sixties in Queen*, Ebury Press, London, 1987

Connickie, Yvonne, *Fashions of a Decade: The 1960s*, B. T. Batsford, London, 1990

Drake, Nicholas, *The Sixties: A Decade in Vogue*, Prentice Hall, New York, 1988

Edelstein, A. J., *The Swinging Sixties*, World Almanac Publications, New York, 1985

Harris, J., S. Hyde and G. Smith, *1966 and All That*, Trefoil Books, London, 1986

Lobenthal, Joel, *Radical Rags: Fashions of the Sixties*, Abbeville Press, New York, 1990

Peacock, John, *Fashion Sourcebooks: The 1960s*, Thames & Hudson, London and New York, 1998

Salter, Tom, *Carnaby Street*, M. and J. Hobbs, Walton-on-Thames, Surrey, 1970

Wheen, Francis, *The Sixties*, Century, London, 1982

#### 1970s–1990s

Barr, Ann and Peter York, *The Official Sloane Ranger Handbook*, Ebury Press, London, 1982

Coleridge, Nicholas, *The Fashion Conspiracy*, Mandarin Heinemann, London, 1988

Fraser, K., *The Fashionable Mind: Reflections on Fashion 1970–1982*, Nonpareil Books, New York, 1985

Herald, Jacqueline, *Fashions of a Decade: The 1970s*, B. T. Batsford, London, 1992

Johnston, Lorraine (ed.), *The Fashion Year*, Zomba Books, London, 1985

Khornak, L., *Fashion 2001*, Columbus Books, London, 1982

Love, Harriet, *Harriet Love's Guide to Vintage Chic*, Holt, Rinehart & Winston, New York, 1982

McDowell, Colin, *The Designer Scam*, Hutchinson, London, 1994

Milinaire, C. and C. Troy, *Cheap Chic*, Omnibus Press, London and New York, 1975

O'Connor, Kaori (ed.), *The Fashion Guide*, Farrol Kahn, London, 1976

— , *The 1977 Fashion Guide*, Hodder & Stoughton, London, 1977

— , *The 1978 Fashion Guide*, Hodder & Stoughton, London, 1978

Peacock, John, *Fashion Sourcebooks: The 1970s*, Thames & Hudson, London and New York, 1997

— , *Fashion Sourcebooks: The 1980s*, Thames & Hudson, London and New York, 1998

Polan, Brenda (ed.), *The Fashion Year*, Zomba Books, London, 1983

— , *The Fashion Year*, Zomba Books, London, 1984

York, Peter, *Style Wars*, Sidgwick and Jackson, London, 1978

## Designers

### Azzedine Alaïa
Baudot, François, *Alaïa*, Thames & Hudson, London; Universe Publishing, New York, 1996

### Hardy Amies
Amies, Hardy, *Just So Far*, Collins, London, 1954

— , *Still Here*, Weidenfeld & Nicolson, London, 1984

### Giorgio Armani
Martin, Richard and Harold Koda, *Giorgio Armani: Images of Man*, Rizzoli, New York, 1990

### Laura Ashley
Sebba, Anne, *Laura Ashley*, Weidenfeld & Nicolson, London, 1990

### Cristobal Balenciaga
Deslandres, Yvonne *et al.*, *The World of Balenciaga*, exhibition catalogue, Metropolitan Museum of Art, The Costume Institute, New York, 1973

Jouve, Marie-Andrée and Jacqueline Demornex, *Balenciaga*, Editions du Regard, Paris, 1988

Miller, Lesley, *Cristobal Balenciaga*, B. T. Batsford, London, 1993

Musée Historique des Tissus, *Hommage à Balenciaga*, exhibition catalogue, Lyons, 1985

### Pierre Balmain
Balmain, Pierre, *My Years and Seasons*, Cassell, London, 1964

Musée de la Mode et du Costume de la Ville de Paris, Palais Galliéra, *Pierre Balmain: 40 années de création*, exhibition catalogue, Paris, 1985

Salvy, Gérard-Julien, *Pierre Balmain*, Editions du Regard, Paris, 1996

### Geoffrey Beene
Beene, Geoffrey, *Beene Unbound*, Fashion Institute of Technology and Geoffrey Beene Inc., New York, 1994

Cullerton, Brenda, *Geoffrey Beene: The Anatomy of his Work*, Abrams, New York, 1995

### Biba
Hulanicki, Barbara, *From A to Biba*, Hutchinson, London, 1983

### Roberto Capucci
Bertelli, Carlo *et al.*, *Roberto Capucci*, Editori Fabbri, Milan, 1990

### Pierre Cardin
Mendes, Valerie (ed.), *Pierre Cardin, Past, Present and Future*, Dirk Nishen, London, 1990

### Oleg Cassini
Cassini, Oleg, *In My Own Fashion: An Autobiography*, Pocket, New York, 1987

— , *A Thousand Days of Magic: Dressing Jacqueline Kennedy for the White House*, Rizzoli, New York, 1995

### Jean-Charles de Castelbajac
Castelbajac, Jean-Charles de *et al.*, *J. C. de Castelbajac*, Michel Aveline, Paris, 1993

### Coco Chanel
Baillen, C., *Chanel Solitaire*, Collins, London, 1973

Baudot, François, *Chanel*, Thames & Hudson, London; Universe Publishing, New York, 1996

Charles-Roux, Edmonde, *Chanel*, Jonathan Cape, London, 1976

— , *Chanel and Her World*, Weidenfeld & Nicolson, London, 1981

Haedrich, Marcel, *Coco Chanel: Her Life, Her Secrets*, Robert Hale, London, 1972

Haye, Amy de la and Shelley Tobin, *Chanel: The Couturière at Work*, Victoria and Albert Museum Publications, London, 1994

Leymarie, Jean, *Chanel*, Rizzoli, New York, 1987

Madsen, Axel, *Coco Chanel: A Biography*, Bloomsbury Publishing, London, 1990

Morand, Paul, *L'Allure de Chanel*, Hermann, Paris, 1976

### Comme des Garçons
Grand, France, *Comme des Garçons*, Thames & Hudson, London; Universe Publishing, New York, 1998

Kawakubo, Rei, *Comme des Garçons*, Chikuma Shobo, Tokyo, 1986

Sudjic, Deyan, *Rei Kawakubo and Comme des Garçons*, Fourth Estate, London, 1990

### André Courrèges
Guillaume, Valérie, *Courrèges*, Thames & Hudson, London; Universe Publishing, New York, 1998

### Charles Creed
Creed, Charles, *Maid to Measure*, Jarrolds Publishing, London, 1961

### Sonia Delaunay
Damase, Jacques, *Sonia Delaunay Fashion and Fabrics*, Thames & Hudson, London and New York, 1991

### Christian Dior
Bordaz, Robert *et al.*, *Hommage à Christian Dior 1947–1957*, exhibition catalogue, Musée des Arts et de la Mode, Paris, 1986

Dior, Christian, *Talking about Fashion to Elie Rabourdin and Alice Chavanne*, Hutchinson, London, 1954

— , *Dior by Dior*, Weidenfeld & Nicolson, London, 1957

Giroud, Françoise, *Dior: Christian Dior 1905–1957*, Thames & Hudson, London, 1987

GraxLott, Pierre, *Christian Dior et moi*, Amiot Dumond, Paris, 1956

Keenan, Brigid, *Dior in Vogue*, Octopus Books, London, 1981

Martin, Richard and Harold Koda, *Christian Dior*, exhibition catalogue, Metropolitan Museum of Art, New York, 1996

### Dolce & Gabbana
Casadio, Mariuccia, *Dolce & Gabbana*, Thames & Hudson, London; Gingko Press, Corte Madera, Calif., 1998

Dolce & Gabbana *et al.*, *10 Years of Dolce and Gabbana*, Abbeville Press, New York, 1996

### Perry Ellis
Moor, Jonathan, *Perry Ellis: A Biography*, St Martin's Press, New York, 1988

### Jacques Fath
Guillaume, Valérie, *Jacques Fath*, Editions Paris-Musées, Paris, 1993

### Louis Feraud
Baraquand, Michel *et al.*, *Louis Féraud*, Office du Livre, Fribourg, 1985

### Mariano Fortuny
Deschodt, A. M., *Mariano Fortuny, un magicien de Venise*, Editions du Regard, Paris, 1979

Desvaux, Delphine, *Fortuny*, Thames & Hudson, London; Universe Publishing, New York, 1998

Kyoto Costume Institute, *Mariano Fortuny 1871–1949*, exhibition catalogue, Kyoto, 1985

Los Angeles County Museum, *A Remembrance of Mariano Fortuny, 1871–1949*, exhibition catalogue, Los Angeles, Calif., 1967

Musée Historique des Tissus, *Mariano Fortuny Venise*, exhibition catalogue, Lyons, 1980

Osma, Guillermo de, *Fortuny, His Life and His Work*, Aurum Press, London, 1980

### John Galliano
McDowell, Colin, *Galliano*, Weidenfeld & Nicolson, London, 1997

### Jean-Paul Gaultier
Chenoune, Farid, *Jean Paul Gaultier*, Thames & Hudson, London; Universe Publishing, New York, 1996

### Rudi Gernreich
Moffitt, Peggy and William Claxton, *The Rudi Gernreich Book*, Rizzoli, New York, 1991

### Hubert de Givenchy
Join-Diéterle, Catherine, *Givenchy: 40 Years of Creation*, Editions Paris-Musées, Paris, 1991

### Madame Grès
Martin, Richard and Harold Koda, *Madame Grès*, Metropolitan Museum of Art, New York, 1994

### Gucci
McKnight, Gerald, *Gucci: A House Divided*, Sidgwick and Jackson, London, 1987

### Halston
Gaines, Steven, *Simply Halston: The Untold Story*, Penguin Putnam, New York, 1991

### Norman Hartnell
Hartnell, Norman, *Silver and Gold*, Evans Bros., London, 1955

Museum of Costume, Bath, and Brighton
  Museum, *Norman Hartnell*, exhibition
  catalogue, Bath and Brighton, 1985

**Elizabeth Hawes**
Hawes, Elizabeth, *Radical by Design: The Life
  and Style of Elizabeth Hawes*, Dutton,
  New York, 1988

**Charles James**
Coleman, Elizabeth Ann, *The Genius of Charles
  James*, exhibiton catalogue, Holt, Rinehart
  & Winston for the Brooklyn Museum,
  New York, 1982
Martin, Richard, *Charles James*, Thames
  & Hudson, London, 1997

**Donna Karan**
Sischy, Ingrid, *Donna Karan*, Thames & Hudson,
  London; Universe Publishing, New York,
  1998

**Kenzo**
Davy, Ross, *Kenzo: A Tokyo Story*, Penguin,
  Harmondsworth, Middx, 1985

**Calvin Klein**
Gaines, Steven and Sharon Churcher, *Obsession:
  The Lives and Times of Calvin Klein*, Birch
  Lane Press, New York, 1994

**Krizia**
Vercelloni, Isa Tutino, *Krizia: Una storia*, Skira,
  Milan, 1995

**Christian Lacroix**
Baudot, François, *Christian Lacroix*, Thames
  & Hudson, London; Universe Publishing,
  New York, 1997
Lacroix, Christian, *Pieces of a Pattern: Lacroix
  by Lacroix*, Thames & Hudson, London and
  New York, 1997
Mauriès, Patrick, *Christian Lacroix: The Diary of
  a Collection*, Thames & Hudson, London, 1996

**Karl Lagerfeld**
Piaggi, Anna, *Karl Lagerfeld: A Fashion Journal*,
  Thames & Hudson, London and New York,
  1986

**Jeanne Lanvin**
Barillé, Elisabeth, *Lanvin*, Thames & Hudson,
  London, 1997

**Ralph Lauren**
Canadeo, Anne and Richard G. Young (eds),
  *Ralph Lauren: Master of Fashion*, Garrett
  Editions, Oklahoma, 1992
Trachtenberg, J. A., *Ralph Lauren*, Little,
  Brown; Boston, Mass., 1988

**Lesage**
Palmer White, Jack, *The Master Touch of
  Lesage*, Editions du Chêne, Paris, 1987

**Lucile**
Etherington-Smith, Meredith and Jeremy
  Pilcher, *The IT Girls*, Hamish Hamilton,
  London, 1986
Gordon, Lady Duff, *Discretions and Indiscretions*,
  Jarrolds Publishing, London, 1932

**Claire McCardell**
Kohle, Yohannan, *Claire McCardell: Redefining
  Modernism*, Abrams, New York, 1998

**Missoni**
Casadio, Mariuccia, *Missoni*, Thames
  & Hudson, London; Gingko Press, Corte
  Madera, Calif., 1997
Vercelloni, Isa Tutino (ed.), *Missonologia*,
  Electa, Milan, 1994

**Issey Miyake**
Benaïm, Laurence, *Issey Miyake*, Thames
  & Hudson, London; Universe Publishing,
  New York, 1997
Holborn, Mark, *Issey Miyake*, Taschen,
  Cologne, 1995
Koike, Kazuko (ed.), *Issey Miyake: East Meets
  West*, Heibonsha, Tokyo, 1978
Miyake Design Studio, *Issey Miyake by Irving
  Penn*, Tokyo, 1989, 1990 and 1993–95

**Franco Moschino**
Casadio, Mariuccia, *Moschino*, Thames
  & Hudson, London; Gingko Press, Corte
  Madera, Calif., 1997
Moschino, Franco and Lida Castelli (eds),
  *X Anni di Kaos! 1983–1993*, Edizioni Lybra
  Immagine, Milan, 1993

**Thierry Mugler**
Baudot, François, *Thierry Mugler*, Thames
  & Hudson, London; Universe Publishing,
  New York, 1998
Mugler, Thierry, *Thierry Mugler: Fashion,
  Fetish and Fantasy*, Thames & Hudson,
  London; General Publishing Group, Santa
  Monica, Calif., 1998

**Jean Muir**
Leeds City Art Galleries, *Jean Muir*, exhibition
  catalogue, Leeds, 1980

**Bruce Oldfield**
Oldfield, Bruce and Georgina Howell, *Bruce
  Oldfield's Seasons*, Pan Books, London, 1987

**Madame Paquin**
Arizzoli-Clémentel, P. et al., *Paquin: une
  rétrospective de 60 ans de haute couture*,
  exhibition catalogue, Musée Historique
  des Tissus, Lyons, 1989

**Jean Patou**
Etherington-Smith, Meredith, *Patou*,
  Hutchinson, London, 1983

**Paul Poiret**
Baudot, François, *Paul Poiret*, Thames
  & Hudson, London, 1997
Deslandres, Yvonne, *Paul Poiret*, Thames
  & Hudson, London, 1987
Iribe, Paul, *Les Robes de Paul Poiret racontées par
  Paul Iribe*, Société Générale d'Impression,
  Paris, 1908
Musée de la Mode et du Costume de la Ville
  de Paris, Palais Galliéra, *Poiret et Nicole
  Groult*, exhibition catalogue, Paris, 1986
Musée Jacquemart-André, *Poiret le magnifique*,
  exhibition catalogue, Paris, 1974
Palmer White, Jack, *Paul Poiret*, Studio Vista,
  London, 1973
Poiret, Paul, *My First Fifty Years*, Victor
  Gollancz, London, 1931

**Emilio Pucci**
Casadio, Mariuccia, *Pucci*, Thames & Hudson,
  London; Universe Publishing, New York,
  1998
Kennedy, Shirley, *Pucci: A Renaissance in
  Fashion*, Abbeville Press, New York, 1991

**Mary Quant**
London Museum, *Mary Quant's London*,
  exhibition catalogue, London, 1973
Quant, Mary, *Quant by Quant*, Cassell, London,
  1966

**Paco Rabanne**
Kamitsis, Lydia, *Paco Rabanne*, Editions
  Assouline, Paris, 1997

**Zandra Rhodes**
Rhodes, Zandra and Anne Knight, *The Art
  of Zandra Rhodes*, Jonathan Cape, London,
  1984

**Nina Ricci**
Pochna, Marie-France, Anne Bony and Patricia
  Canino, *Nina Ricci*, Editions du Regard,
  Paris, 1992

**Marcel Rochas**
Mohrt, Françoise, *Marcel Rochas: 30 ans
  d'élégance et de créations*, Jacques Damase,
  Paris, 1983

**Sonia Rykiel**
Rykiel, Sonia, Madeleine Chapsal and Hélène
  Cixous, *Rykiel par Rykiel*, Editions Herscher,
  Paris, 1985

**Yves Saint Laurent**
Benaïm, Laurence, *Yves Saint Laurent*, Grasset
  Fasquelle, Paris, 1993
Bergé, Pierre, *Yves Saint Laurent*, Thames
  & Hudson, London; Universe Publishing,
  New York, 1997
Duras, M., *Yves Saint Laurent: Images of Design
  1958–1988*, Alfred A. Knopf, New York,
  1988
Madsen, Axel, *Living for Design: The Yves
  Saint Laurent Story*, Delacorte Press,
  New York, 1979
Musée des Arts et de la Mode, *Yves Saint
  Laurent*, exhibition catalogue, Paris, 1986
Rawsthorn, Alice, *Yves Saint Laurent:
  A Biography*, HarperCollins, London,
  1996
Saint Laurent, Yves et al., *Yves Saint Laurent*,
  exhibition catalogue, Metropolitan
  Museum of Art, New York, 1983

**Elsa Schiaparelli**
Baudot, François, *Elsa Schiaparelli*, Thames
  & Hudson, London; Universe Publishing,
  New York, 1997
Musée de la Mode et du Costume de la Ville
  de Paris, Palais Galliéra, *Hommage
  à Schiaparelli*, exhibition catalogue,
  Paris, 1984
Palmer White, Jack, *Elsa Schiaparelli*, Aurum
  Press, London, 1986
Schiaparelli, Elsa, *Shocking Life*, J. M. Dent,
  London, 1954

**Paul Smith**
Jones, Dylan, *Paul Smith True Brit*, Design
  Museum, London, 1996

**Emanuel Ungaro**
Guerritore, Margherita, *Ungaro*, Electa,
  Milan, 1992

**Valentino**
Morris, Bernadine, *Valentino*, Thames
  & Hudson, London; Universe Publishing,
  New York, 1996
Valentino et al., *Valentino: Trent'anni di Magia*,
  exhibition catalogue, Accademia Valentino,
  Bompiani, Milan, 1991

**Gianni Versace**
Casadio, Mariuccia, *Versace*, Thames & Hudson,
  London; Gingko Press, Corte Madera,
  Calif., 1998
— , *Gianni Versace*, Metropolitan Museum of
  Art and Abrams, New York, 1997
Martin, Richard, *Versace*, Thames & Hudson,
  London; Universe Publishing/Vendome,
  New York, 1997

Versace, Gianni *et al.*, *A Sense of the Future: Gianni Versace at the Victoria and Albert Museum*, Victoria and Albert Museum Publications, London, 1985
— , *Men without Ties*, Abbeville Press, New York, 1994
Versace, Gianni and Roy Strong, *Do Not Disturb*, Abbeville Press, New York, 1996

## Madeleine Vionnet
Demornex, Jacqueline, *Madeleine Vionnet*, Thames & Hudson, London, 1991
Kamitsis, Lydia, *Vionnet*, Thames & Hudson, London; Universe Publishing, New York, 1996
Kirke, Betty, *Madeleine Vionnet*, Chronicle Books, New York, 1998
Musée Historique des Tissus, *Madeleine Vionnet – Les Années d'innovation 1919–1939*, exhibition catalogue, Lyons, 1994

## Louis Vuitton
Sebag-Montefiore, Hugh, *Kings on the Catwalk: The Louis Vuitton and Moët-Hennessy Affair*, Chapmans, London, 1992

## Vivienne Westwood
Krell, Gene, *Vivienne Westwood*, Thames & Hudson, London; Universe Publishing, New York, 1997
Mulvagh, Jane, *Vivienne Westwood: An Unfashionable Life*, HarperCollins, London, 1998

## Worth
De Marly, Diana, *Worth, Father of Haute Couture*, Elm Tree Books, London, 1980

## Yohji Yamamoto
Baudot, François, *Yohji Yamamoto*, Thames & Hudson, London, 1997

## Yuki
Etherington-Smith, Meredith, *Yuki*, Gnyuki Torimaru (published privately), London, 1998
Haye, Amy de la, *Yuki: 20 Years*, Victoria and Albert Museum Publications, London, 1992

## Dictionaries, guides and journals
Annual Journal, *Fashion Theory*, Berg, Oxford
Anthony, P. and J. Arnold, *Costume: A General Bibliography*, rev. ed., Costume Society, London, 1974
Baclawski, Karen, *The Guide to Historic Costume*, B. T. Batsford, London, 1995
Calasibetta, Charlotte Mankey, *Fairchild's History of Fashion*, Fairchild Publications, New York, 1975
Cassin-Scott, Jack, *The Illustrated Encyclopaedia of Costume and Fashion*, Studio Vista, London, 1994
Casteldi, A. and A. Mulassano, *The Who's Who of Italian Fashion*, G. Spinelli, Florence, 1979
Davies, Stephanie, *Costume Language: A Dictionary of Dress Terms*, Cressrelles, Malvern Hills, Herefordshire, 1994
Ironside, Janey, *A Fashion Alphabet*, Michael Joseph, London, 1968
Journal of the Costume Society (UK), *Costume*
Journal of the Costume Society of America, *Dress*
Lambert, Eleanor, *World of Fashion: People, Places, Resources*, R. R. Bowker, New York, 1976

McDowell, Colin, *McDowell's Directory of Twentieth Century Fashion*, Frederick Muller, London, 1984
Martin, Richard (ed.), *The St. James Fashion Encyclopedia: A Survey of Style from 1945 to the Present*, Visible Ink Press, Detroit, New York, Toronto and London, 1997
Morris, Bernadine and Barbara Walz, *The Fashion Makers: An Inside Look at America's Leading Designers*, Random House, New York, 1978
O'Hara Callan, Georgina, *Dictionary of Fashion and Fashion Designers*, Thames & Hudson, London and New York, 1998
Picken, Mary Brooks, *The Fashion Dictionary*, Funk & Wagnalls Co., New York, 1939
— and D. L. Miller, *Dressmakers of France: The Who, How and Why of French Couture*, Harper and Bros., New York, 1956
Remaury, Bruno, *Dictionnaire de la mode au XXe Siècle*, Editions du Regard, Paris, 1994
Stegemeyer, Anne, *Who's Who in Fashion*, Fairchild Publications, New York, 1980
Thorne, Tony, *Fads, Fashion and Cults*, Bloomsbury Publishing, London, 1993
Watkins, Josephine Ellis, *Who's Who in Fashion*, 2nd ed., Fairchild Publications, New York, 1975
Wilcox, R. Turner, *The Dictionary of Costume*, B. T. Batsford, London, 1970

## Biography and cultural history
Adburgham, Alison, *A Punch History of Manners and Modes, 1841–1940*, Hutchinson, London, 1961
Asquith, Cynthia, *Remember and Be Glad*, James Barrie, London, 1952
Ballard, Bettina, *In My Fashion*, Secker & Warburg, 1960
Balsan, C. V., *The Glitter and the Gold*, Heinemann, London, 1954
Beaton, Cecil, *The Wandering Years. Diaries 1922–1939*, Weidenfeld & Nicolson, London, 1961
— , *The Years Between. Diaries 1939–1944*, Weidenfeld & Nicolson, London, 1965
— , *The Happy Years. Diaries 1944–1948*, Weidenfeld & Nicolson, London, 1972
— , *The Strenuous Years. Diaries 1948–1955*, Weidenfeld & Nicolson, London, 1973
— , *The Restless Years. Diaries 1955–1963*, Weidenfeld & Nicolson, London, 1976
— , *The Parting Years. Diaries 1963–1974*, Weidenfeld & Nicolson, London, 1978
Beckett, J. and D. Cherry, *The Edwardian Era*, Phaidon and Barbican Art Gallery, London, 1987
Bloom, Ursula, *The Elegant Edwardian*, Hutchinson, London, 1957
Buckley, V. C., *Good Times: At Home and Abroad Between the Wars*, Thames & Hudson, London, 1979
Campbell, Ethyle, *Can I Help You Madam?*, Cobden-Sanderson, London, 1938
Carter, Ernestine, *With Tongue in Chic*, Michael Joseph, London, 1974
Chase, Edna Woolman and Ilka, *Always in Vogue*, Victor Gollancz, London, 1954
Clephane, Irene, *Ourselves 1900–1939*, Allen Lane, London, 1933
Cooper, Diana, *The Rainbow Comes and Goes*, Rupert Hart-Davis, London, 1958
— , *The Light of Common Day*, Rupert Hart-Davis, London, 1959

— , *Trumpets from the Steep*, Rupert Hart-Davis, London, 1960
Elizabeth, Lady Decies, *Turn of the World*, Lippincott, New York, 1937
Garland, Ailsa, *Lion's Share*, Michael Joseph, London, 1970
Garland, Madge, *The Indecisive Decade*, Macdonald, London, 1968
Graves, Robert, *The Long Weekend*, Faber and Faber, London, 1940
Hawes, Elizabeth, *Fashion Is Spinach*, Random House, New York, 1938
— , *Why Is a Dress?*, Viking Press, New York, 1942
— , *It's Still Spinach*, Little, Brown; Boston, Mass., 1954
Hopkins, T. *et al.*, *Picture Post 1938–1950*, Penguin Books, Harmondsworth, Middx, 1970
Keppel, Sonia, *Edwardian Daughter*, Hamish Hamilton, London, 1958
Laver, James, *Edwardian Promenade*, Edward Hulton, London, 1958
— , *The Age of Optimism*, Weidenfeld & Nicolson, London, 1966
Littman, R. B. and D. O'Neil, *Life: The First Decade 1939–1945*, Thames & Hudson, London, 1980
Margaret, Duchess of Argyll, *Forget Not*, W. H. Allen, London, 1975
Margetson, Sheila, *The Long Party*, Saxon House, Farnborough, Hants, 1974
Marwick, Arthur, *The Home Front*, Thames & Hudson, London, 1976
— , *Women at War 1914–1918*, Fontana, London, 1977
Mirabella, Grace, *In and Out of Vogue: A Memoir*, Doubleday, New York, 1994
Newby, Eric, *Something Wholesale*, Secker & Warburg, London, 1962
Nicols, Beverley, *The Sweet and Twenties*, Weidenfeld & Nicolson, London, 1958
Penrose, Antony, *The Lives of Lee Miller*, Thames & Hudson, London and New York, 1985
Pringle, Margaret, *Dance Little Ladies: The Days of the Debutante*, Orbis Books, London, 1977
Sackville-West, Vita, *The Edwardians*, Bodley Head, London, 1930
Seebohm, Caroline, *The Man Who Was Vogue: The Life and Times of Condé Nast*, Weidenfeld & Nicolson, London, 1982
Settle, Alison, *Clothes Line*, Methuen, London, 1937
Sinclair, Andrew, *The Last of the Best*, Weidenfeld & Nicolson, London, 1969
Snow, Carmel, *The World of Carmel Snow*, McGraw-Hill, New York, 1962
Spanier, Ginette, *It Isn't All Mink*, Collins, London, 1959
— , *And Now It's Sables*, Robert Hale, London, 1970
Sproule, Anna, *The Social Calendar*, Blandford Press, London, 1978
Stack, Prunella, *Zest for Life: Mary Bagot Stack and the League of Health and Beauty*, Peter Owen, London, 1988
Stanley, Louis T., *The London Season*, Hutchinson, London, 1955
Vickers, Hugo, *Gladys, Duchess of Marlborough*, Weidenfeld & Nicolson, London, 1979
— , *Cecil Beaton: The Authorized Biography*, Weidenfeld & Nicolson, London, 1986
Vreeland, Diana, *D. V.*, Alfred A. Knopf, New York, 1984

Westminster, Loelia, Duchess of, *Grace and Favour*, Weidenfeld & Nicolson, London, 1961

Withers, Audrey, *Lifespan*, Peter Owen, London, 1994

Yoxall, H. W., *A Fashion of Life*, Heinemann, London, 1966

## Fashion theory

Barnes, Ruth and Joanne Eicher (eds), *Dress and Gender: Making and Meaning*, Berg, New York, 1992

Barthes, Roland, *The Fashion System*, Jonathan Cape, London, 1985

Bell, Quentin, *On Human Finery*, Hogarth Press, London; Schocken Books, New York, 1976

Bergler, Edmund, *Fashion and the Unconscious*, Robert Brunner, New York, 1953

Binder, P., *Muffs and Morals*, Harrap, London, 1953

Breward, Christopher, *The Culture of Fashion*, Manchester University Press, Manchester, 1995

Brydon, A. and S. Niessen, *Consuming Fashion*, Berg, New York, 1998

Craik, Jennifer, *The Face of Fashion: Cultural Studies in Fashion*, Routledge, London, 1994

Cunnington, C. Willet, *Why Women Wear Clothes*, Faber and Faber, London, 1941

Davis, Fred, *Fashion Culture and Identity*, University of Chicago Press, Chicago, Ill., 1992

Flügel, J. C., *The Psychology of Clothes*, Hogarth Press, London, 1930

Glynn, Prudence, *Skin to Skin: Eroticism in Dress*, Allen & Unwin, London, 1982

Hollander, Anne, *Seeing through Clothes*, University of California Press, Berkeley, Calif., 1978

— , *Sex and Suits*, Alfred A. Knopf, New York, 1994

Horn, Marilyn J., *The Second Skin: An Interdisciplinary Study of Clothing*, 2nd ed., Houghton Mifflin, Boston, Mass., 1975

Langner, L., *The Importance of Wearing Clothes*, Constable & Co., London, 1959

Laver, James, *Taste and Fashion*, Harrap, London, 1937

— , *How and Why Fashion in Men's and Women's Clothes Have Changed during the Past 200 Years*, John Murray, London, 1950

— , *Modesty in Dress*, Heinemann, London, 1969

Lipovetsky, Gilles, *The Empire of Fashion*, Princeton University Press, Princeton, N. J., 1994

Lurie, Alison, *The Language of Clothes*, Hamlyn, Middx, 1982

McDowell, Colin, *Dressed to Kill: Sex, Power and Clothes*, Hutchinson, London, 1992

Roach, Mary Ellen and Joanne B. Eicher, *Dress, Adornment and the Social Order*, John Wiley & Sons, New York, 1965

Rudofsky, Bernard, *The Unfashionable Human Body*, Doubleday, New York, 1971

Ryan, Mary S., *Clothing: A Study in Human Behaviour*, Holt, Rinehart & Winston, New York and London, 1966

Schefer, Doris, *What Is Beauty? New Definitions from the Fashion Vanguard*, Thames & Hudson, London; Universe Publishing, New York, 1997

Sproles, G. B., *Fashion: Consumer Behaviour towards Dress*, Burgess, Minneapolis, 1979

Steele, Valerie, *Fashion and Eroticism*, Oxford University Press, Oxford and New York, 1985

Veblen, Thorstein, *The Theory of the Leisure Class*, Macmillan and Co., New York, 1899

Warwick, A. and D. Cavallaro, *Fashioning the Frame*, Berg, New York, 1998

Wilson, Elizabeth, *Adorned in Dreams: Fashion and Modernity*, Virago, London, 1985

## Fashion illustration

Barbier, George, *The Illustrations of George Barbier in Full Colour*, Dover Publications, New York, 1977

Barnes, Colin, *Fashion Illustration*, Macdonald Orbis, London, 1988

Bure, Gilles de, *Gruau*, Editions Herscher, Paris, 1989

Drake, Nicholas, *Fashion Illustration Today*, Thames & Hudson, London and New York, 1987

Gaudriault, R., *La Gravure de mode féminine en France*, Editions Amateur, Paris, 1983

Ginsburg, Madeleine, *An Introduction to Fashion Illustration*, Warmington Compton Press, London, 1980

Grafton, Carol Belanger (ed.), *French Fashion Illustrations of the Twenties*, Dover Publications, New York, 1987

Hodgkin, Eliot, *Fashion Drawing*, Chapman and Hall, London, 1932

Marshall, Francis, *London West*, The Studio, London and New York, 1944

— , *An Englishman in New York*, G. B. Publications, Margate, Kent, 1949

— , *Fashion Drawing*, Studio Publications, 2nd ed., London, 1955

Packer, William, *The Art of Vogue Covers*, Octopus Books, New York, 1980

— , *Fashion Drawing in Vogue*, Thames & Hudson, London and New York, 1983

Ramos, Juan, *Antonio: Three Decades of Fashion Illustration*, Thames & Hudson, London, 1995

Ridley, Pauline, *Fashion Illustration*, Academy Editions, London, 1979

Sloane, E., *Illustrating Fashion*, Harper and Row, London and New York, 1977

Vertès, Marcel, *Art and Fashion*, Studio Vista, London, 1944

## Fashion photography

Avedon, Richard, *Avedon Photographs 1947–1977*, Thames & Hudson, London, 1978

Beaton, Cecil, *The Book of Beauty*, Gerald Duckworth & Co., London, 1930

Dars, Celestine, *A Fashion Parade: The Seeberger Collection*, Blond & Briggs, London, 1978

Demarchelier, Patrick, *Fashion Photography*, Little, Brown; Boston, Mass., 1989

Devlin, Polly, *Vogue Book of Fashion Photography*, Thames & Hudson, London; William Morrow & Co., New York, 1979

Ewing, William A., *The Photographic Art of Hoyningen-Huene*, Thames & Hudson, London; Rizzoli, New York, 1986

Farber, Robert, *The Fashion Photographer*, Watson-Guptill, New York, 1981

Gernsheim, A., *Fashion and Reality 1840–1914*, Faber and Faber, London, 1963

Hall-Duncan, Nancy, *The History of Fashion Photography*, Alpin Book Company, New York, 1979

Harrison, Martin, *Appearances: Fashion Photography since 1945*, Jonathan Cape, London, 1991

— , *Shots of Style*, exhibition catalogue, Victoria and Albert Museum Publications, London, 1985

— , *David Bailey/Archive One*, Thames & Hudson, London; Penguin Putnam, New York, 1999

Klein, William, *In and Out of Fashion*, Jonathan Cape, London, 1994

Lang, Jack, *Thierry Mugler: Photographer*, Thames & Hudson, London, 1988

Lichfield, Patrick, *The Most Beautiful Women*, Elm Tree Books, London, 1981

Lloyd, Valerie, *The Art of Vogue Photographic Covers*, Octopus Books, London, 1986

Mendes, Valerie (ed.), *John French Fashion Photographer*, exhibition catalogue, Victoria and Albert Museum Publications, London, 1984

Nickerson, Camilla and Neville Wakefield, *Fashion Photography of the 90s*, Scalo, Berlin, 1997

Parkinson, Norman, *Sisters under the Skin*, Quartet Books, London, 1978

Penn, Irving, *Passages*, Alfred A. Knopf/Callaway, New York, 1991

Pepper, Terence, *Photographs by Norman Parkinson*, Gordon Fraser, London, 1981

— , *High Society Photographs 1897–1914*, National Portrait Gallery Publications, London, 1998

Roley, K. and C. Aish, *Fashion in Photographs 1900–1920*, B. T. Batsford, London, 1992

Ross, Josephine, *Beaton in Vogue*, Thames & Hudson, London; Potter, New York, 1986

## Fashion in film

Beaton, Cecil, *Cecil Beaton's Fair Lady*, Weidenfeld & Nicolson, London, 1964

Chierichatti, David, *Hollywood Costume Design*, Studio Vista, London, 1976

Gaines, Jane and Charlotte Herzog (eds), *Fabrications: Costume and the Female Body*, Routledge, London, 1990

Greer, Howard, *Designing Male*, Putnams, New York, 1949

Head, Edith and J. K. Ardmore, *The Dress Doctor*, Little, Brown; Boston, Mass., 1959

Kobal, John (ed.), *Hollywood Glamor Portraits*, Dover Publications, New York, 1976

La Vine, W. R., *In a Glamorous Fashion*, Allen & Unwin, London, 1981

Leese, Elizabeth, *Costume Design in the Movies*, BCW Publishing, Isle of Wight, 1976

McConathey, Dale and Diana Vreeland, *Hollywood Costume: Glamour! Glitter! Romance!*, Abrams, New York, 1976

Maeder, E. (ed.), *Hollywood and History: Costume Design in Film*, Thames & Hudson, London; Los Angeles County Museum of Art, Los Angeles, Calif., 1987

Metropolitan Museum of Art, Costume Institute, *Romantic and Glamorous Hollywood Design*, exhibition catalogue, New York, 1974

Sharaff, Irene, *Broadway and Hollywood: Costumes Designed by Irene Sharaff*, Van Nostrand Reinhold, New York, 1976

Whitworth Art Gallery, *Hollywood Film Costume*, exhibition catalogue, Manchester, 1977

## Magazines

Braithwaite, B. and J. Barrell, *The Business of Women's Magazines*, Associated Business Press, London, 1979

Ferguson, M., *Forever Feminine: Women's Magazines and the Cult of Femininity*, Gower Publishing, Aldershot, Hants, 1986

Gibbs, David (ed.), *Nova 1965–1975*, Pavilion Books, London, 1993

Kelly, Katie, *The Wonderful World of Women's Wear Daily*, Saturday Review Press, New York, 1972

Millum, T., *Images of Woman*, Chatto & Windus, London, 1975

Mohrt, Françoise, *25 Ans de Marie-Claire, de 1954 à 1979*, Marie-Claire, Paris, 1979

Piaggi, Anna, *Anna Piaggi's Fashion Algebra*, Thames & Hudson, London and New York, 1998

White, Cynthia, *Women's Magazines 1693–1968*, Michael Joseph, London, 1970

Winship, L. W., *Inside Women's Magazines*, Pandora Press, London, 1987

Woodward, H., *The Lady Persuaders*, Ivan Obolensky, New York, 1960

## Mannequins

Castle, C., *Model Girl*, David and Charles, Newton Abbott, Devon, 1976

Clayton, Lucie, *The World of Modelling*, Harrap, London, 1968

Dawnay, Jean, *Model Girl*, Weidenfeld & Nicolson, London, 1956

Freddy, *Flying Mannequin: Memoirs of a Star Model*, Hurst & Blackett, London, 1958

Graziani, Bettina, *Bettina by Bettina*, Michael Joseph, London, 1963

Gross, Michael, *Model: The Ugly Business of Beautiful Women*, William Morrow & Co., New York, 1995

Helvin, Marie, *Catwalk: The Art of Model Style*, Michael Joseph, London, 1985

Jones, Lesley-Ann, *Naomi: The Rise and Rise of the Girl from Nowhere*, Vermilion, London, 1993

Keenan, Brigid, *The Women We Wanted to Look Like*, Macmillan, London, 1977

Kenore, Carolyn, *Mannequin: My Life as a Model*, Bartholomew, New York, 1969

Keysin, Odette, *Presidente Lucky, Mannequin de Paris*, Librairie Artheme Fayard, Paris, 1961

Liaut, Jean-Noël, *Modèles et mannequins 1945–1965*, Filipacchi, Paris, 1994

Marshall, Cherry, *Fashion Modelling as a Career*, Arthur Barker, London, 1957

— , *The Catwalk*, Hutchinson, London, 1978

Menkes, Suzy, *How to be a Model*, Sphere Books, London, 1969

Moncur, Susan, *They Still Shoot Models My Age*, Serpent's Tail, London, 1992

Mounia and D. Dubois-Jallais, *Princesse Mounia*, Editions Robert Laffont, Paris, 1987

Praline, *Mannequin de Paris*, Editions du Seuil, Paris, 1951

Schoeller, Guy, *Bettina*, Thames & Hudson, London; Universe Publishing, New York, 1997

Shrimpton, Jean, *The Truth about Modelling*, W. H. Allen, London, 1964

— , *An Autobiography*, Ebury Press, London, 1990

Sims, Naomi, *How to be a Top Model*, Doubleday, New York, 1989

Thurlow, Valerie, *Model in Paris*, Robert Hale, London, 1975

Twiggy, *Twiggy: An Autobiography*, Hart-Davis MacGibbon, London, 1975

Wayne, George, *Male Supermodels: The Men of Boss Models*, Thames & Hudson, London; Boss Models Inc., New York, 1996

## Menswear

Amies, Hardy, *An ABC of Men's Fashion*, Newnes, London, 1964

Bennett-England, Rodney, *Dress Optional*, Peter Owen, London, 1967

Binder, Pearl, *The Peacock's Tail*, Harrap, London, 1958

Brockhurst, H. E. et al., *British Factory Production of Men's Clothes*, George Reynolds, London, 1950

Buzzaccarini, Bittoria de, *Men's Coats*, Zanfi Editori, Modena, 1994

Byrde, Penelope, *The Male Image: Men's Fashion in Britain, 1300–1970*, B. T. Batsford, London, 1979

Chenoune, Farid, *A History of Men's Fashion*, Editions Flammarion, Paris, 1996

Cohn, Nik, *Today There Are No Gentlemen*, Weidenfeld & Nicolson, London, 1971

Constantino, Maria, *Men's Fashion in the Twentieth Century*, B. T. Batsford, London, 1997

Corbin, H. E., *The Men's Clothing Industry: Colonial through Modern Times*, Fairchild Publications, New York, 1970

De Marly, Diane, *Fashion for Men: An Illustrated History*, B. T. Batsford, London, 1985

Edwards, Tim, *Men in the Mirror*, Cassell, London, 1997

Farren, Mick, *The Black Leather Jacket*, Plexus Publishing, London, 1985

Giorgetti, Cristina, *Brioni: Fifty Years of Style*, Octavo, Florence, 1995

McDowell, Colin, *The Man of Fashion: Peacock Males and Perfect Gentlemen*, Thames & Hudson, London and New York, 1997

Martin, Richard and Harold Koda, *Jocks and Nerds: Men's Style in the Twentieth Century*, Rizzoli, New York, 1989

Peacock, John, *Men's Fashion: The Complete Sourcebook*, Thames & Hudson, London and New York, 1996

Ritchie, Berry, *A Touch of Class: The Story of Austin Reed*, James & James, London, 1990

Schoeffler, O. and Gale William, *Esquire's Encyclopaedia of 20th Century Men's Fashions*, McGraw-Hill, New York, 1973

Taylor, John, *It's a Small, Medium, Outsize World*, Hugh Evelyn, London, 1966

Wainwright, David, *The British Tradition: Simpson – A World of Style*, Quiller Press, London, 1996

Walker, Richard, *The Savile Row Story: An Illustrated History*, Prion, London, 1988

## Street, pop and subcultural styles

Barnes, Richard, *Mods*, Eel Pie Publishing, London, 1979

Cohen, S., *Folk Devils and Moral Panics: The Creation of the Mods and Rockers*, MacGibbon & Kee, London, 1972

Dingwall, Cathie and Amy de la Haye, *Surfers, Soulies, Skinheads and Skaters*, Victoria and Albert Museum Publications, London, 1996

Hall, Stuart and Tony Jefferson, *Resistance through Rituals*, Routledge, London, 1990

Hebdige, Dick, *Subculture: The Meaning of Style*, Methuen, London, 1979

Hennessy, Val, *In the Gutter*, Quartet Books, London, 1978

Kingswell, Tamsin, *Red or Dead: The Good, the Bad and the Ugly*, Thames & Hudson, London; Watson-Guptill, New York, 1998

Knight, Nick, *Skinhead*, Omnibus Press, London and New York, 1982

McDermott, Catherine, *Street Style*, Design Council, London, 1987

Polhemus, Ted, *Street Style*, Thames & Hudson, London and New York, 1994

— , *Style Surfing: What to Wear in the Third Millennium*, Thames & Hudson, London and New York, 1996

— , *Diesel: World Wide Wear*, Thames & Hudson, London; Watson-Guptill, New York, 1998

— and Lynn Proctor, *Pop Styles*, Hutchinson, London, 1984

Savage, Jon, *England's Dreaming: Sex Pistols and Punk Rock*, Faber and Faber, London, 1991

Stuart, Johnny, *Rockers*, Plexus Publishing, London, 1987

## Sportswear

Colmer, M., *Bathing Beauties: The Amazing History of Female Swimwear*, Sphere Books, London, 1977

Fashion Institute of Technology, *All American: A Sportswear Tradition*, exhibition catalogue, New York, 1985

Lee-Potter, Charlie, *Sportswear in Vogue since 1910*, Thames & Hudson, London; Abbeville Press, New York, 1984

Probert, Christina, *Swimwear in Vogue since 1910*, Thames & Hudson, London; Abbeville Press, New York, 1981

Silmon, Pedro, *The Bikini*, Virgin Publishing, London, 1986

Tinling, Teddy, *White Ladies*, Stanley Paul, London, 1963

— , *Sixty Years in Tennis*, Sidgwick and Jackson, London, 1983

## Royal dress

Blanchard, T. and T. Graham, *Dressing Diana*, Weidenfeld & Nicolson, London, 1998

Christies, *Dresses from the Collection of Diana, Princess of Wales*, auction catalogue, New York, June 1997

Edwards, A. and Robb, *The Queen's Clothes*, Rainbird Publishing Group, London, 1977

Hartnell, Norman, *Royal Courts of Fashion*, Cassell, London and New York, 1971

Howell, Georgina, *Diana: Her Life in Fashion*, Pavilion Books, London, 1998

McDowell, Colin, *A Hundred Years of Royal Style*, Muller, Blond & White, London, 1985

Menkes, Suzy, *The Royal Jewels*, Grafton, London, 1986

— , *The Windsor Style*, Grafton, London, 1987

Owen, J., *Diana Princess of Wales: The Book of Fashion*, Colour Library Books, Guildford, Surrey, 1983

## Underwear

Carter, Alison, *Underwear: The Fashion History*, B. T. Batsford, London, 1992

Cunnington, C. Willet and Phyllis, *The History of Underclothes*, Michael Joseph, London, 1951

Ewing, Elizabeth, *Dress and Undress: A History of Women's Underwear*, B. T. Batsford, London; Drama Book Specialists, New York, 1978

Koike, Kazuko et al., The Undercover Story, New York Fashion Institute of Technology and the Costume Institute, Tokyo, exhibition catalogue, New York and Tokyo, 1982

Martin, Richard and Harold Koda, Infra-Apparel, Metropolitan Museum of Art, New York, 1993

Morel, Juliette, Lingerie Parisienne, Academy Editions, London, 1976

Musée de la Mode et du Costume de la Ville de Paris, Palais Galliéra, Secrets d'élégance 1750–1950, exhibition catalogue, Paris, 1978

Page, C., Foundations of Fashion: The Symington Collection, Leicestershire Museum, Leicestershire, 1981

Probert, Christina, Lingerie in Vogue since 1910, Thames & Hudson, London; Abbeville Press, New York, 1981

Saint-Laurent, Cecil, The History of Ladies' Underwear, Michael Joseph, London, 1968

Waugh, Norah, Corsets and Crinolines, B. T. Batsford, London, 1954

## Accessories

Amphlett, H., Hats, Richard Sadler, London, 1974

Baynes, Ken and Kate, The Shoe Show: British Shoes since 1790, The Crafts Council, London, 1979

Centre Sigma Laine, Souliers par Roger Vivier, exhibition catalogue, Bordeaux, 1980

Chaille, François, The Book of Ties, Editions Flammarion, Paris, 1994

Clark, Fiona, Hats, B. T. Batsford, London, 1982

Corson, R., Fashions in Eyeglasses from the 14th Century to the Present Day, Peter Owen, London, 1967

Cumming, Valerie, Gloves, B. T. Batsford, London, 1982

Daché, Lilly, Talking through My Hats, John Gifford, London, 1946

Doe, Tamasin, Patrick Cox: Wit, Irony and Footwear, Thames & Hudson, London; Watson-Guptill, New York, 1998

Double, W. C., Design and Construction of Handbags, Oxford University Press, London, 1960

Doughty, Robin, Feather Fashions and Bird Preservation, University of California Press, Berkeley, Calif., 1975

Eckstein, E. and J. Firkins, Hat Pins, Shire Album 286, Shire Publications, Princes Risborough, Bucks, 1992

Epstein, Diana, Buttons, Studio Vista, London, 1968

Farrell, Jeremy, Umbrellas and Parasols, B. T. Batsford, London, 1986

—, Socks and Stockings, B. T. Batsford, London, 1992

Ferragamo, Salvatore, Shoemaker of Dreams: The Autobiography of Salvatore Ferragamo, Harrap, London, 1957

Foster, Vanda, Bags and Purses, B. T. Batsford, London, 1982

Friedel, Robert, Zipper: An Exploration in Novelty, W. W. Norton & Co., New York, 1994

Ginsburg, Madeleine, The Hat: Trends and Traditions, Studio Editions, London, 1990

Gordon, John and Alice Hiller, The T-shirt Book, Ebury Press, London, 1988

Grass, Milton E., History of Hosiery, Fairchild Publications, New York, 1955

Houart, Victor, Buttons: A Collector's Guide, Souvenir Press, London, 1977

Luscomb, S. C., The Collector's Encyclopaedia of Buttons, Crown, New York, 1968

McDowell, Colin, Hats: Status, Style and Glamour, Thames & Hudson, London and New York, 1992

Mazza, Samuel, Scarparentola, Idea Books, Milan, 1993

Mercié, Marie, Voyages autour d'un chapeau, Editions Ramsay/de Cortanze, 1990

Peacock, Primrose, Buttons for the Collector, David and Charles, Newton Abbott, Devon, 1972

Probert, Christina, Hats in Vogue since 1910, Thames & Hudson, London; Abbeville Press, New York, 1981

—, Shoes in Vogue since 1910, Thames & Hudson, London; Abbeville Press, New York, 1981

Provoyeur, Pierre, Roger Vivier, Editions du Regard, Paris, 1991

Ricci, Stefania et al., Salvatore Ferragamo: The Art of the Shoe 1898–1960, Rizzoli, New York, 1992

Richter, Madame Eve, ABC of Millinery, Skeffington and Son, London, 1950

Smith, A. L. and K. Kent, The Complete Button Book, Doubleday, New York, 1949

Solomon, Michael, Chic Simple: Spectacles, Thames & Hudson, London; Alfred A. Knopf, New York, 1994

Swann, June, Shoes, B. T. Batsford, London, 1982

Thaarup, Aage, Heads and Tales, Cassell, London, 1956

— and D. Shackell, How to Make a Hat, Cassell, London, 1957

Trasko, Mary, Heavenly Soles, Abbeville Press, New York, 1989

Wilcox, Claire, A Century of Style: Bags, Quarto, London, 1998

Wilcox, R. Turner, The Mode in Hats and Headdresses, Charles Scribner's Sons, New York and London, 1959

Wilson, Eunice, A History of Shoe Fashions, Pitman, New York, 1969

Yusuf, Nilgin, Georgina von Etzdorf: Sensuality, Art and Fabric, Thames & Hudson, London; Watson-Guptill, New York, 1998

## Hairstyles and cosmetics

Angelouglou, M., A History of Make-up, Studio Vista, London, 1970

Antoine, Antoine by Antoine, W. H. Allen, London, 1946

Banner, L. W., American Beauty, Alfred A. Knopf, New York, 1983

Castelbajac, Kate de, The Face of the Century: 100 Years of Make-up and Style, Thames & Hudson, London and New York, 1995

Chorlton, Penny, Cover-up: Taking the Lid off the Cosmetics Industry, Grapevine, Wellingborough, Northants, 1988

Cooper, Wendy, Hair, Aldus Editorial, Mexico, 1971

Corson, R., Fashions in Hair, Peter Owen, London, 1965

—, Fashions in Make-up from Ancient to Modern Times, Peter Owen, London, 1972

Cox, J. Stevens, An Illustrated Dictionary of Hairdressing and Wig-making, Hairdressers Technical Council, London, 1966

Garland, Madge, The Changing Face of Beauty, Weidenfeld & Nicolson, London, 1957

Ginsberg, Steve, Reeking Havoc, Warner Books, New York, 1989

Graves, Charles, Devotion to Beauty: The Antoine Story, Jarrolds Publishing, London, 1962

Lewis, A. A. and C. Woodworth, Miss Elizabeth Arden: An Unretouched Portrait, W. H. Allen, London, 1973

Linter, Sandy, Disco Beauty, Angus and Robertson, London, 1979

MacLaughlin, Terence, The Gilded Lily, Cassell, London, 1972

Michael, Liz and Rachel Urquhart, Chic Simple: Woman's Face, Thames & Hudson, London; Alfred A. Knopf, New York, 1997

Perutz, K., Beyond the Looking Glass: Life in the Beauty Culture, Hodder & Stoughton, London, 1970

Price, Joan and Pat Booth, Making Faces, Michael Joseph, London, 1980

Raymond, The Outrageous Autobiography of Mr Teasie-Weasie, Wyndham, London, 1976

Robinson, Julian, Body Packaging, Watermark Press, Sydney, N.S.W., 1988

Rubinstein, Helena, The Art of Feminine Beauty, Victor Gollancz, London, 1930

—, My Life for Beauty, Bodley Head, London, 1964

Sassoon, Vidal, Sorry I Kept You Waiting Madam, Cassell, London, 1968

Scavullo, Francesco, Scavullo on Beauty, Random House, New York, 1976

Wolf, Naomi, The Beauty Myth, Chatto & Windus, London, 1990

## Patterns

Arnold, Janet, Patterns of Fashion 2, c.1860–1940, Macmillan, London, 1977

Hunnisett, Jean, Period Costume for Stage and Screen: Patterns for Women's Dress 1800–1909, Players Press, Studio City, Calif., 1991

Kidd, Mary T., Stage Costume, A. & C. Black, London, 1996

Shaeffer, Clare B., Couture Sewing Techniques, Taunton Press, Newton, Conn., 1993

Waugh, Norah, The Cut of Women's Clothes 1600–1930, Faber and Faber, London, 1968

# Sources of illustrations

The publishers would like to thank all the designers and companies who generously made available original sketches and photographs from their archives.

James Abbe: 16; © ADAGP, Paris and DACS, London 1999: 61, 62, 63, 64; The Advertising Archives: 84, 100, 101, 162; AKG, London: 115, 116; Courtesy Hardy Amies: 152; Courtesy Giorgio Armani: 249, 250, 265 (Photo © Peter Lindbergh); Courtesy Peter Ascher: 181; Courtesy Laura Ashley: 225; Barnabys Picture Library: 60, 113; Private Collection/Christie's Images/Bridgeman Art Library, London/New York. © Salvador Dali – Foundation Gala-Salvador Dali/DACS 1999: 106; Photo courtesy Brooklyn Museum of Art: 2; Camera Press: 201 (Photo Hans de Boer), 229 (U. Steiger/SHE), 237, 238, 239 (Photo Glenn Harvey); Courtesy Pierre Cardin: 179, 185, 207; Centre de Documentation de la Mode et du Textile, Paris: 68, 70; Courtesy Fonds Chanel, photo © Karl Lagerfeld: 246; Christie's Images: 111; © Condé Nast/Vogue: 105, 114; Corbis: 121 (Hulton Getty), 124 (Hulton Getty), 129 (Genevieve Naylor), 130 (Hulton Getty), 131 (Hulton Getty), 132, 133 (UPI/Bettmann), 154 (Genevieve Naylor), 156, 157 (Genevieve Naylor), 159 (Hulton Getty), 163 (Genevieve Naylor), 215 (UPI/Bettmann), 220 (UPI/Bettmann), 263, 264 (Vittoriano Rastelli); Private collection. © DACS 1999: 30; Pamela Diamond: 79; Discovery Museum, Newcastle upon Tyne (Tyne & Wear Museums): 224; E.T. Archive: 12, 94, 95; Courtesy Ferragamo: 96, 97; Chantal Fribourg, Paris: 164; *Gazette du bon ton*: 28, 29, 57, 69; Courtesy Jean-Paul Gaultier: 257; Courtesy Rudi Gernreich: 197; Ronald Grant Archive: 65, 161, 204; Courtesy Shirin Guild: 262 (Photo Robin Guild); Courtesy Lulu Guinness: 276; Courtesy Halston: 216; *Harper's Bazaar*: 81, 103 (Photo © George Hoyningen-Huene); Hulton Getty: 3, 10, 23, 24, 38, 51, 55, 66, 71, 75, 76, 78, 80, 85, 86, 88, 93, 99, 117, 136, 151, 160, 165, 186, 187, 188, 189, 190, 191, 194, 198, 199, 200, 210, 218, 219, 221; *i - D* magazine. 230 (Photo © Barry Lategan); The Trustees of the Imperial War Museum, London: 54, 123; Courtesy Betsey Johnson: 193; Courtesy Norma Kamali: 256; Courtesy Kenzo: 209; Courtesy Calvin Klein: 253; Photo © Nick Knight: 241; Kobal Collection: 174; Krizia: 214 (Photo Alfa Castaldi); Courtesy Christian Lacroix: 247 (Photo © Jean-François Gâté); Courtesy Ralph Lauren: 254; Library of Congress, Washington DC: 21, 39; London Features International: 184; Courtesy Mary McFadden: 217; Photos © Niall McInerney: 226, 231, 232, 233, 234, 235, 236, 240, 242, 243, 244, 245, 248, 255, 258, 259, 260, 261, 266, 267, 268, 269, 270, 271, 273, 274, 275, 277, 279, 280; Magnum/ Photo © Robert Capa: 139; Maryhill Museum of Art: 137, 138; © Association Willy Maywald/ © ADAGP, Paris and DACS, London 1999: 135, 140, 141, 142, 143, 144, 145 146, 148, 153, 166, 167, 168, 177, 178; Lee Miller Archives: 114, 134; Courtesy Missoni/ Gai Pearl Marshall: 211, 212, 252; Courtesy Moschino/Gai Pearl Marshall: 228; Museum of London: 20; By courtesy of the National Portrait Gallery, London: 15; Copyright SYLVIE NISSEN Galleries http://www.rene-gruau.com: 104; Collection Edouard Pecourt: 37; Pictorial Press: 98; Private Collection: 1, 4, 5, 6, 7, 8, 9, 11, 13, 14, 17, 18, 19, 22, 25, 26, 34, 35, 36, 40, 41, 42, 43, 44, 45, 46, 48, 49, 50, 52, 56, 59, 74, 77, 82, 83, 87, 89, 90, 91, 92, 108, 110, 118, 119, 120, 125, 126, 127, 128, 149, 150, 158; Popperfoto:183; Emilio Pucci: 182; Rapho: 147 (Photo © Robert Doisneau); Zandra Rhodes, UK: 222, 227 (Photo Clive Arrowsmith); Courtesy Clements Ribeiro: 278 (Photo Tim Griffiths); Royal Photographic Society: 72 (Photo © Hoyningen-Huene); Courtesy Sonia Rykiel: 206, 208; Courtesy Yves Saint Laurent: 169, 170, 171, 172, 202 (Photo © Helmut Newton), 203, 205; Seeberger Archive, Bibliothèque Nationale, Paris: 31, 47, 67, 102; Courtesy Sotheby's, Cecil Beaton Archive: 2–3, 107; Courtesy Gianni Versace: 251; Courtesy Valentino: 213; Victoria & Albert Museum: 27, 32, 33, 73, 109, 112, 122, 155, 173, 175&176 (Photos © John French): 192; Courtesy Roger Vivier: 195, 196; Courtesy Yuki: 223.

# Acknowledgments

We are grateful to many people for their support and for generously sharing information, especially Professor Lou Taylor, Marie-Andrée Jouve, Elizabeth Ann Coleman, Timothy d'Arch Smith, Ernest and Diane Connell, Faith Evans, Professor John Stokes, Susan North, Jane Mulvagh, Avril Hart, Sarah Woodcock, David Wright, Michael Neal, Lucy Pratt, Professor Bruno Remaury, Claire Wilcox and Debbie Sinfield. We also extend thanks to all the designers and their PRs as well as to the owners of fashionable clothes, who have kindly provided facts and illustrative material.

A-line 131, 184
Accademia dei Sartori 173
Adler & Adler 185
Adrian, Gilbert (Adrian
  Adolph Greenburg; 1903–59;
  b. Naugatuck, Conn., USA) 88,
  119–20, 147, *163*
Agnès 104
Alaïa, Azzedine (1940–;
  b. Tunisia, North Africa)
  237–8
*Album de la mode* 125
Alexandra, Queen, influence
  on style 22
Alix *see* Grès
Alix Barton *see* Grès
Allan, Maud 24
Amies, Hardy (1909–; b. London,
  England) 76, 112, 140, 142–4,
  175–6, *152*
Anderson & Sheppard 150, 264
androgynous styles 210, *202*,
  *242, 252 see also* gender-
  blurred fashions
Anello & Davide 186
ankle socks 80, 109, *159*
Anti-Iron-Collar League 71
Antoine (Antek Cierplikowski;
  1884–1976; b. Sieradz, Poland)
  156
Antonelli, Maria 118
Aquascutum 50, 78, *84*
Arden, Elizabeth 154, 184, *128*
Armani, Giorgio (1934–;
  b. Piacenza, Italy) 201, 212,
  233, 243–4, *249*, 250, 265
Armstrong-Jones, Antony (later
  Lord Snowdon) 187
Arnault, Bernard 239, 263–4
Arrow shirts *39*
Art Deco, influence on fashion
  66, 200, *104*
art silk 75
Ascher, Zika 111, 171, *181*
Ashley, Laura (Laura Mountney;
  1925–85; b. Merthyr Tydfil,
  Wales) 217, 219, *225*
Astaire, Fred 90
Astor, Mrs Vincent *154*
Atelier Martine 36
Au Printemps 20, *22*
Augustabernard (Augusta
  Bernard; 1886–1946;
  b. Biarritz, France) 93
Australia, fashion designers
  242–3, 270–1
*The Avengers*, influence on style
  176, 181
Ayscough, Bessie 20
Ayton, Sylvia 214

Babb, Paul *199*
bags 65, 86, 104, 156–7, *266*,
  267–8, 269, *1, 5, 94, 150, 275,
  276*
Bailey, David 182, 187, 188
Bakst, Léon *32, 27*
Balenciaga, Cristobal
  (1895–1972; b. Guetaria,
  Spain) 76, 101, 103, 106, 128,
  131–5, 148, 160, 162, 165, 194,
  270, *113, 138, 142*
ball gowns 26–7, 148, *105 see
  also* evening wear
Ballets Russes, influence on
  fashion 10, 32, 69, 255, *27, 76*
Balmain, Pierre (1914–82;
  b. St Jean-de-Maurienne,
  France) 106, 136–8, *145, 146*
bandeaux 67, *71*

Banks, Jeff (1943–; b. Ebbw Vale,
  Wales) 181
Banton, Travis (1894–1958;
  b. Waco, Tex., USA) 88
Barbier, George *34*
Barbour 78
Barran, John 55
Barrie, Scott 208
Barton, Julie 93
Basile 243
Bates, John (1938–;
  b. Northumberland, England)
  181
beachwear 120–1, 126, 147,
  242–3, *91 see also* swimwear
beads 24, 32, 65, 208, 215, 241,
  *19, 66, 158, 242*
The Beatles, influence on fashion
  176, *186*
Beatniks 152–3
Beaton, Cecil 66, *2–3*
Beau Brummell Neckwear 207
Beaux, Ernest 57
Beene, Geoffrey (1927–;
  b. Haynesville, La., USA)
  185, 200, 205
Beerbohm, Max 42
Bell, Vanessa 71, *79*
belts 50, 78–9, 85–6, 112, 119,
  120, 149, 157, 250, *53, 156,
  158, 208, 215, 228, 244, 246,
  251*
Bendel, Henri 20, 48, 139
Bender, Lee 181
Bender, Marilyn 185
Benito 58
Bennett, Stephen 242
Bérard, Christian 98
Bergdorf Goodman 20, 78, 184
Bergé, Pierre 162, 194
Bettina (Simone Bodin) 155
Biagiotti, Laura (1943–; b. Rome,
  Italy) 204
Biba 181, 213, 217, *191, 222, 224*
biker clothes 153, 162, 183, *226*
bikinis 126
Bikkembergs, Dirk (1962–;
  b. Bonn, Germany) 260–2
Birkenstock sandals 256
Birtwell, Celia 214, *221*
black: Chanel and 72;
  existentialist dress 153;
  Kawakubo and 234; Punk
  styles 220, *226*
Blahnik, Manolo (1943–; b. Santa
  Cruz, Canary Islands) 228
Blaisse, Maria 233
blazers 70, 72, 92, 109, *77*
Bloomberg, Leonard *199*
Bloomsbury Group 24, 71
blouses 29, 52, 103, 107, 109,
  120, 172, 230, 244, *21, 53, 147,
  203, 213, 225, 249, 254*
Blyth, Ann *162*
bodices 31, 37, 50, 58, 79, 101,
  106, 136, 142, 147, 167, 231,
  247, 265, *1, 17, 217, 227, 248,
  258*
Body Map 226, 228
body piercing 222, 252
bodystockings 171
Bohan, Marc (Roger Maurice
  Louis Bohan; 1926–; b. Paris,
  France) 162
boilersuits 192
Bolan, Marc 210
Boldini, Giovanni 22
Bolger, Brian 226
bondage styles 220–2, 236
Bonwit Teller 184

boots *see* footwear
Boulanger *see* Louiseboulanger
Boulet, Denise 36
Boussac, Marcel 128
Boutique Simultané 66
boutonnières 46, *44*
Bowie, David 210, 225, *218*
Boyd, John 231
bra-tops 121, 237
braces 78, 92, 114–15
bras *see* brassieres
brassieres 55, 79, 109, 154, 179,
  191, 225, *55, 87, 231*; 'No-Bra'
  bra 186
breeches 55, 224
Breton, André, *Surrealist
  Manifesto* 97
Brioni 173
'Britain Can Make It' exhibition
  (1946) 140
Brooks Brothers 175, 207
Brooks, Louise 61, *65*
Browns 225
Brunhoff, Michel de 125
Bunka College of Fashion 200
Burberry 31, 50, 78, *101*
Burrows, Stephen (1943–;
  b. Newark, N. J., USA) 208
Burton's 115, 150
busks 13
bustiers 233
Butterick 140, *26, 82, 83*
buttonholing 55
buttons 55, 112, 167, 234, *181,
  272*

Cadette 245
caftans 186, 207
Callot Soeurs 24, 54, 57
camiknickers 80, 109
camisoles 65
Campbell, Naomi 258
capes 32, 79, 173, 270, *33, 166*
Capezio 122
'capsulas', by Pucci 172
Capucci, Roberto (1930–;
  b. Rome, Italy) 145, 171, *181*
Caracciolo, Princess Giovanna
  (Carosa) 171
Caraceni, Domenico 173
cardigan suits 69, 72, 138, *246*
cardigans 52, 109, 230, *208, 234,
  254*
Cardin, Pierre (1922–; b. Sant
  Andrea Barbarana, Italy) 158,
  168–70, 175–6, 191, 196–7,
  236, *177, 178, 179, 185, 206,
  207*
Carnaby Street 174, 180, *189, 190*
Carnegie, Hattie (Henrietta
  Kanengeiser; 1889–1956;
  b. Vienna, Austria) 62, 78,
  118, 147, 149, 185, *129*
Carosa (Princess Giovanna
  Caracciolo) 171
Carter, Ernestine 140
Cashin, Bonnie (1915–; b. Oakland,
  Calif., USA) 121, 185
Cassini, Oleg (Oleg Loiewski;
  1913–; b. Paris, France, of
  Russian parents) 184, *194*
Castellane-Novejean, Boniface,
  Comte de 42
catsuits *182*
Cavanagh, John (1914–;
  b. Ireland) 140, 144
Cecil Gee 150
Céline 266
Central Saint Martin's College
  of Art and Design 264

ceramic fibres 273
ceramics, influence on design 234
Cerruti, Nino (Antonio Cerruti;
    1930–; b. Biella, Italy) 212,
    243, 266
Chanel, Adrienne 52
Chanel, Gabrielle ('Coco';
    1883–1971; b. Saumur, France)
    52–4, 57, 62–3, 65–6, 69, 72,
    74, 76, 82, 87, 96, 106, 138,
    194, 52, 53, 76, 77, 147, 148,
    246
Chanel, House of 61, 72, 228,
    232–3, 238–9, 252, 265, 266,
    267, 52, 81, 82, 246, 248;
    Chanel 'No 5' 57; costume
    jewelry 65–6, 223, 70, 147, 246
Charles, Caroline (1942–;
    b. Cairo, Egypt, of English
    parents) 231
Chase, Edna Woolman 48
chemise dress 62, 184, 158
chemises 12, 28, 65
chemisettes 52
Chez Ninon 185
Chloé 198, 266, 270, 272
chokers 97, 209
Claire, Ina 61, 87
Clark, Ossie (Raymond Clark;
    1942–96; b. Liverpool,
    England) 213–14, 221
Clements Ribeiro 270, 278
Clements, Suzanne (1968–;
    b. Surrey, England) 278
    see also Clements Ribeiro
Clifford, Camille 20, 22, 15
cloaks 31, 32
cloche hats 60, 61, 63, 66
The Cloth 226
coat dresses 234
coats 46, 50, 84, 104, 118, 144,
    151, 162, 168, 191, 196, 215,
    243, 249, 250, 92, 114, 177,
    222, 224, 244 see also frock
    coats; jackets; maxi-coats;
    morning coats; tailcoats;
    trench coats
cocktail dresses 136
Cocteau, Jean 98
Colbert, Claudette 90
Colcombet 84
collars 29, 42, 44, 69, 71, 114,
    134, 136, 149, 150, 168, 176,
    196, 209, 234, 39, 43, 44, 177,
    186, 223, 254
Collot, Marthe 61
Colonna, Jean (1955–; b. Oran,
    Algeria) 269
colours: Edwardian period 24,
    32; First World War 50, 52,
    48, 49, 50; post-First World
    War 65, 66, 70, 94, 60; post-
    Second World War 134, 150,
    154; sixties 166; seventies
    195–6, 198, 206, 217; eighties
    246–7, 251
Comme des Garçons 233, 234,
    270, 240
Complice 243
Computer Aided Design (CAD)
    245, 258
Computer Aided Manufacturing
    (CAM) 258
La Confédération Générale
    de Travail (CGT) 96
Conran, Jasper (1960–;
    b. London, England) 231
Coolio 273
copying 72–4, 88, 139, 141, 162,
    166, 250

corsets 12–14, 28, 30, 32, 36, 55,
    65, 79–80, 153, 237, 21, 111
cosmetics see makeup
Costin, Simon 271
Cotton Board, Design and Style
    Centre 111
Council of Fashion Designers
    of America 185
Council for Industrial Design 140
Country Road 242
Courrèges, André (1923–;
    b. Pau, France) 158, 165–7,
    186, 175, 176
Courtaulds 191
Courtelle 178
Cox, Patrick (1963–;
    b. Edmonton, Canada) 228
Crawford, Cindy 258, 264
Crawford, Joan 61, 88, 116, 98
Creed, Charles (1909–66; b. Paris,
    France) 31, 106, 112, 144
Cripps, Sir Stafford 128
crocheted work 24, 194
Crolla, Scott 226
Crosby, Caresse 55
culottes 106, 120, 37
Curzon, Lady Mary (née Leiter),
    Vicereine of India 20
cyber fashions 258

Daché, Lilly (c. 1907–89;
    b. Bègles, France) 78, 157
Dada 236
Dali, Salvador 98, 99, 101, 106,
    107
Davis, Angela 213
day dresses 62, 90, 102
Debenham & Freebody 20
décolletage 106, 105, 238
de la Falaise, Loulou 194
de la Renta, Oscar (1932–;
    b. Santo Domingo, Dominican
    Republic) 184
Delaunay, Sonia (Sonia Terk;
    1884–1979; b. Odessa, Russia)
    66, 68, 250, 279
Dell'Olio, Louis (1948–; b. New
    York, USA) 249
Delphos gowns 24, 16
Delys, Gaby 20
Demeulemeester, Ann (1959–;
    b. Kortrijk, Belgium) 260, 269
demob suits 126, 150, 136
denim 120, 121, 205, 204, 215
department stores 20, 76, 22
Depression, fashion industry
    and the 76
Derry & Toms 217
designer labels and logos 223–4,
    232–3, 266–7, 273
Dessès, Jean (Jean Dimitre
    Verginie; 1904–70;
    b. Alexandria, Egypt, of Greek
    parents) 76, 204
Destrelles, Maroussia 6
devoré printed textiles 64
Diaghilev, Serge 10, 32, 76
Diana, Princess of Wales 229–31,
    237, 238, 239
Dietrich, Marlene 87, 98, 90, 136
diffusion lines 232–3, 266, 263,
    274
dinner jackets (tuxedos) 46, 238,
    172, 203
Dinnigan, Collette (c. 1966–;
    b. Durban, South Africa) 270
Dior, Christian (1905–57;
    b. Granville, France) 128–31,
    160, 232, 264, 270, 135, 139,
    140, 141, 168, 279

Dior, House of 162
Directoire style 32
Dispo 191
DKNY 266, 269, 274
Doctor Marten 222, 234, 236, 234
Doeuillet 54, 62
Doisneau, Robert 147
Dolce & Gabbana 252, 259, 264,
    266, 267
Dolce, Domenico (1958–;
    b. near Palermo, Sicily) 259
    see also Dolce & Gabbana
Donovan, Terence 187
Dorothée Bis boutique 182
Dorothy Perkins 278
Doucet, Jacques (1853–1929;
    b. Paris, France) 24, 36, 55, 62,
    18, 62, 63, 64
draped garments 36, 81, 92–3,
    94, 118, 197, 217, 234, 238,
    245, 247, 28, 29, 223
Dress Review 12–13
dressing gowns 47
'Drizabone' oilskin coats 243
drop-waisted dresses 62, 63, 66
Du Pont 104, 153, 191, 217
Duetti 173
Duff Gordon, Lady Lucile see
    Lucile
Dufour 138
Duncan, Isadora 24
dungarees 14
Dylan, Bob 211

Edward VII, arbiter of fashion
    42–3, 38
Edward VIII: as Prince of Wales
    69, 75, 76, 85 see also Windsor,
    Duke of
Egypt, influence on fashion
    63–4, 94, 68
Eisen, Mark (1960–; b. Cape
    Town, South Africa) 269, 270
Elbaz, Alber (1950–; b. Morocco,
    North Africa) 266
Les Élégances Parisiennes 53
Elizabeth II 140–1, 144, 151
Elizabeth, Princess Elizabeth
    of Toro 213
Elizabeth, Queen Mother 96–7,
    141
Ellis, Perry (1940–86;
    b. Portsmouth, Va., USA)
    250, 255
Elsie, Lily 36
Emanuel, David (1953–;
    b. Bridgend, South Wales) 231,
    238
Emanuel, Elizabeth (1953–;
    b. London, England) 231, 238
embroidery 12, 14, 24, 50, 65, 76,
    80, 94, 98, 100, 103, 107, 136,
    142, 208, 241, 270, 20, 53, 57,
    113, 158, 248
Empire line 32, 28, 29, 227
English Eccentrics 226
espionage 139
Esprit 251
Esquire 90, 151
ethnographic styles 63–4, 101–3,
    185, 200, 208, 222, 252, 262,
    204, 217, 222, 257, 268
Eton crops 60
Etro 270
Evangelista, Linda 258, 269
Evans, Alice 120
evening wear: Edwardian period
    26–7, 31–2, 16, 17, 18, 28, 29,
    32, 33, 46; First World War
    50, 51–2; post-First World

War 64, 65, 75, 79, 81, 88, 96,
    101, 64, 81, 89, 92, 98, 103, 113;
    Second World War 106, 107,
    118, 119; post-Second World
    War 131, 136–8, 142, 147,
    149–50, 139, 140, 141, 146,
    154, 158, 163; sixties 162, 172,
    166, 167, 168, 178; seventies
    195, 205, 207, 208, 214–15,
    216, 202, 216, 217; eighties
    222, 230, 231, 236, 244–5, 250,
    238, 239, 247, 248; nineties
    258, 277, 279; body sculptures
    195; corset tops 101, 112;
    crinoline and bustle styles 50,
    96 see also ball gowns
exercise garments 172–3

Fabiani, Alberto (dates unknown;
    b. Tivoli, Italy) 145, 171–2
fabrics: Edwardian styles 24, 28,
    29, 32, 36, 32, 33; First World
    War 52–4; post-First World
    War 57–8, 64, 65, 69, 72, 81–2,
    84, 92–3, 96, 58, 69, 81; Second
    World War 104, 106, 120, 121,
    123; post-Second World War
    134–5, 136–8, 147, 148, 155;
    sixties 166–7, 171–2, 180,
    185, 181; seventies 197, 200,
    201, 205, 206, 213–14, 216,
    221; eighties 233, 237–8, 243,
    247, 248, 240, 251; nineties
    256, 269–70, 271–3
The Face 224
facial hair 43, 189, 211
Factor, Max 92, 155, 117, 162
Fairbanks, Douglas 61
Fairchild, John B. 205
falsies 154
fans 15, 96
Farhi, Nicole (1946–;
    b. Nice, France) 269
Fashion Institute of Technology
    205, 208, 250
fashion portraits 20–2, 216
fashion press 20, 139–40, 147,
    156, 175, 176
Fassett, Kaffe (1937–;
    b. San Francisco, Calif., USA)
    216
Fath, Jacques (1912–54;
    b. Maisons-Laffitte, France) 76,
    106, 135–6, 162, 270, 143, 144
Fauves 32
Fawcett-Majors, Farrah 213
feathers 24, 30, 110, 215, 1, 13,
    15, 17, 18, 23, 30
Félix 26
feminism, Kawakubo and 234
Fendi 204, 233, 239, 263
Ferguson Brothers, cottons 82
Ferragamo, Salvatore
    (1898–1960; b. Bonito, Italy)
    86, 118, 157, 96, 97
Ferre, Gianfranco (1944–;
    b. Legnano, Italy) 244, 269, 280
Ferry, Bryan 212
fetishistic styles 220–2, 259
Feure, Georges de 30
Fibrone 55
figure-shaping treatments 80
film stars: influence on fashion
    60–1, 90, 92, 116, 153, 156,
    162–5, 211, 243, 99, 100, 161,
    174, 220 see also Hollywood
Fiorucci, Elio (1935–; b. Milan,
    Italy) 209
fitness and health 80–1, 194,
    212–13, 88

Fitz-Simon, Stephen 217
flowers 24, 37, 97, 107, 111, 241, *1*, *115*, *116*
Foale, Marion 226
Foale & Tuffin 181, 213
folk designs 63, 66, *63*, *252*
Fonda, Jane 213
Fontana, Sorelle 118
footwear *see also* platform soles, wedge soles
footwear, men's 43, 46, 69, 70, 88–90, 107, 109, 114, 153, 157, 174, 222, 243, *1*, *40*, *41*, *42*, *183* *186*, *204*
footwear, women's: Edwardian 15, *5*; post-First World War 51, 54–5, 63, 65, 86, 90, *51*, *53*, *95*, *96*, *97*, *102*; Second World War 104, 107, 109, 114, 118, 121, 122; post-Second World War 149, 153, 156–7, *150*, *152*, *159*; sixties 166, 170, 174, 179, 184, 186, *166*, *175*, *176*, *183*, *188*, *192*, *195*, *196*; seventies 195, 196, 209, 204, 209, *210*; eighties 222, 225, 228, 234, 236, 254, *226*, *227*, *232*, *244*, *245*, *254*, *255*; nineties 256, 263, *269*, *274*
Ford, Tom (*c.* 1962–; b. Texas, USA) 267
Forster & Son Ltd 86
Fortuny, Mariano (Mariano Fortuny y Madrazo; 1871–1949; b. Granada, Spain) 24, *16*
Foster Porter & Co Ltd *48*, *49*, *50*
Fougasse 111
Fowler, Timney 226
Fox, Harry *190*
Franklin, Jessie 78
Fraser, Honor 258, 277
Fratini, Gina (Georgina Butler; 1931–; b. Kobe, Japan, of English parents) 213
French, John *175*, *176*
Friedan, Betty 192
frock coats 44–5, 264, 265, *41*
frou-frou 32, *46*
Frowick, Roy Halston *see* Halston
Fry, Roger 32, 71
Fuller, Loïe 20, *24*
fur 15, 24, 50, 82, 195, 204, 256–7, *9*, *145*, *263*

Gabbana, Stefano (1962–; b. Milan, Italy) 259 *see also* Dolce & Gabbana
Gala 189
Galanos, James (1924–; b. Philadelphia, Pa., USA) 185–6, 251
Galeries Lafayette 20
Galliano, John (1960–; b. Gibraltar) 225–6, 228, 254, 264, 270, *233*
Gamba *192*
Garbo, Greta 87, 88, 90, *99*
*garçonne* look 58–9, 61–2, 74, *51*, *56*, *59*, *60*, *82*, *83*
Gaultier, Jean-Paul (1952–; b. Paris, France) 236–7, 252, 260, 270, *242*, *257*
Gazaboen 231
*Gazette du bon ton* 28, 29, 57, 69
Gellé, cosmetics *6*
gender-blurred fashions *257*, *266*, *267 see also* androgynous styles
Genesco 176

Gernreich, Rudi (Rudolph Gernreich; 1922–85; b. Vienna, Austria) 185, 186, *197*
Ghesquiere, Nicolas 270
Gibb, Bill (1943–88; b. Fraserburgh, Scotland) 213, 216
Gibson, Charles Dana 22
Gibson Girls 20, 22, *15*
Gieves (& Hawkes) 43, 150, 264
Gigli, Romeo (1951–; b. Castel Bolognese, Italy) 246–7, 254–5, 264, 270, *258*
Gilbey, Tom 176
Gill, Winifred 79
Giorgini, Giovanni Battista 145
girdles 87
Givenchy, Hubert de (1927–; b. Beauvais, France) 162, 200, 232, 264, 265, 266, 270, *174*
Glitter, Gary 209–10
gloves 15, 96, 156–7, 166, *1*, *40*, *41*, *47*, *102*, *150*, *152*, *166*, *174*, *175*, *176*, *194*, *245*, *248*, *263*
Goalen, Barbara 155, *150*
Godley, Georgina (1955–; b. London, England) 228
Gold, Warren and David *189*
Goldwyn, Samuel 87
Greco, Juliette 154
Greece, influence on fashion 94, 265
Greene, Alexander Plunket 177
Greenwood, Charlotte 87
Greer, Germaine 192
Greer, Howard (1886–1974; b. Nebraska, USA) 147
Grès, Madame (Germaine Emilie Krebs: Alix/Alix Barton; 1903–93; b. Paris, France) 76, 93–4, 101–2, 106, 158
Gross, Valentine 58
Gruau, René *104*
Grunge look 252–4, *255*
Gucci 267
guêpières 128
Guild, Shirin (1946–; b. Tehran, Iran) 255, *262*
Guinness, Lulu 269, *276*
Gunning, Anne 155
Gunther 48

H-line 131
Hachi 231, *239*
hair colourings 17
*Hair*, musical 192–4, *204*
hair-pieces 22, 17
hairstyles: men's 43, 153, 211, 222, *184*, *186*, *204*, *220*; women's 17, 22, 59–60, 90, 97, 116, 156, 184, 188, 189, 213, 222, 234, *7*, *30*, *65*, *166*, *174*, *200*, *204*, *226*, *229*
Hall, Jerry 213
Halston (Roy Halston Frowick; 1932–90; b. Des Moines, Iowa, USA) 205, 206–7, *216*
Hamnett, Katharine (1948–; b. Kent, England) 228, 256, *235*, *236*
Hamnett, Nina 79
handbags *see* bags
Handley, Seymour, Mrs 28
Haring, Keith 226, *232*
Harlow, Jean 90
*Harper's Bazaar* 128, *81*, *103*
Harrods 20, 216, *12*
Hartnell, Norman (1901–79; b. London, England) 62, 76, 96–7, 140–1, *105*, *151*

Harvey Nichols *150*
haute couture, decline of 158–60, 194
Hawes, Elizabeth (1903–71; b. New Jersey, USA) 78, 122–3; *Fashion Is Spinach* 123
Head, Edith (1899–1967; b. Los Angeles, Calif., USA) 88, *174*
headgear: Edwardian 30, 36, *1*, *12*, *13*, *15*, *17*, *18*, *21*, *23*, *30*, *31*, *35*; First World War 50, 47, 48, 49, *50*; post-First World War 60, 85, 88, 99, *51*, *61*, *62*, *71*, *99*, *100*, *102*, *108*; Second World War 104, 107, 110–11, 120; post-Second World War 156–7, *145*, *150*, *152*, *164*, *165*; sixties 168, 169, 170, 184, 186, *179*, *198*; seventies 195, 207, 208, *209*; eighties 228, 231, 233, 243, *228*, *235*, *242*, *245*; nineties 266; men's 42, 43–4, 45, 92, 115, 151, *1*, *40*, *41*, *43*, *44*; Surrealist 99, *108*
Hearst, Mrs William Randolph 147, *148*
Heim, Jacques (1899–1967; b. Paris, France) 66, 101, 106, *93*
Heller, Richard 62
Helleu, Paul 22, *14*
Helvin, Marie 213
Hemmings, David 188
Heng, Marius 7
Henri Bendel 20, 48, 184, 208
Henry Poole 43
Hepburn, Audrey 156, 162–5, *174*
Hepworths 115, 174, 175
Hermès 232–3, 241, 267
Highland dress, fashion influences 216
Hilfiger, Tommy (1952–; b. USA) 266, 273
Hippie movement, influence on dress 192–4, 210–11, 220, 252, 219
Hiroko (Matsumoto) 169, *179*
hobble skirts 41, *36*
Holah, David (1958–; b. London, England) *see* Body Map
Hollywood: influence on fashion 87–92, 96, 116, 119, 153, 191, *98*, *161*, *162 see also* film stars
home dressmaking *74*, 110, 140, *92*
*Honey* 182
Hope, Emma (1962–; b. Southwick, Hampshire, England) 228
Hopper, Denis 211
Hornby, Lesley *see* Twiggy
Horrockses, cotton dresses *149*
hosiery *see* stockings; tights
hot-pants 205, 250, *214*
Howell, Margaret (1946–; b. Surrey, England) 229
Hoyningen-Huene, George 66, 93, *72*, *89*, *103*
Hulanicki, Barbara (1936–; b. Palestine, of Polish parents) 181, 217

*i-D* 224, 230
Iman 213
Incorporated Society of London Fashion Designers 112, 140, *114*
Irene (Irene Lentz Gibbons; 1901–62; b. Brookings, S. Dak., USA) 147

Isogawa, Akira 270
Italian fashion industry: Second World War 116–18; post-Second World War 144–5, 151; sixties 171–4; seventies 192, 201–5; eighties 243–7, *249*, *250*, *251*, *252*; nineties 259–60, 265, 266, 267
Ivy League style 175

Jackets: leather 153, 211, 220, 222, 266–7, *161*, *170*, *220*, *275*; men's 46–7, 92, 109, 151, 173, 175, 176, 209, 243, *38*, *280*; women's 50, 54, 72, 85, 96, 101, 112, 118, 119, 134, 162, 166, 209, 230, 243, 250, 265, *68*, *109*, *112*, *114*, *123*, *147*, *176*, *192*, *194*, *233*, *245*, *249*, *268*, *269*
Jackson, Betty (1949–; b. Backup, Lancashire, England) 226
Jackson, Linda 242
Jacob, Mary Phelps 55
Jacobs, Marc (1960–; b. New York, USA) 250, 252, 266, 267
Jacobson, Jacqueline and Elie 182–3
Jacqmar 111, 216
Jaeger 216
James, Anne Scott 140
James, Charles (1906–78; b. Sandhurst, England) 101, 106, 118, 147–8, *2–3*, *111*, *112*, *155*
Jane & Jane 216
Jansen 68
*Jardin des modes* 176
Jeanmaire, Zizi 154
jeans 153, 208–9, 243, *263*
Jelmini, Rosita (1932–; b. Varese, Italy) 204 *see also* Missoni
Jenny 62
jerkins 176, *204*
jewelry 32, 65–6, 97, 121, 207, 230, *70*, *152*, *246*, *273*
Johnson, Betsey (1942–; b. Hartford, Conn., USA) 183–4, 208, *193*
Johnson, Beverly 213
Jones, Pat 185
Jones, Stephen (1957–; b. West Kirby, Liverpool, England) 228
Jones, Terry 230
Joseph (Joseph Ettedgui; 1937–; b. Morocco, North Africa) *234*
Jourdan, Charles (1886–1976; b. France) 186
Jourdan, Louis 157
jumpers 52, 109 *see also* sweaters
jumpsuits 186, 196, 197, *216*
Jungle JAP 200

Kamali, Norma (Norma Arraez; 1945–; b. New York, USA) 248, 250, 256
Karan, Donna (Donna Faske; 1948–; b. Forest Hills, N.Y., USA) 233, 248–9, 254, 266, 269, *274*
Kawakubo, Rei (1942–; b. Tokyo, Japan) 233, 234, *240 see* Comme des Garçons
Kayser Bondor 153
Kee, Jennie 242
Kennedy (later Onassis), Jacqueline 184, 185, 204, 206, *194*
Kenzo (Kenzo Takada; 1939–; b. Himeji, Japan) 200, 224, *209*

Keogh, Lainey (1957–; b. Dublin, Ireland) 270
Keppel, Alice 22
Kerouac, Jack 153
Kestos 87
Khanh, Emanuelle (1937–; b. Paris, France) 182
Kiam, Omar (Alexander Kiam; 1894–1954; b. New York, USA) 62
Kidman, Martin 226, 234
King, Muriel 78
Klein, Anne (Hannah Golofski; 1923–74; b. New York, USA) 249
Klein, Calvin (1942–; b. New York, USA) 205–6, 233, 248, 266, 269, 253, 259
Klimt, Gustav 273
Knapp, Sonia 168
knickerbockers 177
Knight, Nick 241
knitted garments 52, 69, 72, 75, 110, 194, 204–5, 209, 216, 226, 242, 245, 250, 266, 118, 119, 210, 211, 212, 234, 255, 266, 267
Kors, Michael (1959–; b. Long Island, N.Y., USA) 266, 269
Kozel, Ina 251
Kraus 129
Krizia 204–5
Kurzman 48
Kwan, Nancy 189

labour force 258; sweatshops 19, 46, 10
lace 12, 14, 24, 32, 50, 58, 80, 135, 241, 265, 269, 105, 113, 225, 247
Lachasse 76, 142
Lacroix, Christian (1951–; b. Arles, France) 239–41, 247
Lady Jane 180, 190
Lady's Realm 20
Lagerfeld, Karl (1938–; b. Hamburg, Germany) 198–200, 204, 228, 238–9, 252, 246
Lake, Veronica 116
Lalanne, Claude 195
Lamour, Dorothy 88
Lang, Helmut (1956–; b. Vienna, Austria) 262, 269
Langtry, Lillie 22
Lanvin, Jeanne (1867–1946; b. Paris, France) 57–8, 62, 67, 74, 106, 191, 57
Laroche, Guy (1921–89; b. La Rochelle, France) 200, 204, 266
Lastex (Latex yarn), underwear 80
Laszlo, Phillip de 22
Lategan, Barry 230
Latin-American styles 120
Lauren, Ralph (Ralph Lipschitz; 1939–; b. New York, USA) 207–8, 209, 233, 248, 254, 266, 269, 254
Laurens, Henri 76
Lawrence, Gertrude 61
layered-look clothes 195, 200, 250, 252, 231, 262
leggings 212, 250
Legroux 137
Leiber, Judith (Judith Peto; 1921–; b. Budapest, Hungary) 269
leisurewear 46–7, 81, 88, 92, 126,
145, 150, 151, 175, 180, 212–13, 222, 250, 100, 255, 274
Lelong, Lucien (1889–1952; b. Paris, France) 67, 93, 96, 101, 103, 106, 128, 162
Lenglen, Suzanne 66–7, 69, 71
Lennon, John 212
leotards 122, 172, 212
Lepape, Georges 58, 104
Lesage, Albert (1888–1945; b. Paris, France) 76, 98, 100, 135, 136, 270
Leser, Tina (Christine Wetherill Shillard-Smith; 1910–86; b. Philadelphia, Pa., USA) 121
'Letty Lynton' dress 88, 98
Levi Strauss 208
Leyendecker, J. C. 39
Liberty & Company 24, 27, 265
Lindbergh, Peter 265
Lobb, shoemakers 43, 157
Loewe 266
London: Edwardian 10, 14, 27–8, 36, 43–4; post-First World War 70–1, 76–8, 82, 84–5, 84; Second World War 104, 108–16; post-Second World War 140–4, 150–1; sixties 158, 177–82; seventies 212–19; eighties 220–2, 224–32; nineties 264–6; the 'Season' 141–2
London College of Fashion 217
Lord & Taylor 78
Lord John 180, 189
Louis, Jean (Jean Louis Berthault; 1907–97; b. Paris, France) 185
Louis Vuitton Moet Hennessy (LVMH) 238 see also Vuitton, Louis
Louiseboulanger (Louise Melenotte; 1878–c. 1950; b. Paris, France) 62
Lucas, Otto (1903–71; b. Germany) 157
Lucile (Lady Duff Gordon; 1862–1935; b. London, England) 36–40, 57, 33, 58
Luna, Donyale 171
Lycra 191, 212–13

McCall Pattern Company 74, 140, 192
McCardell, Claire (1905–58; b. Frederick, Md., USA) 78, 121–2, 148–9, 156, 157
McCartney, Stella (1971–; b. London, England) 266, 272
MacDonald, Julien (1972–; b. Merthyr Tydfil, Wales) 265–6, 266, 270, 277
McFadden, Mary (Josephine McFadden; 1936–; b. Maryland, USA) 208, 217
McLaren, Malcolm 220, 224, 225, 226
McNair, Archie 177
McQueen, Alexander (1969–; b. London, England) 254, 264–5, 266, 269, 270, 271
Macy's 88
Madame Doret 72
Madame Récamier style 32
Madonna 237
mail order 18, 20, 54, 90
Mainbocher (Main Rousseau Bocher; 1891–1976; b. Chicago, USA) 78, 101, 106, 122, 147, 86, 154
Maison Jacqueline 48
'Make-do and Mend' campaign 115–16, 126, 127
makeup 15–17, 22, 60, 90–2, 116, 154–5, 160, 188–9, 213, 217, 222, 234, 256, 262, 6, 128, 162; leg makeup 109, 117
Man Ray 66, 93
Mandelli, Mariuccia 204 see Krizia
Mangone, Philip 120, 122
Margiela, Martin (1957–; b. Genk, Belgium) 260, 267
Margueritte, Victor, La Garçonne 58, 59
Marlborough, Consuelo, Duchess of (née Vanderbilt) 22, 14
Marni 270
Marriott, Steve 184
Mars Manufacturing Corporation 191
Marshall Field 139
Marshall Plan (1947) 126
Martial et Armand 57
Martin, Richard 200
Marty, André 58
Mary Janes (shoes) 166
Mascotte 28
Mattli, Giuseppe (1907–82; b. Locarno, Switzerland) 76
maxi styles 191, 192, 205, 206, 224
MaxMara 243
Maxwell, Vera (Vera Huppé; 1903–95; b. New York, USA) 121
Men's Dress Reform Party (MDRP) 71, 71
metallic garments 170–1, 244–5, 269, 171
Metro-Goldwyn-Mayer (MGM) 87–8
Meyer, Baron de 66
micro-fibres 258, 273
midi styles 192, 205, 206
Miller, Lee 125, 89, 114, 134
Millett, Kate 192
Millings, Dougie 176
mini dresses and skirts 158, 167, 170, 178, 192, 222, 187, 188, 201, 206
Miranda, Carmen 90
Mirman, Simone (Simone Parmentier; c. 1920–; b. Paris, France) 157, 165
'Miss Hollywood' 90
Missoni, Ottavio (1921–; b. Dalmatia, Yugoslavia) 204, 245, 260, 211, 212, 252
Miyake, Issey (1938–; b. Hiroshima, Japan) 200–1, 233, 255, 260
Mizrahi, Isaac (1961–; b. New York, USA) 266–7, 269, 275
'Mod' clothes 174, 252, 183, 184
Mode und Heim 115
models 60, 155, 169, 185, 186, 187–8, 189, 213, 244, 258, 89, 150, 179, 197, 198, 199
Les Modes 20, 50
Moffitt, Peggy 171, 186, 197
Molyneux, Edward (1891–1974; b. London, England) 61, 62, 74, 76, 101, 104, 106, 112, 135, 140, 144, 153
Mondrian, Piet 162, 173
Monroe, Marilyn 156, 172, 184
Montana, Claude (1949–; b. Paris, France) 238, 244
Moore, Henry 111
Mori, Hanae (1926–; b. Shimane, Japan) 200
morning coats 42, 45, 1, 12, 40, 78
Morrell, Lady Ottoline 71
Morris, Leslie 78
Morton, Digby (1906–83; b. Dublin, Ireland) 76, 104, 112, 140, 144, 122
Mosca, Bianca 112, 140
Moschino, Franco (1950–94; b. Abbiategrasso, Milan, Italy) 223, 245–6, 259, 228, 280
Moss, Kate 258, 259
mother-and-daughter dresses 58, 57
motoring dress 30, 46, 151, 25
mourning dress 24, 52, 91
Mr Freedom, boutique 217
Mugler, Thierry (1948–; b. Strasbourg, France) 224, 237, 243
Muir, Jean (1933–95; b. London, England) 181, 198, 213, 216–17
munitions workers' dress 54–5

Nast, Condé 48, 50
Nattier 167
necklaces 65–6, 121, 5, 66, 152
necklines 52, 64, 69, 81, 114, 134, 149, 167, 168, 219, 234, 144, 151, 194, 216, 223, 249, 274
neckwear 44, 92, 153, 174, 42, 160, 263, 269
Neiman Marcus 20; Fashion Awards 130, 204, 208
neo-Edwardian look for men 150
neo-Victorian styles 96–7
neoprene 258
Nestlé, Charles 17
New Age influences on fashion 254, 256, 261
'New Look' 128–31, 135
Newton, Helmut 205
Nijinsky, Vaslav 27
Nirvana, pop group, 'Grunge' and 252
Norell, Norman (Norman Levinson; 1900–72; b. Noblesville, Ind., USA) 120, 147, 149–50, 184, 158
Nostalgia of Mud, boutique 225
Nova 205
Nutter, Tommy (1943–92; b. London, England) 212
nylon 104, 153, 159 see also synthetic fabrics

'off-the-peg' see ready-to-wear
O'Hara, Mollie 48
Ohrbach 185
Oldfield, Bruce (1950–; b. London, England) 231
Omega artists 79
OMO (On My Own), boutique 250
Onassis (previously Kennedy), Jacqueline 184, 185, 204, 206, 194
Ono, Yoko 212
Op Art, influence on fashion 169, 213
Orhozemane, Mounia 213
oriental influences 32, 88, 101–3, 200–1, 233–4, 251, 254–5, 260, 34, 68, 210, 241, 251, 260, 262, 268
Orlon 198
Orry-Kelly (John Kelly; 1897–1964; b. Kiama, New